SECOND EDITION

Democracy & DIFFERENCE

Through the Aesthetics of Film

RICHARD TAHVILDARAN-JESSWEIN

One-Time
Online
Access Code
Included

HELP!
Need money
God Bless You

Kendall Hunt
publishing company

MW00770445

Cover image © Shutterstock, Inc. Used under license.

Kendall Hunt
publishing company

www.kendallhunt.com
Send all inquiries to:
4050 Westmark Drive
Dubuque, IA 52004-1840

Copyright © 2010, 2018 by Richard Tahvildaran-Jesswein

PAK ISBN: 978-1-5249-0082-3
Text ISBN: 978-1-5249-4194-9

Kendall Hunt Publishing Company has the exclusive rights to reproduce this work,
to prepare derivative works from this work, to publicly distribute this work,
to publicly perform this work and to publicly display this work.

All rights reserved. No part of this publication may be reproduced,
stored in a retrieval system, or transmitted, in any form or by any
means, electronic, mechanical, photocopying, recording, or otherwise,
without the prior written permission of the copyright owner.

Printed in the United States of America

for Nova and Zane

Contents

Preface

Can *we*, some identifiable and politically salient *we*, envision U.S. democratic politics across difference lines? The density and complexity of this question suggests an awkwardness and an arrogance in even thinking for a moment that a clear-cut answer might be available to us. However, this awkwardness and fear of being arrogant has not discouraged me from pushing forward in my own development of a discussion that might, in some small way, inform and contribute to a greater understanding of the importance in asking this question and in aiding my own local and personal endeavors at understanding the self.

Acknowledging the troublesome nuances associated with suggesting that a helpful answer might be available uncovers a host of more complex and ambiguous questions. In hoping to envision such a democratic politics of difference I must assume that such a politics—and a sound space in which it can be located—is credible, even if yet unimagined. Suggesting that it might be possible to cut across difference lines implies that it is possible for democratic reconciliation to triumph over seemingly irreconcilable differences, to cut across if not eliminate them. Asking whether we might be able to transcend difference, without eliminating or erasing it, and thus allow some *we* and numerous *theys* to engage and respect the ambiguities of difference within the context of difference is a better suited endeavor. Thus, full and complete reconciliation should not be expected nor sought after. Instead, the possibility of a democratic politics of difference should inform, and possibly transform, one's sensibilities; that is, affecting how we see difference and how we view the question as to whether *we* can envision U.S. democratic politics in ways that both respect and transcend difference lines.

The "*we*" in this query is incredibly consequential to our understanding the importance of the overall question. Who are *we*,[1] Americans, as a group of diverse individuals and what political difficulties are *we* facing as peoples living in the United States at the start of the millennium? This "*we*," whether as his/herstorically located individuals or as people with a strongly shared identity, is at the center of our national, state, and local politics; at the heart of our extended and nuclear and nonconventional families, and at the heart of my work. And this "*we*," in large part, is somehow present in a visible place where U.S. democratic politics operate justly, where difference ebbs and a notion of a common community flows, where a single political identity is sought after and, on occasion, privileged. Believing in this "*we*" can at times be harmful as it reinforces an "us" versus "them" mentality; where those who find themselves outside the dominant "*we*" may be relegated to the margins and made Other.

Through acts of deconstruction we may find common places where we are able to transcend difference and engage in democratic politics. I was born in 1968 to a Christian mother, an often-absent Muslim father, and to a poverty that was only somewhat alleviated by AFDC[2] and public housing. Early on,

[1] Who is this "*we*"? Is there a single identity required for this "*we*"? And, what might some of the consequences be of a common political sense of self? For example, in my home state capital punishment is an accepted and legal form of "justice." When a criminal is charged, prosecuted, and put to death it is all done under the "legitimate" heading of "*we*" the people of the "Great State of California," regardless of whether all of us making up that "*we*" believe capital punishment to be moral, fair, or just. These are important and serious questions, especially when we consider the complex notion of difference.

[2] *Aid to Families with Dependent Children*, a federal direct-cash assistance program. This program no longer exists.

I recognized the difference of my dark Muslim father, and I learned to appreciate the importance, the comfort, of assimilation as I was called "Amir the queer" and "sand-nigger." For me, it became easy to become a part of the "*we*"; it became easy to become Richard with my light skin, to become a conservative so as to hide my welfare associations, to become a Christian so that I could reconcile the American myth with reality. However, for most people who live in the framework of difference, it is not so easy to become a part of the *we*, one with, and of, the social majority.[3] And at the beginning of the twenty-first century, when more and more people[4] who live on the margins of our uncertain and ambiguous "*we*" society begin to claim their too-often denied political selves, the question of, "Can *we* envision U.S. democratic politics in ways that both respect and transcend difference lines?" takes on a heightened importance as well as posing a significant threat. In other words, the question is important if we as a nation wish to maintain a traditional sense and structure of a U.S. democracy while also protecting ideals[5] that are synonymous with that sense and structure. If we find that we are unable to envision U.S. democratic politics in ways that respect and transcend difference lines, I suspect that a prominent understanding of our political, social, and cultural selves will be justifiably threatened; that is, if we are unable to reconcile our differences, and thus the ways in which we see ourselves and others who are not like ourselves, we will be forced to re-examine deep differences within the rhetoric of an American myth—specifically, the notion that there is in existence a basic fundamental understanding of what it means to be an "American" where the presence of a reasonably clear democratic politics that is just and fair, that is open and respectful of difference, is visible or within reach.

Those of us born toward the end of the 1960s, born into a generation that is often referred to as Generation X[6], a generation without a sure sense of self, without the primary motivation to succeed financially or professionally in a material world—slackers—we often found ourselves untested (uninterested) in the realm of U.S. democratic politics and without a clear understanding of our collective political, social, and cultural selves. We did not stormed the beaches of Normandy, nor did we burned our draft cards on the steps of the state capitol or march on the Mall in Washington, D.C. for civil rights. Yet many questions about difference and U.S. democratic politics have been put aside by the older generations of Americans who did these things, only to be left for another day, another generation. And in keeping with the stereotype of Generation Xers, if it were possible to maneuver through this

[3] I am not suggesting nor do I mean to imply that all individuals who find themselves on the margins of a dominant *we* society wish to become one with, and of, the dominant; on the contrary, as I discuss in Chapter One there are many "homeplaces" and "enclaves of resistance" to this dominant *we*. This does not erase the fact, however, that a power of assimilation exists within our U.S. society. This power has prompted discussions and efforts at recovery by those who have had their identity and experiences silenced and/or erased by a dominant cultural hegemon (note, Toni Morrison's work on "rememory," *Beloved*, 1988).

[4] Here I mean to represent individuals who find that their identity, their sense of themselves, somehow and in a variety of ways, is incongruent with a larger assumed and often proclaimed national, "American-self." For example, there are in existence identities that are considered by a dominant public to be peripheral, and often unacceptable. Much of an urban black youth culture is considered to be dangerous and out of control by a dominant white suburban culture, while a gay sub-culture is often, as of late, described as prurient and immoral by those who help to define dominant culture and public policy (e.g., leave former Senate Majority Leader, Trent Lott, and his description of homosexuality as an infliction not unlike kleptomania and alcoholism) and the anti-gay stances of vice President, mike Pence).

[5] By ideals I mean to suggest those tightly held beliefs centering around one's right to express, freely, him- or herself, and thus, live a life that is safeguarded from those tyrannies that erupt in a society where difference is not tolerated and where the imagining of the self, outside the accepted framework of a dominant cultural understanding of self as citizen, is not only frowned upon, but prohibited and punished in both official and unofficial ways (e.g., modern day Islamaphobia).

[6] The term "Generation X" was coined by Douglas Coupland in his first novel, *Generation X: Tales for an Accelerated Culture*, 1991. The term quickly took hold, to the chagrin of many of those young people who found themselves depicted as underemployed, overeducated, intensely private, and unpredictable. Coupland's characters are intended to be representative of the generation at large; that is, "they have nowhere to direct their anger, no one to assuage their fears, and no culture to replace their anomie." Coupland is also credited with coining the term, "McJob"—"A low-pay, low-prestige, low-dignity, low-benefit, no-future job in the service sector" (5).

life without confronting those questions, we would. However, the new millennium and the millennial generation may not allow for us to clack on this one, and this "Reagan Generation"[7] will be forced to deal with serious critiques of the American experiment[8] and the ire of a younger millennial generation angry at our paralysis; that is, questions directed at democracy, difference, and politics. How should we respond to those critiques? How should we respond to the question: Can *we* envision U.S. democratic politics in ways that both respect and transcend difference lines? In our response we will draw from our own experiences and our own politics—regardless of whether clearly defined.

I suggest we turn to personal narratives, storytelling, as we attempt to envision democratic politics in such ways. I learned about politics when I was sent out of the family room because there was Vietnam War coverage on our television. I learned about politics by cheering for Luke Skywalker as he battled Darth Vader's Imperial forces.[9] I was inspired to learn about politics from the exhilaration I shared with Norma Rae[10] as she stood on her workstation demanding workers' rights. Later, television and films exposed me to a more complex politics; that is, a politics that couldn't be pushed away from

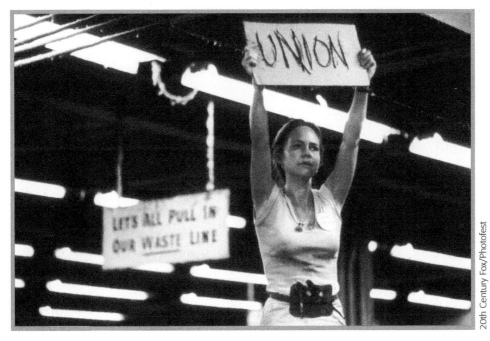

20th Century Fox/Photofest

Norma Rae, 1979

[7]Coupland's definition of Generation X describes those individuals coming-of-age during the Reagan era (U.S. President, Ronald Reagan. Note, however, that Reagan's political philosophies were shared by other world leaders, Western world leaders, in England, France, Germany, and Canada. Coupland is Canadian.). I employ the term "Reagan Generation" as a complement to Coupland's "Generation X." I do this so to underscore the supposed feel-good era of excess, while recognizing its partnership with a current-day set of problems that have themselves informed how many young people, Gen Xers, feel about themselves, others, and the life-chances that lie before them.

[8]Often, American government, and thus American democracy, is referred to as an experiment. This stems from the country's founding and the principle documents defining a U.S. philosophy of governance, *The Declaration of Independence*, *The Federalist Papers*, and *The Constitution*. My use of the term is meant to inform how a "Reagan generation" and perhaps the millennials who follow will be forced to confront many of the long-standing critiques of American democracy, an experiment of governance; specifically controversies surrounding notions of inequality and injustice, forces that have historically been enacted upon those who reside outside a dominant we culture (remembering that "All men are created equal" has meant a lot of different things over our brief, but historically rich, national life span).

[9]*Star Wars* (U.S.A., 1977).

[10]*Norma Rae* (U.S.A., 1979).

or ignore difference—different experiences, different places, and different ways of life; difference that not only challenged my socialized perceptions of the "*we*," but came to inform it as well. And I suspect that for many of my peers, and most millennials, visual imagery, and especially film, has also been a significant contributor to the socialization and/or construction of the self and a tool for understanding our world and our politics.

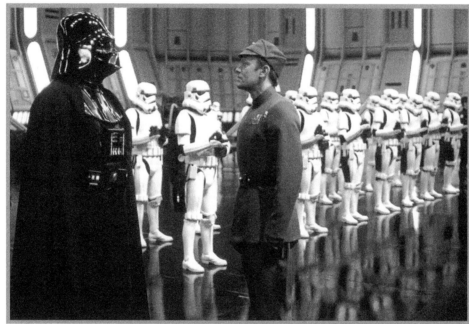

Star Wars, 1977

I have chosen film, cinema, in this work in order to theorize difficult questions regarding democracy and difference. There are, however, many points of caution in choosing to use film. Films often can reinforce and affirm stereotyped and demeaning images of others; that is, film is as effective a tool for installing as it is for challenging and overcoming oppression. However, as I write in Chapter One, the fictionalized realism of film can allow for a sharing of the different experiences that individuals live through and can serve as a helpful tool to uncover the raw materials that make up our various social or cultural identities. In other words, and more specifically, film and film criticism facilitate the search for a location from which to envision a democratic politics in ways that are respectful of difference and that quite possibly can contribute to the transformation of one's sensibilities by providing an opportunity to theorize and imagine a new or emerging politics from a position of eyewitness.

What follows is a consideration of these questions. Can *we* envision U.S. democratic politics in ways that both respect and transcend difference lines? The question must be pursued in a world, in a country, where our different understandings of ourselves continually threaten to confuse us and to tear us apart. How does the advocate for gay rights converge on a political stage and interact with the Christian Coalition conservative and manage not to get bloodied by a dominant Christian force? How does a poor woman of color converge and address serious public policy issues on a political stage with her white Republican representative and manage to be recognized and thus respected and protected, even celebrated? How does a black woman conservative converge on a Senate Judiciary committee hearing, charging sexual harassment against a white conservative president's Supreme Court nominee, and manage to walk away respected and recognized by those committee members and with her dignity

intact? Or, perhaps the question we should be asking is whether these questions are, at this time, of compelling importance? In other words, by asking how to avoid a politics of separation, conflict, and confusion through a yet-undetermined reconciliation of difference and a particular vision of transcendence, the assumption is made that a politics of separation should be shunned at all costs. Another intriguing and provocative question is unearthed.

The social, political, and aesthetic implications involved in answering these questions, while complex and diverse themselves, now require our attention. I intend to pursue these questions and look for, struggle for, an envisioning of a political space that may transcend lines of difference—while not discrediting or devaluing the richness or the importance of difference.

Key word: Difference

"us"

"Other"

The (In)Visibility of Difference

Institutionalized rejection of difference is an absolute necessity in a profit economy which needs outsiders as surplus people. We have no patterns of relating across our human differences as equals. As a result, those differences have been misnamed and misused in the service of separation and confusion.

Audre Lorde *(Sister Outsider, 1984)*

As we, middle-North-Americans,[1] settle into the new millennium, it becomes more and more apparent that our sense of ourselves, and the groups we identify with, often stand in stark contrast to one another. This social heterogeneity within our national borders complicates and challenges a traditional socialization and understanding of what it means to be an American in a cultural sense.[2] With this in mind, it does not seem farfetched to suggest that present understandings of difference may prevent us from arriving at a differently shared collective location—a unifying (un)common place—from which we might do our particular not-yet-named brand of democratic politics, U.S. democratic politics.[3] I am not suggesting that an all-encompassing collective location or universal unifying common place currently exists, or is yet imaginable: It is difficult to imagine such a place within the confines of our present social and cultural environment. While I do not believe that an all-encompassing collective location or universal unifying common place currently exists, or is yet imaginable, I am committed to an exploration into its possibilities. In other words, I am intrigued by the thought that one might

[1] I use the term "middle-North-Americans" to differentiate U.S. residents from residents of other nation-states geographically located in the Western hemisphere. This usage is intentional so as to be sensitive and avoid what is often referred to as an "American arrogance" when we refer to ourselves as Americans, in an exclusive sense. I do not mean or intend to speak for or about Canadians or Mexicans.

[2] The process by which people acquire views and orientations about cultural and political life. Through cultural and political socialization, individuals adopt general as well as specific beliefs, feelings, attitudes, and values concerning cultural norms and the political system, and their role in it. Socializing agents in the United States include the family, the educational system, the mass media—the cinema, religion, clubs, organizations, friends, and other elements in society to which the individual is exposed in some culturally or politically relevant way. (Plano and Greenberg, *The American Political Dictionary*, 1993)

[3] As a political system, American democracy starts with the assumption of popular sovereignty, vesting ultimate power in the people. Theoretically, in the modern pluralistic democratic state, power is exercised by groups or institutions in a complex

be able to transcend difference, while at the same time respecting and honoring it, and uncover some shared experience(s) that may affect one's sensibilities.

I am not suggesting that variations, simple differences, in hair and eye color, accent or dialect, or likes and dislikes of art and music are prohibitors of democratic politics, although art and music can be quite telling and intriguing. Rather, it appears that in our search for identity—whether that search be an individual or collective one—we as a diverse people are continually involved in differentiating ourselves from one another on very deep levels. Thus the emphasis should be on *deep* differences in our cultural and social identities, specifically our culturally constructed identities stemming from sexual orientations, racial classifications, and gender assignments or constructions. These differences inform and enable us to see the world in specific ways, in ways that are far more complicated than those that arise in a culturally homogeneous community or society.[4] In other words, I am interested in probing further and deeper into the understanding of strong cultural or social difference than the traditional liberal conception of this complex concept and its particular focus on differences of opinion that are mediated through procedural and electoral politics.[5] I want to align myself with theorists who call for a re-introduction of the body, a culturally produced body, back into our politics and our understandings of ourselves. For example, Jean Cohen (*Democracy, Difference, and The Right of Privacy*, 1996) writes, "By this I mean that our bodies, our symbolic interpretation of our bodies, our imaginary identification of our bodies and selves, and our sense of control over our bodies are central to our most basic sense of self, to our identity and our personal dignity" (Cohen, 1996: 205). By directing the attention to difference away from a traditional liberalism (and its focus on a procedural framework that erases the face of an individual with a strong social identity, leaving only the mark of citizen as an individual who bargains) and toward a body politics (our sexualities, our color, our genders—our experiences), I hope to begin a process of imagining the possibilities, and then explore those possibilities, for a unifying (un)common location that allows for a just democratic politics; that is, a politics that recognizes and respects difference and aims at connecting one kind of experience with another while ensuring the rights and welfare of all society's members.

There is an inherent power in imagination. By setting aside that which we often consider to be real—perhaps experiences that are thought to be personally exclusive and in some neat way catalogued within the realm of what is conventionally considered to be rational—and allowing our sensibilities to

(continued)

system of interactions that involve compromises and bargaining in the decision process. The [dominant U.S.] "democratic creed" includes the following concepts: (1) individualism, which holds that the primary task of government is to enable each individual to achieve the highest potential of development; (2) liberty, which allows each individual the greatest amount of freedom consistent with order; (3) equality, which maintains that all persons are created equal and have equal rights and opportunities; and (4) fraternity, which postulates that individuals will not misuse their freedom but will cooperate in creating a wholesome society. The term politics is often defined by the means or processes by which decision-making and decision-implementation are carried on within and between societies. Ideally, every social group through the activity of 'politics' decides who shall receive benefits and who shall pay the costs. Politics is closely associated with the exercise of influence and the struggle for power that characterizes every political system. (Plano and Greenberg *The American Political Dictionary*, 1993)

[4]Recognizing that such a community or society may not exist, but also keeping in mind that there are more homogeneous societies than ours—the United States (e.g., Japan, China, Korea).

[5]My aims are to identify and then recognize and legitimize deep differences that exist in our culture and that inform the construction of the self and the polity. A traditional liberalism ignores the significance of difference, deep differences, in that it aims at creating and protecting citizenship and rights. Difference is encouraged when it is mindful of the overall epistemological underpinnings of liberalism (John Stuart Mill); however, difference outside this framework is not recognized. Rather, an individual is seen primarily as a citizen and a member of a community that comes ready-made when rights and procedures are privileged.

be transformed in ways that aid in our feeling freer to imagine ourselves and others in (un)common ways, where quite distinct moments in our memories, in our imaginations, connect with those distinct moments in Others memories and imaginations, we position ourselves and our discussions and conversations regarding *deep* differences in our cultural and social values on a level other than that which has been established by a traditional liberalism. At this alternative level of understanding difference it becomes necessary to alter conventional meanings of particular terms in order to open up and to transform our sensibilities, the ways in which we see ourselves and others.

In relation to this aspect of *deep* differences, I will also note the problematic and enormous effects violence has on the makeup of our social or cultural identities. For those of us confronting the questions surrounding identity and the ability to envision democratic politics in a way that both respects and transcends difference lines, violence, in its many forms, deserves our attention as well because of the ways it affects identity across difference lines: gay bashing, lynching, police violence, black-on-black and other violent crimes, domestic violence, and assimilation processes. Here again, I am suggesting a focus that goes deeper than conventional understanding of a contemporary term, violence—one that gives greater attention to nonconventional forms. I mean to suggest that assimilation, poverty, and alienation, among other acts, can invade one's self and cause direct harm. And although this harm cannot be characterized as direct physical violence in a conventional sense, it is by all means bodily harm in the manner it affects a person. I do not concur with those who claim that violence does not exist unless there is a physical act of beating someone over the head, actual physical harm. Chantal Mouffe (*"Democracy, Power, and the Political,"* 1996) describes this non-conventional threat of violence to democracy when considering the notion of a universal rational consensus and the violence involved in these aims. She writes, "Indeed, this [a universal rational consensus] can lead to violence being unrecognized and hidden behind appeals to 'rationality,' as is often the case in liberal thinking, which disguises the necessary frontiers and forms of exclusion behind pretenses of neutrality" (1996:248). Thus, many people living within what I have identified as difference circles,[6] nonlinear geometric groupings of people who sit on the margins of a dominant *we* society and identify as such, as Other—people who may reason differently than those living within a dominant *we* society—have experienced a direct violence that pervades their identity and their lives. This should be addressed. The difference circles can be seen below in Figure 1-1.

Does a just democracy rest exclusively within a homogenizing model of identity where not only the citizens' culturally produced bodies are homogeneous, but where their values are also neutral, the same? Is it possible that the ideal of a universal democratic U.S. citizenship accommodates difference? Can we hope for a democracy that moves beyond exclusive attention to rights and procedure and recognizes, as well as respects, difference in substantive terms through recognition? In other words, can we improve upon our democracy by incorporating alternative and nonconventional ways of looking at and recognizing difference? Democratic rights and procedures are worthwhile, yes, and necessary to our democracy; however, directing the study of difference into additional spaces will only complement conventional arguments and thus strengthen U.S. democracy. While the divide of difference is not new to the United States—cultural diversity has been paramount to the

[6]I use the term *difference circles* so to group, in a nonlinear fashion, people who are on the margins of a dominant *we* society. For example, African Americans with their experience(s), both historical and contemporary, may constitute a difference circle. I am not suggesting, however, that all African Americans be placed, or choose to be placed, within such a specific designation. Nor do I mean to imply that someone outside of an African American experience has the power to segregate African Americans (or others) in a difference circle and thus define a group of people as Other. Rather, I mean to conceptualize difference in a manner that is respectful of an inherent complexity, in that it is nonlinear, yet in a way that is also tangible.

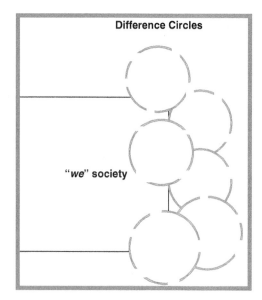

Figure 1-1 Difference Circles.

American myth[7] and the topic of liberal scholarly investigation for some time—it appears to be more pronounced at the far edges of modernity as people on the margins of the dominant culture claim their voices, and those not on the margins resist these efforts at recovery.

Is there a place where we as transformed citizens and residents[8] of the United States can envision and celebrate difference (sexual orientations, racial classifications, and gender assignments or constructions) without demanding or coercing assimilation, and envision a location where we can conduct, or perhaps redefine or re-imagine, a just democratic politics? Again, can we prevent a politics of separation, conflict, violence, and opposition by creating or imagining some (un)common grounds from which to freely express our diverse social and cultural identities, our sexuality, our various experiences as persons of color, and/or our genders without the threat of violence—where we can connect one kind of human experience with another? Is this possible? Or is there simply no answer to this question—leaving separatism, conflict, assimilation, violence, and opposition as the sole ways to address difference? I want to examine how the literature on difference informs these questions so that I may identify gaps in the research, and thus push forward with a search for a richer sense of identity and difference and how our politics might be affected; for example, how one's sensibilities may be affected or transformed.

IDENTITY AND DIFFERENCE: A SELECTED REVIEW OF THE LITERATURE

Satya Mohanty (*The Epistemic Status of Cultural Identity*, 1993) suggests that finding a place where we as citizens and residents can transcend difference might be possible. However, this search for a (un)common ground involves serious work directed at identifying genuine cultural differences and similarities across groups and a recognition of sorts, as well as a reexamination, of the relationship between personal experience and public meaning.[9] What is most interesting in Mohanty's work is her construction of a realist theory of social or cultural identity; specifically, the theory's focus on *experience* as "raw material"

[7]The American myth rests upon the notion of a melting pot, where all peoples regardless of differences assimilate into a dominant cultural and political system. Assimilation is problematic for some peoples; specifically for peoples of color who find assimilation impossible because of the color of their skin. This can cause serious and harmful psychological damage as well as perpetuate discrimination and prejudice.

[8]My work does not differentiate between "citizen" and "resident." I recognize that only citizens are privileged with certain U.S. democratic and Constitutional rights; however, for the purposes of this study there is not a line drawn in order to separate the two concepts or individual designations.

[9]Jean Cohen (*Democracy, Difference, and the Right of Privacy*, 1996) suggests that we "rethink" privacy rights and the public/private dichotomy that has informed and reinforced particular social hierarchies and inequalities in thought— e.g., How do our personal experiences translate into the public domain? Mohanty focuses on Toni Morrison's *Beloved* (1988); specifically, Sethe's murder of her child as a personal experience and how the public domain relates to this personal experience—recognizing the density of both while endeavoring to locate common grounds.

for the construction of identities. She defines identities as "theoretical constructions that enable us to read the world in specific ways. For it is in them and through them that we learn to define and reshape our values and our commitments, that we give texture and form to our *collective* futures" (55). Mohanty's questioning of identity involves a reexamination of the relationship between personal experience and public meaning. She argues that the relationship between experience and identity is a genuine philosophical and theoretical issue to be addressed. And that experience, the variety of ways in which humans process information, is the raw material in the creation of the self, identity. Our experiences, according to Mohanty, are not ours alone; rather, our experiences are shared with others, and in order to recover ourselves we must uncover our shared experiences. Her assertions are important to any search for a democratic politics aimed at recognition and respect of difference in that a realist theory of identity informs any work at connecting one kind of human experience with another.

This notion of social or cultural identity suggests that ownership of ourselves is not purely an individual affair, rather there is a differently shared collective identity that materializes after we gain access to the buried memories and experiences of those who might have shared our lives and experiences. Alasdair MacIntyre (After Virtue, 1984) would concur by explaining how we are merely co-authors[10] of our own narratives. By suggesting that we are storytellers, MacIntyre claims our co-authored stories aspire to truth. Thus, Mohanty's theory seems well placed and appropriate when discussed within the confines of difference circles, as illustrated in her focus on Toni Morrison's literary text, *Beloved* (1988),[11] as well as the intersections between sexual orientations, racial classifications, and gender assignments or constructions. What she does not address directly, however, is whether a realist theory of identity, and its reliance on access to buried memories and experiences, aids us in moving beyond homogeneous difference circles or the intersections between various difference circles that sit on the cultural margins, to intersections and connections with persons not living on those margins (not gay, not of color, not female). For example, while Mohanty's work, and thus her attention to Toni Morrison's narrative in *Beloved*, suggests that by sharing and recognizing a common authorship, a common experience shared by individuals, in this case Morrison's protagonists Sethe and Paul D., a collective or partial identity can be uncovered and explored, she does not address whether such a realist theory of identity can transcend a homogeneous difference circle, a circle constructed primarily of an African American experience (in Morrison's narrative, a slave experience), to intersections and connections with persons not living on the margins and not sharing those raw materials that contribute to the creation of identity (e.g., African American experiences).

Charles Taylor (*The Politics of Recognition*, 1992) hints that this connection or recognition between the dominant social or cultural identity and those who sit on the margins may be possible. Arguing specifically for a recognition of social and cultural differences, a recognition by public institutions, Taylor asserts that human identity is created dialogically[12] in response to our interactions and relations with others. Thus Taylor claims that public recognition is essential in order to allow for a location from

[10]This suggests that we author ourselves in collaboration with society's response to us.

[11]In Morrison's text, the serious work directed at locating common ground between the two protagonists, Sethe and Paul D., and the work at reconciling personal experience with public meaning, is confined to a homogeneous difference circle—both characters are black slaves, sharing recoverable memories and experiences.

[12]Taylor writes, "The crucial feature of human life is its fundamentally dialogical character. We become full human agents, capable of understanding ourselves, and hence of defining our identity, through our acquisition of rich human languages of expression. I want to take language in a broad sense, covering not only the words we speak, but also other modes of expression

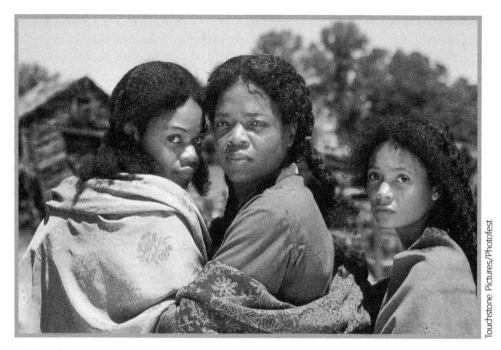

Beloved, 1998

which we can deliberate openly and publicly about those fundamental parts of our identities that we share, or potentially share, with one another. He suggests that there may be parts of our identities that we do share and these parts need to be uncovered.

In Taylor's now famous essay, he presents a host of important questions regarding the recognition of difference; specifically, he contemplates whether a democratic society can treat all of its members, citizens, fairly and justly—as equals. Should a government "try to ensure the survival of specific cultural groups"? "Is political recognition of ethnicity or gender essential to a person's dignity?" Taylor advocates for a procedural government that "nurtures" a particular culture while giving recognition to, and thus protection of the basic rights and welfare of those who sit on the margins of society. Taylor writes, "Due recognition is not just a courtesy we owe people. It is a vital human need" (1992b:26). In asserting this, Taylor and other communitarians (Benjamin Barber, Alasdair MacIntyre, Michael Sandel, Michael Walzer) appear to push a step further than Mohanty's work with an optimistic assessment about the possibility of finding or creating such a location where we can connect upon some commonalties of identity with the dominant culture and thus find a place to do a *cooperative* politics. Taylor argues that a society that is able to recognize individual identities, and the commonalties or potential for commonalties, will be a "deliberative, democratic society because individual identity is partly constituted by collective dialogues" (1992b:7). Barber, for example (Strong Democracy, 1984), would agree and suggest that it is a creative consciousness—a concept that arises out of what he calls

(continued)

whereby we define ourselves, including the "languages" of art, of gesture, of love, and the like. But we learn these modes of expression through exchanges with others. People do not acquire the languages needed for self-identification on their own. Rather, we are introduced to them through interaction with others who matter to us—significant others. The genesis of the human mind is in this sense not monological, not something each person accomplishes on his or her own, but dialogical" (32).

common talk, common decision, and common work and is premised on an active and perennial participation that aids us in this endeavor.

This is a powerful assertion as it suggests that our identities are shaped not only by the recognition, but also the misrecognition of others. In other words, nonrecognition or misrecognition can inflict direct harm on those persons who are not seen for who they are or who are characterized as something they are not. Taylor would concur as he recognizes how nonrecognition or misrecognition can cause harm, can be oppressive as it imprisons individuals in "a false, distorted, and reduced mode of being" (1992b:25). He continues, "The thesis is that our identity is partly shaped by recognition or its absence, often by the misrecognition of others, and so a person or group of people can suffer real damage, real distortion, if the people or society around them mirror back to them a confining or demeaning or contemptible picture of themselves" (Taylor, 1992b: 25). Here, MacIntyre's suggestion that the narrative concept of selfhood is twofold contributes to our discussion: "I am what I may justifiably be taken by others to be in the course of living out a story that runs from my birth to my death; and I am the subject of a history that is my own and no one else's, that has its own peculiar meaning" (MacIntyre, 1984: 217). I accept Taylor's argument, but it is important to expand upon, and thus complement, his and other's assertions regarding recognition and the ways in which we engage in public dialogue.

James Baldwin (The Fire Next Time, 1963), writing before Mohanty, Taylor, and MacIntyre, also addresses the notion of identity and specifically the powerful effects of misrecognition or being a part of a story that marginalizes particular individual and group experiences. His work focuses on the understanding of, and the movement toward, a social or cultural identity across color lines to incorporate a deeper knowledge of both black and white experiences and thus identity constructs. Baldwin's narrative is designed and presented as two letters, one to his nephew on the 100th anniversary of emancipation, and the other entitled, "Down at the Cross: letter from a region in my mind," 1963. In the first letter, Baldwin cautions his nephew that he should rely on his experience and never consider himself to be what white people have called a "nigger"; that is, Baldwin suggests an avoidance and an active struggle against the ways a dominant society sees the "Other," foreshadowing Taylor's notion of misrecognition. "Trust whence you came" is the suggestion made by Baldwin in a move to demonstrate the need for remembering who you are as a person of color, thus incorporating Mohanty's attention to buried memories and experience.

But the contribution to political theory and cultural studies comes from Baldwin's telling of how he knows the experience of Harlem, whereas the white man does not, but should. Regardless of whether that experience of knowing Harlem is good or bad for white America's psyche,[13] Baldwin argues that in order for our politics to be just there needs to be a recognition on the part of white America of this shared experience—specifically, a recognition of black identity and the fact that people of color are co-authors of the American, United States, story. Baldwin eloquently states that black people already have a sense of this experience of co-authorship since it has been their struggle for identity, in conjunction with white America's pursuit of a cultural dominance, that has structured and developed the ways they see themselves. However, Baldwin is convinced America as a whole will not survive if whites do not make the same efforts at coming to terms with their collective stories and shared experiences that have been co-authored by black America, as well as homosexual and non-male America. Baldwin writes, "Whatever white people do not know about Negroes reveals, precisely and inexorably, what they do not know about themselves . . . What it comes to is that if we persist in thinking of ourselves as one, we condemn ourselves, with the truly white nations, to sterility and decay, whereas if we could accept

[13]Baldwin was aware of the problems in recognizing one's oppressive nature, a dominant group's exercise of oppression in light of a myth that purports the acceptance of difference and the promotion of egalitarian ideals.

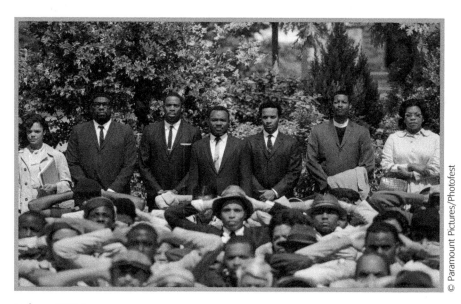

Selma, 2014

ourselves as we are, we might bring new life to western achievements, and transform them" (1963:108). In essence, Baldwin is warning against both non- and misrecognition, while at the same time calling for a collective understanding of our co-authored stories (across difference lines—black and white) so that a just democracy might be obtained.

Bell hooks (Black Looks: Race and Representation, 1992) also speaks to misrecognition in a series of critical essays on representation. She writes, "The critical essays gathered in *Black Looks* are gestures of defiance. They represent my political struggle to push against the boundaries of the *image*, to find words that express what I see, especially when I am looking in ways that move against the grain, when I am seeing things that most folks want to believe simply are not there" (1992:4). And when hooks addresses difference and the possibilities of connecting one kind of human experience with another she warns us about the obstacles to this endeavor:[14] obstacles clearly represented in her mind by the commodification of difference and the consumer cannibalism that can result from cultural tourism.[15] In Spike Lee's film, *Do the Right Thing* (U.S.A., 1989),[16] we are presented with a clear example of a commodification of black culture when an audience encounters Pino (John Turturro), an Italian American, who, when asked who his favorite athlete is, responds, "Magic Johnson"; his favorite comedian, "Eddie Murphy"; and his favorite rock star, "Prince." "Trying to explain these loyalties in one who hates Blacks, Pino fumbles for reason: 'It's different, Magic, Eddie, Prince, are not niggers. I mean are not Black. I mean they're Black, but not really Black. They're more than Black. It's different'" (Lindroth, 1996:29). Lee's aim is to imply not only an absence of recognition, but a misrecognition that is somewhat perpetuated by a commodification of black culture in that it denies

[14]Note my concerns about creating or envisioning a location where we can do democratic politics across difference lines without assimilating or coercing Other—the domination of one story or experience over another. Obviously, this location is a difficult place to find or create; but if we do find it, it may be more difficult to maintain this location as there is a very real possibility that difference may be exploited, and then consumed, and forgotten.

[15]Relegating difference as a commodity to be consumed by those who live within the core of our dominant *we* society devalues the experience and identity of the individual who resides on the margins.

[16]*Do the Right Thing* is the subject of Chapter Four.

the essence of difference. Drawing on hooks, we must recognize the oppositional space that has been created where sexuality, race, and gender are named and represented without then being absorbed into a dominant social or cultural identity. Maybe oppositional space can act as a starting point in the search for a creative transformative process—a place where we might begin to understand and/or envision how to do politics in ways that both respect and transcend difference lines; that is, a place from which black life (and life other than what is identified as dominant) can be recorded outside and away from filters that have been constructed by a dominant cultural hegemon. In *Beloved*, Toni Morrison wrote, "definitions belong to the definers not the defined" (1988:162). Hence hooks's oppositional space, what she at times calls her homeplace, serves as a place of recovery and resistance to a dominant and harmful representation of difference, but also points to different areas that might be shared in common.

Resistance to this oppositional space is powerful. Following the era of New Social Movements[17] in the 1960s and specifically the avoidance of politicizing themes in ways that are within the binary code of the universe of social action, the attack on liberal theory's assumption that all action can be boxed quite nicely in either private or public corridors has been under counterattack for some time from conservative communitarians. New Social Movements effectively challenged, and continue to challenge, the dual understanding of politics—public versus private issues and concerns. Essentially, new social movements have deconstructed our theoretical understandings of what is to be considered appropriate public debate.

New social theorists have suggested that the social movements of the 1960s and beyond (gay rights, civil rights, women's rights), movements directed at the personal and focused on individual identity and body politics, represent a paradigm of new politics. This struggle for a new understanding suggests a move away from money, property, political position, and other material resources toward knowledge and values that are informed by our sexual orientations, racial classifications, and gender assignments or constructions (McCrea and Markle, 1989). In essence, through these movements people were and are claiming collectively their right to realize their own identities, identities grounded in nontraditional and nondominant experiences, and thus challenging the conventional separation between private and public political spheres (Melucci, 1980; Croteau, 1995). This work, at times, is dependent upon coalitional politics[18]—a shared politics across difference lines—and a politics that is not easy; but, one that still should be celebrated.

Those who oppose New Politics, conservatives like Arthur Schlesinger (The Disuniting of America, 1992), William Bennett (The De-Valuing of America, 1992), Alan Bloom (The Closing of the American Mind, 1987), and Lynne Cheney (Telling the Truth, 1995), have suggested that the deconstruction of experience and Truth, coming out of the new social movements and the advances made by those activists in academics with regards to black, ethnic, gay, and gender studies programs, have helped to unravel the moral framework of the United States by disregarding and diminishing a genuine understanding of this culture's true moral values. In her book, Cheney writes, "I want to show how we have come to live in a world where offenses are constantly being redefined. I want to consider the

[17]Claus Offe claims that new social movements are the bearers of the paradigm of new politics and suggests that this new politics is very personal, and focused upon individual identity. This understanding becomes problematic for the liberal theorist who assumes that all actions can be boxed cleanly into either private or public corridors. Rather, the personal and social identity of individuals is increasingly perceived as a product of social action, public action that involves collectively claiming identity (The New Social Movements: A Theoretical Approach, 1985).

[18]Coalitional politics identifies the fusion of various political elements into a major or substantial political force. "Coalition is also used to describe any alliance among political groups;" that is, groups that may or may not represent various difference circles and whose partnership or fusion extends beyond particular difference lines (Plano and Greenberg, The American political Dictionary, 1993:64).

distortions and diversions being wrought by a kind of thinking that denies there is truth and to examine how it is that this postmodern approach has become entrenched and powerful" (Cheney, 1995:21). For Schlesinger, Bennett, Bloom, and Cheney, and many of their like-minded colleagues, difference is not acceptable and should not be recognized when it challenges the canonical thinking of what acceptable identity and knowledge are—difference becomes a distortion, a diversion—and the powerful assertions of liberal assimilation. These assertions are often understood by some (cultural theorists and scholars of color) in terms of violence and coercion. ✴

Similar attempts to offer reasons to reject the place of personal and individual identity and difference in a political sphere are present in the work of John Rawls (Political Liberalism,1971, 1993; A Theory of Justice, 1971). Specifically, his work privileges individual rights and a set of democratic procedures for protecting those rights—what is characterized as a system of fair social cooperation between free and equal persons—over individual identity and any proclaimed notion of difference (Rawls, 1993). The difficulty with this is that identity and selfhood are made subordinate to democratic procedures, in addition to being discredited when contrasted to the dominant view of citizenship. And procedures are known to, at times, force assimilation; in other words, the privileging of procedure over dissenting voices when discussing the possibilities for a just democracy can be harmful to those persons within various difference circles as well as oppressive to any creative or imaginative efforts at transcending difference for the very reasons identified by Taylor—lack of recognition. Mouffe explains the liberal's procedural objective: It " . . . is to provide a moral, albeit minimal, consensus on political fundamentals. Their 'political liberalism' aims at defining a core morality that specifies the *terms* under which people with different conceptions of the good can live together in political association" (1996:249). These *terms* are supposedly neutral with respect to controversial images of sexuality, race, and gender, and thus provide political principles that are assumed to be acceptable to all persons despite their individual differences (1996:249). However, this is clearly not representative of the United States today.

✏ Anne Phillips (Democracy and Difference, 1993) rightfully suggests that we abandon any desire for an "undifferentiated unity" as the foundation for our democratic politics.[19] She suggests instead that we turn our attention to what she calls a "complex unity"[20] comprised of different and potentially conflicting solidarities. We should not remain harnessed to the notion that equality is only possible when our differences are finally erased and a consensus recognized (1993:8). This complex unity is fragile and suggests an incompleteness that may persist inevitably. Bonnie Honig (*"Difference, Dilemmas and the Politics of Home,"* 1996) explains that "to take difference—and not just identity—seriously in democratic theory is to affirm the inescapability of conflict and the ineradicability of resistance to the political and moral projects of ordering subjects, institutions, and values" (1996:258). Mouffe (The Return of the Political, 1993) also contributes by uncovering what she calls "an illusion of consensus" and the call for "anti-politics" as being fatal to democracy.[21] Specifically, Mouffe calls for a pluralism that shines positively on difference and rejects what she calls "the objectivity of unanimity and homogeneity" (1996:246). However, while these critiques shift our attention by suggesting an absence of a liberal utopian place where those living on the margins of society feel they are full members and partners in a democratic endeavor with those not living on the margins, they do not release us from attempting to locate, create, or imagine some capacity for

[19]Phillips uses the term "undifferentiated unity" to explain how we are consumed with a solidarity that unites us through every aspect of our existence (1993:8).

[20]Phillips characterizes "complex unity" as a fragile and inevitably incomplete concept (1993:8).

[21]Mouffe asserts that democracy be seen as a construct that is forever uncertain and improbable—there is no, in her words, "threshold of democracy" that can be reached and thus guarantee the citizenry of its continued existence (1993:6).

✶
connecting one kind of human experience with another; that is, finding a place where we can both recognize and accept that community does not come ready-made nor is it reached through a procedural democracy that underscores *terms* for suffrage and representation, a political equality. Rather, Phillips and Mouffe call for a radical politics of democratic engagement where both community and solidarity are constructed through the "active involvement of people trying to sort out their difference themselves" (Phillips, 1993: 20) and the recognition that there will never be a rational political consensus. Mouffe describes any attempt at a universal rational political consensus as a "horizon that can never be reached" (1996:254). ✶

A theorist like Charles Taylor, on the other hand, suggests that through a public exchange one can discover him or herself and recognize his or her co-membership in democratic society; thus, we may be able to arrive at a consensus of some sort. We learn of commonalties and differences—of who we are and who we want to be—through a public exchange based upon free discussion among equal citizens. However, how does one conceptualize this notion of a public exchange within a public sphere? What language does one use? Whose meanings are to be relied upon? And is it possible to avoid a communitarian common good that is oppressive in nature? This conceptualization is essential if we are to better understand what Seyla Benhabib refers to as the present "democratic moment"[22] and the possibilities I have outlined for this work (Benhabib, 1996:5). Specifically I will suggest that film be considered as a form of democratic communication that will help to illuminate the commonalties and differences in our society and thus serve as a complementary approach to Taylor's. However, in a complementary approach we should not expect consensus or to arrive upon an anti-politics that erases our differences and establishes a neutral political arena.

DELIBERATIVE DEMOCRACY

Can free and unconstrained public deliberations foster legitimacy in complex democracies? Moreover, can such public deliberations inform our various identities in a fashion that allows for the recognition, survival, and acceptance of difference? According to the deliberative model of democracy, collective or rational deliberation is as much a requisite for producing fair and just decisions in a polity as are certain procedures. Joshua Cohen (*Procedure and Substance in Deliberative Democracy*, 1996) explains how deliberative democracy is not simply a form of politics; rather, it "is a framework of social and institutional conditions that facilitates free discussion among equal citizens by providing favorable conditions for participation, association, and expression—and ties the authorization (legitimacy) to exercise public power to such discussion by establishing a framework ensuring the responsiveness and accountability of political power to it through regular competitive elections, conditions of publicity, legislative oversight, and so on" (1996:100). This model can be viewed as proceduralist because it institutionalizes certain procedures and practices that allow for specific decisions on matters involving all citizens and gives a sense of legitimacy to those who exercise the use of democratic power via deliberative means (Benhabib, 1996:73). A potential problem with this proceduralism can be identified in the privileging of consensus or unanimity (the tyranny of the majority) that appears as a result of what deliberative theorists call rational argument when discussing public issues, discussing difference.

✶come to a fair and just conclusion as a collective.

[22]Benhabib, in arguing the importance of what she refers to as, a "self-clarification of our times by analyzing the conceptual, cultural, and institutional quandaries and puzzles" regarding the questions that continually hover over the notions of "identity/difference," uses the phrase, "democratic moment," to capture the nuances and the complexities of democracy at quite literally, the current moment, time, or age. In so suggesting, Benhabib implies that democracy, its implications, and its effects on identity/difference are ever changing.

In other words, political value is weighted in a collective good that surfaces and is recognized by all after engaging in rational argument/debate (Dryzek, 1990). However, this model may work to silence or harm an individual and violate his or her basic rights and liberties by quieting minority viewpoints and those who choose to resist the alleged rational conclusion or common good.

Modern liberals raise somewhat different concerns with this model: specifically, the placement of the public sphere within civil society rather than the state, and the open and expansive public agenda—an agenda that is not confined to what Rawls has termed constitutional essentials. Procedural liberals also perceive public reason differently than some deliberative theorists. If public deliberation is a procedure for keeping well informed, for making rational decisions, and arriving at consensus, then "when presenting their point of view and positions to others, individuals must support them by articulating good reasons in a public context to their co-deliberators" (Benhabib, 1996:72). This contrasts with the contractarian liberal view of public reason as a regulative principle, a principle that places limits on how people, institutions, and agencies should reason about public issues (1996:75). In the liberal conception, public reason is limited and does not allow for what Rawls refers to as background cultural conditions to enter into public debate (Rawls, 1993). This limitation also becomes problematic and stands in opposition to Mohanty's realist theory of identity and its emphasis on cultural experience as the raw materials that construct the self. Without the inclusion of background cultural conditions, the discourse can be limited in the scope of its understanding the self, but it can, at times, also be limited by the assumption that background cultural conditions carry no value to our democratic discussions (Young, 1996).

While clear critiques of some of the deliberative tenets exist— questions surrounding rational argument and consensus—by no means have the critiques forced an abandonment of the discourse ideal all together. On the contrary, many theoretical adjustments and expansions, adjustments and expansions that have been made to counter or answer some of the criticisms, have strengthened the fundamental deliberative argument and work to enhance my aims in this work. Specifically, these adjustments and expansions are important to the larger questions asked in this work as to whether we can envision U.S. democratic politics in ways that both respect and transcend difference.

RE-THINKING DELIBERATIVE DEMOCRACY: ADJUSTMENTS AND EXPANSIONS

There is value in engaging the deliberative debate and its suggestion that through open dialogue and discourse individuals will be able to identify not only conflicts, but hidden agreements as well— partial consensus. However, whether we are able to rightfully assume a shared unity at the start of any dialogue or that we will be able to identify that unity after the engaging of a particular type of discourse appears questionable. Possibilities forwarded by some deliberative theorists can be quiet attractive— shared rationality, the power of deliberative debate to smooth over conflict and difference, and the arrival at democratic consensus. All of these are intriguing. However, are they plausible? Should we subordinate the substantive values embedded within difference to the ideal utopian notion of rational political consensus? Or can deliberation be aimed at a recognition of difference? I believe it can. I also believe however, that any efforts to eliminate difference through rational consensus and assimilation to be dangerous. And it is clear that there are a number of other theorists who agree (Mansbridge, 1996; Benhabib, 1996; Mansbridge, 1996; Young, 1996).

✶ Jane Mansbridge (*Using Power/Fighting Power: The Polity*, 1996) in her discussion on coercion and persuasion suggests that our democracy works at nurturing what she calls "enclaves of resistance"[23] (1996:47). These enclaves in many ways are similar to the oppositional spaces referred to by bell hooks—"homeplaces"[24] where individuals who sit on the margins of the dominant society can deliberate in a protected environment; that is, an enclave where individuals can "rework their ideas and their strategies, gathering their forces and deciding in a more protected space in what way or whether to continue the battle(s)" (1996:47). This support for enclaves of resistance places a needed value on the survival of difference while also valuing and maintaining the larger deliberative assumptions surrounding discourse and debate. ✶

Recognizing the value in deliberation, Mansbridge's suggestion aims at protecting the Other while still advancing the important transformative process involved in what she calls "good deliberation"— the transformation of interests, the uncovering of unrealized areas of agreement, and the clarification of conflict, or as I will suggest, the transformation of one's sensibilities. By no means does this suggest, however, that we will necessarily reach a mutual agreement—what is often referred to as a rational consensus. Rather, in her words, through good deliberation, "The participants will have come to understand their interests, including their conflicting interests, better than before deliberation" (1996:47). This is a fair aim. We cannot assume an ability or power that will allow us to always reconcile the interests and ideals of one group of individuals with another; nevertheless, there is merit in good deliberation. But, how does one define "good deliberation"? Can we identify an acceptable language and rules of deliberation that provide for those who sit on the margins of a dominant society, protecting and nurturing not only resistance, but difference in the language of deliberation?

Seyla Benhabib (*Toward a Deliberative Model of Democratic Legitimacy*, 1996) argues for a deliberative model of democracy that incorporates what she refers to as "practical rationality" (1996:87). It is this model, based on the "centrality" of public discourse, that can "inspire the proliferation of many institutional designs" (1996:87). Benhabib's design involves a "universal moral respect" and an "egalitarian reciprocity" (1996:78). Accepting and arguing that certain moral rights exist, Benhabib explains how the recognition of a universal moral respect will contribute to a process of good deliberation. ✶ This universal moral respect becomes an entitlement or a basic right or liberty and serves to protect individuals from the majority's dismissal of minority viewpoints✶ In addition, Benhabib's deliberative adjustment affords for individuals "the same symmetrical rights to various speech acts, (the power) to initiate new topics, to ask for reflection about the presuppositions of the conversations, and so on—" egalitarian reciprocity (1996:78). However, are these adjustments sufficient at protecting against the silencing of dissent and the tyranny of a democratic majority? Can an alternative assertion of moral rights from sites of difference combat an articulate debate formulated by those using a language not

[23]"Mansbridge utilizes the term 'enclave politics,' and also drawing from an essay by Nancy Fraser, she writes of 'subaltern counter-publics." For groups and social movements seeking to express diversity, the goals of such counter-publics [enclaves of resistance] would include 'understanding themselves better, forging bonds of solidarity, preserving the memories of past injustices, interpreting and reinterpreting the meaning of those injustices, working out alternative conceptions of self, of community, of justice and of universality . . . deciding what alliances to make both emotionally and strategically, deliberating on ends and means, and deciding how to act, individually and collectively." (Benhabib, 1996:10).

[24]Places where "marginal peoples, objectified by a dominant racist and sexist culture, treat each other as subjects and further develop their capacities for agency, care, and respect" (Honig, 1996:269). "Homeplaces serve as invaluable sites that enable not only care but also resistance, including the writing and preservation of secret counter-histories, and hidden transcripts" (1996:269).

known to or familiar to those who reside on the margins and in enclaves of resistance? Here again one should be cautious of any form of anti-politics.

Iris Marion Young (*Communication and the Other: Beyond Deliberative Democracy*, 1996) addresses these questions and sheds some light on them by focusing on a culturally biased conception of discussion inherent in deliberative theory. She first suggests, and I agree, that we view difference as a resource: "I propose that we understand differences of culture, social perspective, or particularistic commitment as resources to draw on for reaching understanding in democratic discussion rather than as divisions that must be overcome" (1996:120). Not unlike James Baldwin's claim, she also takes aim at how we communicate—how we deliberate—by suggesting that we move beyond conventional *argument* as the only democratic discussion and the assumption that unity is "either a starting point or goal of democratic discussion" (1996:122). Instead, Young suggests an expansion of democratic communication to include what she has identified as greeting, rhetoric, and storytelling.[25] Accordingly, all of these forms of communication, in addition to argument, contribute to our political dialogue, our discussions.[26]

Essentially, Young is insisting that communication across difference cannot and should not be limited to argumentation, but must include a variety of communication. I will suggest an embrace of film as one alternative form of democratic communication. And in accepting Young's assertion, the bias toward a rational consensus diminishes and a greater equilibrium becomes possible with the recognition of gesture, emotion, and stories based on human experiences and culture. Young refers to this as "a theory of communicative democracy that attends to social difference, to the way that power sometimes enters speech itself, recognizes the cultural specificity of deliberative practices, and proposes a more inclusive model of communication" (1996:123). What should be avoided at all costs are the forms of argumentation that are difference-denying.

Mansbridge, Benhabib, Young, and others have suggested these particular critiques and edits, these adjustments and expansions, of deliberative democratic theory. I believe their contributions enhance and further our understanding of the present debate over democracy and difference. However, how do we move even further along—how should difference be represented and then recognized in this public discourse?

THE REPRESENTATION AND RECOGNITION OF DIFFERENCE

For many liberal theorists difference is something that pertains to a diversity of opinions, preferences, and/or beliefs and is not necessarily tied to a dynamic and *deep* personal identity based upon clear personal experiences, a body-politics.[27] In challenging a liberal understanding of difference it is important to ask what place or places exist in the public realm for identifying and then recognizing *deep* differences. And specifically, I suggest that we consider or imagine just ways of recognizing and giving legitimacy to difference beyond the basic liberal notion of citizenship and rights.

Will Kymlicka (*"Three Forms of Groups-Differentiated Citizenship in Canada,"* 1996) specifically argues for the protection of civil and political rights of individuals within difference circles through

[25]Young classifies her arguments as communicative, not deliberative, theory.

[26]It is from this position that I later introduce film as a form of communication that contributes to our political dialogue.

[27]"Differences other than political ones are nobody's business but one's own and therefore belong in the private sphere, together with one's religion, one's moral beliefs, and one's family practices" (Gould, 1986:182).

the protection of these common rights and basic citizenship.[28] He suggests recognition through citizenship—institutional recognition and representation—in conjunction with a necessary movement to include special legal or constitutional measures. If necessary, these measures exceed the common rights of citizenship for some and are the only way to respect difference, yet these discussions and assertions are nowhere close to providing us with a blueprint for a sustainable cultural community that transcends difference. In the United States, policies that have been designed to provide for the protection of basic common citizenship often do so without consideration of the *deep* personal differences I have identified (sexuality, gender, and race). In addition, any suggestion here in the States to incorporate any special legal or constitutional measures for certain peoples have often been met with fierce opposition. (Note Lani Guinier's work, *Tyranny of the Majority*, 1994,[29] and the ongoing debate regarding Affirmative Action[30]).

Our discussions about difference are perpetually confined within these various frameworks and discussions of citizenship, rights, and lobby and electoral politics. Again, I am not arguing that we abandon these discussions; however, I am suggesting that we dismantle the current rigid framework so that we might consider too theories of difference and recognition and representation outside the confines of a basic common citizenship that rests solely on political rights. It is important that differences be recognized in this public and institutional context; however, I agree with Carol Gould (*"Diversity and Democracy: Representing Differences,"* 1996) and her presentation of an alternative theoretical approach "to the question of differences in the public sphere" (1996:171). She writes, "The alternative view of the public that I am proposing would allow for more differentiated and localized centers of activity, representing common interests that are not necessarily global or society-wide. In such diverse common activities and the institutions organized around them, the opportunities for the expression and recognition of difference and for their representation are greater" (1996:173). Gould, however, also privileges the notion of rights, albeit differently from classical assertions, when she advocates a recognition of difference focused on "individuated needs, as well as the protection of the rights of difference" (1996:180). Calling for a respect of one another's differences and the protection of equal rights, she suggests that the best hope for the representation, and thus recognition, of difference can be found in the "expansion of opportunities for participation in a diversity of common activities" (1996:185). Not unlike Barber's work and his attention to common talk and common work, we find ourselves again saddled exclusively with a solution that relies heavily on a universal rationality and equal rights and the development of shared values for the protection of difference. This may be too harsh an assessment; I do not mean to suggest that equal rights are not essential to finding, creating, or envisioning some common grounds from which we can do our U.S. democratic politics. The greater value in Gould's work is in the suggestion that we recognize a diversity in our common activities or what we consider to be common. Like Mansbridge's

[28]"The protection afforded by these common rights of citizenship is sufficient for many of the legitimate forms of diversity in society" (Kymlicka, 1996:153).

[29]Guinier in this text contemplates and theorizes the possibilities of giving or affording additional political representation to minority communities in order to combat the power and tyranny of the majority, a majority voting public. This contemplation, although set within the realm of academics and postured as provocative material aimed at a contemporary debate regarding difference, cost Guinier her nomination as Undersecretary of Civil Rights at the Department of Justice. Under fire for Guinier's theoretical assumptions, President Clinton withdrew his nomination of her.

[30]Policy changes aimed at eliminating Affirmative Action programs have been visible across the United States (e.g., California's U.C. Board of Regents' decision to eliminate all Affirmative Action programs in college admissions and that state's ballot initiative eliminating state Affirmative Action programs). Former President Clinton's remark that Affirmative Action "is broken" and "needs repair" illustrates well the hostile climate toward any special or legal constitutional measures aimed at protecting or guaranteeing not only an equality of opportunity, but of outcome.

enclaves of resistance, Gould is arguing for a place, "smaller-scale" or localized discourse, within the public sphere and in the social and political institutions that make up our public domain where difference can be represented (1996:185). It is here that difference can be best recognized and respected in a manner that is honest to and supportive of those living within difference circles.

This raises certain questions, however, about the context in which we recognize and perceive difference through a localized discourse, democratic communication. Are there authentic subjects within difference circles, in enclaves of resistance, or in homeplaces waiting to be recognized and respected? And if so, does a notion of essential and perhaps fundamentally opposed identities preclude any endeavors at imagining some (un)common grounds from which we can engage in a cooperative democratic politics? I suggest one consider the work of Anne Phillips and her assessment of the status of our current politics. She writes, "Far more dominant today is the notion of multiple identities or multiple subject positions, each of which is subject to political transformation and change" (1993:142). I concur with this assessment and suggest that there is not wholesale commonality within difference circles that would make representation somewhat easier. Phillips writes: "An attention to difference does not entail an essentialist understanding of identity; nor does it demand any wholesale rejection of the politics of competing ideas" (1993:142). This statement is exciting and intriguing in that in frees us from looking for, or hoping for, a universal (un)common grounds. Instead, there is a projection of a "politics of mutual challenge" where we are "constantly reminded of the contingent nature of our identities" (1993:144). Any (un)common grounds we might imagine are limited, yes, but they very well could

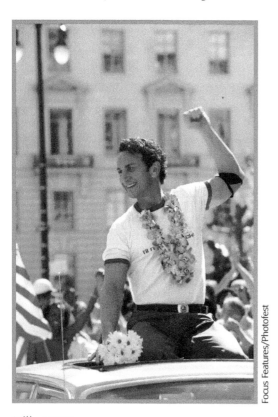

Milk, 2008

Focus Features/Photofest

be sturdy enough to support a cooperative politics, one where justice is aligned with recognition and one that considers and recognizes a shared human uncertainty. By human uncertainty, I mean to illustrate a human contingency that pervades all of our lives regardless of difference; that is, all of our lives are uncertain.

The goal is not to escape difference, but to engage it and represent it in a way that might enrich our public debate and better our understanding of our shared uncertainties and vulnerabilities—and to do a cooperative politics, if only from time to time. It is clear to me that institutional recognition of difference and the protection of equal rights and citizenship will not deliver us to a place absent of difference. Nor would we want it to. Fred Dallmayr ("*Democracy and Multiculturalism*," 1996) writes, "Whereas the politics of universalism seeks to safeguard a general human sameness (termed 'equal dignity'), the politics of difference insists on the need to recognize the 'unique identity of this individual or group,' that is, their differentiation from everyone else" (1996:286). We should bring our differences to the public stage in alternative ways and when we arrive, we should engage in a dialogue that is free from the confines of traditional understandings of argument. Then and only then can we engage in a politics that does not evade difference, but rather allows for an alternative recognition of difference.

✱ we should not ignore difference instead we should
respect difference

IDENTITY, DIFFERENCE, AND DELIBERATIVE DEMOCRACY: THE SEARCH FOR (UN)COMMON GROUNDS

With these contributions to an understanding of democracy and difference in mind, I want to explore and extend the possibilities they raise. Specifically, I will incorporate Mohanty's ideas regarding a realist theory of identity—especially its effort to identify genuine cultural differences and similarities—into a (re)imagining of difference and a just democratic politics. Mohanty claims that a collective identity can materialize after we gain access to our shared buried memories and experiences. In order to gain that access we must recognize and engage one another in an alternative discourse, democratic conversation. And what I will suggest specifically is an alternative public discourse conducted through the cinema, films produced in the United States. Taylor's notion of nonrecognition and misrecognition of difference, as well as Taylor's and other deliberative theorists' particular understanding of dialogue's contribution to the creation of identity and to the study of and respect for difference is important to my aims. What I will offer is a complementary approach to the theories already presented by those deliberative theorists advocating for a particular conventional democratic dialogue, conversation.

Some of the problems resulting from the social or cultural differences in our society, and the questions that seem to naturally evolve from the politics of new social movements, have been recognized. Communitarians like Taylor, Walzer, MacIntyre, Barber, and Sandel suggest that we answer the challenges of difference in U.S. democratic politics with a public recognition of different identities and then embrace the newly shared values that come from common talk, decision, and work. However, this is limited in its substantive scope and still very much engaged within the parameters of the dominant political paradigm, liberal pluralism—and the rules of that game. We can build from the wariness of theorists like Phillips, Mouffe, and Honig toward the communitarian desire to identify a rational consensus and common good. We could accept the necessity of what Mouffe calls the "political" and "the impossibility of a world without antagonisms"; however, we would then find ourselves engaged in a search that avoids substantive reconciliation of difference while trying to enhance a radical democracy that privileges Other as an adversary and competitor whose existence is legitimate and must be procedurally tolerated. Mouffe writes, "Agonistic pluralism is constitutive of modern democracy and, rather than seeing it as a threat, we should realize that it represents the very condition of existence of such democracy" (Mouffe, 1993:4). This may be acceptable if our goal is only to identify, as Mansbridge suggests, that which comes from good deliberation—the transformation of interests, the uncovering of unrealized areas of agreement, and the clarification of conflict. Good deliberation framed by Benhabib's universal moral respect and egalitarian reciprocity may also aid in our endeavors to imagine a unifying (un)common place.

If we hope to uncover that which we might share or have in common, we must engage in a dialogue that transcends difference circles. This does not mean, however, that there is a single rational way to go about communicating with one another through those circles. Nor does it mean that individuals living within difference circles are necessarily willing or able to engage in a dialogue with those not living on the margins of our dominant society or to accept a dominant understanding of deliberative procedures. However, as Mansbridge, hooks, Fraser, and Gould have suggested, limited discussions may take place when those who are marginalized feel safe and are free to retreat back to their homeplaces, enclaves, or counter-publics when necessary. Furthermore, our exchange may be more honest and sincere and reach further if we build our understandings of that exchange, as Young has suggested, by including alternative forms of communication. To this end, I am going to introduce cinema as such an alternative form.

By introducing film, I am focusing on a hope for a substantive reconciliation, or at the very least the need to imagine one. And I am as willing to consider that these points of connection across difference circles, this notion of some collective identity or (un)common ground and the transformation that comes about when it is discovered, is out of reach as I am willing, hopeful, that it might be within our grasp.

INVOLVING FILM THEORY AND CRITICISM

The film medium is capable of both documentation and fantasy, of copying as well as creation. But the central achievement of film is to be found in fictional narration. . . . Cinema obscures the distinction between authentic and staged events, making us feel like eyewitnesses. (Mast, 1992: 6)

With its mass audience and its ability to "reproduce the raw material of the physical world within the (a) work of art" (Kracauer, 1992a:10), the fictional realism of film allows for a sharing of the radically different experiences and can serve as a tool to help uncover the commonalties within our various social or cultural identities. In other words, and more specifically, film criticism facilitates the search for a location from which to envision a democratic politics in ways that both respect and transcend difference by providing an opportunity to theorize a new politics from a position of "eyewitness." As eyewitnesses or spectators, we are situated physically in the space of a dark theatre, and by the camera in a very definite and constructed position with respect to the depicted action on screen: We occupy a "place allied to the place" (Broune, 1990:218) of the on-screen protagonists and within our own social system. And the only way we "can account for our responses is by identifying with a character's position in a certain situation" (Mast, 1992:210).

Film has become the medium that may best uncover and explore American culture. Thomas Doherty, in his critique of Steven Spielberg's, *Schindler's List* (1994, U.S.A.) writes, "More and more, too, Hollywood has come to seem the prism through which all history, genocidal or otherwise, is witnessed and felt" (*Cineaste*, 1994). Therefore, watching movies is equated with "participating in history," and analyzing films suggests a participation in politics. Thus, I present two case studies or samples of films to serve as the foundation from which the substantive questions within this work are explored; that is, two sets of film narratives dealing with social or cultural identities stemming from sexual orientations and gender assignments or constructions, racial classifications, and the effects of violence.

In engaging film to address difference and, at a more practical level, to envision democratic politics, films can be viewed as acts of discourse; specifically, as artistic and political dialogues that invite us to a shared aesthetic sensibility as well as a mutual comprehension of the contexts of production and reception (Andrew, 1984). Directors, writers, producers, distribution companies, and even the actors and stars of film become important for understanding the discourse. Because of the multiplicity of elements involved (narrative segmentation, punctuation, camera techniques, characterization, and mise-en-scene), I present sets of films rather than two specific or universal samples. It is also important to keep in mind that in dealing with film criticism, as with any cultural criticism, the critic must try to avoid requiring film to meet his or her own definitions. The wise critic works to find a description that best fits both the film and the projected political theory, and thus the best film to exemplify or represent those particular politics of perception (Perkins, 1992:57).

To better understand both the promises and the difficulties involved in using film to study politics, it seems imperative to begin with more familiar narrative criticism; that is, with literary theory and the novel (Chatman, 1990). Many cultural and social theorists (Barbara Christian, Paul de Man, Edward Said, Catherine Belsey, and Shoshana Felman) suggest that the texts "we customarily call literature constitute a privileged site where the most important social, psychological, and cultural forces combine and contend" (Davis and Schleifer, 1994:3). While I agree with this contention, I am suggesting that at the start of the twenty-first century, film—the narrative medium of the twentieth century—continues to strongly challenge literature as the "privileged site."

The films discussed will be limited to films produced in the United States. This is a political choice. It is also a personal choice, as I present myself as a spectator of the privileged site focusing on an American cultural inquiry set within the boundaries of my own adult life span—my own "experiences."

Film, Aesthetics, and Politics

We all know and admit that film art has a greater influence on the minds of the general public than any other art. The official guardians of culture note the fact with a certain amount of regret and uneasiness. But too few of us are sufficiently alive to the dangers that are an inevitable consequence of this fact. Nor do we realize clearly enough that we must be better connoisseurs of the film if we are not to be as much at the mercy of perhaps the greatest intellectual and spiritual influence of our age as to some blind and irresistible elemental force. And unless we study its laws and possibilities very carefully, we shall not be able to control and direct this potentially greatest instrument of mass influence ever devised in the whole course of human cultural history. One might think that the theory of this art would naturally be regarded as the most important field for present-day art theory. No one would deny today that the art of the motion picture is the popular art of our century—unfortunately not in the sense that it is the product of the popular spirit but the other way round, in the sense that the mentality of the people, and particularly of the urban population, is to a great extent the product of this art, an art that is at the same time a vast industry. Thus the question of the films is a question of the mental health of the nations. Nevertheless, too few of us have yet realized how dangerously and irresponsibly we have failed to promote such a better understanding of film art.

Bela Balazs *(Theory of the Film, 1953)*

Most social theorists would agree that cinema is a powerful artistic medium. Film can be seen as either a rich artistic interpretation of reality or a powerful and threatening manipulation of reality.[1] As social theorists, these two general understandings of film as an artistic medium limit our use of cinema in commenting on our social and political worlds. In other words, it is necessary to identify the form and function[2]

[1]While I have introduced this long-standing debate into this text, I find, generally, taking a definitive position to be irrelevant to my larger argument. Thus, the reader should not expect an argument for either position in this work; rather, the mention of the debate is intended to illustrate a complexity and a density that informs the art, and the study of the medium itself.

[2]The film form represents the general system of relationships among the various parts, while the film function is the role or effect of any element within the film's form (Bordwell and Thompson *Film Art*, 1993).

of film as a social phenomenon in order to expand the interpretation[3] of the medium and use specific films, or genres of films, in asking whether one can use film as a specific form of communication in order to understand, to critique or imagine better, U.S. democratic politics in ways that both respect and transcend difference lines. In essence, our general understanding of cinema needs to include film as a vehicle that enhances social and political analyses—as an alternative form of democratic communication—in addition to the dominant dichotomous interpretation of film as a realistic or artistic medium.[4]

This suggestion is not without controversy. Sari Thomas in her work, *Film/Culture: Explorations of Cinema in Its Social Context* (1982), explains how "science"—including political science—seeks clear and certain answers, a practice she finds incompatible with film study simply because cinema, like art generally, may present a variety of interpretations (some of which may conflict with one another) that cannot be presumed to reach definite conclusions or a point of rational consensus.[5] Sol Worth, in "Pictures Can't Say Ain't"(1982) concurs with Thomas: "[P]aintings, movies, television, or sculpture—cannot be either true or false signs, and therefore they cannot communicate the kind of statement, the meaning of which can be interpreted as true or false" (Worth, 1982: 97). By agreeing with Thomas and Worth's assertion that film cannot be read in a way that communicates the kind of statement that supports a true or false dichotomy, critics may ask what film can be, if not a true or false statement. The answer may at first appear to be an avoidance of the question. However, what is important for this project is a movement away from a conventional understanding of rational argument and, thus, right and wrong, true and false. Specifically, film can be an expression of experience and the telling of narratives that are or have been excluded from a dominant culture and politics. Attempting to conceptualize film narrative solely in a way that screams for a linear projection, one that rejects a complex and unstructured storytelling, only works to affirm a dominant politics that often charges the Other with an irrationality and/or inability to argue or persuade within the framework of a dominant discourse. Often this poses serious problems for traditionally trained political scientists. This does not, however, lessen the importance of cinema in our social and political analyses: Film is inextricably entwined with our social and political institutions and should be studied and utilized in the social sciences as a tool to better our understanding of society. For example, films like *Primary Colors* (U.S.A., 1998) and *All the Presidents Men* (U.S.A., 1976) captured, for many people, *real* politics. And films like Francis Ford Coppola's *Apocalypse Now* (U.S.A., 1979) with its overwhelming cinematic experience, an experience that transports the moviegoer to a place where the conception of war is best represented as a "monstrous threat to the soul,"[6] along with Oliver Stone's *Platoon* (U.S.A., 1988), have given the Vietnam War its "definitive dramatic shape in American pop culture" (417). These two films, and Stone's direction particularly, blazed a path for a new wave of films engaged in the Vietnam experience—an experience that "Hollywood and the rest

[3]The movie-goer's activity of analyzing the implicit and symptomatic meanings suggested in a film (Bordwell and Thompson *Film Art*, 1993).

[4]Often film is considered by many to be merely entertainment, even though cinema clearly illustrates some sort of social or political context. Gary Crowdus writes, "All filmmakers—and therefore all films—have a point of view. Even a filmmaker's conscious effort to avoid any political expression is in itself a political statement. And today 'political' no longer refers only to those films dealing with politicians, international affairs, or government scandals. One of the key lessons of feminism and other consciousness-raising movements of the last few decades is that 'the personal is political,' too. Indeed, in its broadest and most compelling definition, politics involves any aspect of human and social relations. A film may not have been motivated by any conscious political intentions on the part of the filmmaker, it may nevertheless be rich in political implications—implications that may have little to do with the filmmaker's ostensible artistic aims" (Crowdus *The Political Companion to American Film*, 1994:xi).

[5]There are a variety of competing film theories including genre, auteur, psychoanalytic, Marxist, feminist.

[6]*The Political Companion to American Film* Crowdus, 1994:89.

of the country had repressed" (417)—reigniting a national debate over the war. Other films like John Singleton's *Boyz N the Hood* (U.S.A., 1988)[7] and the documentary *Hoop Dreams* (U.S.A., 1994) provide glimpses of or snapshots into the violent and complex environments of the urban corridors in the United States. These films,[8] and others, position the moviegoer as an eyewitness to a cycle of poverty, violence, and alienation; that is, moviegoers who may not have experienced first-hand certain historical events and conditions do so, in important ways, through such films. Thus, films often influence our social perceptions, our human sensibilities, and our political institutions; they foster public dialogue and uncover stories, both real and interpretive, that have been repressed or not known. Cinema presents political, social, and cultural messages and challenges that affect how people think and feel. Film requires our attention.

If we believe, with Balazs, that film represents an important element in our socialization and cognitive process and warrants our attention to its conventions, then the patterns used by filmmakers to communicate meanings to audiences—the conventions of film—take on special significance for the social theorist who critically examines U.S. politics. The positioning of the camera, the placement of objects in certain shots, the lighting, the dialogue, and the plot structure make up the all important structural elements present in all films and contribute to the overall dialogue or communication of cinema (Carey, 1982).

The rose-colored-window-that-distorts-the-world versus the accurate-reflection-of-reality debate resides here in a discussion of film conventions. These conventions inform our questions about socialization and imagination by identifying a major debate within film theory. Rudolf Arnheim, Film as Art (1957), suggests that film structure is tied in some innate fashion to visual reality. Worth disagrees: "Visual conventions are social pacts negotiated between those who create communications and those who receive them"[9] (Carey, 1982: 119). Worth's understanding is intriguing because he presents film as a dialogue between those who create films and those who view them, all of this without arguing for an accepted reality. This split between Arnheim and Worth does not, however, lessen the importance of film in our social and political discussions, nor does it suggest that we should abandon our consideration of the power of film that informs our cultural values, perpetuates moral norms, and "instructs all of us in the viewing audience of the rules that govern ideal social behavior" (Sobchack, 1982: 148). Instead, it illustrates a rich debate between those who view film as a realistic depiction of the world and those who understand film as a rich and powerful artistic interpretation of reality. This division is not unlike the one I have described in Chapter One, where a dominant faction in society is convinced of the existence of a rational consensus on basic social and political values that both reflect and make possible the attainability of a fair and just politics—one that opposes those who suggest a recognition, a tolerance and an acceptance of different interpretations of reality. Politics, and political theories specifically, are no different from art; that is, like art generally, political science, too, presents a variety of interpretations and understandings of what constitutes the world around us, a form of reality. However, some interpretations resonate more strongly and offer a richer and more compelling argument that may suggest and lend to a transformation in how we see ourselves in relation to others—and to a perhaps new and unnoticed basis for changing our politics.

With this in mind, the film viewing experience should be understood as a collection of a variety of elements: (1) the physical characteristics of the setting, (2) the social characteristics of the moviegoing

[7]*Boyz N the Hood* is the subject of Chapter Four.

[8]These films are presented as examples and are not necessarily superior to other, unnamed, films.

[9]This may be a reference to auteur theory, which refers "to a critical approach which emerged in the postwar period, especially in France, and which was formulated most notably by Andre Bazin in France and by Andrew Sarris in the United States." In a 1975 article, "La Politique des Auteurs," Bazin characterized auteurism as "choosing in the artistic creation the personal factor as a criterion of reference, and then postulating its permanence and even its progress from one work to the next."

activity, and (3) the social and political characteristics of the moviegoer that require consideration when employing film and justifying its use in the social sciences (Linton, 1982). Film theory maintains a richness in its attention to the physical features of the viewing experience and a clarity in its differentiation of film-viewing experience vis-à-vis that of television (Tudor, 1969; Noble, 1975; Taylor, 1975; Cook, 1976; Linton, 1982).

Considering these elements allows us to understand as best we can the complexities of the viewing experience and how best to apply the cinema to a discussion focused on difference and democracy. Included in this cinema-going experience is a darkened theatre that allows for a heightened intensity of message stimuli with its large screen, high picture resolution, and sound clarity. This experience provides for an increased sense of social isolation; that is, an isolation that brings on an increased relaxed posture that makes the messages more salient with the moviegoer. bell hooks writes, "Whether we call it willing suspension of disbelief or just plain submission, in the darkness of the theatre most audiences choose to give themselves over, if only for a time, to the images depicted and the imaginations that have created those images" (hooks, 1996:3). I agree with hooks; however, the imaginative possibilities are more complex and deserving of a richer description, something other than "giving oneself over." If film is to truly be considered as a vehicle that can transport one's sensibilities from one place to another, from a place where one does not know difference, to one where he or she somewhat does, then it is important that film be framed as a temporary suspension from one's own place, where his or her experiences serve as a construct of the self, to another place, constructed by different experiences and perceptions. In other words, I am suggesting one see film as an incredible and strong and imaginative and emotional transporting or migration of the self. ✳

Thus the viewer finds him- or herself more susceptible emotionally to the stimuli—the alternative form of argument—than is the case with television or other visual media (Tudor, 1969). Also, most of us do not consider the cinematic experience to be an isolating one; rather, the social characteristics of the moviegoing activity also include some sort of community interaction. In other words, most people do not go to the movies by themselves, nor do they consider a film or a film's conventions in isolation,

Smoke Signals, 1998

Miramax Films/Photofest

✳

a vacuum. Instead, moviegoers typically discuss with family and friends the film content—its visual conventions and its social pacts—as films permeate our thoughts and actions.[10] Here enters the important social and political characteristics of the moviegoer and the projection of his or her political and moral values into the communication and or dialogue with a film's conventions.

A THEORY OF IDENTIFICATION

How do we best describe and explain the relationship between the moviegoer and the "world" presented on the screen? This question is central to this work as I attempt to present cinema as a tool for uncovering various experiences across difference lines in order to imagine some (un)common ground. In film theory, the event of the moviegoer transcending space so as to enter the world being depicted on screen is called identification (Balazs, 1953; Dart, 1976). And while the research on identification is not new, it commands wide acceptance and is of considerable value in explaining the importance of film.[11]

Identification theory suggests that a moviegoer experiences vicariously, but deeply, the events, the story, the setting, and the characters that are portrayed on screen; that is, the viewer puts him- or herself in the place of a character or empathizes with one of the characters and his or/ her circumstances (Linton, 1982). Andrew Tudor, in *"Film and the Measurement of its Effects"* (1969) suggests a four-point model of identification that includes (1) an emotional affinity where the audience feels a loose attachment to a particular protagonist; (2) a self-identification where the individual sees him- or herself on the screen, rather than the actor—either a similarity or wishful thinking identification; (3) imitation where the identification moves outside the immediate cinema-going experience; and (4) a projection where the viewer lives his or her life in terms that are implicit with the favored protagonist. Nick Broune, in *"The Spectator-in-the-Text: The Rhetoric of Stagecoach"* (1976) sharpens this model by explaining identification in a triangular fashion—the spectator position, the camera point of view, and a character's perspective. Of importance to this work is an emphasis on the social and cultural contexts that inform and help shape this notion of perspective. Broune continues with an expansion of the notion of identification by addressing identification with a character's position in a certain situation.[12] He writes, "The way we as spectators are implicated in the action is as much a matter of our position with respect to the unfolding of those events in time as in their representation from a point in space" (1976:219). Thus, in order for cinema to be used as a tool for social and political analyses, we need to understand as much as possible the process and implications of identification, the language of film, and the conventions of film within a particular social and cultural context. This involves an understanding of the viewing experience and how it can possibly affect moviegoers.

[10]Jeanette Winterstone (1996"*Art Objects: Essays on Ecstasy and Effrontery*") writes, "Strong texts work along the borders of our minds and alter what already exists. They could not do this if they merely reflected what already exists" (1996:2). Thus, there is possibly a transformative quality involved in film viewing; however, quantifying transformation is no doubt difficult. bell hooks writes, "Often what we learn (in film) is life-transforming in some way. I have never heard anyone say that they chose to go to a movie hoping it would change them utterly—that they would leave the theatre and their lives would never be the same. And yet there are individuals who testify that after seeing a particular film they were not the same" (1996:2).

[11]James Linton writes, "This widely accepted notion of identification emerges from the popular belief that in order for dramatic materials to function properly, the viewer must be made to experience vicariously the events that occur within the dramatic world" (*The Nature of the Viewing Experience: The Missing Variable in the Effects Equation*," 1982).

[12]Specifically, Broune comments on identification as it pertains to a filmmaker's deliberate manipulation of identification through camera angle, camera time, etc.

Lionsgate/Photofest

Precious, 2008

Cinema and films are often devalued by the social scientist because of the perception that films are "light, somewhat frivolous, value-neutral and socially" and politically "innocent experiences" that allow people to *escape* from their everyday lives (Linton, 1982:192). But it is exactly this understanding or feel for cinema that allows the filmgoer to relax and enter a receptive state where he or she may become susceptible to new attitudes and opinions; attitudes and opinions that deal with difference in a way that may transform one's sensibilities and allow for a connection of one kind of experience with another.

∗A critique of this assumption suggests that dealing differently with difference in this manner is nothing more than manipulation through the employ of propaganda.∗ I question this critique when it is applied to films that aim at giving voice—at uncovering stories—to those who have been silenced and repressed by a dominant cultural hegemon, a dominant "*we*" society. For example, there are thousands of films that have been produced to shore up U.S. anti-Communist sentiment, to perpetuate and protect racial divisions—most notably the Western—and to (re)affirm negative stereotypes of women and homosexuals. Films that challenge the content of these dominant texts and aim at telling specific stories differently (gay, of-color, and female) only enrich our understanding of their condition and move us closer to a point of mutual recognition and connection.[13]

CONNECTING A THEORY OF IDENTIFICATION TO POLITICAL THEORY: FILM AS ARGUMENT

Satya Mohanty's work directed at identifying genuine cultural differences and similarities across difference lines by uncovering and recognizing the importance of experience(s), what he refers to as

[13]Films that are able to challenge a dominant cultural hegemon have taken aim at the fissures and cracks in the hegemon's story; that is, a story that is riddled with lies, lies that are visible in the lives of those who are marginalized and who sit on the periphery of the hegemonic story.

"raw materials," in the construction of identity is enhanced by an inclusion of cinema and a theory of identification. Coupling his realist theory of identity with film criticism and theory better defines how various identities (re)shape our values and collective futures. So, in asking the question, What is the relationship between the moviegoer and the "worlds" of others presented on the screen and depending on the "world" or conventions of the film, we position ourselves to uncover that which is not purely an individual affair, our collective experiences.

Alasdair MacIntyre's suggestion that we are always co-authors of our own narratives underscores the cinema-going experience—specifically, the power of film and the transcendence of space by the moviegoer to the "world" on screen, whether it be the world of John Singleton's *Rosewood* (U.S.A., 1997) or Steven Spielberg's Nazi Germany in *Schindler's List* (U.S.A., 1994). Both films allow the viewer to transcend space to a specific point in history where the exclusionary practices and the injustices met by people living on the margins come to life. Identification by some moviegoers with the events, the story, the setting, and the characters portrayed on screen often can effectively serve as a recognition of an experience that may have been forgotten, suppressed, or simply not known. The co-authorship or co-ownership of a narrative as referred to by MacIntyre, and to a certain extent Baldwin and Wright, may then be discovered to be a thing shared somewhat in common among people who may have thought their lives entirely different and exclusive.

Whether the filmgoer identifies with the protagonist, antagonist, or merely the values and norms of a specific time period, the identification illustrates how, where, and how much our lives intersect and informs how we can begin to connect one kind of experience with another. Mohanty writes, "To adequately understand this ownership, we need access to the buried memories and experiences of others who might have shared our experience. We need to reconstruct what our relevant community might have been, appreciate the social and historical dimensions of our innermost selves" (Mohanty, 1993:60).[14] This does not suggest, nor do I mean to imply, that we will always come upon or uncover

© Lionsgate/Photofest

CesarChavez, 2014

[14]Our lives intersect in a variety of ways. Both the slave and the slave owner, the oppressed and the oppressor, share a history, an experience. James Baldwin recognizes this when he calls for white America's further education on the African American experience, e.g., white Americans need to know the experience of Harlem as they are contributors to that experience.

localized shared experiences. Rather, both James Baldwin and June Jordan,[15] when referring to an "American experience," have suggested that the complex African American experience, an experience often invaded by violence and poverty (e.g., police violence, black-on-black crime, the political economy of drugs, the deterioration of the country's urban infrastructure), has intersected the experience of white "America." In other words, a shared experience is not necessarily an exclusively local one, nor is it cast as an identical one: growing up in the South, living in a poverty-stricken urban corridor, or growing up gay in the heartland. I suspect that the point of connection, if it were to be revealed, would not be grounded in a love of nation or a particular respect for truth and thus a particular set of democratic procedures; rather, the point of connection might be found in a shared sense of doubt, uncertainty or fear, or alienation and unfulfillment[16]—hence a recognition by those who are not gay, not of-color, not female, of the lives of those who reside on the margins and their contributions to our society.

While Mohanty does not use cinema, the cinema aids us in this endeavor as it gives a certain type of access to these memories and experiences while noting that we should avoid understanding these memories and experience as carbon copies of one another.

Mohanty is not clear whether he believes that access to various buried experiences across difference lines will allow for a (re)construction of a healthy heterogeneous political community, let alone a community that envisions U.S. democratic politics in ways that both respect and transcend difference lines. Rather, his attention is focused specifically within identified difference circles—e.g., Toni Morrison's narrative construction in *Beloved* and the recovery of shared experience between Sethe and Paul D. However, Charles Taylor's focus on the recognition and misrecognition of social and cultural differences suggests the possibility of something distinct: that is, a commonality across difference lines, albeit, according to Taylor, constructed through collective dialogues.[17] Baldwin, while not suggesting or arguing for a procedural politics, also suggests work and movement toward a social or cultural identity across difference lines as he calls for a deeper knowledge of both black and white experiences. Here one recognizes the appropriateness of film and the importance of cinema as a vehicle that allows for a sharing of different experiences and a possible connection of one kind of experience with another.

Filmmakers, from Spike Lee and John Singleton to Jonathan Demme, have uncovered human experiences—film experiences aimed at uncovering and remembering stories, sometimes with wide appeal, that have often been suppressed and forgotten, stories of difference.[18] Lee and Singleton specifically have answered, in an important way, Baldwin's charge that white America does not know the experience of Harlem, but should. However, both men have stated that their films are not necessarily for white audiences—they do not make films for white people, but white movie-goers are not prohibited from viewing their, Lee and Singleton's, films. In essence, both of these filmmakers have uncovered stories that illustrate how black and white buried, contested, and potentially fused imaginary

[15]Poet, essayist, and political activist.

[16]This notion of connection, of a shared alienation and human uncertainty, is explored further in Chapter Three.

[17]I do not mean to suggest that one should embrace Taylor and his larger assertions. However, it seems clear that Taylor's work is something to build on, to enhance and push further.

[18]One question that arises out of this work at uncovering and remembering stories aimed at representing those who sit on the cultural margins, Other, is whether only a black filmmaker can make a film or uncover a story or represent blackness, or if a non-black, non-gay, non-female director can represent the Other in a fair and honest manner. bell hooks writes about this. She says, "For individual traditional black film critics and many of us new kids on the block it was difficult to face that in some rare moments there were more progressive representations of blackness in the work of exceptional visionary white filmmakers than in the work of individual conservative black filmmakers. Their representations of blackness, along with others, were the positive interventions providing concrete interrogative evidence that it was not so much the color of the person who made images that was crucial but the perspective, the standpoint, the politics" (1996:7). I include this so to make clear how I reject an exclusive essentialist point of view or perspective when engaging film's power to transform and re-imagine our politics.

experiences intersect, albeit within an often hostile racial and caste-like structure. The point is, white "America" often only knows part of the story—the manifest destiny/missionary part if you will—and therefore has a protracted, distorted view of the Other.

It is important to note, though, that film can also be used as a vehicle to cover, to suppress, and to represent negatively stories of difference. bell hooks (Reel to Real: Race, Sex, and Class at the Movies, 1996) writes, "Even though so much critical work has emerged in cultural studies and/or film studies interrogating old colonizing racial imagery, particularly the representation of blackness, creating a new awareness, standpoint and accountability, some filmmakers still don't get it. Ironically, the focus on diversity has inspired some white filmmakers (for example, Quentin Tarantino and Larry Clark) to exploit mainstream interest in the 'Other' in ways that have simply created a new style of primitivism" (8). This power of the medium has been felt throughout the world, and its ability to serve as a negative socializing agent should not be forgotten or lost. Specifically, major studio films especially have served as propaganda,[19] as well as a dominant form of social communication. And because films are technically and socially portable, they reach massive audiences across difference lines and transmit memorable ideas and images, both negative and positive, to audiences worldwide. Often these film images and ideas can be harmful to those individuals living on the margins of a dominant *we* society, as film can serve to (re)affirm and to perpetuate damaging behaviors and perceptions.[20] For example, throughout the 1980s Hollywood produced a series of films that depicted Arabs and other peoples of Middle-Eastern dissent as dangerous Muslim fundamentalists/terrorists (re)affirming negative stereotypes in light of larger political conflicts (Iranian hostage crisis) and perpetuating damaging behaviors by those people who embraced Hollywood's representation as an accurate reflection. All films have propaganda value and most movie industry players have recognized film's power of advocacy, yet not all films are oppressive. Another important question is uncovered. Which films are important to our understanding of difference and which ones work to maintain a dominant cultural hegemon?

Conservative social theorists like Arthur Schlesinger, William Bennett, Alan Bloom, and Lynne Cheney and conservative politicians like Sarah Palin, Dick Armey, and Newt Gingrich might have a serious problem with privileging the independent film (e.g., queer and black cinema) as I do.[21] For them, independent films like Gus Van Sant's *My Own Private Idaho* (U.S.A., 1991)[22] represent a challenge to core social values, the dominant thinking of what identity, morality, rationality, and (T)ruth are. These conservative social theorists are not unlike the power wielders in Hollywood, working to maintain a financial, moral, and political status quo. Hollywood has its own bedrock of canonical thinking, its own way of doing business and viewing of the world. And while Hollywood's conservative thinking is better informed by the risk of losing profits rather than eroding American morality cited by conservative theorists and politicians, the implications are similar—the distorting and silencing of difference.

This distortion and silencing of difference in Hollywood is problematic to any attempt at using film as an alternative and additional form of understanding/communication in a deliberative public realm. Because of the industry's preoccupation with profits, a theory of identification is typically

[19]Propaganda is a form of communication that is geared at influencing how people think, how they act, and react emotionally. The assumption involved in the employment of propaganda is that changes in people's thinking will prompt changes in their actions. Propaganda is not necessarily true nor false; it is based on a careful selection and manipulation of data (Plano and Greenberg *The American Political Dictionary*, 1993).

[20]Again, note Charles Taylor's notion of misrecognition.

[21]These genres are not representative of all independents.

[22]*My Own Private Idaho* is the subject of Chapter Three.

skewed by the Hollywood blockbuster and its presentation of films like *Rambo* (U.S.A., 1982, 1985, 1998) where Sylvester Stallone's character at times battles people of-color for the survival of all that is good and just in "America." In addition, the depiction of women, homosexuals, and people of-color in mainstream film are often cast in either small or on-the-periphery roles and are often represented negatively in character in that they (re)affirm and perpetuate established, harmful stereotypes.

HOLLYWOOD AS A PROFIT INDUSTRY

The motion picture business is extremely risky financially. As a consequence of this high risk, most film ideas, especially those with challenging subject material, challenging to a dominant societal and cultural hegemon, are rarely acted upon and produced, and those that are often lose money (Prindle, 1993). When a film is successful, the major studios take notice and try to replicate that event by recycling the story (genres[23]) and relying on specific star power—e.g., the Western and John Wayne, the modern action film with Sylvester Stallone, Arnold Schwarzenegger, and Tom Cruise, and the comedy/drama with Tom Hanks (note the female absence).[24] Ultimately, however, no one knows which film will be perceived as a "good movie," and thus a profitable one. This begins to explain why Hollywood is often unwilling to take progressive artistic and political risks: that is, produce films that both represent and challenge dominant understandings of identity and lifestyle. The motion picture industry, and specifically the major studios[25] ("the majors"), make up an industry driven by profits and not necessarily the pursuit of artistic exploration or the uncovering of Other's stories, the presentation of alternative texts. For the most part, the majors do not produce films that advance the work of uncovering or recovering certain life experiences, histories, or personal identities.

The majors do work at reducing the risks involved in filmmaking. Their attempts, however, are limited to what is referred to as vertical integration, foreign sales, and audience research, so as to protect profits, and not necessarily to provide for a positive environment for artistic innovation. A strategy that combines production,[26] distribution,[27] and exhibition[28] into a single corporate whole, vertical integration involves the production of many films, recognizing that most will fail; however, a few will succeed marvelously, making the enterprise profitable (Prindle, 1993). Foreign sales now represent up to 90 percent of a film's gross, and both the majors and the Indies[29] work to nurture the foreign market (1993:24). But audience research represents the most influential consideration in the majors' artistic and marketing decisions because of the audience's desire for familiar plots, characters, and morals over more artistically innovative and challenging material. Thus, the motion picture industry and the dominant moviegoing audience are partners in creating stories that are "the same but different," stories that for the most part do not challenge a dominant way of seeing the world (Prindle, 1993:25). This is problematic in that the (majors are continually recycling stories) that are (appealing to those people

[23]"A movie genre is at base a story formula, a system of narrative and dramatic conventions. Genres like the gangster film, the Western, the sci-fi film, and the musical involve established character types acting out familiar patterns of conflict and resolution within a familiar setting" (Schatz, 1994:177).

[24]While women like Meryl Streep, Whoopi Goldberg, Demi Moore, and others have seen their work succeed, revenues/profits generated by their work does not begin to compare with the male hero archetype.

[25]For example, Universal, Paramount, Warner Brothers, Touchstone.

[26]The process of creating the film (Bordwell and Thompson, *Film Art*, 1993).

[27]The process of supplying the finished film to the places where it will be shown (Bordwell and Thompson, *Film Art*, 1993).

[28]The process of showing the finished film to audiences (Bordwell and Thompson, *Film Art*, 1993).

[29]Independent cinema.

who are not on the margins of our dominant *we* society.) Subsequently, the majors find themselves under attack by independent filmmakers who claim the majors lack vision and dominate the market by exercising their distribution arms in a manner that obstructs the marketing of independent films. Independents often do not possess a distribution arm and are left without the benefits of vertical integration; thus, they lose automatically 35 percent of their profits to distribution fees because they rely on the majors for distribution services (Prindle, 1993:30). In addition, when the independents contract with the majors to distribute their films, the advertising of the Indie is less than vigorous. In essence, the independent filmmaker sits on the periphery, or on the margins, of a dominant industry and finds itself continually facing financial ruin or extinction.[30] Independent filmmakers, for the most part, are not yet engulfed within the marketplace practices of the majors and thus are willing to present stories differently, different stories. They are best equipped to contribute to my positioning of film as an expansion of traditional argument as they represent an important and required element needed to better communication, or in Mansbridge's words, to better "good deliberation" or public deliberation.

David Prindle in his work, *Risky Business: The Political Economy of Hollywood* (1993), asks specifically whether independents do anything that the majors don't do just as well. His answer is a resounding yes. Prindle explains how the Indies provide a "proving ground" for female talent and serve as an important employer helping to alleviate the 90 percent unemployment rate in the industry. More significant, however, is "the serving of the public interest" by independent filmmakers who make films that take progressive artistic chances and uncover stories and histories that often are absent in mainstream cinema (1993:33).(The independent filmmaker sits on the margins of the dominant Hollywood industry and takes progressive artistic risks, risks that the majors shun for fear of profit loss.) The Indie becomes responsible for cinema's innovation and vitality and can often be recognized as a place of resistance and or a homeplace/counterpublic for writers, directors, and artists whose aims are directed at (re)framing Other.

Fictional film has been vital for independent African American filmmakers wanting to present the experiences and social environments of black people in the United States. Kathleen Collins, the first African American woman to direct a feature length film, *Losing Ground* (U.S.A., 1982), portrayed the "experiences of a female philosophy professor whose intellectual pursuits and marriage tend to restrict her self-realization" (Reid, 1994:7) This film presents serious "treatment" of the black middle-class professional woman. Along with independent filmmaker Julie Dash's *Daughters of the Dust* (U.S.A., 1991) and its treatment of women of the African American Gullah community, we are exposed to film texts that would not be profitable for the majors because they tell stories that are not fundamentally different, but that are told by different people who reside on the margins of a dominant *we* society.

Additionally, the independents differ from the majors with respect to their corporate responsibility to stockholders and profits. For the Indies, breaking even on a project often represents success; thus, the independent filmmaker does not have to be as cautious with regard to artistic decisions nor is she or he anchored to stars, sequels, or series (33). More importantly, however, the independent filmmaker distances him- or herself from what is known as high-concept ideas: ideas that can be "encapsulated in a sentence or two and whose commercial potential is immediately discernible" (33).[31] The majors assume that audiences, and specifically middle-North American audiences, are limited to high-concept cinema, featuring "cardboard characters, melodramatic plots, flashy special effects, and as much

[30]It is important to note that, like many artists, independent filmmakers do not appear, at first, to be driven by economic gain/profits.

[31]For example, George Lucas and Steven Spielberg's partnerships with *Star Wars* (U.S.A., 1977) and *Raiders of the Lost Ark* (U.S.A., 1981), any Bruce Willis, Sylvester Stallone, or Arnold Schwarzenegger film, disaster films like James Cameron's *Titanic* (U.S.A., 1997), and comic book genre films, *Batman* (U.S.A., 1989), *Superman* (U.S.A., 1978) etc.

violence as possible" (34). This assumption carries with it a harmful effect: the ability to perpetuate a cinematic hegemon unwilling to imagine diversity and difference.

Yes, the Indies can do things that the majors can't or are unwilling to do: The Indies engage and consider diversity, imagine and communicate difference, and demonstrate how cinema can be used as a tool of across-difference-communication and recognition. In addition to studying the core, the majors, one should pursue what sits on the periphery, pursue that which sits on the margins—the independent film.[32]

CINEMA AS AN EXPERIENTIAL ENVIRONMENT

Cinema[33] can give richness to and complement an environment where conventions, moral codes, and ways of life are continually and quickly challenged. The pace, the novelty, and the spontaneity of the medium are expected by a generation who have been grown on a culture of 30-second television commercials (Schillaci, 1971). Anthony Schillaci in his work, "Film and Environment," explains how film represents an environment where the filmgoer demands a different kind of structure and a different mode of attention than any other art; the filmgoer demands a fully absorbed and all-engaging experience. Quite simply, he asserts that the filmgoer is inflicted with a hunger for "mind-expanding" experiences that can only be realized in the movie environment (1971:215). The filmgoer wants to transcend his or her space and enter the on-screen world where he or she will be confronted with signals that cause us to think and feel differently; that is, where sensibilities are (re)imagined and transformed. In Ridley Scott's *Thelma & Louise* (U.S.A., 1991) (screenplay by Callie Khouri), the moviegoing audience, especially the female audience, found themselves on the open road with two women who were

Thelma and Louise, 1991

[32]I am not proposing any mandatory viewing of independent film as part of a larger civic duty. Because this work is not aimed at outlining specific procedures for involving film in public dialogue and communication regarding politics and difference, the question as to whether it is important that independent film be viewed by a mass audience is not engaged directly. However, at this juncture, simply identifying and recognizing the power of film, of independent film specifically, is of great importance to my aim at uncovering some (un)common ground across difference lines in the United States.

[33]Both major and independent cinema.

fully absorbed in their recognition of themselves. Peter Roffman and Beverly Simpson (The Political Companion to American Film, 1994) write, "As outlaws, no longer governed by the rules and regulation of male-governed society, they (Thelma and Louise) realize just how constricted their past lives have been" (345). And without a doubt, gauging from the success of the film, many women, and some men too, were able to identify with the characters, the story, and the signals presented in this film—the social pact. And while most certainly more women than men identified with the heroines, there is an obvious experience depicted in this film that crosses any lines of gender and provides the movie's audience with the desired hunger for experience.

The difference between television and its fast-paced commercialness and the moviegoing experience that at times shares this pace and attention to "mind-expanding" special effects is best illustrated by the relationship between the individual and the medium—a relationship not unlike the one Scott aimed for in *Thelma & Louise*. Those of us who had television as a babysitter, those of us who grew up with television in our homes, have learned to not be held captive by the small screen. Rather, we move about in our homes paying attention to numerous tasks and responsibilities while relegating the always-on television to a position of audience as if Thelma and Louise themselves were the ones engaged in transcendence and identification, into our environment.

This is quite unlike the attention we give to film. In other words, filmgoing has become a more focused and private affair than television viewing, an experience, an activity, almost as private, according to Schillaci, as reading (1971:216). We give little attention to our fellow audience members as we engage ourselves in the activity of transcendence. And when the film is over, we do not quickly forget the array of images, the sequence of events, nor the position of characters in a specific story. On the contrary, we move into the local coffee house, restaurant, and private home to discuss among ourselves the unforgivable acts and the troubling experiences brought to life in Steven Spielberg's *Schindler's List* (U.S.A., 1994) or the injustice displayed in Jonathan Demme's *Philadelphia* (U.S.A., 1994). bell hooks contributes to this understanding of film discussion: "As a critic who has always worked to address audiences inside and outside the academy, I recognized that oral critical discussions of films took place everywhere in everyday life. Across class, race, sex, and nationality, people would see a film and talk about it" (1996:5). While the viewing experience and thus transcendence is a private affair and only communal with those on screen, at a film's close we find ourselves wanting to share our interpretation of the image-events, tell of our transcendence and identification·with characters, stories, and moral codes, with those around us, our various communities. Consequentially, film is both a private and public affair.

Film can be both a private and public affair, and I want to be somewhat cautious not to overemphasize one realm over another; that is, a private change in sensibilities over a public dialogue in search of a deliberative democracy. Certainly, I find a film's power to privately open up new sensibilities or trigger latent ones to be of incredible significance. In other words, if a film is to connect our experiences with others, then there is a possibility of an enhanced treatment of others and possibly a more attentive-to-others politics. This may be enough. However, the politics of a shared community, of conversation, and of democracy-as-dialogue, while at times nowhere in sight, remains intriguing as well.

The cinema formulates its own space while moving time forward and backward, humanizing change and altering our attitudes about what films—and others-in-films—are about; film intensifies experience, developing a sensitivity on the part of the filmgoer "to challenging comments on what it means to be human" (220). Such experiences alter, as well, community and political conversations.

We have moved beyond a stage where film is viewed within the limited confines of *escape*. Instead, we view movies in search of identity and with a recognition of various experiences, different experiences, and at a different level. This began with the Baby Boomers and such films as *Bonnie and Clyde* (U.S.A., 1967) and *The Graduate* (U.S.A., 1967), to *Easy Rider* (U.S.A., 1969), *Apocalypse Now*

Philadelphia, 1993

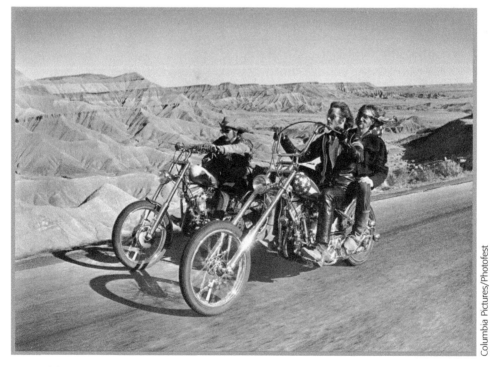

Easy Rider, 1969

(U.S.A., 1979), and *Coming Home* (U.S.A., 1978), and into a younger generation's films, Generation X, with movies like *My Own Private Idaho* (U.S.A., 1991), *Reality Bites* (U.S.A., 1994), *Do the Right Thing* (U.S.A., 1989), and *Swingers* (U.S.A., 1997). Here, Schillaci comments on how "youth in search of identity is often presented as ridiculous spectacle—'Who am I?' Nevertheless, the quest is real and

is couched in terms of a hunger for experience" (1971:221). Film is a means to learn and describe, imagine and understand our sometimes collective identities.

IMAGING, COMMUNICATING, AND RECOGNIZING DIFFERENCE VIA THE INDIES

How does independent film communicate? What should we be looking for; what are the rules, and what are the definitions that will help us discern the importance of film, of independent film, and lead us to a place where we can infer a meaning from the medium?[34] Stan Vanderbeek in his work, *"Re:Vision"* (1976),[35] sees the motion picture as the "emotion-picture" representing a new structure of a nonverbal "international picture language" that allows for a wider communication among people. But, before we can embrace Vanderbeek's assertion concerning this wider communication among people, we must ask, What does film communicate and how does the process work?

Sol Worth addresses this question and develops a helpful model.[36] He confronts film as a "mediating object, and process, through which humans interact in certain ways" (Worth, 1966:180). In other words, Worth looks to film as a signal being transmitted primarily through visual receptors, which we then, in turn, as members of the audience, regard as a message by inferring meaning from the signal (1966:180). This meaning of the film, according to Worth, illustrates a relationship between the filmmaker and the audience:[37] what we infer from the various elements of the film, various elements presented to the audience in a visual manner by the filmmaker. Thus film communication becomes synonymous with the transfer of these inferable meanings through "the range of materials that a film offers or does not offer as signals, and through the elements and combinations of elements it allows or does not allow" (1966:182). Our identification with events, stories, and characters is made possible by the transfer of these inferable meanings—the various signals and elements that film communicates. For example, Oliver Stone's work is both political and conventional in the way it transmits various messages. And we, the moviegoers, infer meaning from what we have experienced in the movie house while viewing one of his films—the "range of materials" that Stone offers as signals. Specifically, in *JFK* (U.S.A., 1991) Stone not only suggests, but sets out to support in a film-ic way to the people of the United States a major national conspiracy. Andrew Horton (The Political Companion to American Film, 1994) writes of Stone's success, *"JFK* appears bound to hold its place in American cinema as what historian Marcus Raskin, writing in the *American Historical Review* (April 1992), has called 'a work of art' which 'succeeds because it confronts powerful emotions and political truths that are as age-old as Homer and Sophocles.'" He continues, *"JFK* became much more than a 'must-see' film; it also became, even during its production, the object of a national controversy that engaged Americans from all walks of life in a dialogue unprecedented in terms of Hollywood cinema. Senators and other government officials attacked the film long before its release as did major journals and newspapers such as *The New York Times*, *Time*, and *The Washington Post*" (1994:318). This film, along with others of Stone's productions, was successful in creating a social pact with the audience. Filmgoers were able to infer a message or meaning from the film, were able to identify with the film, and chose to engage in a national debate that was clearly reignited by the director's work.

[34]I am not suggesting that there are two distinct ways to examine film, major versus independent; rather, I am only setting up a method for my analysis of specific films for this work.

[35]*Schillaci Perspectives on the Study of Film*, 1971.

[36]Worth is not only speaking of independent film; rather, he applies his model to both major and independent endeavors.

[37]Social pact.

The number of scholars who argue that films, and in general the cinema, are of no value as we try to understand the world around us appears to be small. However, those of us advancing film theory and a greater focus on the medium in general as a form of communication and alternative to traditional argument, and thus as a tool in our work at uncovering a shared experience, must address critics like Rudolf Carnap and a behavioral legacy that claims that "only verifiable statements of specific empirical sciences can be legitimately conceived as knowledge of the states of nature or of matters of fact" (184). In answering critics like Carnap, consider the work of Jacques Maritain, a film theorist, who explains how a work of art is "an object of experience," an object that serves as a tool in our larger endeavors at getting to the self (note again, Satya Mohanty's attention to experience). Also, I rely on Worth's film communication model geared at the search for an "understanding of those processes of cognitive interaction that will help us to formulate the processes occurring when we see a film and when we infer meaning from it" (188).

Worth outlines a three-point model that is helpful in the debate with critics like Carnap and his behavioral followers. First, he has identified what he calls a "Feeling-Concern." This term describes a "vague, amorphous, internalized belief" held by the filmmaker, an internalized belief that demands it be communicated. Clearly, here, we can characterize Oliver Stone's political beliefs as a Feeling-Concern. Second, Worth explains the "Story-Organism," where the filmmaker's Feeling-Concern is simplified, organized, and given life so that it can be externalized and communicated on the screen—a written text or screen play (190). According to Worth, it is only after the filmmaker has recognized his or her Feeling-Concern and developed the Story-Organism that he or she begins collecting what is referred to as external "Image-Events" (190). These Image-Events are stored on film and sequenced, and hence become the film's communication (190). The moviegoer then experiences and identifies with the model in reverse: that is, the moviegoer first sees the Image-Events on screen, and then infers meaning from the Story-Organism that may or may not lead to a knowledge of the filmmaker's Feeling-Concern.

The most significant aspect of this model, and the point on which this work is most concerned, is the nodal point of the process, the point most common to both the filmmaker and the moviegoer—the Image-Event (191). Worth writes, ". . . to both sender and receiver, creator and re-creator, the Image-Event is different from the other two terms, both as a part of the process for the filmmaker and as a part of the process for the viewer. It is the only unit of this process that is directly observable"—the visual aesthetic of the film itself—frame by frame (191). Because of this direct observation, the study of the Image-Events (the various properties, units, elements, conventions, and systems of organization and structure) becomes the focus of my inquiry. This does not mean, nor am I suggesting, however, that the Image-Events can be seen or taken to be something clear, concrete, measurable, and rational. The Image-Events represent art; and again, are open to a number of various interpretations. This leads back to the original debate and the focus on film as either an artistic interpretation of reality or a realistic depiction of the world. (No doubt Oliver Stone's work has been characterized as both.) Just because we cannot, as social theorists, assert with any certainty a concrete and/or universal vision of an Image-Event, we are far from relieved of our responsibilities to engage art, to engage difference and Other, around us—and to be open to shared imaginative sensibilities and possibilities.

Remarkably, each film becomes a vehicle of communication for a variety of unique changing perspectives of our world and of ourselves. Or, in the words of film theorist Edmund Carpenter, each film "allows us to see from here, another from there, a third from still another perspective; taken together they give us a more complete whole, a greater truth" (209). Taken together they give us a more complete whole, a greater truth. In essence, the cinema represents a means to learn, describe, and

understand, and serves not only as a pool of unconscious feelings, but it expresses "a variety of political, cultural, and aesthetic meanings and functions" (Williams, 1976:11). bell hooks best explains this pedagogical role for film:

> *Whether we like it or not, cinema assumes a pedagogical role in the lives of many people. It may not be the intent of a filmmaker to teach audiences anything, but that does not mean that lessons are not learned. It has only been in the last 10 years or so that I began to realize that my students learned more about race, sex, and class from the movies than from all the theoretical literature I was urging them to read.*
>
> *Movies not only provide a narrative for specific discourses of race, sex, and class, they provide a shared experience, a common starting point from which diverse audiences can dialogue about these charged issues (1996:2).*

While most people will claim that they see movies in order to be entertained, they also go because they want to "learn stuff" (hooks, 1996:2) and they may "learn stuff" they hadn't counted on, hadn't imagined. I am suggesting that we consider film in all its complexities, that we view film, in part, as conversation, or as an opening to the possibility of a democratic conversation.

INDEPENDENT FILM IN THE CONTEXT OF GENERATION X

Film has the power not only to speak to, but to define, in a variety of ways, a generation. And if we are to better understand the world we live in—the society we make up, the community we identify with

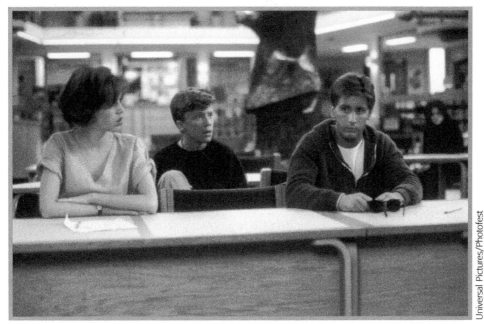

Universal Pictures/Photofest

The Breakfast Club, 1985

or may come to identify with—it is important that we view film as a tool in our ongoing conversations with one another and in the (re)imagining of ourselves.

The language of film, like the slang of a particular generation, is ever changing. Keeping this in mind, we should recognize how certain films, more than others, are encoded with a language, a slang—expressing emotions, ambitions, mysteries—of a particular generation; in this case, Generation X.

Recognizing the profitability of films dealing with issues and themes prevalent to those who identify as Gen X, Hollywood has cashed in on our parents and now us by creating, and then continuing with, the production of films that can easily be classified in their own genre, "Coming of Age Films"—Gen X style. For example, films like *The Breakfast Club* (U.S.A., 1985), *Sixteen Candles* (U.S.A., 1984), and *Some Kind of Wonderful* (U.S.A., 1987) all attempted, albeit in major Hollywood fashion, to present the trials and tribulations of growing up in the 1980s. While these films were not always intelligent, nor were they wholly original, for those of us who were teenagers in the mid 1980s and, who were well immersed in the Reagan era, these films offered a depiction of young people who were supposedly engaged in the same challenges of coming of age. There was a problem, however, in that the depictions were wholly and universally of white, straight, well-to-do kids. These rosy Hollywood pictures seemed to go hand in hand with the themes coming out of the Reagan White House and the "new day in America" description of Reagan's presidential campaigns being placed in the media for general consumption. To be fair, it is important to note how several of these films confronted class and domestic violence as subtexts. For example, in *The Breakfast Club*, Judd Nelson's character is a victim of physical abuse and Ally Sheedy's character suffers from emotional trauma. Along with the depiction of both of these characters comes the difficult experiences of more than a handful of youth as their voices are aired when they share a piece of their lives with one another on a Saturday afternoon while doing a stint of detention. This film is important, as are segments of *Pretty in Pink* (U.S.A., 1986) and *Some Kind of Wonderful* for their clear depictions of a class divide in America, a clear and direct challenge to Reagan's "new day" imagery.

Photofest

Rambo: First Blood, 1982

Generation X cut its teeth on these films, this genre of films, along with more overtly political and violent films like the Rambo series. Hollywood quickly recognized how it could make a quick and sure dollar by pulling together pretty faces and benign non-threatening story lines; that is, quality quickly found its way to the Hollywood back-shelf, as more and more, prettiness, sex, and violence became the defining marketing factors for larger-than-life Hollywood Gen X productions. And these films were made by individuals who were outside the realm of Gen X, directors and producers who found themselves profitable and successful with their presentation of benign films; films where the only thing that was challenged was the tyrannical authority of a school principal or English teacher. As a response to the feel-good Reagan era and the host of films that were pervaded by those themes and produced by middle-aged white males, we have witnessed a true to life coming of age of Gen X via Gen X directors and the boom of independent films.

While Hollywood tried to hold on to what it thought was a sure-fire formula for Gen X films like *St. Elmo's Fire*

(U.S.A., 1985) and *About Last Night* (U.S.A., 1986), it was the expression found in independent films, and the attractiveness of an independent voice, that first began to deconstruct and better explain the complex imagery of an American universal well-being that had been purported by Reagan and presented by Hollywood. Notions of alienation and abandonment made their way to the surface of society via independent film, as a natural by-product of an era where material possessions ruled and everything and everyone was disposable.

We find ourselves, now, looking back and viewing our experiences in relation to a reality of alienation and abandonment in contrast to that which was projected onto our psyches. And for many of us, we have found an outlet for our once-duped voices through music, film, and sometimes television. Expression, and a richness in a diversity of expression, has come to be as important for many who identify as Gen X as the material goods that once claimed our identities; that is, our non-consumer identities have been awakened. For example, through the Grunge phenomenon and the music of Nirvana, Pearl Jam, and the power of rap, Public Enemy, Tupac, and NWA, we have witnessed an expression of a diverse voice and a diverse experience that is honest in telling different story(ies), ones other than those put before us by mainstream politicians, schoolteachers, and religious leaders. And those stories are not without a spirituality, a respect for life, or a reverence for difference. They are, however, stories that challenge a dominant cultural hegemon, one that tells us continually that everything is "okay," will be okay as long as "standards" are followed and adhered to. We have seen how Gen X musicians and filmmakers respond to these standards in their presentation, in the artistic expression of their versions of the world, and at times these views have shocked many filmgoers. Whether we consider *River's Edge* (U.S.A., 1986) or *Kids* (U.S.A., 1995) and the apparent disregard for human life and standard Republican morals and values, we are made witness to Gen X "taking things on," taking on a national state of affairs. Often this act is in contrast to what we thought we were supposed to see, say, and be and what is of importance and what is not. These independent voices, films, are just that—independent representations of those living on the margins of a society coming to terms with an end of modernity in ways that are alien to those who have come before us. The independent filmmaker sits on the margins of a film industry that gives more to marketing and the assurance of profits than it does to the art form and its ability to bear witness and resist what I believe to be oppressive tendencies. *Slacker* (U.S.A., 1991), often referred to as the premier independent film of Gen X (although the film now seems elementary and dated), represents an important cultural milestone with its postmodern feel and its subtle rejection of a modern liberal epistemology. This film has inspired other independent filmmakers in their endeavors to shape an art form, film, as a means of making social comment and engaging in a political dialogue. Stanley Kauffmann, writing for *The New Republic*, comments, "There's a unique situation today in film—internationally. Films about young people—say, those under 30 [Gen X]—are being made by people under 30" (1993:24). Young filmmakers are giving voice to their own diverse stories, perceptions, and identities from a variety of standpoints.

This recognition, and the subsequent attempts at understanding the stories of a particular group of people, may provide us with a richer understanding of those complexities that both make up our commonalties and define the differences between us. This does not mean, however, that once recognized, an obvious translation—a dictionary of sorts availing to us a comprehensive knowledge—can be established or even imagined. Rather, our sensibilities might be affected in an important way, in that the act allows us to check and recheck how we see, how we sense, our identities and our boundaries, so that we may better communicate with one another, do politics a bit better, live more peaceably with one another, with greater care.

As I have already mentioned, it is important that one consider not only the Image-Event(s), the aesthetic whole of a film, but the thoughts and considerations of the directors and actors as well. So,

while I am uncomfortable disclosing my passion for film, and thus my work, as an answer to the difference problems pervading our national psyche, I am quite relaxed and comfortable in my presentation of particular themes for a larger debate, within the constructs or confines of what is now commonly known and referred to as Generation X. And through my own life travels at the end of modernity, on the cusp of a new postmodern era, perhaps an era can emerge that will be known for expanding the boundaries of how we view and study difference and ourselves. Perhaps it can be a place where the alienation, abandonment, and uncertainty that seems to define so many of our lives comes to define a new site of humanity from where we can begin to dialogue with one another: Slackers meet Reaganites meet Millennials.

SUMMARY

In this chapter I have examined the importance of film in our efforts to uncover and recognize difference, to locate or imagine some shared footing or common authorship. I have done this by first exploring one of the major debates amongst film theorists: the notion of reality versus fantasy. I question assertions that suggest that somehow this debate compromises or diminishes the work of social theorists. Cinema is more than just an art medium, more than just a battlefield where those who advocate film as fantasy or fiction and interpretation contend with those who claim film represents reality. In my mind, cinema can use tenets of both assertions as film represents a means for communicating with one another. We need to, we must, include all aspects of the cinema in our work at uncovering, recovering, imagining, or creating a space where we are able to connect one kind of experience with another. I suggest this because I, too, want to interrogate specific films in order to uncover "messages embedded" in (the) text so that I may, like other theorists and social critics, examine whether a politics more open to difference is within our grasp.

There are consistent patterns—conventions of film—observed by filmmakers in order to communicate with an audience. These patterns are incredibly influential as they shape our socialization processes, our political understanding, and our imaginary possibilities. The power of film, the power in the viewing experience, can be harnessed to help us gain access to our cultural values and assist in transcending the space between the moviegoer and the motion picture movie screen and the space that divides us as people living in a dominant *we* society and those who live on the margins of that dominant society, individuals living within difference circles.

I have privileged the viewing experience and, specifically, a theory of identification that allows us to employ film theory in political analysis. Because film provides for an environment where the moviegoer falls into a receptive state, and transcends space, he or she may become more susceptible to new attitudes and opinions. A struggle may take place between one set of personal ideas and beliefs over another. For me, this is suggested by Satya Mohanty, in that film becomes a powerful tool for gaining access to buried memories, stories, and experiences that can lead us to some common place, possibly a shared place, of recognition and acceptance.

I have suggested a host of problems that come hand in hand with an attention to film. Specifically, I have expressed my concern with films produced by Hollywood's major studios; that is, films that typically serve as reinforcing agents of a dominant *we* society's oppressive and exclusionary nature. But, while some films can and do, more often than not, suppress stories of difference, independent films often challenge replication of the status quo by engaging and considering diversity, imaging and communicating difference, and demonstrating how cinema can be used as a tool for the recognition of Other. However, while I have taken aim at and have been critical of the majors in this chapter, it should be clear that the majors too have made incredible contributions to the conversation regarding difference,

oppression, and marginalization in the United States and elsewhere as I have also used specific major films as illustrations to stress theoretical points, for example, *Schindler's List*. I am not suggesting that majors are made, are produced, without innovation or that they all as a grouping lack a critical or challenging edge. Of course there are exceptions. However, I do want to be clear in my selection of films for this work: presenting progressive film texts, the viewing of those texts, and the discussions surrounding those texts as contributing factors to the imagining of a shared location across difference lines. This, I find, is more likely when employing independent texts, independent films.

In this chapter, there are two major assertions being made. First, I have suggested that film may be essential to a study that tries to imagine a (un)common location, a shared space, a shared identity, where we can envision U.S. democratic politics in ways that both respect and transcend difference. Second, I have explained how I will approach individual films; specifically, I will consider the conventions of film via Sol Worth's model, approaching identification and the inference of various meanings by looking at the Image-Events of various films and their contributions to discourse, and thus, a deliberative democracy.

In Chapter Three I will investigate Gus Van Sant's *My Own Private Idaho* (U.S.A., 1991), an independent endeavor, while also considering, albeit in a more narrow fashion, Fred Schepisi's *Six Degrees of Separation* (U.S.A., 1993), a major studio release.[38] My investigation is not designed to produce a strong, certain argument, and thus the reader should not expect any definitive answers to persistent national or global questions regarding difference. Instead, what the reader can expect, and what I hope to achieve, is a thoughtful consideration of certain aspects of these two particular films and how they either challenge or (re)affirm specific stereotypes by privileging certain sites, characters, and experiences. In essence, my aims are directed at contributing to a larger and richer discussion surrounding the aesthetics of difference and of the two particular films introduced.

[38] *Degrees* is presented as an illustration of how major cinema often puts forth films that privilege a dominant "*we*" in society. This is in contrast to Van Sant's *Idaho*.

Connections Within/Beyond Sexuality

My Own Private Idaho is a deeply moving film about unrequited love, abandonment, poverty and loss, realized with a gaiety of invention and a lightness of touch that would do Lubitsch proud, or Mozart.

Stuart Klawans *(The Nation, 1991)*

You can always tell where you are by the way the road looks. Like I just know that I been to this place before. I just know that I been stuck here like this one fuckin' time before, you know that?

There ain't no other road on earth that looks like this road. I mean, exactly like this road. One of a kind. Like someone's face. Like a fucked up face . . .

Mike Waters, My Own Private Idaho

My Own Private Idaho (1991, U.S.A.)[1] is a film that attempts to uncover and explore the lives of young men on the streets of Portland, Oregon. They are young men who sit on the cultural margins of society hustling their bodies for cash and survival while wondering who they are and how they got there, (re)making themselves in the process. "*Idaho* is the story of a rich boy who falls off the hill and a kid on the street," remarks writer-director, Gus Van Sant—where high culture meets low culture (1993).[2] The significance of the work for me, however, is more complex than Van Sant first lets on and is veiled

[1]Referred to as "*Idaho*."

[2]Henry R. Greenberg, clinical professor of psychiatry at Albert Einstein College of Medicine in New York and author of *Movies on Your Mind*, comments on Van Sant's work: "A body of work written against the grain of humanistically inclined narrative about the joys and sorrows of 'ordinary people' documents life on the road in the depths, or otherwise at the margins of society. A contemporary literature of the damned specifically addresses the experience of gay males at the edge. One recalls the tarnished street angels of Jean Genet (*The Thief's Journal*) and John Rechy (*City of Night*); the transvestite flaming creatures of Hubert Selby (*Last Exit to Brooklyn*); the bizarre futurist sadomasochists of William Burroughs (*Naked Lunch*). Very different writers in this sub-genre share the same fierce lucidity about their tawdry milieus, as well as an ironic compassion for the lost souls inhabiting them, notably regarding their anguished, hopeless loves. Burroughs explains the title of his seminal

behind what many critics have referred to as a "cut-up"[3] director's technique that can be perceived as scattered and unfocused. In other words, Van Sant's direction in *Idaho* attempts to travel multiple roads at once and undoubtedly loses some more traditional critics and moviegoers on the way. His work is associative—non-didactic; it is also at times abstract, linking various story fragments and ideas together in order to present and uncover a larger and richer picture of life on the streets as Van Sant searches for understanding in a "secret world" he "knew nothing about" (Van Sant, 1996). However, I believe the film works beautifully as a study of difference and the circles of difference regardless of some rough technical spots by allowing an audience to encounter the lives and experiences of extraordinary film characters like Mike Waters (River Phoenix) and Scott Favor (Keanu Reeves). Viewing the film creates a momentary pause so that one might check, and then (re)consider, his or her sensibilities—positioned as eyewitness to the lives and experiences crafted by Van Sant, Phoenix, and Reeves.

SEX, LOVE, AND SENSIBILITIES: THOUGHTS ON *IDAHO*

Idaho presents Phoenix and Reeves as male hustlers grappling with identity and in search of a place to call home, within an independent text that more than resembles the Hollywood road film.[4] Jim Kline explains, "*My Own Private Idaho* is a visually rich, stylistically eclectic odyssey detailing one man's desperate search for comfort, compassion, and a place to call home. The desire to establish family roots in a harsh environment populated by urban derelicts is a theme that Van Sant has toyed with in all of his films" (1992:250). Both of Van Sant's characters are in search of some abstract personal and familial fulfillment—an act that has come to characterize and define many of us who were born within boundaries that identify one as slacker,[5] within Generation X—and the search takes both young men down multiple roads at once. Of specific importance, and of great interest to me, is the depiction of sexuality in the film and the sexual identification of both actors' characters and how their identification

(continued)

novel: Naked lunch is when everyone gets to see exactly what's at the end of the fork, no matter how distasteful or disturbing the view. The gutter poets' objective take on their protagonist's self-destructiveness often articulates with an ideological position that the flagrantly 'bent' life-style is inherently dangerous to the 'straight' status-quo. Authors like Genet regularly employ the decadent mode to critique bourgeois oppressiveness and hypocrisy. Until very recently, mainstream cinema has found little place for the marginal, let alone the conforming gay. With loosened censorship in the past few decades, art films have occasionally portrayed the seedier side of gay culture and the defiance of the quotidian supposedly embodied therein (*Taxizum Klo* and *Prick up Your Ears* and, notably, *Fassbinder of Fox* and *His Friends* and *Querelle*). In *My Own Private Idaho*, director/writer Gus Van Sant draws liberally on the above literary and filmic sources to present his third, most subversive vision of life at the end of the fork" (1992:23).

[3]This technique is credited to writer William S. Burroughs as a method involving various story lines, fragments, and ideas, combined and attached to create a unique story. In an interview with Manohla Dargis of *Artforum*, Van Sant explains how the Burroughs cut-up method allows him to interpret a text in a different way by "playing with the narrative in a very fanciful way, a collage of styles, of attitudes, of philosophies." For me, this clearly signifies a postmodern technique. Van Sant continues, "In *Idaho* in particular we played with a lot of different film sensibilities. When he [River Phoenix/Mike Waters] was on the road it was more a minimalist thing, and when they [Phoenix and Keanu Reeves/Scott Favor] were in the old hotel it was mimicking a Shakespearean play, and then when they were in Italy it was picking up on Italian cinema, as a stylistic reference" (1993:76). This technique allows Van Sant and other filmmakers to push further hegemonic film and social boundaries.

[4]In the January/February 1992 issue of *Films in Review*, *Idaho*, while referenced as a road film (as in many other reviews and journal articles), is more accurately described not by a search for place, but, rather a search for emotional roots and belonging: "It's the personal odyssey, often surreal of two young ambisexual street hustlers."

[5]I understand the term *slacker* to represent an individual within Gen X who has largely abandoned the conventional code of believing that hard work, ingenuity, and the like will pay off in a social and economic affluence.

and experience might inform and perhaps transform one's sensibilities,[6] a moviegoer's sensibilities[7] regarding the naturalness and moral virtue of heterosexuality. However, I am not suggesting, nor does the film suggest, a narrow and conventional or straightforward understanding and viewing of sexual identification; on the contrary, Van Sant presents a complex interpretation of sexual desire and rooted love.[8] Van Sant explains how *Idaho* is about "an area of society—prostitution—that's not defined in terms of gay or straight" or by any other sexual label (Van Sant, 1991). Instead, in this film narrative, a narrative that follows the fictional lives and experiences of these two primary characters, we as an audience bear witness to these particular men's lives and experiences, in all their complexities: Mike as a narcoleptic hustler[9] who drops into a deep sleep whenever he becomes distressed allows us access to his past experiences, his pain and longing, through a dream state that transcends what we often consider to be a traditional sense or presentation of the personal. We as an audience know and share his memories, even though we may not fully grasp or understand them;[10] and Scott, as the blue-blooded son of the mayor of Portland who is hustling mostly to anger his father is also fascinating as the person who embodies that absent piece of self that Waters is searching for, family. However, Van Sant's characters do not clearly and conventionally announce what is specifically absent in their lives. Rather, the characters are unclear themselves, and the recognition of that uncertainty, the act of it, is as significant to the narrative as the absent piece of self. As an audience we become eyewitness to these certain spaces of these lives and of our own. And in bearing witness to these lives we recognize them, and we resist the continued silencing of them by a dominant *we* society by also recognizing the oppressive nature in which different peoples are silenced and marginalized. This act of bearing witness, of being an eyewitness to diverse lives, is central to basic social and cultural transformation and a virtue of film as a social, transformative, medium.

Amy Taubin (*Sight and Sound*) explains how "Van Sant connects with his characters through a shared sense of alienation" (1992:10). This shared experience of alienation between Waters and Favor is wrapped in a complex way with notions of love, sex, and desire and draws an audience into an act of identification whether that act be defined as bearing witness or making judgment on the protagonists' lives and experiences. This shared sense of alienation is defined by the shared feelings of loneliness, isolation, the loss of identity, and the feeling of not being cared for, an alienation that is shared by the Gen X slacker and one that informs his or her attitude regarding opportunity, affluence, and conventional success.

The film helps propel my argument regarding the role of film in (re)imagining politics and a new sensibility across difference lines by incorporating alternative forms of argument; specifically, seeing and

[6]This is also of interest to *Idaho's* director, Van Sant, as he often has identified his desire to expand sexual frontiers. For example, when asked about the frontiers he is interested in pushing further, Van Sant responds, "Sex is the obvious one." And in a telling comment about the majors, he responds to Manohla Dargis' question, "Do you worry money-people might be scared off by some of these frontiers?" "Oh, yeah, they're scared. They get scared," Van Sant says. Dargis continues, "What do you do to placate their fear?" "You just work cheaper," is Van Sant's independent response (Artforum, 1993:76).

[7]There are, as well, other equally significant, but more subtle, related themes like class.

[8]The sexuality of Van Sant's characters, Mike Waters and Scott Favor, is implicit and has been questioned by critics and moviegoers alike.

[9]Mike Waters' narcoleptic seizures emphasize his extreme vulnerability in a world filled with "brutal, manipulative con artists and border line degenerates" (Kline, 1992:250).

[10]Jim Kline writes for *Magill's Cinema Annual*, "Mike is obsessed with his early memories of family life, the only pleasant memories that he has. His narcoleptic seizures are filled with dreams of his personal conception of paradise, one that includes a comforting mother and a small farmhouse surrounded by dynamic natural beauty. Whenever harsh reality becomes too threatening or too ugly, Mike sinks into his perfect dream world and finds the life that he longs to live" (1992:250)

Fine Line/Photofest

My Own Private Idaho, 1991

recognizing democratic conversation differently through street stories.[11] For example, their relationship (and their sexualities), Waters' and Favor's and how it informs their individual search for personal fulfillment, suggests a reliance on one another through a shared street experience that both informs and transforms their lives, albeit in different ways, and pushes an audience to either accept, and thus connect one kind of experience (belonging to Van Sant's characters) with another (belonging to the moviegoer) or reject those experiences and the social/cultural values that define their lives, or perhaps to land somewhere in between.

This, along with other themes like shared generational alienation, hopelessness, and loss of modernist notions of love and family, illustrate how film can be a privileged site for not only viewing, but often engaging and better understanding difference and the Other—whether that Other be defined by sexuality, race, or gender—by uncovering and presenting stories that might allow for or prompt a transformation in one's sensibilities, a connection of some sort in that film allows for a viewing of difference that may be absent in a moviegoer's life. *Idaho* presents an interpretation of street life to those who do not know the street. In viewing the film, an audience may recognize, and possibly even identify with, particular notions of alienation and hopelessness—loneliness, isolation, lack of or loss of identity, absence of care—or the search for unrequited familial love that is at the core of *Idaho*. This core may not be exclusive; in other words, particular notions of alienation and hopelessness might be quite fluid and flow in and out of our lives. However, there is a possibility for connection between different people who have, in some manifestation, experienced similar feelings of human uncertainty.

[11]Cherry Smith writing for *Sight and Sound* contributes to this larger question about crossing difference lines when she says, "What I'm trying to grapple with is whether my sexuality has any relevance to the broader world. How does it allow certain insights which are not necessarily related to (our) homosexuality? I want to use these formal devices, that outlook and sensibility to look at a wider society. I hope we don't get a series of films over the next decade which are obsessively about the transgressive nature of our sexuality. A film does not have to be about gay/queer sexuality, or even about sexuality at all, to be queer. It's taken on taboos, saying the unsayable—to me that's what queer is" (1992:35). tough Mickey Rooney to his model 'town' to reform him. There, a snarling, nasty Rooney quickly forgets the wounds of his impoverished city childhood and reverts to his more familiar Andy Hardy persona" (Crowdus, *The Political Companion to American Film*, 1994:396).

SEXUALITY, ALIENATION AND HOPELESSNESS IN *IDAHO* AND GENERATION X: A CHALLENGE TO CONVENTION

Both characters, Waters and Favor, are social outcasts living on the fringes of society. And both are in search of some unidentified piece of themselves.[12] Scott is the modern day prince Hal[13] (*Henry IV*) slumming the streets of Portland in rebellion against his father (the manifestation of modernity and corporatism) and protector of Mike, his best friend. Their relation to the larger community of male hustlers on the fringes represents a legion of urban youth standing in resistance to modern conceptions of Truth, Rationality, and Morality. As an audience, we find ourselves presented with fascinating explorations into street life, into the margin or the fringes of a dominant *we* society. *My Own Private Idaho* is visually rich and "stylistically eclectic" in its presentation of a subculture's desperate search for "comfort, compassion, and a place to call home"[14] in a larger society identified, classified, and represented by conservative utopian thinkers like Newt Gingrich and his particular psychosis as illustrated in his public comments about *Boys Town*[15] (U.S.A., 1938) and its now neoconservative, nineteenth-century presentation of discipline that gives way to transformation for modern urban teenage youth. Quite simply, Gingrich and others are willing to disregard the angst of Gen X in that they offer a prescription for a conventional discipline in order to hammer home the presumably moral values of a WWII generation and thus cure Gen X with a moral code that suggests that through hard work and ingenuity social and cultural affluence and moral redemption is accessible to everyone. This prescription represents an antithesis to a Gen X sense of alienation and hopelessness as we are discredited by Gingrich and other conservative utopian thinkers as whiners.

Van Sant is willing to walk the edge and push the boundaries with respect to this dominant conservative utopian vision in that he dares to fold in an explicit appropriation of Shakespeare's "slacker plot" (Ottenhoff, 1994:613). Many critics and cultural theorists, John Ottenhoff being only one, have framed Van Sant's inclusion of Shakespeare's language and plot (specifically *Henry IV*) as a challenge to the notion or vision of this conservative utopia; that is, Van Sant employs Shakespeare not for the purpose of stabilizing public anxieties in order to give an air of civility and power in our postmodern day; rather, Van Sant aims at depicting a theme that suggests while "entry into the world of respectable adults may be possible, it's [most likely] suspect and probably constitutes betrayal" (1994:613). David Roman (*Shakespeare Out in Portland: Gus Van Sant's My Own Private Idaho, Homoneurotics, and Boy Actors*, 1994) writes: "Shakespeare is brought out by those in power[16] in order to stabilize public

[12]Of interest are film critic Harlan Kennedy's comments regarding Van Sant's direction: "Van Sant boldly floats us off on a sea of visions with no visible anchor. All we have and need are a few recurring touchstone images—notably the desert road of Phoenix's end and beginning—to guide us through a tale of personal and planetary growing up. For *My Own Private Idaho* isn't just about two male hookers learning Who They Are. It's a fable about the leaps in perception by which a world grows up. The narcolepsy that gives Phoenix his blackout ellipses between scenes and events (just like the shuttered intervals between movie frames) emblemizes the free-form imagination itself" (1991:43).

[13]*Idaho* recounts the story of Shakespeare's Prince Hal (Henry IV), who, "having slummed through the underbelly of England's social landscape, emerges triumphant in his transformation as King Henry V" (Roman, 1994:312). "Mike's primary human interaction is with fellow hustler Scott Favor, the Hal like son of Portland's mayor. Scott throws off his slumming life of hustling, squatting and poverty midway through the film and renounces his Falstaffian companion Bob Pigeon (William Reichert) and pal Mike in order to return to respectability" (Ottenhoff, 1994:613).

[14]Kline, 1992:250.

[15]"The simplistic *Boys Town* suggests that if city slums cause delinquency, then the answer is to simply move the kids to the country. Armed with his faith that 'there's no such thing as a bad boy,' Father Flanagan (Spencer Tracy) takes slum

[16]David Roman explains, "Marjorie Garber (noted Shakespearean and cultural critic) aptly has argued that the current manifestation of the Shakespeare fetish in fashion these days 'has come to stand for a kind of humanness that, purporting to

On the set of My Own Private Idaho, 1991

anxieties regarding gender and race relations, in Van Sant's *Idaho*—a different set of dynamics are at play that focuses on anxieties about (homo)sexuality" (1994:312). Van Sant's employ of Shakespeare is not at all like Gingrich's employ of *Boys Town* and its focus on discipline as a cure for those who challenge conventional codes of conduct and behavior and dominant notions of identity; rather, Van Sant challenges the "fantasy of original cultural wholeness, the last vestige of universalism" (1994:312). For example, Ottenhoff writes, "This Hal [Scott Favor/Keanu Reeves] finds no glory in battle, and Van Sant borrows only the darker elements of Shakespeare's story. The Scott Favors of the world can follow their parents into affluence, but more often this generation [Generation X] is left with Mike Waters on the road to nowhere" (1994:613). Thus, in foregrounding Mike Waters and not Scott Favor in *Idaho*, Van Sant essentially takes aim at a perceived cultural "destiny" by privileging an implicit homoerotics of male bonding and a sexuality that clearly challenges many of those living within the dominant *we* in our society as it also propels a debate surrounding the shifting social ideologies of gender and human sexuality. In an interview with Peter Bowen (*Off Hollywood Report*, 1991), Van Sant explains his Shakespearean intentions, Bowen writes, "Rather than marking the hustlers' story in the elevated ranks of the official and socially sanctioned, Van Sant's use of Shakespeare works more to destabilize our sense of historical continuity and cultural destiny than it does to affirm it" (1991:28). Essentially, Van Sant's work challenges an audience to either consider or reconsider

(continued)

be inclusive of race, class, and gender, is in fact the neutralizing (or neutering)' of those potent discourses by appropriation."
He continues, "Garber cites some of the events in the late 1980s—Laurence Olivier's funeral, Secretary of Education Lynne Cheney's report on the humanities, and U.S. actor Sam Wanamaker's campaign to rebuild the Globe theatre—to make her point, but the events of the fall of 1991 demonstrate that the Shakespeare fetish phenomenon continues, if not grows. The Senate confirmation hearings, with Alan Simpson of Wyoming acting as if he were the head of a doctoral defense, correcting Joseph Biden's mistaken allusion to Shakespeare and grilling Thomas on his recollection of *Othello*, only added to Garber's thesis that Shakespeare's uncanny recurring presence in our time materializes as a type of cultural assurance of civility and power, however ironic its staging may be. That Simpson himself failed to recognize that the quote he cited to support Judge Thomas is actually spoken by the duplicitous villain Iago was ironic, but, by then, beside the point. That Shakespeare was introduced—inevitably and deliberately—placed Thomas's position in the arena of the universal, legitimate, true" (1994:312).

its sensibilities with regard to sexuality in a postmodern age; that is, a hetero/homo binarism is placed within a core story that addresses alienation and hopelessness and the search for familial love. Male-male sexual activity, and the depiction of it and a surrounding lifestyle in the cinema, creates a space where debates regarding morality, transgression, and political agency are vigorously argued. This is fairly obvious; hence, when Van Sant explains that "It's a political act to do a film like this," we are not at all surprised (American Film, 1991).[17] In fact, one can characterize *Idaho* as a story-as-argument that can perpetuate a (re)consideration of our sensibilities, as an audience, where gender and sexuality are concerned.

Van Sant's divides the film text into at least three major story lines—the search for Mike's mother, and thus familial love; the retelling of *Henry IV* through an adaptation of Shakespearean prose that is intended to challenge convention;[18] and the often graphic, surreal, and documentary-like presentation of life on the street, a presentation of the Other. These three interrelated stories are presented with a chopiness, a fractured narrative, of which many film critics, and some filmmakers for that matter, would be fearful. But this presentation, with its absence of a Hollywood-like fluidity and narrowness (a linear, liberal notion or sensibility) that often focuses on high-concept stories and characters, gives the richer and more complex picture of a subculture that Van Sant is trying to depict. It also identifies and underscores feelings of alienation and vulnerability that often are common amongst Generation X, Slackers.[19] These feelings of alienation and vulnerability are not exclusive to Gen X, to Waters and Favors. And in considering how connections across generations could be made through a recognition of these similar feelings, of uncertainty and alienation, albeit under different historical circumstances, we may discover a way in which transgenerational connections could allow for a transformation in sensibilities that would enrich and better inform our lives.

INDEPENDENT "POLITICS": ADDRESSING VAN SANT'S FEELING CONCERNS[20]

Van Sant is well known for his unique exploration into the depths of alienation and vulnerability when embarking upon a trip into subculture and film.[21] Taubin calls Van Sant, "a distinctly American film-maker with an extraordinary sense of place" (1992:8). And as an independent filmmaker, Van

[17]"Both River Phoenix and Keanu Reeves seem to notice the political stakes involved in performing gay male sexuality. River Phoenix's remarks in *Interview* convey the homoerotic bond the two actors needed to forge, on Santa Monica Boulevard no less, in order to guarantee that they themselves would be equipped to combat the inevitable innuendo concerning their own sexuality. And, if River Phoenix's description of their promise—'I'll do it if you do it, I won't do it if you don't'—sounds less like a bad dream and more like a wet one, Keanu Reeves's comments in *US Magazine* negate the sexual acts of male hustlers along with his own complicity in the homoerotics of male bonding by explaining that the film is about something else, and something 'better,' entirely: 'I mean, its more.' Through out the film and in their own perceptions of their roles in the film, the boy actors in *My Own Private Idaho* embody the simultaneous arousal of homoerotic possibility and its homoneurotic disavowal" (Roman, 1994:319).

[18]Influenced by Orson Welles' *Chimes at Midnight* (U.S.A., 1967).

[19]Harvey Greenberg (*Movies on Your Mind*) writes, "Criticism melts before the buoyant, unstable fertility of Van Sant's invention, the unerring correctness of his cinematic choices. With perfect ease, he circulates between verite reality (the hustlers' grimy, hilarious histories spoken directly to the camera are especially fine); surreality (the opening a wonderful case in point); and hyperreality (the detritus Mike takes from his pocket and shovels at a cashier—a condom, candy wrappers, bills— owns a diamond-hard edged life of its own. One intuits the jumble is his life.)" (1992:25).

[20]See Chapter Two.

[21]Van Sant's exploration is conducted with compassion. Kline writes, "Van Sant also specializes in compassion. His previous film, *Drugstore Cowboy* (1989), was a profoundly moving examination of the life of a teenage junkie as he and his

Gus Van Sant, My Own Private Idaho, 1991

Sant works to give voice in a manner that is not political in a conventional sense. By this, I mean he attempts to show life within a subculture without gratuity and thus without a pure commercial goal, without glorification, and without a damning gaze that often privileges a wider and larger public debate between competing versions of morality.[22] For example, in *Drug Store Cowboy* (1989, U.S.A.), Taubin explains how the strength of this Van Sant film lies "in its detailed depiction of lower-middle-class suburbia and its non-judgmental and non-romanticized attitude towards drugs." She continues, "With Nancy Reagan's hypocritical 'just say no' campaign in full swing (Matt) Dillon's speech about how heroin made it possible for him to tie his shoes every morning without going nuts was as subversive as it was honest" (1992:12).

Van Sant's films do not exploit or romanticize their "seedy" content nor are they constructed for the sole purpose of a social or moral comment. Rather, his films are associative rather than didactic in their narrative presentation of peoples living on the margins of a dominant *we* society. He presents his characters impartially, leaving the construction or formation of any value judgments to an audience.

Can a filmmaker shake up the apparatus? In an interview with Manohla Dargis (*Artforum*), Van Sant responds to such a question by pointing to D.W. Griffith and David Lynch as individuals who invented a new way of looking at the *image*. This invention is not unlike my suggestion for a prescribed shift and expansion in what is considered to be rational argument, how we argue and what is considered to be rational argument in a postmodern world; that is, a shift in sensibilities—from seeing the world in one way, to seeing it through a (re)imagined lens—seeing homosexuality through a (re)imagined lens that

(continued)

muddle-headed gang of drug addicts stumble around the pacific Northwest robbing drug stores and hospitals. Although the characters were hardly model citizens, Van Sant managed to make them wonderfully real and compassionate human beings worthy of the audience's sympathy" (1992:247).

[22]Greenberg writes, "Despite its lurid subject matter, nothing prurient and little offensive will be discovered in *My Own Private Idaho*, unless one is put off by its subject matter. The film is surprisingly innocent. The hustlers, with their loopy johns and cracked dreams of glory, are never romanticized as in *Pretty Woman* but treated with evenhanded generosity" (1992:25).

positions it, not unlike a conventional understanding of heterosexuality, as natural and moral. Speaking of Lynch, Van Sant says, "What he does is present the emotions, as opposed to logical dialogue and stories . . . presenting the emotion as opposed to the logic. You could watch movies in a string of, say, emotions, so eventually that would be the story, more like a poem as opposed to prose" (123). Van Sant has succeeded in *Idaho* with a presentation of emotion—his Feeling-Concern—that screens more like poetry than the typical Hollywood linear norm or high-concept cinema. The choices Van Sant has made in the filming of *Idaho*—specifically the cut-up technique—suggests a requisite for film goers in that they must be willing to consider their own lives alongside those of the characters depicted on the screen, and thus consider various interpretations of reality.

Van Sant has directed four major films over the past fifteen years including *Mala Noche* (1985, U.S.A.), a black-and-white film about a gay, poverty-stricken store clerk and his particular sexual obsession with an illegal migrant worker; *Drugstore Cowboy*, the very successful film about a quartet of junkies starring Matt Dillon; *Good Will Hunting* (1997, U.S.A.), the recent Academy Award—winning film; and *My Own Private Idaho*, the subject of this work. With the exception of *Good Will Hunting*, these films illustrate a foregrounding of emotion over a logical high concept story line that is often requisite for the industry's major distribution. They also illustrate the importance of a director's politics (an independent politics), his or her Feeling-Concern, and how those emotions and sensibilities are produced, and thus how they inform the Image-Event that is presented to an audience for their consumption and interpretation.

It is through these films that we learn of Van Sant's identification with various subcultures depicted in his body of work; specifically, his focus on characters that share a sense and experience of alienation and vulnerability, often across difference lines. These experiences are not exclusively tied to homosexuality and/or drug use (noting *Drugstore Cowboy*). Rather, Van Sant's work is broader in its attempt to capture and then present an interpretation of "reality" that is shifting, complex, and ambiguous, and he does not limit or confine his work to that of only gay cinema.[23] However, his films do fall into a category of cinema, a genre, where there is a presentation of the "bleak world facing a generation of Americans with the most—if not the best—education in our nation's history." John Ottenhoff, in *Christian Century*, suggests we view *Idaho* within this framework, a film that "stands [with others][24] united in condemning the materialism and blithe hopes of progress of the baby-boomers" (1994:615). *Idaho* clearly represents, and to some extent even defines, a world where Generation X faces an uncertain future in a "messed-up" country. Van Sant is able to show sexually ambiguous characters confronting the expansive questions and problems facing a whole generation of middle-North-Americans, gay or straight.

Van Sant, who is openly gay, in an interview responds to a question about sexuality in his films by saying, "A person's sexuality is so much more than one word, 'gay.'[25] No one refers to anyone as just 'hetero' because that doesn't say anything. Sexual identity is broader than a label" (1992).[26]

[23]Note Van Sant's works, *To Die For* (U.S.A., 1995) and *Good Will Hunting* (U.S.A., 1997), and his remake of the Alfred Hitchcock classic, *Psycho* (U.S.A., 1998).

[24]*Reality Bites* (U.S.A., 1994), *What's Eating Gilbert Grape* (U.S.A., 1994), and *Slackers* (U.S.A., 1991).

[25]In an interview with Amy Taubin, Van Sant responds to being asked about his and the film's sexuality, "It's not that it's not a gay film, but it doesn't play into any obvious gay politics. I've been noticing that when people write about me, they say I'm 'openly gay.' John Waters and I were talking about it and he said, 'in a list of forty things that I am, gay is not the first thing'" (1992:23).

[26]Again, Cherry Smith contributes by explaining how she is "wary of talking about an overarching queer aesthetic, as my sensibility comes as much from my culture and race as from my queerness. In queer discourses generally there is a worrying tendency to create an essentialist, so called authentic, queer gaze" (35).

This is evident in *Idaho*; that is, Van Sant presents the contingent life of street hustlers as boys who are looking for guidance: "Sex was something they did, but it was unimportant. What was really important was sometimes control and sometimes attention and focus from somebody who could be like their dad . . . It's about abandonment" (Van Sant, 1992). I believe that Van Sant's attention to alienation and abandonment strikes a particular chord with those living as slackers at the end of a modernist era. Sexuality, while foregrounded, shares space with an equally important attention to an identity formulated through deep-seated issues and experiences with alienation, vulnerability, and abandonment. This shared space presented in Van Sant's independent cinema holds a possibility for a transformation of one's sensibilities—for the heterosexual who has learned he or she has gay friends or family and for those whose sexuality falls short of a conventional hetero image and whose sexual desires range, at times, sometimes more and sometimes less, outside normal depictions and expectations presented by a dominant *we* society. In other words, hope for connecting one kind of experience with another, and thus a revealing of a richer understanding of difference, is reliant upon a moviegoer identifying with the alienation and uncertainty presented in the lives of *Idaho's* characters.

VAN SANT'S CHARACTERS AND AUDIENCE: CONNECTING ONE KIND OF EXPERIENCE WITH ANOTHER

As an audience, as a filmgoer, we are introduced to Mike Waters (Phoenix) after being presented with a dictionary definition of narcolepsy. Then, standing on a deserted highway with his hands framing the long path of asphalt before him, we hear Waters describe both the uniqueness of, and his familiarity with, this particular road—"One of a kind. Like someone's face" (Van Sant, 1993:110). He continues, "Once you see it, even for a second, you remember it, and you better not forget it, you gotta remember people and who they are, right? Friends and enemies. You gotta remember the road and where it is too . . ." (110). This dialogue foreshadows as it uncovers the director's aim at presenting people and their varied lives in a manner that is both familiar and permeable. Waters says, "I always know where I am by the way the road looks," suggesting an interaction of sorts, a coexistence, with both friends and enemies. This road is marked by different experiences and is traveled by different people, yet it represents a common life-route shared by both friends and enemies, those who are like us and those who reject us in that the road represents life itself.

In this opening scene Mike suddenly falls into a narcoleptic attack and we, as an audience, are transported into his dream world, a world that is filmed in 8mm as if the dream were a faded home-movie, a recorded memory—however, an incomplete one. The narcoleptic attacks or spells are an important motif to Van Sant's work; specifically, they emphasize Mike's vulnerability and represent a portal into his world, his past experience, memories, loves.[27] These memories, these "home" movies come to represent the private *Idaho*[28] of the film's title giving us impartial and unromanticized glimpses into Mike's dreams, desires, and longings. An audience is eyewitness to these dreams, desires, and longings—a collection of memories that can affect one's sensibilities—as they either identify with or reject Mike Waters' experience.

[27]Ottenhoff describes Mike's narcoleptic seizures as a way of "defending himself from reality by lapsing into [narcoleptic] seizures of escape" (1994:613).

[28]Gus Van Sant titled his film after hearing *Private Idaho* on the radio, a song written and performed by the B-52s.

This particular episode presents Mike as a child safe in his mother's arms on the porch of an old wooden house. Van Sant's creation of a fluidity between close-up shots and panoramic vistas of the Idaho landscape coupled with the surreal, with intimacy and distance—the montage of clouds rushing across the sky and salmon leaping up stream as if to spawn—comes to a head when Mike's dream is halted and the wooden house drops from the sky as if it were being dropped by a tornado, broken and destroyed.[29] Then all eyes are on Mike being "sucked off" by an older, fat, and balding john, then reaching orgasm.[30] Van Sant's cut from footage aimed at presenting a longing for the tender love of mother and family, this dream, to that of oral copulation as labor complicates for the audience their interpretation of Mike—son and hustler—and underscores a theme of complexity and uncertainty, and of vulnerability. However, Mike's search for his mother is presented as a continual theme juxtaposed with this gritty depiction of street life as he battles the consequences, both physical and emotional, of abuse, abandonment, and alienation throughout the film. Here, as an audience, one must wade through the fractured narrative and leave behind any assumptions one might have referencing a liberal social or political outlook; that is, you are no longer in a linear Kansas where film texts move on a higher plane from one point to the next with clear motivation; no, you are fully immersed in a postmodern aesthetic that at times can be both confusing as it is intriguing, a postmodern Oz (*The Wizard of Oz*, U.S.A., 1925).

Some in the audience will no doubt prefer convention and tradition; that is, some will be unable to imagine and identify with a new world and a changed or transformed set of sensibilities, a black-and-white-Kansas-rationality that stands in ignorance of Oz.

This social, cultural, and political battle informs in many ways Mike's relationship with Scott Favor. Taubin writes, "Deeply regressive, Mike's desire for family is for the safety of the mother's body; his narcolepsy is his defense against the agony of his childhood abandonment. Anything that reminds him of his lost mother triggers a violent psychosomatic reaction" (1992:12). Favor becomes Mike's guardian and only family, sharing time and experience with one another, as together they search for Mike's mother. And it is this relationship, more than the work-like sexual encounters Waters engages in on the street, that inform and challenge our sensibilities in a way that screams for a thoughtful consideration, or reconsideration, of a socially constructed, destined sexuality that often prohibits one from understanding and then respecting difference, homo or bisexuality. Roman writes, "Throughout the film, Keanu Reeves's Prince Hal character calls attention to his non-gay identity; he has little interest in sex with males other than as a means to upset his father and set up his climactic redemption at the end through heterosexual marriage. River Phoenix's Mike, on the other hand, articulates homosexual desire and calls attention to both the homosocial and homoneurotic[31] components of his encounters with Scott and other Portland hustlers" (1994:319). This divide between Scott and Mike sets up one of the film's greatest moments in that an audience is presented with a confrontation of two distinct identities and the uncovering, and thus recognition, of self by Waters. This scene demands a response from an audience, if only a momentary pause.

[29]Van Sant explains the barn (house) crashing down to the ground as "the character crashing to the ground, emotionally, which was a more abstract explanation of his point of view" (*Artforum*, 1993:76).

[30]This scene and several others are directed in a way that resembles Andy Warhol's *Trash*. Van Sant says, "I've been really influenced by his work" (*Artforum*, 1993:76).

[31]Homoneurotics as described by David Roman serve to pressure what he calls the "presumptive universalizing" of modernity that "normalize heterosexuality and homosexuality as an essential binarism." He clarifies homoerotics as conveying possible pleasures within homosociality and homoneurotics as naming the "individual and cultural anxieties" regarding those pleasures (1994:318).

IDAHO'S TRIUMPH—THE CAMPFIRE SCENE: BEARING WITNESS

While Favor is Mike's protector and best friend, both *Idaho's* object of affection and villain, his story takes a back seat to what Taubin has referred to as the governing consciousness of the film, Mike Waters. Particularly important to my work is what has come to be known as "the campfire scene" and Waters' confession of love for Favor. Almost universally, critics have recognized this scene as the highlight of the film. Whether the scene is described as an "old-fashioned wonderful movie moment"[32] or one that is filled "with an absolute, naked need that blasts through easy tags of homo/hetero/bi,"[33] we find ourselves as an audience moved and transformed by an honesty that has the power to transcend difference lines and (re)shape our sensibilities.

River Phoenix's film performance, in the words of John Ellis (<u>Stars as a Cinematic Phenomenon</u>, 1992), "permits moments of pure voyeurism for the spectator, the sense of overlooking something which is not designed for the onlooker but passively allows itself to be seen" (619).[34] Here lies one of the greatest powers of film, and again one of its dangers in that an audience can look in on the private lives of these characters. *Film Quarterly* explains the depiction of Waters as being "so passive, so fluid in his defenselessness that he sometimes seems to dissolve into his surroundings. . . . It's often unclear whether we're inside or outside Mike's skull, in real time or dream space" (Ellis, 1992:23). And Edward Guthmann of the *San Francisco Chronicle* writes, "Over a campfire with his best friend, Scott, Mike confesses his love and whispers, 'I want to talk to you.' He doesn't mean 'talk,' really. What he wants is connection, an intimacy he's never known. Embarrassed, Mike hugs his knees to his chest, looks down at the ground and lets out a tiny whimper" (Nov. 17, 1993:F1). Scott Favor, on the other hand, is on the streets and participating in homosexual sex only for money and in rebellion against his upscale mayor of Portland father; that is, he identifies himself as heterosexual, at least implicitly according to the director, Van Sant. Throughout Phoenix's performance, however, Mike displays an implicit gay sexuality that clearly contrasts with Reeves' depiction of Scott and of heterosexual privilege.

At one point in the film, we as an audience learn of Favor's identification while viewing a counter display inside an adult book shop; specifically, a homoerotic section of the store where there are groups of men loitering around flipping through various gay pornographic books and magazines. Then the camera gives a full view of a particular magazine, *Male Call*, with Reeves' character on the cover. Scott comes to life and begins to speak to the audience: "I never thought I could be a real model, you know fashion—shit, cause I'm better at full body stuff. It's okay so long as the photographer doesn't come on to you and expect something for no pay. I'm trying to make a living, you know, and I like to be professional. 'Course if the guy wants to pay me, then shit/yeah. Here I am for him. I'll sell my ass, I do it on the street all the time for cash. And I'll be on the cover of a book. It's when you start doing it for free that you start to grow wings, right, Mike?" Mike, on the cover of *G-String*, responds, "What are you talking about. What wings?"/ "Wings, man, you grow wings and become a FAIRY," Scott says. David Roman argues, and I agree, that in many ways it is homosexual love and not sexual desire that enacts the ultimate social transgression described in this sequence:

[32]Frank Maloney, 1998.

[33]Amy Taubin, 1992.

[34]*Films in Review* (January/February, 1992) also recognized Phoenix's remarkable performance: "River Phoenix as the gentle Mike, whose coitus is often literally interruptus during bouts of narcolepsy, breaks through his former teen screen image and emerges as an actor of potent force and sensitivity" (36).

Van Sant encapsulates this dialectic: the camera swoops through a porno shop as the viewer, following a cowboy-hatted number inside, is led to a gay porno display of such mags as Homo on the Range, Joyboy, Male Call, and G-String. Once in this nebulous male space, Van Sant displays his boy actors on the covers of these skinmags as the pinups they indeed are— suggesting that in contemporary U.S. culture, the road from Teen Beat to Beat Meat is not quite as long as one might think. Objectifying and commodifying—indeed, marketing—the sex appeal of both Reeves and Phoenix, Van Sant has his cover-boy stars come to life. The pinups exchange glances and engage in cross-rack chatter as if they were on the opening credits of The Brady Bunch or Hollywood Squares. Despite such campy invocations, this moment demonstrates the operative dynamics of the homoneurotics engendered by boy actors. As hustlers, these pinups articulate their views of their profession; yet these discussions soon come down to the central differences between Mike and Scott. Scott explains that, unlike Mike, he never gives away his body for free. Such a claim distinguishes for Scott the line imagined between straight and gay identities, an arbitrary distinction that Mike doesn't quite understand" (1994:320).

Following this exchange an audience is presented with Mike's campfire confession and his declaration that he loves Scott even though Scott does not pay him for his affection. Taubin explains the confession as a risk of a "repetition of his primal loss by confessing his love to Scott, 'I just want to kiss you, man,' he says softly, hugging his arms around his chest" (1992:22).

Phoenix's language and the film's dialogue is simple; however, the physical movement and the emotion portrayed in Phoenix's facial expressions strongly illustrates his longing for family, home, and love.[35]

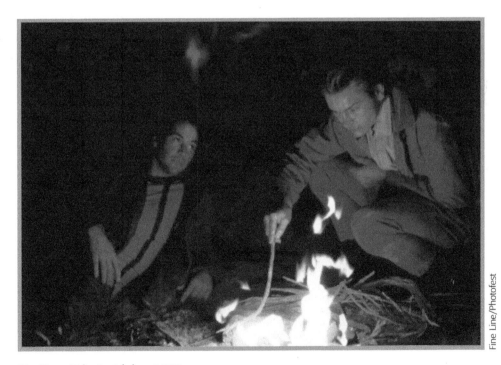

My Own Private Idaho, 1991

Fine Line/Photofest

[35] *The Nation's* review of Phoenix's performance is noteworthy: "Phoenix plunges into the role of Mike with a recklessness that's almost shocking. He's so deep inside the character, you feel he'd do anything—sleep on broken glass, set himself on fire—and not even notice the camera was rolling (Klawans, 1991:530).

Mike tells Scott that he wants to be a part of a normal family. "What's normal?" asks Scott. "A mom and a dad, a dog and shit like that," Mike answers. Lizzie Francke (*Sight and Sound*) writes, "There is a terrible pathos and deep loneliness—as deep as his frequent bouts of sleep—to Mike's desires. He loves Scott, the inveterate user, who has stated that he will only have sex with men for money. 'I could love somebody else if I wasn't paid for it,' says Mike in one of the most moving scenes in the film, truly solemn moment amongst all the playfulness, and a tender and sad evocation of unrequited love in a loveless nexus of relationships" (1992:56). The campfire scene is the scene to consider when viewing *Idaho* because of the private nature of the setting, the sharing of self, and the exposure of vulnerability and uncertainty through a personal honesty. Here, a moviegoer must truly consider Van Sant's characters and their lives. And while Favor identifies as heterosexual, there is a pause, a connection, between the two young men that avoids a conventional sensibility, where the rich-up-town boy who identifies as being heterosexual connects with Waters.[36]

MAKING SENSE OF *IDAHO*

In Clint Eastwood's film, *Midnight in the Garden of Good and Evil* (U.S.A., 1997), Kevin Spacey's character says, "Like art, truth has many interpretations." And no doubt, people will perceive, have perceived, Van Sant's work in *Idaho*, and its presentation of sexuality, in a multitude of ways; the interpretation is by no means universal. Quite simply, many people have found the film and Van Sant's direction of it to be prurient, gratuitous, and obscene. And clearly this represents a challenge for me as I argue for the film's importance and its contribution to a larger discussion regarding Other and difference. Now while we as individuals may not always be able to identify[37] with a film's character

[36]How important is this sexuality, the sexuality of Van Sant's characters? And does it really inform better, or enrich our sensibilities and understandings of difference? We should again consider Van Sant's interpretation as the author of the piece and then the contributions made to the characters' development by the actors playing the roles; specifically River Phoenix. Taubin asked Van Sant whether Phoenix had written the campfire scene as was rumored. He responded, "The character wasn't originally like that; originally, he was more asexual. I mean sex was something he traded in, so he had no real sexual identity. But because he's bored and they're in the desert, he makes a pass at his friend. And it just sort of goes by, but his friend also notices that he needs something, so he says we can be friends and he hugs him."/ "But River makes it more like he's attracted to his friend . . . That he's really in love with him," Taubin says. "Yes, that he's in love with him. He made the wholecharacter that way, whereas I wrote the character as more out of it, more myopic" (Van Sant, 1992). Phoenix also made the character consistent throughout the film—responding to a question by Paige Powell and Gini Sikes in a November 1991 interview, Phoenix comments on the *Idaho* campfire scene: "The campfire scene was definitely a combination of Keanu and me working together off-set, fucking around with improv, talking about our characters. Getting deeper into it, we discovered a lot about our relationship within the film and by the time we were ready to shoot the last scene in the States, we had enough insight to go a hell of a lot deeper than the script ever told us it would."/ "That's the scene where Mike tells Scott that he loves him," Powell responded. Phoenix says, "There was a lot of deep love [in the film]. You don't know until you see the dailies whether it comes across or not. But because we shot in sequence, we were watching the film unfold before us and when that scene came around we could just like ad-lib it" (Phoenix, 1991).

[37]How gay and mainstream publications go about representing and/or critiquing *Idaho* is noteworthy. We see the picture being depicted to straight audiences by straight publications through an affirmation of assumed heterosexuality of the actors and a characterization of the film as non-gay. On the other hand gay critics aim at casting doubt on assumed heterosexuality of actors. In an interview with *US Magazine* Keanu Reeves commented on the risks of being in a gay film, "I don't think the part is risky; there's not a lot in the film about sucking dick and getting fucked. I think it's more about family and the lives out there. I mean it's more" (1991). Warren Sonbert of the *Bay Area Reporter* writing for a largely gay audience cast doubts on Reeves', let us say, position: "Van Sant was disingenuous in an interview with me when he couldn't recall in the rapid fire gay three-way who was doing what to whom. I guess he didn't want to 'compromise' Reeves' standing when it was pointed out to him—confirmed definitely on a repeat viewing—that Hans has his finger buried in Scott's butt . . . and he seems to be enjoying it—above and beyond the financial returns involved" ("Tale of Two Hustlers," *Bay Area Reporter*, October 17, 1991:29). David Roman suggests that we forget this seemingly everlasting hetero/homo binarism and instead recognize Judith Butler's argument for what she calls "the enabling capacity of indeterminacy" (1994:322).

or narration, we are not relinquished or excused from considering how a narrative and the characters acting within that narrative affect our own sensibilities, our outlook on our lives, our relationships, our world. For example, Van Sant was clearly aware that his opening shot of River Phoenix receiving oral sex would turn people off immediately from his overall work. I know this to be true because acquaintances of mine have explained to me how they were unable to continue with the film. And certainly that is their right. I do hope, however, that an audience might ask why, or consider how a narrative has affected their sensibilities. In this act of asking why and how we see the needed work required for good deliberation as suggested by Jane Mansbridge—the transformation of interest, the uncovering of unrealized areas of agreement, and the clarification of conflict (difference). The situation can present an interesting dilemma, however, for me and for the power of film to connect people across difference lines by way of connecting one kind of human experience with another; that is, connecting those who are not gay, who are not of color, who are not male with those I have identified earlier as the dominant *we* in our society.

Recognizing how I have abandoned and rejected the dichotomous split in political science and other places between those who feel and then theorize about our inability to get along completely with the Other, and therefore conclude that in order to best respect difference we'd better accept the need for, and then push for a sensibility based upon an agonistic respect, and those who suggest that if we could only talk, if we could only communicate better, we would eventually understand one another and accept a fully assimilated position as people living within specific geographic boundaries such as middle-North-America, I am suggesting that *Idaho* serves an important alternative purpose: It may affect our intellectual and aesthetic distinctions, feelings, or tastes in a manner that is exclusive of the aforementioned dichotomy, without diminishing the importance of either argument. I am not suggesting, however, that people will view *Idaho*, and after watching the film and the "campfire scene" in particular, walk out embracing homosexuality or homosexual love absent of sexual desire, gritty street life, or decide to vote one way or another, Clinton rather than Dole. Nor am I suggesting that moviegoing audiences across the country will walk out of theatres with a respect that overrides their moral values. Rather *Idaho*, and similar independent films allow for a different and much more complex, whole, and honest engagement of difference and the Other. They may offer us the best hope for, the best chance at, seeing this postmodern world in a way that positively affects our sensibilities and how we get along with one another. At the very least, this film and the "campfire scene" specifically, affect our sensations, our aesthetics in a way that directs our attention and hopefully our honest responses.

VIOLENCE IN *IDAHO*: CONSIDERING THE NUANCE

Henry Giroux in *Fugitive Cultures: Race, Violence & Youth* (1996) analyzes and then explains *My Own Private Idaho* within a context aimed at uncovering representations of violence in youth culture. In doing so he suggests that there are social and political implications of stylized, cinematic violence. Now one could argue, and I believe quite effectively, the existence of a stylized violence in *Idaho*, albeit associative and non-gratuitous. Quite simply, however, Giroux has engaged and interrogated[38] an aesthetic of violence in cinema, and specifically in Van Sant's *Idaho*. Of the set of films Giroux has chosen to interrogate, of which *Idaho* is only one, he writes, "These films both frame the ways in which youth can be taken up by diverse audiences and argue for particular pedagogical readings over others. They point to some of the economic and social conditions at work in the

[38]Giroux's word choice.

formation of different racial and economic strata of youth, but they often do so within a narrative that combines a politics of despair with a fairly sophisticated depiction of the alleged sensibilities and moods of a generation of youth growing up amid the fracturing and menacing conditions of a postmodern culture" (Giroux, 1996:33).

I have selected *Idaho* primarily as a text that challenges and (re)forms a dominant sensibility regarding sexuality and a common human fallibility and vulnerability: Giroux's focus is equally as intriguing and important; in fact, his work helps to articulate my aims with regards to enriching our sensibilities. Interestingly, Giroux writes of a politics of despair, where youth is mediated in a postmodern world: "Popular cultural criticism has captured much of the alienation among youth and has made clear that what used to be the pessimism of a radical fringe is now the shared assumption of a generation [Generation X]" (1996:33). *Idaho* is a film that has contributed to our understanding of youth culture—representations "at work in the construction of a new generation, representations that cannot be abstracted from the specificity of race, class or gender" (1996:33). Giroux claims that through film we might better understand Other. In this case, youth culture.

Explaining how postmodern youth are uniquely alien and disconnected from the world, a dominant *we* society, Giroux writes of Mike Waters, the main character in *Idaho*:

> *Who hustles his sexual wares for money, [as] a dreamer lost in fractured memories of a mother who deserted him as a child. Caught between flashbacks of Mom shown in 8mm color and the video world of motley street hustlers and their clients, Mike moves through his life by falling asleep in times of stress only to awaken in different geographic locations. What holds Mike's psychic and geographic travels together is the metaphor of sleep, the dream of escape, and the ultimate realization that even memories cannot fuel hope for the future. Mike becomes a metaphor for an entire generation [Generation X] of lower middle-class youth forced to sell themselves in a society governed by the market, a generation that aspires to nothing, works at degrading McJobs, and lives in a world in which chance and randomness rather than struggle, community, and solidarity drive their fate (1996:33).*

Giroux's attention to *Idaho* is significant as he suggests that it is youth, a shared lived experience of being young, that informs and allows us to interrogate our postmodern society. He defines the concept as a representation of an inescapable intersection of the "personal, political, and pedagogical" (1996:3). As working-class youth, we are "border crossers," kids who out of necessity "learn to negotiate the power, violence, and cruelty of the dominant [*we*] culture through our own lived histories, restricted languages, and narrow cultural experiences" (1996:6). This negotiation is represented in *Idaho* and the narrow, but shared, experiences of Mike Waters and Scott Favor. As a moviegoing audience, we can, if we choose to, bear witness to the exclusion and silencing of Other, and the relegating of difference to the margins of society. In that act of bearing witness one becomes implicated, not only in a past, but also in a present and a future that governs Other.

Giroux points to Shoshana Felman and Dori Laub in order to underscore the importance of this witnessing and testimony, both acts that "lie at the heart of what it means to teach and to learn" (1996:6). He writes, "Witnessing and testimony mean listening to the stories of others as part of a broader responsibility to engage the present as an ethical response to the narratives of the past" (1996:6). And just as Giroux wonders about his border crossings as a youth, moving in and out of cultures, jobs, and ideologies, so do I wonder how my similar (personal) crossings have served as a form of bearing witness. This is an act of interrogation as defined by Giroux, an act aimed at learning

and understanding, an act that no doubt affects one's sensibilities. This learning is no longer housed within a framework and structure of a modernist world. We should push further than Charles Taylor and others in considering difference—engaging difference—so that we might connect one kind of experience with another and in that act (re)imagine a (new)politics.

In a postmodern culture, a culture where schools, family, church, and the workplace have had their authority undermined by the images of an electronic media, an electronic culture, we discover alternative discourses, alternative arguments, stories, and narratives. More and more, conversations and discussions on important social and cultural controversies are experienced through media; specifically, through the cinema and film. Thus Generation X is inextricably rooted in what Giroux has identified as a set of postmodern cultural conditions,[39] conditions that have resulted in a shared world without "secure psychological, economic, or intellectual markers" (1996:31). What we have instead is a "shared postmodern space," one where identities merge and shift rather than becoming uniform and then falling into a pool defined by an assimilation rhetoric. Giroux explains, "No longer associated with any one place or location, youth increasingly inhabit shifting cultural and social spheres marked by a plurality of languages, ideologies, and cultures" (1996:32). This is evident in Van Sant's *Idaho*. And Giroux is absolutely correct when he argues that for many youth, for many who have grown up Generation X, meaning is in "rout," as media, as film, have become a substitute for experience. Film is (becomes) experience. Here lies one of the greatest arguments for the need to observe, to study, and recognize the power of film both in shaping our identities and sensibilities and in fostering and inciting various social forces and cultures in debates that surround and engage gender and sexuality.

Mike Waters and Scott Favor are not film heroes in a Stallone sense; however, the characterizations created by Van Sant, Phoenix, and Reeves are representations of a larger postmodern culture where identities merge and shift, sexual identities. Returning to the issue of sexuality and the depiction of it in this film, one can view the border crossing of youth, by witnessing Van Sant's characters and sharing in their interpretative construction. Van Sant himself aimed at creating characters who were to be perceived as asexual, only to float in and out of hetero/homo/bi locations. At the same time he provided a new twist to an old slumming story between famed characters like Prince Hal and Falstaff, Scott Favor and Bob. Equally powerful in this film, however, is the search for home and familial love and the stunning recognition, and then complete acceptance, on the part of Phoenix's character that it is out of reach. This acceptance often has become synonymous with the description of those living as Generation X.

If we accept the argument regarding a shared postmodern space, we find ourselves accepting a fluid space, ever ebbing and flowing, where inhabitants move in and out, from one corridor to another, engaging one kind of experience with another.

Idaho allows us to examine both the social and cultural contexts of life on the street, on the margins of a dominant *we* society. In many respects I agree with Giroux when he says that the significance of *Idaho* is in part its attempt to capture "the sense of powerlessness that increasingly affects working-class and middle-class white youth" (1996:38). Perhaps this represents a temporary shared location or space from which to comment on a particular human experience. However, in addition to this representation, *Idaho's* "campfire scene" and the film's overall attention to alienation and the search for rooted love provides for

[39]Giroux identifies these post modern cultural conditions as (1) A general loss of faith in the narratives of work and emancipation. (2) The recognition that the indeterminacy of the future warrants confronting and living in the immediacy of experience. (3) An acknowledgment that homelessness has replaced security, if not misrepresentation, of a home as a source of comfort and security. (4) An experience of time and space as compressed and fragmented within a world of images that increasingly undermine the dialectic of authenticity and universalism (1996:31).

those who identify with being Generation X an experience that is riddled with familiarity regardless of sexual identification. And for those outside a postmodern cultural understanding of Generation X, those looking in, the film "provides [an] opportunity for examining the social and cultural contexts to which [it] refers" (1996:39). An experience that while maybe outside the realm of identification for some (outside the imagination of those who are more firmly rooted in a conventional culture and politics) rests clearly within what I have identified as an act of "eye [bearing] witness." It is clear that River Phoenix's character, Mike Waters, serves to unsettle what David Roman has referred to as the "hegemony of normative sexual identity" and we as an audience experience this. However, one can only hope that the banishment of, and thus the rejection of, both Bob and Mike by Scott Favor as he climbs the ladder of affluence, and the throwing off of his own queerness in this act, will be recognized as the discarding of difference, the discarding of those on the margins, the fringes, for the sake of empowerment in a dominant *we* society.

CONTRASTING FILMS: *IDAHO'S* INDEPENDENT INNOCENCE TO *DEGREES'* LIBERAL PRIVILEGE AND OVERT COMMODIFICATION OF OTHER

Films like *My Own Private Idaho* reveal a newly shared (un)commonness as vulnerability and alienation. It is this newly recognized and shared (un)commonness that leads to a (re)imagining of a new sensibility toward difference and thus a new politics. But *Idaho* also illustrates how difference can be consumed and then discarded and forgotten. For example, when Scott Favor, not unlike Prince Hal in *Henry IV*, swears off street life and the band of Others, he is throwing off his own queerness, his own difference and his one-time challenge to convention. This is most obvious in the film's conclusion where Van Sant juxtaposes Favor's father's funeral with that of his street father, Bob (the Falstaff character). Here an audience sees a clear distinction, a clear contrast, between the conventional and the imaginative, the dominant "*we*" and Other as those who mourn Favor's father are without imagination. More than any other scene, an audience sees a creative lyricism in the street life that Van Sant depicts and a non-recognition that appears requisite for a dominant "*we's*" survival.

Van Sant's associative work stands in stark contrast to Fred Schepisi's didactic *Six Degrees of Separation* (U.S.A., 1994).[40] Recognizing how *Idaho* engages the lives of individuals on the street with those who make a conscious decision to interact with those individuals—prostitutes and johns—Fred Schepisi's direction of John Guare's Tony Award winning stage play, *Six Degrees of Separation*, aims to illustrate how the lives of seemingly unrelated characters intersect with one another. This film, unlike *Idaho*, presents Paul (Will Smith), an African American street hustler posing as Sidney Poitier's son, as an illustration of Black Other, connecting across difference lines with those individuals living as the "*we*" in our dominant society, Ouisa (Stockard Channing), a Fifth Avenue art dealer's wife, and Flan (Donald Sutherland) Kittredge. *Variety* says that Guare's work has, "pierced with expert wit the pretensions of the Reagan '80s, when the equation between the possession of expensive things and self-satisfaction seemed indisputable" (Isherwood, 1996:79). No doubt this was partly intended by the author; however, I find what Charles Isherwood (writing for *Variety*) deemed a deeper concern of the author to be of greater intrigue: "Its (*Degrees*) deepest concerns are of more eternal questions, most intriguingly the power of art to liberate the imagination, forging connections between people separated by social caliber, skin color or circumstance" (1996:79). However, the problem with *Degrees* is that, unlike *Idaho*, an audience only sees a privileged site of white liberalism. The narration, the filming, the editing, the plot, the story, all favor characters that are themselves privileged and who are not of color and who

[40]Referred to as *Degrees*.

are not gay, not Other. The story that is being told, the narration, is one that defines our dominant *we* society, through that particular lens.

Loosely based on a true New York story,[41] Guare in his screenplay and Schepisi in his direction build on the notion that all of us, all men and women world wide, are somehow connected by a string of six people—our lives intersect, if only briefly. Ouisa comments: "Everybody on this planet is separated by only six other people." It is this theoretical connection that serves as what is proposed to be a (un)common ground, a universal humanity, across difference lines that once recognized gives us an ability to imagine ourselves. After being charmed by Paul, Channing's character is presumably afforded an opportunity for an emotional connection with this young man who is apparently so full of life, Smith's depiction of Paul, a well-spoken black youth. Ouisa says, "I just loved the kid so much. I wanted to reach out to him." The premise of the film is that a con man (who happens to be both black and gay) would have very little difficulty in fooling an intelligent and wealthy liberal couple. While we are made to feel as an audience that Flan and Ouisa Kittredge are devoted to money, material possessions, and the high status of the New York elite, we are also asked to believe that this wealthy liberal couple has a place in their heart for the underprivileged as well. After Ouisa discovers the true non-identity of Paul, an audience is to assume a connection between the two based on Paul's desire to have the Kittredge's and other New York elite experiences. Paul pushes aside his own experience and identity so that he can assume an identity in line with a cultural hegemon, and, in doing so loses himself. Stockard Channing's character begins to question her life in light of Paul's desires and discovers that she herself has been colonized. Subsequently, the film ends with Ouisa Kittredge's rejection, somewhat, of her experience and position—a self-discovery for the colonizer at the expense of Other.

The film opens with the Kittredges frantically moving about their Fifth Avenue apartment, believing they have been burgled in the middle of the night, checking for valuables. We, as an audience, are then transported to the country where Flan and Ouisa are attending an elite wedding, and where they tell "*their* story" to a larger group of the *we* in our dominant society. *New York* magazine says, "The movie is as much about telling as it is about being: Whatever happens to the Kittredges, they convert it to anecdote" ("*Six Degrees of Separation*," 1993:171). Schepisi brings to life the Kittredges' various flashbacks, first at this upscale wedding, and then at other fancy get-togethers, allowing them to recount a fractured narrative to a variety of glamorous and middle-aged New York cliques. Quite clearly, an audience becomes aware of this anecdotal theme that sets one up for a troubling and tragic ending; that is, the short narratives concerning the interesting events surrounding Paul's interaction with their lives contrasts with what one might consider to be an experience—the process of personally encountering an event, having been vested in an event.

This anecdotal theme gives power to a class dynamic that feels both real and troubling in this filmic text. And it is clear, as David Roman (*Fierce Love and Fierce Response: Intervening in the Cultural Politics of Race, Sexuality, and AIDS*, 1993) has pointed out, that "For Ouisa this concept [six degrees of separation] holds the key to, as well as the 'torture' of intimacy: that despite differences, there is a fundamental humanity shared by all people" (198). These differences can be found in our sexualities, our genders, or our colors. However, this belief and interpretation on the part of Ouisa puts the film in jeopardy of falling into a realm of cultural tourism and an unfortunate and possibly oppressive consumption of difference. In the February 1994 issue of *Artforum*, Richard Flood writes, "The scary plight of the hustling black antihero is left willfully unresolved in order to serve up an epiphany of

[41] "*Six Degrees of Separation* is based in part on the true life story of David Hampton, a young black bisexual man who in the early 1980s posed as the son of Sidney Poitier to get inside elite and trendy New York establishments, and later into the homes of prominent New Yorkers, only to be arrested in 1983 and made to serve 21 months in prison" (Roman, 1993:203).

conscience to its careless white heroine" (9). This epiphany of Ouisa's as a result of her encounter with Paul the con-man, creates a feeling of discontent for some, myself included.

In the first flashback we learn how Paul came upon the Kittredges' apartment, and thus into their lives: While Ouisa and Flan are entertaining an old friend, "Geoffrey," a wealthy British-born South African businessman, with hopes that he will front them a much needed $2 million so that Flan, the swanky art dealer, can secure a prized Cézanne from a nasty divorce, sell it to "the Japanese," and thus save his and Ouisa's Reaganesque Fifth Avenue lifestyle, there is a knock at the door. Paul enters claiming to have been mugged and stabbed in the park below, Central Park. Telling the Kittredges that he chose their apartment over the others in the building because he "knows" their "kids," he not only gains entry, but also finds acceptance in their home as he tells of life with his father, Sidney Poitier, and his father's most recent project, the filming of *Cats*, for which he is in New York for the casting (*Degrees* is in many ways a comedy).

The New York elite as identified by Guare and Schepisi in the Kittredges and their wealthy South African businessman friend are taken in by this smart, well-dressed, and well-spoken African American male, clearly Other by way of the color of his skin, yet resembling so much the Fifth Avenue elite, who entertains with his intellect—he not only convinces his hosts to stay in for dinner so that he may cook for them and in essence show his appreciation for their kindness in opening their door and home to him—but he also explains and defends his master's thesis in a monologue that connects J.D. Salinger's *Catcher in the Rye* to notorious assassins like Mark Chapman, John Hinckley, and the overall moral corruption of American life. Andy Pawelczak writes for *Films in Review*: "*Degrees* is replete with full blown speeches, big dramatic confrontations, a closing epiphany, and witty, literate dialogue. It's also full of certified 20th century literary themes that already have an almost antique feeling: the alienation of parents and children, the denaturing of experience in the modern world, the fragmentation of self-hood, the hegemony of exchange value over all human values" (1994:56).

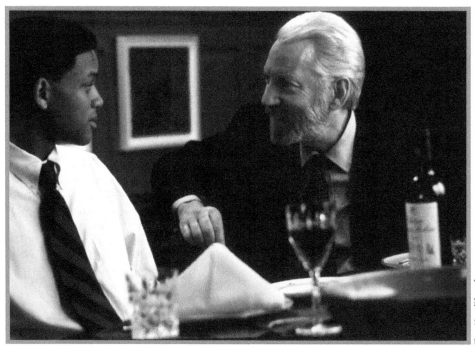

Six Degrees of Separation, 1993

Unfortunately, he, Smith's character, tells them and us, the audience, that the muggers got away with the only copy of his work, a work that gives validity to Pawelczak's assessment as it upholds modernist values and reprimands those who might spit in the eye of modern morality. This rhetoric separates Paul, the black youth, from the street muggers who stole his work; that is, Paul is visibly and audibly different from those notorious assassins and the "fucking black kid crack addict(s)" and "black fraud(s)."[42] Before long it is two or three in the morning, Flan has his $2 million from Geoffrey, Geoffrey is sold on the idea of a South African film festival featuring the work of African American writers and directors, and all three, Ouisa, Flan, and Geoffrey, are assured they will be cast in Poitier's film, *Cats*. Ultimately, Paul, "the agent of chaos," the Other, brings a touch of reality into Ouisa's Fifth Avenue life.

While this opening dialogue between these characters is smart and convincing, it is also telling of film's ability to (re)affirm dominant cultural understandings and structures in that we learn of, we become intimate with, a liberal white guilt. For example, there are several exchanges in the opening dialogue that suggest that while the New York elite is intrigued by having the son of Sidney Poitier in their apartment, an apartment that resembles a virtual fortress, clearly and visibly dividing the upper class from those down below, those who fall into the category of Other, they are also somewhat cautious and fearful of (this) black youth, regardless of his parentage. Whether it be the looks that Flan throws to Ouisa when asking her for a first-aid kit (so that he might tend to Paul's stab wound in an opening scene), and simultaneously and secretly miming a need for gloves so as not to contaminate himself (as if Other were a contagion), or Ouisa's questioning of her liberal politics and identity over the gaze of this black youth and his obvious infatuation with her. Even more interesting, however, is the anxiety one senses among the white characters and especially Flan and Ouisa as they fear that somehow Paul will jeopardize the art deal and the needed $2 million. Roman comments on this anxiety: "(Geoffrey, a wealthy white British South African who can help finance Flan's private art dealings,) South African politics and race relations become the litmus test for [their] white liberal politics and affinities, as the Kittredges delicately, and quite humorously, maneuver around Geoffrey's obvious pomposity—"One needs to stay [in South Africa] to educate the black workers and we'll know we've been successful when they kill us" (1993:10)—in order to secure the $2 million Flan needs to close a deal. But if Geoffrey's views of South Africa proved a challenge for the Kittredges, Paul's immediate arrival at their door puts into motion the vexed history of U.S. race relations for the white liberal politics they have been espousing all evening. Paul's seductive narrative detailing the class privileges available to him as the son of Sidney Poitier—"I don't feel American. I don't even feel black" (1993:30) —puts Ouisa and Flan at ease, and "Even Geoffrey was touched" (25) (1993:200). These white characters are put at ease by Paul's comment and denial of his black self, and, at least initially, the New York elite is spared having to deal directly with the complexities of a liberal white guilt and class identification that defines Paul as something Other than the Harvard man he claims to be—as what might be lurking down on the streets of New York, say in Central Park—a hustler.

Having asked Paul to stay the night, the Kittredges are shocked in the morning when awakened by a noise that ends up being Paul engaged in, and receiving, oral sex from a white male prostitute. The illusion is shattered and Paul and the hustler are evicted from the apartment. Later, Ouisa and Flan learn that their good friends, Kitty and Larkin, and Dr. Fine, an obstetrician, have all, too, been conned by Paul and the common thread through all of these "experiences" are their college-aged children.

[42]This is the language used to describe Paul after he is found with a white male hustler in the home of Ouisa and Flan Kittredge—when he is accused of being a fraud.

After being "duped," Ouisa Kittredge begins to question her white liberal politics and her own identity. Regardless of the "fakery" presented to her the evening before, she still hopes to hold onto the "experience" of Paul. Ouisa is plagued by attempts to find meaning in her interactions with Smith's character. Roman claims that it is the "revitalization that the black gay man has provided for them [the Kittredges] through his attentive and demonstrative interest in her life" that propels her continued interest in this young man who walked unexpectedly into her home, out of the margins (1993:198). For Ouisa Kittredge, Paul's humanity must be available to her regardless if he is who he claimed to be or not. This assumption of availability and connection screams a cultural tourism that at once is both troubling and intriguing in Schepisi's film direction. For example, Sutherland's character, Flan, asks Ouisa, "Why does it mean so much to you [Paul]?" And she offers a response that is both full of confusion and honesty—"How do we keep the experience?" Obviously, Ouisa has been transformed by her experience with Paul in that even after learning of Paul's true non-identity, she hopes to maintain the sense of awakening and her transformed sensibilities that evolved as a result of her encounter with him. Despite his ambiguous identity, Ouisa questions her own liberal politics and her identity as she also recognizes the harm in relegating Paul, Other, to an anecdote "to dine out on" (Ouisa).

The central metaphor of the film is a double-sided painting, a Kandinsky—a canvas that is painted on both sides.[43] One side is linear and circular, geometric, representing control—the Kittredges, the *we* in our dominant society; the other is abstract and chaotic, wild, representing the encounter and existence of Paul's character. Roman writes, "The painting becomes the emblem of the screenplay's leitmotif that 'there are two sides to every story' and announces Ouisa's own reconnection with her own imagination" (1993:199). The two sides signify chaos and control for Channing's character. In the opening scenes dominated by chaos, the camera gazes upon the two primary characters, Ouisa and Paul, and the viewer, once fed a barrage of movement, is directed to Paul's gaze and his focus on Ouisa. We, the audience, get a sense that this movement is somehow telling as it foreshadows the "reverberation of the soul," her soul, an effect ascribed to Kandinsky's work, and a visual and metaphysical metaphor woven into the film, " a double-sided Kandinsky . . . Chaos, control, chaos, control . . . you like, you like?"

In a review of *Degrees*, *Sight and Sound* magazine claims the film in its entirety as an "allegory excoriating race, class, and everything else which divides contemporary America" (Macnab, 1995:54). However, the film is much more troubling, and arguably violent, in that it presents only one side of the story, one side of a painting or the divide, Ouisa's story (the film also suggests that there are only two sides of a story); that is, the story is told from a position of privilege far removed from Other, or in this case, Paul. Here again lies the anecdotal theme. We as an audience see almost everything from the Kittredges' perspective; that is through Ouisa's eyes. *Sight and Sound*: "Gay, black, from the underclass, Paul is regarded less as a character than as an 'exotic Other,' a catalyst to stimulate their [the Kittredges and others] imaginations and consciences" (1995:54). Thus, it seems only appropriate to interrogate the role Paul plays in Ouisa's determination to "keep the experience." Roman suggests that we consider how "race is immediately and obviously marked in the text by the actors who perform the roles and further established by the textual narrative that insists on maintaining whiteness and blackness as two opposing defining social categories" (1993:199). Again, the Kandinsky metaphor informs the film's bias in that whiteness and convention is represented as control and Other as chaos, rationality versus irrationality. However, I prefer that we first consider how (homo)sexuality is conveyed and how it is subjugated over a white, straight imagination. We are to believe as an audience that Paul is merely, desperately, living out his fantasies, living within his own imagination, in the midst of "other people's superior reality" (Flood, 1994:9).

[43]"One side is geometric and somber. The other side is wild and vivid" (Flan, in *Degrees*).

Specifically, the embodiment of the white liberal in the Kittredges suggests a revulsion inherent to a liberal psyche when confronted with the spectacle of sexuality, as Ouisa and Flan kick Paul and the white male hustler out of their home. However, those same white liberals who found themselves duped or conned by Paul, also find themselves in the days to come attempting to reconcile "their seduction by Paul's rhetoric with their own unimaginative lives," particularly Ouisa. Roman writes, "As she [Ouisa] continues to unpack the events of the Paul incident she discovers that his presence has initiated a series of questions about herself, questions about her identity that can no longer be left unanswered. The black gay man thus becomes the vehicle for Ouisa to reevaluate her own beliefs and sense of self" (1993:200). Essentially, we are to assume that Ouisa's interaction with Paul, both before and after becoming aware of his complex non-identity, prompts a reconsideration or re(imagination) of her own sensibilities and identity. At the film's climax, she declares: "It was an experience. I will not turn him into an anecdote. . . . How do we keep what happens to us . . . How do we fit it into life? Without turning it into an anecdote? It was an experience . . . how do we keep the experience?"

Is this oppressive? Does this relegate difference as a commodity for the *we* in our dominant society? A vehicle that transports one from the realm of the unimagined to an exotic place where modernity is questioned?[44] Is Paul's existence primarily to serve Ouisa's awakening? Certainly, this would be oppressive; however, Paul, too, may have benefited from their (Ouisa's and his) shared experience or encounter. But, if so, we as an audience are unaware of a mutual and neutral connection. We know Paul to have been directly harmed by a white elite in that he is jailed for having connected in some fashion his life with theirs. This is the major controversy haunting this film: The dominant *we* gets a laugh out of the "story" as told by the Kittredges, while Paul, the Other, suffers real harm, real injustice.

John Clum suggests that it is not Paul's race that provokes chaos, no, his race presents and provokes a mixture of liberal guilt and uncertainty; rather, it is his gayness that hooks us into the metaphor with the Kandinsky and its presentation of chaos. I am yet unsure, however, as to whether I agree with or believe that such a separation between sexuality and race can be argued, yet another binarism. Rather, I am more interested in what David Roman has to offer and his conviction of a greater complexity. He suggests that "Gayness alone is not what 'provokes chaos' but, more to the point, Paul—as a black gay man—embodies the chaos in the text." He continues, "[The fact] that Paul is the only non-white character in the text further facilitates such a reading" (1993:200). But Paul's sexuality is really never made clear in the film; that is, he is not presented as a homosexual. Rather, Paul is made the site of white liberal anxieties where assumptions are made and chaos either created or perceived regarding his sexuality. Roman explains: "*Six Degrees* demonstrates that being both black and gay only heightens the suspicions of the white heterosexual characters who interpret black and gayness as doubly duplicitous and inherently associated with AIDS. Yet, in light of these various incidents Paul is still always cast as an 'experience:' one that must be contained within the racialized sexual discourse of white liberalism" (1993:201). And the only character interactions that do not affirm this racialized sexual discourse are those between Paul and Trent Conway, a gay college student who is the link between the children of the Kittredges and the other white liberal elite and Rick, an aspiring (straight) actor who goes into a sexual encounter with Paul with his eyes wide open, so to speak. These two relationships were open doors that the director immediately closed, doors that would have allowed us to view Paul from his own space, from his own site of existence.

[44]Many critics have said that the distinction between experience and anecdote "would carry more weight" in the film "if we had seen any depth in the experience." For example, "What did she learn? That there are people more needy than she is? That some of them are clever con men? In any case, how does that experience lead to the chaos-and-control mantra?" (Kauffmann *The New Republic*, 1993:25). Perhaps Richard Flood is a bit more harsh: "Stockard Channing striding up Park Avenue in a designer suit, transformed by the awareness that she too is responsible for the way things are. Well isn't that nice?" (1994:10).

The first missed opportunity arises when Paul meets up with Trent and evidently spends three months living with this white MIT college student. And the second, Paul's relationship with Rick, who engages in homosexual sex with Paul after being wooed at the Rainbow Room and deciding that he was in for the experience. However, these two supporting characters are quickly disposed of as one is portrayed as an undesirable deviant, Trent, and the other commits suicide soon after his encounter with Paul. These character constructions and the lack of follow-through underscore the film's dominant discourse and support an assertion of a liberal doctrine, visible from a privileged site only, the Kittredges.

Roman is suggesting not only that this racialized sexual discourse exists but that it is lost on a mainstream white audience. Clearly, the playwright/screen-writer, Guare, and Schepisi, the director, have presented for a primarily white audience a protagonist in Ouisa Kittredge who exemplifies a "spiritual awakening" that is necessary in order to reconcile oneself with the "effects of a postmodern politics of doubt and despair" (1993:202). For instance, Frank Rich of the *New York Times* says that *Degrees* "invades an audience's soul by forcing it to confront the same urgent question asked of its New Yorkers [in the film]. If we didn't come here to be this, then who do we intend to be?" (1990:C1). Rich's perception of the film suggests that the film is primarily for white liberal audiences, white liberal elite, in that the film targets specific issues from Ouisa's point of view. And not only is the film and its text directed at a white elite, but it also suggests that a universality or Truth may exist; that is, a blueprint for navigating a postmodern space where difference exists all around us. Again, I am compelled to borrow from Roman: "Audiences entering the theatre are asked to identify with Ouisa and share her interpretation of Paul. And since Ouisa participates with all of Guare/Schepisi's white characters in the racialized sexual discourse that they use to construct Paul, there is little room for audiences to question the assumptions that the text and the production offer as truths." He continues, "Paul can only be defined as a spectacle of difference recast as an experience for liberal whites. As Guare's creation and Ouisa's fantasy, Paul has no identity other than the one imagined by Guare and his white characters. The ultimate irony brought forth by this process is that Paul could well be the son of Sidney Poitier, at least from the perspective of Paul's description of his supposed father" (1993:203). Essentially, Paul could have had an identity depicted on screen; however, that identity is subjugated.

The complex metaphor of the Kandinsky suggests that there are two sides to every story; however, *Degrees* presents a racialized discourse firmly couched within the constraints of a dominant liberalism. Paul's experience(s) is(are) not of importance to the momentum of the film, nor is the film intended to spark a concern in the audience for him, his background, his experience. Rather the film, in obscuring Paul, privileges the Kittredges and specifically Ouisa's interpretation. Albeit noble, this action is oppressive in its affirmation of a cultural hegemon.[45] This one-sided perspective positions Paul as a catalyst for "whiteness to retain—at whatever cost—its centrality" (1993:203). Quite simply, Paul's identity is a construction imagined by Ouisa, the embodiment of white liberalism and even as she shrugs off her Fifth Avenue existence, the act comes at Paul's expense, while she is still the central figure. For example, in an interesting and clever dialogue where Paul describes modernity and the death of imagination, he

[45] I find myself both liking the film because of the Stockard Channing character, Ouisa, and disliking it for its privileging of the dominant *we* in our society. Of Channing's performance critics like Andy Pawelczak have said, she "turns in a witty, sympathetic performance as Ouisa, a woman who believes we're all separated from—or connected to, depending on your perspective—everybody else on the planet by no more than six people. Ouisa is the movie's most human character, and Channing is very good in the big emotional payoff scene at the end" (1994:56). For me, this attraction to Ouisa is telling in the way that it forces me to consider the complexities of film and specifically this narrative.

quotes Salinger, claiming that everyone is a "phony" and that the greatest sin is to be unconscious—an echo to Trinh Minh-Ha's (1991) warning of going unimagined: ". . . to face ourselves—imagination—God's gift that makes self examination bearable." Here Paul is a tool for Ouisa, a catalyst who sparks a transformation in her.[46] We are to believe at the end of the film that Ouisa has undergone an incredible transformation as she recognizes publicly, among the New York elite, that for the Fifth Avenue cliquish type, the Other has become, is, an anecdote, something to dine out on. Here she stands and leaves her husband as she strides down Park Avenue, newly imagined. All because of Paul.

INTERROGATING WILL SMITH: THE VOICE OF PAUL

Degrees is quite different than *Idaho* in a multitude of ways. There are the obvious differences: for example, one is a major studio production and the other an independent film. But perhaps the most striking is in the risks that one filmmaker or actor is willing to take in putting together a film narrative, the Feeling-Concern. Guare wrote *Degrees* after learning of the true-to-life accounts of David Hampton in the *New York Times* in the mid 1980s. But even at this level, Guare was not interested in Hampton and his story (Hampton later sued and lost over the rights to his life story); rather, from the very beginning Guare intended to write a biting comedy that while poking fun at the New York elite for being duped or conned by someone like Hampton, still persisted in privileging that upper-class and making attractive a specific lifestyle by overtly and willingly avoiding any projection of Paul/Hampton's voice, of Other. This is made clear by the way Will Smith's character is depicted; specifically, his desire for a piece of the Kittredge world—the upscale culture, or as Richard Flood has called it, a piece of "other people's superior reality." The audience is meant to identify with Ouisa Kittredge and hope that she might, through her transformation, be able to save Paul from his own existence.

In Chapter Two I suggested that independent filmmakers are more willing to take risks than their counterparts housed in the major studios. And this goes for actors as well. And I have already explained the political impetus behind Van Sant and Phoenix's work in *Idaho* and their desire to create a film that was both honest and real to those individuals on the street, associative rather than didactic. But in contrast to their work stands John Guare's, Fred Schepisi's, and Will Smith's. While it is impossible to avoid questions about authenticity and voice, it is more difficult to engage in a discussion about these issues when the director and actors involved are unwilling to explore and present, and thus privilege, the site of the Other. Clearly *Degrees* offers up in many ways a privileged site and a liberal transformation for instruction.

Early in the filming of *Degrees*, Will Smith approached the director and explained that he was "a little uncomfortable with that scene," referring to the scene where Paul's character kisses Trent Conway. It was reported that even Denzel Washington advised Smith not to do the kiss.[47] At the time of the filming, Smith perceived the kiss to be a "risk" to both his music and acting career. However, in an interview with <u>The Advocate</u>, Will Smith has since said that he made a mistake, "I wasn't mature enough to handle the homosexuality" (1994:54). Even so, the film is reflective of an unwillingness, not only in that particular scene, but throughout its entirety, to give voice to the Other, a homosexual voice via the gay black male con man, Paul.

[46]"The Kittredges are no less phony than the beguiling fake Harvard man. Ultimately, Paul is the agent of chaos who brings a touch of reality into Ouisa's life, and by the end he's a kind of benign tutelary spirit whose ghostly image appears reflected in a store window" (Pawelczak, 1994:56).

[47]*The Advocate*, 1994.

SUMMARY

In this chapter I have presented two films, one independent and the other a major Hollywood studio release. In presenting the independent *My Own Private Idaho* as an associative film that allows an audience an eyewitness' vantage point into the emotions, ambitions and mysteries of Van Sant's particular characters, I have aimed at uncovering a shared (un)commonness that rests firmly in a generation's shared sense of uncertainty, vulnerability, and alienation. This vantage point may allow for a momentary pause and then (re)considering or (re)imagining of one's sensibilities; that is, a moviegoer may give recognition to those lives on the margin of our dominant *we* society and subsequently understand a bit better the complexities of difference and of a shared human uncertainty that can transcend difference circles.

In contrast to *Idaho* is Schepisi's *Six Degrees of Separation,* illustrating the often fundamental differences between independent and studio films. While Charles Isherwood (*Variety,* 1996) has said that *Degrees* is significant for its presentation of eternal questions and its discussion of art's power to liberate the imagination—"forging connections between people separated by social caliber, skin color or circumstance" (1996:79)—it appears that the only imagination worth liberating is that of a white elite as presented in the film's protagonist, Ouisa Kittredge. The thing that is most often missed by critics, theorists, and moviegoers alike is the overt non-recognition of difference in most Hollywood films. This is the case in *Degrees.*

By considering the conventions of film, the director's Feeling-Concerns and the contributions made to the film by the actors, we understand better the film itself, the Image-Event. *Idaho* presents what I perceive to be an associative depiction of Other and a challenge to a conventional sensibility with regards to sexuality and sexual identification or orientation, while *Degrees* underscores the power of film to reinforce and (re) affirm convention and a dominant political and social space. However, the significance of the chapter is in the suggestion that a moviegoer can become a cultural eyewitness to the lives of particular characters in film, characters that are representative of those who live on society's margins. And in becoming an eyewitness and, in essence, bearing witness to a story that has oftentimes been silenced or simply not recognized, a moviegoer might identify with an aspect, with an experience, belonging to characters on screen and/or a narrative that allows the moviegoer to connect one kind of experience with another, and nurture a greater understanding of difference through a recognition of Other.

The (Un)Certainty of Color

Violence is immoral because it thrives on hatred rather than love. It destroys community and makes brotherhood impossible. It leaves society in monologue rather than dialogue. Violence ends by defeating itself, it creates bitterness in the survivors and brutality in the destroyers.

Martin Luther King

I have to preserve the right to do what is necessary . . . and it doesn't mean that I advocate violence, but at the same time I am not against using violence in self-defense. I don't even call it violence when it's self-defense, I call it intelligence.

Malcolm X

In this chapter I examine two films: first, and primarily, Spike Lee's third feature film, *Do the Right Thing* (U.S.A., 1989)[1], and second, John Singleton's *Boyz 'N the Hood* (U.S.A., 1991). I have selected these two films for analysis for a variety of reasons, which I will explain shortly. However, before I interrogate these two films in the hope of continuing my argument for the inclusion of film in an attempt to better understand people across difference lines, it seems appropriate to briefly address the competing messages presented in the two powerful quotes above. Spike Lee actually presents these messages to his audiences at the conclusion of *Do the Right Thing* (*DRT*) in order to fuel a heated debate focused not only on his film, but in the way we see, discuss (if we discuss at all), and approach race relations and violence in the United States.[2] For example, Lee's presentation of the complex

[1]Spike Lee's two earlier films, *She's Gotta Have It* (U.S.A., 1986) and *School Daze* (U.S.A., 1988) received only limited distribution. *Do the Right Thing* was produced and distributed in partnership by *40 Acres and A Mule*, Lee's own production company located in the heart of Brooklyn among other black-owned businesses, and *Universal*. The film cost roughly $7 million to produce (Wall, 1989:739).

[2]James Wall writes: "Ironically, the response to Lee's picture had more to do with an argument over his attitude toward violence than it did with the power of the work itself. The entire film is a polemic against violence, but Lee's use of a closing quote from Malcolm X was touted by his detractors as an indication that he was advocating Black violence. Some observers warned that the picture would incite Black youth to attack white-owned businesses—an appeal to the 'copy-cat' crime argument that critics occasionally employ when they are uncertain about a picture's vision" (Wall *Christian Century*, 1990:67).

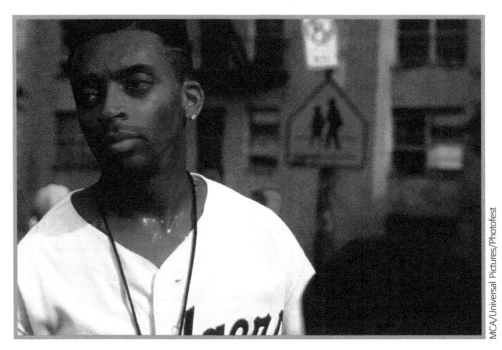

Do the Right Thing, 1989

concept of violence focuses on a riot at the conclusion of *DRT* and the way in which people perceive this supposed act of conventional violence—regardless of whether it can be viewed as self-defense.

Here lies part of the significance of Lee's work: With the selection of these two messages comes a presentation of conflict between the two men's philosophies regarding violence as a tool in the fight against racism and in the protection of a black self. A current-day audience experiences, through Lee's film, a long-time controversy over the competing ways in which one sees or understands U.S. race relations and the means that are employed in a fight for equality and justice. Scholars, critics, and moviegoers alike have seen Lee's film, specifically, the presentation and representation of violence in a variety of ways. Some suggest that Lee is advocating violence when privileging the message delivered by Malcolm X over the nonviolent philosophy associated with Dr. King. Others suggest that Lee, too, only wishes for honest dialogue regarding the current climate in middle-North-America's urban corridors; specifically, a dialogue that engages the difficult questions involving difference in our world. However, regardless of one's take on Lee's decision to use these messages of violence in his film, an audience is asked to come to terms with their own perceptions, sensibilities, and understanding of violence in a context of race relations and difference.

In this chapter I present Lee's *DRT* as a film that goes after, in a direct fashion, white bigotry and dominance in U.S. culture and society. And subsequently, Lee's film is perceived to be far more controversial than Singleton's *Boyz*. In other words, the violence in *DRT* occurs across black and white difference lines, where as the violence in *Boyz* is illustrated as black on black. The latter is more acceptable to a dominant *we* audience in that Singleton's finger-pointing is more blurred than Lee's direct aim at white bigotry and class dominance.

In focusing on the different ways in which we as a society consider violence, Lee underscores one of the more divisive and deep differences in personal sensibilities that pervade our middle-North-American society and culture. In other words, by privileging and encouraging a debate on violence within the

context of race relations, Lee illustrates a divide between older blacks and younger African Americans who see violence differently. More importantly, however, is the charge, mainly by white critics, that Lee aimed to incite violence in multiethnic neighborhoods and communities by aiming violence at white people. Quite simply, the way people view this film and how they reconcile the messages regarding violence has a lot to do with a moviegoer's experiences and memories—experiences and memories that are informed by a person's difference or lack of it.

Lee strives to promote social transformation in a world where difference lines at times seem permeable. Douglas Kellner (*Aesthetics, Ethics, and Politics in the Films of Spike Lee*, 1997) writes, "During the 1980s, Hollywood joined Ronald Reagan and his administration in neglecting African-American issues and concerns. Few serious films during the decade featured Blacks; instead, Blacks were generally stereotypically portrayed in comedies, often with an African-American comic like Richard Pryor or Eddie Murphy playing against a white buddy. In this context, Spike Lee's films [*DRT* and others] constitute a significant intervention into the Hollywood film system" (73).

In many ways, one could argue that Lee's intervention was, and is, an act of self-defense, not unlike what Malcolm X was advocating against a dominant *we* society that is known for exerting claims that the civil rights battle and movement, and subsequently the existence of an institutional racism, have been long over and conquered. The renewed attention to race in middle-North-American film represents a success of sorts for Lee, who in interviews has explained how he hoped for *DRT* to encourage a black—white dialogue on racism that could possibly lead to a better understanding of race and then better race relations.[3]

DRT is an important film in other ways too—beyond the encouragement of a black—white dialogue—as it presents a neglected and often silenced black voice, as does Singleton's *Boyz 'N the Hood* (*Boyz*).[4] The uncovering of these voices gives renewed attention to Dr. King's and Malcolm X's views and the subsequent controversies regarding the state of race relations in the United States. We are challenged to consider when to use and when to avoid violence as a means to a just end; that is, as a means to achieve equality of opportunity and expression/recognition in a democratic society.

DRT: BLACK MAN WITH A CAMERA: GIVING VOICE TO A BLACK FEELING-CONCERN

David Seelow (*Look Forward in Anger: Young,* Black *Males and the New Cinema*, 1996) has said that the "camera" has become "a weapon more powerful than the gun" as film has the unique opportunity to "re-enact [the] struggle for control of the image of Black identity" (154). He suggests, and I agree, that in order for one to think about the image(s) and thus consider one's sensibilities and a proposed hopefulness aimed at cooperation, one must think about how the dominant society fashions identities. For example, it seems obvious to me that in order to understand or at least develop a richer sensibility regarding race, gender, and sexuality, one might commit him- or herself to a study of how the media depicts African Americans. These images are available throughout our culture in an electronic media—that is, film. Here, Kellner's comments about the Reagan administration's era and its overt misrepresentation of and silence toward black identity gains resonance and importance in a discussion of difference—both when considering conventional politics and when considering artistic representation of the Other in film. Unfortunately, in a dominant cinema African Americans are often presented as comedians, criminals, drug dealers, drug addicts, slaves, or servants. These depictions can be exploitive

[3]Rainier *American Film*, 1990:60.

[4]A voice that is by no means universal; that is, homogeneous within a specified difference circle.

and violent because they affect both a dominant society's view of Other and the Other's view of itself. The depiction(s) works to affirm particular stereotypes that are prevalent in a race-caste society.

Stuart Hall[5], too, suggests that one direct his or her attention to those cultural media prevalent in dominant society in order to confront the mystery of image; that is, a society divided by difference lines and constituted by a fragmentation based on class, gender, race, ethnicity, and sexual orientation. The counter images to those dominant media images of Other are often a place of convergence for those who are excluded and are quietly becoming a place of unity for those within and across specific difference circles. Not unlike the homeplace(s) and enclave(s) of resistance presented by bell hooks (1992) and Jane Mansbridge (1996), the (re)claiming of black identity and stories by black auteurs and actors represents an act of resistance and recovery of a black self. While strengthening borders in order to keep a dominant culture out—a dominant media image—and maintain and protect enclaves of resistance and homeplaces, the depiction of Other by Other can perhaps enrich one's sensibilities and set us, some of us, on a personal transformative path. For example, some of us may see differently and feel differently when it comes to imagining those who are different from us as individuals, leading to a greater respect and care for difference.

There is a complex notion of power involved in the creation and maintenance of difference circles. For example, there is both a power that marginalizes and a power in resistance that often comes to fruition in opposition to marginalization. Also noteworthy are the competing visions of difference; that is, Feeling-Concerns[6] that are presented by a white auteur or director who is firmly entrenched in a dominant Hollywood paradigm and conventional politics[7] and thus contributes to a marginalization and a maintenance of that marginalization. Subsequently, there is often a challenge to the dominant cultural hegemon and its sometimes exploitative and violent depiction of African Americans—by those who are not African American—in the works created by Others. For example, the works of Spike Lee and John Singleton, African American auteurs presenting a distinctive and unique African American voice[8] that stands in contrast to those dominant images presented by a dominant cinema—blacks as comedians, criminals, pimps, prostitutes, drug dealers, slaves, or servants. There is clearly a recognizable act of resistance that is unleashed when a filmmaker like Spike Lee gives voice to black stories like the ones told in *DRT*. Like so many others who have been marginalized in this country,[9] Spike Lee has discovered that the image constituted and claimed by the Other within a difference circle represents a place and an act of resistance, rebellion, and refusal; that is, a place of unity for those who are marginalized and one that often exists in contrast to an image that is created outside of a difference circle by a dominant culture and embolden on celluloid.[10] (Quite simply, it can be an act of self recovery and discovery.)

[5]Hall and Jefferson, 1975.

[6]Refer to Chapter Two.

[7]For example, John Guare and Fred Schepisi as viewed in their presentation of *Six Degrees of Separation* and their clear depiction of Other through the lens of a dominant liberalism and white protagonist, Ouisa Kittredge.

[8]There are numerous other successful black filmmakers; however, Lee and Singleton are unique with the levels of success and critical acclaim and recognition they have attained.

[9]By marginalized, I am not suggesting that Lee was or is somehow placed or set on the periphery on the sole basis of socioeconomic, or simply class, status; rather, it is much more complex—the marginalization of Other. Regardless of Lee's preexisting wealth, or lack of it, his black representative voice has been, for an undeniably long time, silenced, pushed aside, or forgotten. Essentially, I am considering Lee's voice as somewhat representative of a larger voice that we as a dominant culture and society know little about.

[10]There is in existence a long list of films, created by white directors and producers, that have portrayed black Americans as slaves, servants, criminals, and comedic laughing places. There are fewer films that aim at naming and representing black Americans by expressing a black voice.

With this knowledge and understanding of resistance, Lee and Singleton have succeeded in their filmmaking. They have resisted a dominant culture's view of African Americans by uncovering a variety of black urban experiences shared by a variety of black peoples. For example, in Singleton's *Boyz* the black male image is one fashioned and focused on strength and responsibility. Kellner, however, writes specifically of Lee's work:

> *DRT transcodes the discourses, styles, and conventions of African-American culture, with an emphasis on Black Nationalism that affirms the specificity of Black experience and its differences from mainstream white culture. Lee presents Black ways of speaking, walking, dressing, and acting, drawing on Black slang, music, images, and style. His films are richly textured ethnographies of urban Blacks negotiating the allures of the consumer and media society and the dangers of racism and an oppressive urban environment. The result is a body of work that represents uniquely Black perspectives, voices, styles, and politics (75).*

Lee's body of work is a revival in many ways of a black nationalism[11] in that he is presenting black identity and black film characters through the eyes of a Black director, actors, and film crews in resistance to an historical Hollywood depiction of black Americans.[12] Pat McGilligan writes in *American Film*, "According to critics, Spike Lee, as writer, director and star of what was certainly the most talked about film of the year, has clearly become a filmmaking force. 'A genuinely Brechtian[13] movie [*DRT*], with audiences debating everywhere, what is the *right thing*?" (1990:27). Lee is a black man with a camera in a society where "media culture is replacing nationalism, religion, the family, and education as sources of identity" (Kellner, 1997:81). Lee challenges a conventional representation of African Americans by uncovering black stories and then (re)telling them in a dominant medium in a uniquely different voice—giving reverence to black ways of speaking, walking, dressing, acting, and so on—and contradicting the criminalization of black slang, music, images, and style. This is no doubt quite troubling for some, especially for those who work to uphold or affirm the current reigning cultural hegemon.[14]

[11] Michael Eric Dyson explains: "Lee in particular creates films that are part of a revival of Black nationalism (neonationalism), a movement that includes provocative expressions in the cultural sphere (elements of rap music, the wearing of African medallions), interesting interventions in the intellectual sphere (articulations of Afro-centric perspectives in academic disciplines), and controversial developments in the social sphere (symbolized by Louis Farrakhan's 'Nation of Islam' ideology, which enjoys narrow but significant popularity among Blacks. Lee, foremost among his Black director peers, is concerned with depicting the sociopolitical implications of his Afro-centric film aesthetic and neo-nationalist world-view" (Dyson, 1989:75).

[12] Spike Lee employs African Americans whenever he can. Often, the majority of his film crew, his actors, and other support staff are of color.

[13] "Like the German artist Bertolt Brecht, Spike Lee dramatizes the necessity of making moral and political choices. Both Brecht and Lee produce a sort of 'epic drama' that paints a wide tableau of typical social characters, shows examples of social and asocial behavior, and delivers didactic messages to the audience. Both Brecht and Lee utilize music, comedy, drama, vignettes of typical behavior, and figures who present the messages the author wishes to convey. Both present didactic learning plays, which strive to teach people to discover and then do 'the right thing,' while criticizing improper and antisocial behavior" (Kellner, 1997:75).

[14] We begin to understand the challenge *DRT* has made to not only a dominant Hollywood filmmaking paradigm, but a larger social and political dialogue when the film is picked overwhelmingly by U.S. film critics as the year's best (and Lee as best director) but snubbed by the American Film Academy and a variety of public leaders as an act to incite violence (McGilligan, 1990:26).

Universal Pictures/Photofest

Spike Lee on the Act of Do the Right Thing, 1989

⁎ Lee's films, and specifically *DRT*, openly provoke the mainstream by confronting race in a manner not only outside of white Hollywood's traditional liberal film conventions; that is, Lee presents a black voice that stands in resistance to dominant society and its stereotypes of black people in the United States, but also outside a dominant academic assumption regarding the accessibility of truth and rationality as he aims to uncover complexities and uncertainties and then blur any notions of absolute truth⁎ Subsequently, many academic and cultural critics have found Lee's inclusion of both Dr. King and Malcolm X's messages to be openly contradictory and irreconcilable, violence as self-defense versus violence as a tool of the master.[15] In other words, violence is often only seen in conventional ways and in such serves the master—a dominant *we* society—when characterizing African Americans as a problem minority. The ideal that violence could be seen as self-defense is not imaginable for some because it would only work to undermine the dominant cultural hegemon and its base of power and authority. Lee is discredited by some for not landing in some concrete fashion upon a barge of truth and rationality that is apparent to all across difference lines. Rather, Lee has decided to leave some of the larger questions to his audiences; specifically, it is up to an audience to dialogue and then decide what the *right thing* is or is not⁎ Is the riot at the end of the film representative of an act of conventional violence or is it an act of self-defense?⁎

Michael Eric Dyson (*Film Noir*, 1989) argues that Lee is foremost "among his Black director peers" in illustrating the "sociopolitical implications of his Afro-centric film aesthetic and neo-nationalist world-view" (75)—a world view that is representative of Lee's cinematic exploration into key issues of race, gender, sexuality, class, and black politics and that snubs a dominant linear understanding of truth and rationality. Lee attempts, and for the most part succeeds, in creating a film that disseminates what Kellner calls, "a wealth of meaning rather than a central univocal meaning or message one that requires an active reader [of the film] to produce the meanings" of the text (1997:76). Thus, unlike Gus Van Sant's, *My Own Private Idaho*, Lee's *DRT* is didactic in that it strives to promote social transformation through the engagement of difference via a dialogue and a continued discussion or debate outside of the theatre, leaving many of the nuances of the film in the hands of the filmgoer.[16] While not willing to tell his audiences exactly what the *right thing* is, Lee does want his audiences to walk out of the theatre

[15]Note Audre Lorde's work in *Sister Outsider* (1984).

[16]Again, I point to James Wall and his comments regarding Spike Lee's ability to provoke conversation for an audience without exclusively defining the parameters of that conversation: "In Lee's case he not only highlights the reality of racial hostility but does so with considerable artistry. The tension in the African-American ghetto is sharply etched, but there is enough ambiguity in the relationships between Blacks and whites to leave the viewer with hope that a sense of community could transcend fear and hate" (Christian Century, 1990:67).

discussing and debating the matter. This is somewhat different than Van Sant's approach in *Idaho*, a non-didactic approach in presenting white male hustlers on the streets of Portland. Lee does desire a truth, albeit a complex one. In seeking a richer understanding and presentation of truth, he has drawn attention to himself as a black man with a camera—a black man with a weapon more powerful than a gun; that is, Lee's art is both a recording and re-enactment of a struggle for control of an "image of Black identity" (Seelow, 1996:154).

Viewing Do the Right Thing: An Exploration into Difference

DRT explores the "rawness of race relations" on a hot summer day in Brooklyn, New York ("Racism, 1989," *The Progressive*, 1989). Peter Travers (*Rolling Stone*, 1989) claims that "Lee isn't afraid of raw feeling, his film—inspired by the Howard Beach incident[17] —has the urgency of a man spoiling to be heard" (23). And James Wall (*Christian Century*, 1989) asks, pointedly, "What exactly does it feel like to be one of 29 million Black people in this country? White observers don't really know the answer to that question. So what better way to get inside the Black experience than to pay heed to 'insiders'— Black artists who have the talent to convey a personal vision?" (739).[18] Francis Ford Coppola or Steven Spielberg could not have made this film.[19] This goes without saying; however, what is less obvious is the measure of impact Lee has made on the national psyche and our attention and understanding of difference and racism and how his film, *DRT*, a film that exudes a particular political rage, has affected or can affect one's sensibilities.

Thomas Doherty (Film Quarterly, 1989) claims that Lee is "unprecedented" in the history of American film; that is, "He makes movies that play in multiplex malls, that inspire think pieces in *The New Republic* and *National Review*, that spark serious discussions on *Oprah* and *Nightline*." And most noteworthy, "his quick elevation to the ranks of marquee auteur is unquestionably a promotion on merit" and thus challenges the often-heard whispers among not only those living within Hollywood, but those who interact with Others all over the country, that somehow *this* is all about tokenism and special treatment (35). These whispers have long underscored black achievement in a multitude and variety of social and political corridors. One should not lose sight of this negativity and the harm it can cause. All this about a film that chronicles a day in the life of people who live in a multiracial Bedford-Stuyvesant community in Brooklyn and one that depicts "white bigotry with all due contempt" (Klawans, 1989:99). James Wall explains, "Lee [did] not [make] a film "about" Blacks. He is a film artist who wants to confront audiences with the reality of the racism that frequently explodes in this nation" (1989:740). Lee resurrects a national discussion/debate regarding race in *DRT* by telling a story that is both uniquely black and representative of a larger feeling of despair and alienation. It is this story that challenges and provokes pause in a moviegoer and can lead to a (re)considering of one's sensibilities in that one will either have to accept or reject Lee's narrative complexity and alternate political view of truth and reality.

[17]According to Lee, *DRT* is loosely based on the Howard Beach incident: a racial incident in 1986 where a gang of whites attacked three black men and chased them from a Queens pizzeria.

[18]I suggest that in paying heed to Lee's vision we remain cautious of the devastating effects of cultural tourism and a consumption of difference that seems to follow. Again, note my concerns as articulated in Chapters One and Two.

[19]Thomas Doherty writes, "Part of the appeal of Lee's films is pure ethnography: his people and stories are simply not accorded a celluloid rendering anywhere else. Hollywood has absolutely no idea what these folks are about. Coppola and Scorsese know the Italians, Allen and Brooks the Jews, Spielberg and Hughes the white-bread 'burbs,' but no brand-name director has inside-dopster access to the vernacular, manners, and values of Black America, still less the Black underclass" (1989:37).

Corection:
The reality of Bed-Stuy
diversity (not only black voices)

Interestingly, Spike Lee plays one of the film's protagonists, Mookie, a young man who is working only to "get paid" as a pizza delivery boy at Sal's Famous Pizzeria, an Italian eatery owned and operated by Sal[20] (Danny Aiello) and his two Italian American sons, Pino[21] and Vito[22] (John Turturro and Richard Edson). Mookie has a girlfriend, Tina (Rosie Perez), and a 3-year-old son that he does not support nor apparently care for,[23] and a sister Jade (played by Lee's real-life sister, Joie Lee). Lee presents Mookie as both a neutral character early in the film and then a deliberative, but distinctively leading, voice at the narrative's end. Mookie balances out the cast of other characters; specifically, Radio Raheem (Bill Nunn) and Buggin' Out (Giancarlo Esposito), who come to represent the angst and alienation that pervade inner city communities.

Buggin' Out is a would-be activist who attempts to enlist his neighbors in a boycott of Sal's Famous Pizzeria. The premise behind the boycott is Sal's Wall of Fame, a gallery of photographs paying homage to a host of Italian Americans from the likes of Frank Sinatra and Sophia Loren to Rocky Marciano and Sylvester Stallone. Buggin' Out wants Sal to add some "brothers" to the Wall of Fame, a representation of the people, African Americans, who make up the majority of patrons at the eatery. Buggin' Out explains how Sal makes "much money" from the brothers and thus should respect and pay homage to them as well as Italian Americans on his Wall of Fame.

Justice moves from the corridors of resource distribution to recognition as Buggin' Out expresses a harm of nonrecognition by uncovering a shared disrespect and distrust across difference lines. And while the request at first does not seem extraordinary, the events that follow are both troubling and complex as they place Mookie, the film's protagonist, in the middle of a controversy between his boss and his friends and neighbors, while at the same time placing an audience in the midst of a controversial debate over (non)recognition, identity, and respect. Colette Lindroth (*Spike Lee & The American Tradition*, 1996) accurately describes the situation like this: "Buggin' Out has a reasonable request, which he communicates with unreasonable force; Sal has a reasonable reservation, which he communicates with contemptuous dismissal. No one is entirely wrong here; two rights block each other" (28). Klawans describes Mookie's involvement, and thus dilemma: "On the one side, there are the protesters—his [Mookie's] own people, even though they can't agree on what they're protesting . . . On the other side, there is Sal. Though Mookie almost likes him, he is white, he's the boss, and he is backed by a police force that's willing to kill Black people" (1989:100). Sal's initial response is to tell Buggin' Out to get his own business, and when he does, then he can create and maintain a Wall of Fame of his own, displaying those icons of his own choosing. There are two representations of Sal in this dispute: First we see Sal as a business owner protecting his property rights, and second we see Sal and his sons, one an

[20]Dyson writes of Sal, "He is a proud businessman whose long standing relationship with the community has endeared him to most of the neighborhood's residents. But when provoked, he is not above hurling the incendiary racial epithet, which on one fateful occasion seals his destiny by beginning the riot that destroys his store" (1989:77).

[21]Colette Lindroth writes of Pino, "He is a complex character." She continues by explaining a particular scene where Pino and Mookie confront one another: "Mookie challenges him to name his favorite athlete—Magic Johnson; his favorite comedian—Eddie Murphy; and his favorite rock star—Prince. Trying to explain these loyalties in one who hates blacks, Pino fumbles for reason: 'It's different. Magic, Eddie, Prince are not niggers, I mean are not Black. I mean they're Black, but not really Black. They're more than Black. It's different'" (1996:28). Dyson calls Pino a "vicious ethnic chauvinist who clings tightly to his Italian identity and heritage for fear of finding himself awash in the tide of 'nigger' loving that seems to soak his other family members" (1989:77).

[22]Dyson describes Vito as "the ethnic pluralist, an easygoing and impressionable young man whose main distinction is that he has no major beef with the Blacks and Puerto Ricans" (1989:77).

[23]Spike Lee says of Mookie, "He can't see beyond the next day. Mookie is an irresponsible young Black youth. He gave Tina a baby. He changes, but up to that point [the riot] he doesn't really care about his son or her" (Glicksman, 1989:14).

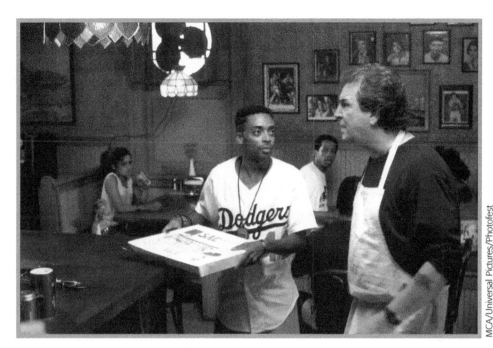

Do the Right Thing, 1989

overt racist, Pino, as Italian Americans both in competition with a black community and as a partner to that community where they have maintained a long-standing business. Lee chooses to explore the racial tensions between Italian and African Americans,[24] and the high physical and natural temperatures affecting this neighborhood on this one summer afternoon becomes a central metaphor for *DRT's* focus on a complex and tense race relations affecting this Bed-Stuy neighborhood, and I would suggest, the country at large. It isn't until the end of the film when Buggin' Out gains the support of Radio Raheem, a young man who sports a T-shirt proclaiming "Bed-Stuy or Die" and carrying the neighborhood's largest "ghetto blaster"—always at full volume and always playing Public Enemy's 'Fight the Power"—that the film erupts in an all-out riot with an all too common violence and destruction, both of lives and property. Dyson writes:

> *Lee wants his movie to provoke discussion about racism in the midst of a racially repressive era, when all such discourse is either banished to academia (though not much discussion goes on there either) or considered completed in the distant past. Lee rejects the premises of this Reagan-era illogic and goes straight to the heart of the mechanism that disseminates and reinforces racial repression; the image, the symbol, the representation.* Do the Right Thing *contains symbols of racism and resistance to racism, representations of Black life, and images of Black nationalist sensibilities and thought (1989:75).*

DRT does not just arrive at this defining, and riotous moment—violence—where Sal destroys Radio Raheem's ghetto-blaster after Raheem refuses to turn the radio off or turn the volume down while in the pizzeria. Rather, there are numerous moments that foreshadow an impending violence

[24]The film also addresses racial tensions that exist between Korean and Puerto Rican Americans, although the primary text is aimed at the relations between Sal and his sons and those in the black community who frequent the pizzeria.

at the film's end, the depiction of Raheem and his ghetto-blaster being only one. However, Lee's representation of Raheem and his ghetto-blaster is quite telling of his larger aims to provoke a discussion that at times will be difficult and controversial for those filmgoers who are off the margins living within a dominant social and political paradigm. Of Raheem's ghetto-blaster, Thomas Doherty says, "As an un-symbol of interracial animosity and class style wars, the boom box [ghetto-blaster] is a perfect radiator for Black anger and white noise (and vice versa). Next to semi-automatic weaponry, the ghetto-blaster is the easiest way for the underclass to exact vengeance and aggression on an unwary bourgeois" (1989:38).

Raheem's boom-box or ghetto-blaster represents his identity—a black identity—and the playing of it, and the volume at which Raheem plays it is an act of resistance to the social, political, and cultural powers that be. Thus Sal's asking him to turn the music off is in essence a move to silence Raheem's Black identity. Sal's means for getting Raheem to comply—the use of a baseball bat to destroy the boom-box and silence Raheem's anthem of "Fight the Power"—is both violent and repugnant in that it displays a hatred and deep distrust across difference lines and leaves Raheem injured both physically and emotionally. Sal is both intolerant and unwilling to recognize his black patrons. This nonrecognition informs the impending violence and thus the controversy that erupts as to whether violence can be seen as an act of self-defense in the midst of an overwhelming power or violence aimed at silencing Other and difference.

There is not, out of the blue, a presentation of racial violence in *DRT*; again, there is a continuous and subtle suggestion of tension and animosity that Lee pays particular attention to and that foreshadows the film's concluding scenes of violence where Radio Raheem and Buggin' Out's confrontation with Sal results in Raheem's being choked to death by the New York City Police. A riot is initiated by the tragedy, led by the once-neutral character Mookie, who takes on the nonrecognition and misrecognitions of a larger society. Dyson characterizes these continuous and subtle suggestions of tension and animosity as the "little bruises, the minor frustrations, and the minute but myriad racial fractures that mount without healing" (1989:75). For example, there is the anger and frustration that is displayed by Lee's Greek Chorus—three middle-aged and unemployed black men who sit on a corner across from a grocery and fruit stand discussing a Korean business owner's success:

> **ML:** "Now for the life of me, I haven't been able to figger this out. Either dem Koreans are geniuses or you Black asses are just plain dumb."
> **Coconut Sid:** "It's gotta be cuz we're Black. No other explanation, nobody don't want the Black man to be about shit."
> **Sweet Dick Willie:** "You mother fuckers hold this shit down. I'm tired of hearing that old excuse. I'm tired of hearing that shit."

There is also the challenge made by a group of Puerto Rican youth to Radio Raheem as to who wields the neighborhood's loudest ghetto-blaster or boom-box, illustrating an obvious split and confrontation in the film between rap and Latin music.[25] And there is the exchange between Buggin' Out and the new "white-man" on the block—the brownstone-owning, Boston Celtics—jersey-wearing

[25]See Victoria E. Johnson's article "Polyphony and Cultural Expression: Interpreting Musical Traditions in *Do the Right Thing*" *Film Quarterly*, Winter(1993).

individual—who accidentally steps on Buggin' Out's new Nike Air Jordans.[26] Perhaps the most offensive suggestion of these little bruises comes in Lee's presentation of a series of racial slurs hurled from one group to another (black to Italian; Italian to black; white to Asian; Asian to Hispanic, etc.).[27] Thomas Doherty describes this scene: "The inter-ethnic, interracial animosity explodes in a montage of face-front slurs—Blacks slam Italians, Italians slam Blacks, Latinos slam Koreans, whites slam Latinos, Koreans slam Jews—that serve as warm-ups for the ultimate bonfire" (1989:38). These little bruises give way to, and inform, a much more severe injury; that is, what would seem an impossible act of violence if we were without knowledge of their existence and of their contribution to U.S. racial tensions and their everyday occurrence in this particular Bed-Stuy neighborhood.

Lee's presentation of these little bruises and his setting up a controversy that engages the competing visions or perceptions that inform a filmgoer's understanding of violence are meant to provoke dialogue across difference lines. (The hope is that in viewing the film those who are maginalized will be able to claim their image and those who are not will be able to give recognition to those lives and stories that inform those who, for so long, have been silenced or presented through a lens that is not Other.) *key*

A Closer Look at the Complexities: Self-Definition, Recognition, and Dialogue

> *Refusing to filter Black life through a racial prism, to record a dialogue in which whites name the topic and define the terms, he [Lee] sets his sights at street level and frames his own conversations. As Toni Morrison wrote in Beloved, "definitions belong to the definers not the defined." Committed to projecting Black experience through its own lens, Lee brings to American cinema a strategy that has animated Black literature since the Harlem Renaissance (Doherty, 1989:35).*

Spike Lee has said that he feels *DRT*, along with his film *Malcolm X*, are his two best works to date.[28] He says of *DRT*, "It's powerful; people are gonna react to it. They're gonna talk about it. It's thought provoking, and it's entertaining. You can straddle that. It doesn't have to be a choice between a documentary or disposable entertainment" (Sharkey, 1989:24). The film is provocative, yes, because of both Lee's political and artistic decisions. In choosing to address the issue of race in New York City, especially when racial tensions were at extremely intense levels, Lee positioned himself and his film in the line of

[26]"You dago, wop, garlic-breath pizza-slinging Vic Damone;" countered by, "You gold-teeth, gold chain-wearing, fried-chicken-and-biscuit-eatin' monkey;" where, "You slanty-eyed, me-no-speak-American, Korean kick-boxing, son-of-a-bitch;" met by, "You Goya bean-eating, 15 in a car, 30 in an apartment, meda-meda, Puerto Rican cocksucker;" and, "It's cheap, I gotta good price for you, B'nai Brith, Jew asshole!" (Glicksman, 1989:13).

[27]In an interview with Bryant Gumbel, formerly of *Today*, Lee said, ". . . personally I think my best work has been *Do the Right Thing* and *Malcolm X*" ("Spike Lee Talks About His Best Films," *Jet Magazine*, 1995:33).

[28]Marlaine Glicksman (1989 *Film Comment*) explains: "Lee's film comes at a time when New York City is a racial tinder-box. The alleged Black gang rape of a white Wall Street woman this April in Central Park angers whites, smears Blacks and triggers Donald Trump to take out a full-page ad in *The New York Times* calling for reinstatement of the death penalty (yet there was no such outcry when Michael Stewart and Eleanor Bumpurs—Blacks to whom Lee dedicates his film—died at the hands of NYC police in separate controversial incidents). *The Amsterdam News*, favored by a Black readership, likened the handling of the Central Park rape to the Scottsboro boys, who were falsely convicted and nearly executed for the rape of a white woman in Alabama 50 years ago. One month later, after a 25-year-old Black man died in police custody, one Black woman told *The New York Times*, "This is crazy. There's going to be a riot. Somebody is going to get killed and it'll probably be us" (1989:13).

fire, so to speak, with both moviegoers and social, political, and cultural critics. Lee says, "The country is so polarized, especially in New York. This is a very angry film. But these are angry times" (Sharkey, 1989:24).

Some of the criticism has been benign, while, in my view, other criticism is clearly harsh and representative of a reactionary rhetoric. For example, Jerome Christensen (*Spike Lee, Corporate Populist*, 1991) accuses Lee of simplifying race relations by "consistently resolving all ethnic issues into Black-and-white alternatives of love and hate, friend and enemy, violence and nonviolence, just as it resolves all the various brilliant colors of the street into the Black-and-white photograph of Martin Luther King and Malcolm X that concludes the film" (583). Christensen is too simplistic in his analysis of *DRT*; rather, *DRT* is a complex text without clearly discernible, or agreeable or universal, messages, let alone full of clearly enunciated dichotomous thematic subsets. Christensen continues by attacking Lee, in his mind a corporate populist, for "marketing" Nike's Air Jordans in the film and for what he sees as an overt reinforcement of consumer capitalism. He says of Lee, "[He] is the first Black filmmaker to transform, deliberately and programmatically, personal responsibility into corporate responsibility" (589). And he argues that the right read of *DRT* involves,

> . . . *appraising its impure effects. What, then, would an impure effect be? It is not something to be cognized out there in nature. But it shows up in a story like this: A young Black filmmaker makes his first feature, She's Gotta Have It, which has surprising commercial and critical success. Not the least measure of its success is that it attracts the attention of Jim Riswold, associate creative director for Wieden and Kennedy, the ad agency that handles Nike. Riswold likes the film and likes the fact that Mars Blackmon, the central character (played by Spike Lee), wears Nikes. In 1987 Riswold makes a deal with Lee to make television commercials for Nike. In 1989, in a new film by Lee, a film about consumption (the consumption of images, the consumption of pizzas, consumption by purchase, and consumption by fire), there occurs an episode in which a white man inadvertently steps on a Black man's shoes. The cry "You almost knocked me down, man! The word is excuse me" is answered by a casual apology, which in turn is met with the indignant rejoinder, "Not only did you knock me down but you stepped on my brand new, white Air Jordans I just bought." Like a projectile, the brand name shatters the glass of realism and momentarily moves the film into the inebriating hyper-reality of product fetishism* (591).

There is something fundamentally wrong in taking aim at Lee on this account alone in order to discredit his film and his clear intent at creating and contributing to a dialogue about race in this country because of his decision to "market" a Nike product. In fact, this criticism as well as other charges only aim at changing the subject; that is, at moving the dialogue outside the director's Feeling-Concern to avoid more complex charges and challenges to the way we see race, race relations, and Others in our dominant *we* society.

No doubt Lee's work in *DRT* is highly stylized. We live in a highly stylized and highly commercial society. The absence of Nike, McDonalds, and Coca Cola would be disruptive to an accurate representation of this multiethnic Bed-Stuy neighborhood. This also begs the question as to whether a similar film produced by a white artist would come under the same scrutiny and discrediting, an act of nonrecognition. Interestingly, Christensen does not object to Lee's direction when Da Mayor (Ossie Davis) enters a family-owned Korean grocery demanding that the owners stock Miller beer. This too could be seen as a corporate plug, but rather it is rightfully seen as a depiction of one behavior in a black subculture, and left alone by Christensen because Miller Beer, at this time, is less likely a target of anti-globalization forces than Nike.

I am opposed to throwing out Lee's attention to race relations in the United States, and specifically New York City, on the basis that Lee is a corporate populist serving his corporate needs. Instead, I suggest one heed the words of W.J.T. Mitchell in his criticism and assessment of not only Christensen's critique, but of all those who claim that Lee's work is not worthy of one's attention. Mitchell characterizes the importance of Lee's artistic and political comment:

Jerome Christensen is not the first to find "counter-currents that trouble the ostensible progressiveness of Spike Lee's ambitious art" (p. 583). Like many of the early reviewers of Do the Right Thing, he discovers deep problems with the film's apparent "messages" on politics, race, and economics. Christensen thinks the film signifies "contempt for sustained political activity," that it expresses a racialist, perhaps even racist appeal to an essentially "Black" identity, and that it is an immoral sellout to the consumerism of corporate capitalism. My view is that the film addresses all these issues (and others, such as gender), but is not reducible to a determinate or specifiable "message" about any of them. I've argued that the film aspires to the condition of a work of "public art," presenting a vivid ensemble of words, images, and sounds that articulates the central controversies of our time: issues of race and ethnicity; of poverty, private property, and public civility in an ethos of consumer capitalism; issues of political and ethical principle, or responsibility to one's tribe, neighbors, "brothers," and to "Others" more generally considered" (1991:596).

The question we should be asking of Lee's work as public art is not whether a determinate or specifiable message is readily available—one that is corporate or anti-globalization—and if we are unable to conjure one up, then with license disregard a clearly articulated challenge and intent and vision claimed by the filmmaker and directed at a dialogue about race and identity. Spike Lee's intent is to (re)claim the black image and give voice to those who are often silenced within the parameters of hurtful social, cultural, and political themes that have infected our society for decades, if not centuries. We should be asking whether the film "dramatizes political issues in a significant way, asks the right questions, expresses the relevant views, and presents the emotional dynamics in the encounters among multiple ethnic public spheres in the United States at the present time" (Mitchell, 1991:597).

Answering these questions, or attempting a dialogue that is informed and facilitated by these questions, allows one to further interrogate whether our sensibilities can enter into a transformative whirlwind while sitting in a darkened theatre and seeing and hearing a voice that arguably as been silenced and marginalized for a long period of time. Lee says, "I always wanted to do something on race relations, and I wanted to show people the New York I know. It's unlike Woody Allen's where there is no ethnicity, no people of color" (Sharkey, 1989:24). Thus, it becomes clear that we are dealing with and experiencing a narrative unlike others that come out of Hollywood; that is, a narrative from a black perspective seen through a different lens, a black lens.[29] And Lee's work, unlike Christensen's and other's assertions, does not aim at presenting a black versus white dichotomy within a realm of good and evil, love and hate, or corporate and anti-corporate politics. Rather, *DRT* interrogates racism and finds that the only discernible view is one that recognizes, accepts, and then depicts a complexity that often challenges many of us who engage in a dialogue about difference and race in this country. For example, Lee's juxtaposition of two major philosophies within the

[29]In an interview with Betsy Sharkey (*American Film*, 1989) Spike Lee explains the importance of black film: "To Hollywood, Black is death at the box office. There is a desperate need in the marketplace for a Black product. Black people are dying to see themselves portrayed realistically. Nobody is doing that type of film" (25).

black community—one articulated by Dr. King and the other by Malcolm X —and his decision not to privilege one over the other suggests a complexity and a controversy yet, if ever, to be reconciled. And this controversy is placed in the laps of moviegoers of all backgrounds; it is presented from the margins and from a place of resistance.

> *Do the Right Thing, like Lee's other films, is a Black insider's perspective on the contradictions and celebrations of African-American life. But Lee's talent lies in creating characters that transcend race and economic status and speak to us all. His Bed-Stuy comes alive with neighborhood people we know: Mother Sister (Ruby Dee), matron of the block; Da Mayor, block philosopher; Sweet Dick Willy (Robin Harris), Coconut Sid (Frankie Faison) and M.L. (Paül Benjamin), a Greek-Chorus triumvirate who seek shelter from the sun in beer and beneath a beach umbrella; and even the Puerto Rican helado "icee" man carting his big block of ice and syrup bottles. It is a block where English intermingles with Spanish, where salsa meets Raheem's rap and the air is radio-active with Senor Love Daddy's (Samuel Jackson) We-Love show, as he does "the nasty to yas ears" with "da platters dat matter," with Black music ranging from rap and juju to reggae and soul—a block where music[30] is a main character" (Glicksman, 1989:13).*

Lee presents his characters as constructed by multiple selves and we as an audience are not presented with a black versus white dichotomy, where white people are evil one-dimensional perpetrators of hate and racism,[31] (although the film clearly takes aim at white racism) and where blacks are one-dimensional victims of an assumed white hate.[32] Instead, Lee's works, and *DRT* specifically, present the complexities of both black and white identity from a black perspective, and yes, black victimization by a white racism is an aspect of that complexity.[33] For example, Lee gives voice to that feeling of victimization through conversations between the members of the Greek Chorus, Mother Sister's exchanges

[30]In an interview with Glicksman, Lee responds to her question about music and its importance to his narrative: Glicksman, "Your screen-writing and film-making aren't strictly narrative. They bear a strong resemblance to a musical score. Each character is a note that you play and then bring all together for a crescendo at the end." Lee, "We just don't like to have narratives that show. They're there, but we just don't want to be out in front, because when narratives are out in front, the audience will be able to guess from watching the first ten minutes of the movie exactly where you're going to go. We like to keep them guessing, just let there be work. I think that for the most part, not enough respect is given to audiences' intelligence" (1989:18).

[31]Lindroth contributes by saying, "Even Pino, the most furiously bigoted man in the movie, is not simply one-dimensional, more weak than evil, he detests the neighborhood, detests its residents, detests his customers and detests his own embarrassment in front of his friends who taunt him for his 'demeaning' job. In his frustration, he, too, has become uncommunicative; his main avenues of expression are through racial insults to Mookie, whom he is constantly calling 'nigger' and punches for his brother, whom he bullies endlessly" (1996:28).

[32]This is obvious in Lee's depiction of Mookie, who has essentially deserted his girlfriend and child; Da Mayor who battles hopelessness and drunkenness; and the Greek Chorus, men who are without jobs and the motivation to face the powers of their own impotence and that of an institutional racism.

[33]The following is an excerpt from an interview with Spike Lee conducted by Marlaine Glicksman for *Film Comment*: Glicksman, "In your book, *Do the Right Thing*, you say that Blacks can't be held responsible for racism, that they're victims. It seems that one's self-perception as a victim reduces one's power—as seen in the conversation between M.L., Sweet Dick Willy, and Coconut Sid about the Korean fruit stand. Lee, "No. How is that going to be 'my perception' if Black people were taken from Africa as slaves? I'm not imagining that. You must acknowledge that, but not use that as an excuse." Glicksman, "I was reading an article in *Premiere* about Blacks in the film industry. And one person was quoted as saying Hollywood films are based on the premise that a Black man or woman can't lead you anywhere. Which is to say that whites' moral/psychological identification can't be with a Black person." Lee, "I truly believe a lot of people—a lot of executives—believe that. There's an age-old axiom in Hollywood

with Da Mayor, and Mookie's telling a group of street kids to "get a job"; but, Lee also gives voice to a black nationalism in the celebrating of black culture through the aesthetics of his filmmaking talent; specifically the images, the music, and the film's textual rhythm.

✳Lee clearly presents a beauty in this Bed-Stuy neighborhood. This is an artistic and political act that is not often seen or accepted in Hollywood, partly because of white fear and the fact that few black artists have been afforded an opportunity to voice black identity in a manner that reaches, like Lee's work, a mass audience.✳A white audience expects to see things through a status quo lens, a lens that is reflective of a dominant voice and dominant culture. For example, for many moviegoers Mookie is at the beginning of the film a *peaceable* character who appears to get along with everyone (excluding Pino), white and black—a black character who is not unfamiliar nor uncomfortable to white audiences. Wall explains, "From a white perspective, Mookie is the one younger character in the film with whom one can rather readily feel comfortable." However, at the end of the film, his behavior, in Wall's words "removes from him the aura of being a poor man's Sidney Poitier" (1989:739). This is troubling for some moviegoers and for many more movie producers because of the representation and the complexity of Lee's characters in that Lee's characters challenge a dominant white audience and motion picture industry because they are characters imagined outside a dominant culture's presentation of Other and they do have an alternate sense of truth and rationality that is informed by a different set of memories and experiences.

Lee accepts a complexity and diversity of a black self and presents that complexity and diversity in *DRT*, in Mookie and in other characters, as he works to destroy the stereotypes that engulf both black and white America and present African Americans' full humanity. Glicksman writes, "As in real life, his [Lee's] characters are neither all good nor all bad. And therein lies their—and Lee's—power: the minute he establishes our identification with a character, Lee turns him inside out to reveal the dark side in us all" (14). Whether Lee is focusing on Mookie, Da Mayor, or the trio making up *DRT's* Greek Chorus, Lee presents characters that are complex, uncertain, vulnerable, and full of contradictions. These contradictions have fueled some debate surrounding the film and specifically Lee's use of violence at the end of the text where Mookie, after deliberating over Radio Raheem's murder at the hands of white New York Police officers, picks up a garbage can and throws it through the window of Sal's Famous Pizzeria, shattering the comfortable Sidney Poitier image. Seemingly uncharacteristic of Mookie, Lee has been charged with creating a dramatic violent episode that feels contrived by many, albeit admittedly white audiences and critics. Yet it is through this act, whether it be seen as violence or self-defense, that Lee establishes the question and hopeful dialogue as to what the *right thing* is or is not.

A Place of Violence? Or Self-Defense?

Lee shows the ugliness of racism, and without a display and representation of a violence that pervades urban neighborhoods across this country and without a representation of oppressive police officers offered through the lens of a black and Other perspective, his efforts would fail in that the depiction would be distorted and would serve to do nothing other than reinforce another of the Reagan culture's myths—that *this*, that racial conflict, is all behind us now and that those who tangle with the police and get hurt or killed are or were deserving of particular consequences.

(continued)

that Black is death at the box-office. Except for very few exceptions—Eddie Murphy being one. Look at *Time* the week they had Mississippi Burning on the cover. Alan Parker said the realities of Hollywood today demand that this film have two white leads. And I'm not going to hang Alan Parker about that statement. I think that he's just echoing what a whole lot of executives feel, the people who get pictures made" (1989:18).

Lee has chosen the art of filmmaking in order to offer up his vision—a vision that informs my continuing claims about film—how, "art reveals—and in revealing, changes our perceptions," our sensibilities (Wall, 1989:740). Also, Dyson contributes by saying:

Lee's portrayal of police brutality, which has claimed the lives of too many Black people, is disturbingly honest. The encounter between Radio Raheem and Sal is poignant and instructive. It shows that a Black person's death may be provoked by incidents of racial antagonism gone amok, and that it is easy for precious Black life to be sacrificed in the gritty interstices between anger and abandonment. Thus, we can understand the neighborhood's consuming desire to destroy property—avenging the murder of a son whose punishment does not fit his crime (1989:77).

"It's a community rising . . . rising out of frustration," Lee explains. "Too many young Blacks murdered, and nothing's going to be done." He continues, "This film is no Disney movie," and if it were, "it would have been the [a] Hollywood movie" (Davis, 1989:26). And in a culture where violence usually is a great marketing tool for Hollywood productions, and where critics often do not comment on violence when it is exacted by whites on whites, or even more troubling, blacks on blacks, *DRT* has come under serious scrutiny for ending its narrative with a violent riot that destroys Sal's Famous Pizzeria, specifically for its black violence against a white property owner. If we consider how Lee came to the point of making *DRT*, and the influence of the Howard Beach[34] incident, it should be of no surprise that Lee would challenge the dominant understanding of violence in this manner. It is the only way to express his black voice as white violence, police violence, is a partner in the lives of Lee and many others who are of color. Violence is a part of their memory and their experience(s). Yet Lee does not necessarily subscribe to the notion that his film ends in violence; rather, he suggests that what transpires at the end of *DRT* is nothing more than self-defense. In an interview with *Film Comment*, Lee was asked about the last scenes of his film and the ambiguity of the juxtaposition of the two quotes, one credited to Dr. King and the other to Malcolm X. He explained how he did not see any ambiguity; rather, he sees, and set out to illustrate, the consequences of a frustration and a hopelessness that runs rampant in black communities. And when asked by Marlaine Glicksman, "Is the riot doing *the right thing*?" He responds, "In that specific case it is, because Mookie and the people around him just get tired of Blacks [Radio Raheem] being killed by cops, just murdered by cops. And when the cops are brought to trial, they know nothing's going to happen. There's complete frustration and hopelessness." He continues, "There's a complete loss of faith in the judicial system. And so when you're frustrated and there's no other outlet, it'll make you want to hurl the garbage can through the window (Mookie's action)" (1989:14).[35] But does that make it right? From a black perspective, maybe, but, what about a white one? Lee explains, "What's really troubling to some white critics is when Mookie throws the garbage can through the window. Because Mookie's one of those 'nice Black people.' I've heard a lot of white friends tell me, 'You're a nice Black person, you're not like the rest.' They really followed Mookie,

[34]"Lee was initially concerned to interrogate the conditions that could lead to the wanton killing of Black youth, spurred on by the Howard Beach killings in which white youths gratuitously assaulted some Black youths, leading to one of their deaths" (Kellner, 1997: 104n20).

[35]Lee continues, "They've seen it so many times [the Black community], Michael Stewart, Tawana Brawley, Eleanor Bumpurs. Nothing happens. The eight cops that murdered Michael Stewart—that's where we got that Radio Raheem stuff. That is the Michael Stewart choke-hold. Except we didn't have his eyeballs pop out of his head like Michael Stewart's did—[the police and medical examiner] greased his eyeballs and tried to stick them back in the sockets" (Glicksman, 1989:14).

they liked Mookie. He was a likable character. They feel betrayed when he throws the garbage can through the window. Can't trust them" (15).

This demonstrates how many white critics, and no doubt white audiences, could only identify with Mookie while he played that "good black" or Sidney Poitier—type of character, a character that has become familiar in American cinema as white directors have often portrayed African Americans in this manner. With this controversy, however, comes the somewhat widely held conclusion that *DRT* is about violence, that there is an act of advocating violence, an act to incite violence, that best describes the film. This is unfortunate as almost as many filmgoers and critics have recognized that it is not the violence, or the act of self-defense, depending on your point of view, that is at the center of Lee's film; but rather, an "impotence, frustration and a sense of being nowhere and getting nowhere" (Nowell-Smith Sight and Sound, 1989:281). It is a continued feeling of being overpowered by the complexity of a racialized construction of identity and community and an alienation that goes hand in hand with that construction. Lee's intent can be lost, even after he responds to the ultimate question, "Are you advocating the riot [violence] at the end?" And he responds, "I'm not advocating anything. I don't think Blacks are going to see this film and just go out in the streets and start rioting. I mean, Black people don't need this movie to riot" (15). Glicksman continues by asking Lee, "White people fear that you are advocating violence." "Look, all they have to do is read the last quote of the movie. I'm not advocating violence. Self-defense is not violence. We call it intelligence. People are full of shit. Israel could go out and bomb anybody, nobody says nothing. But when Black people go out and protect themselves, then we're militants, or we're advocating violence," responds Lee (16).

There is an attitude out there that suggests black people are susceptible to Lee's influence; that is, only black folks are readily incited to violence by suggestions made in a motion picture. James Wall explains this as nothing short of a "suggestion that Black people are prone to act on instinct and en masse." "This is racism," he says, "because it looks at a group and ignores its various elements. It is, in fact, a more sophisticated version of the old canard that *they all have rhythm*" (1989:739).

For a lot of filmgoers, and in my view, even more critics—social, cultural, and political—who have identified the violence or act of self-defense at the end of *DRT* as the *wrong thing*, the death of Radio Raheem is lost in a cultural bias. More pointedly, one might ask, When is violence appropriate and when does it transcend a certain cultural understanding of physical or emotional damage or injury and land in the realm of resistance against an attack, an act of self-defense or self-preservation? In so many articles, the fact that Radio Raheem is essentially murdered by a New York Police officer is lost.[36] The great tragedy according to so many of these critics who have lost sight of Raheem's death is the absence of a coalitional politics (Mookie and Sal joining arm-in-arm) that is more informed and more aware of the great harm done by a virulent racism that is depicted frame by frame, both concretely and abstractly, in Lee's film. It is a political act that represents a melting pot rationality and leads to a universal love for humanity. Our dominant culture, the ever-strong remnants of a Reagan rhetoric demand that we awaken anew in the morning as that city (Bed-Stuy?) on the hill with problems solved and with a conventional and common understanding of truth, rationality, and in the case of *DRT*, violence.

[36]For example, in Jerome Christensen's article in *Critical Inquiry* (1991), he obsesses over the riot, and specifically Mookie's involvement, "Not only is his act unmotivated, there are no bad consequences to his violence. Sure, there's a fire, but no one goes to jail. Sure, property is destroyed, but, as Mookie reminds Sal the next morning, the insurance will pay for it. The fire is contained physically and economically by the same magic with which the streets of Bedford-Stuyvesant have been detoxified of crime and drugs" (588). Where is Christensen's attention to Radio Raheem and the recognition, or at least the speculation, that Raheem's murder may serve as motivation for Mookie's act? The death of a black youth is lost even on the pages of a *Critical Inquiry* piece. Eric Dyson's review of *DRT* in *Tikkun* states, "It is understandable that the crowd [and Mookie] destroys Sal's place, the pizzeria being the nearest representative of destructive white presence, a white presence that has just denied Radio Raheem his future" (1989:77).

Does a film that concludes in violence lead one to understand better, through open discussion and dialogue, race relations in this country? What if one person sees the act as self-defense, and not an act of violence? How can we reconcile differences in perception? Differences that are clearly structured by experiences and memories and thus unknown to so many who live outside the realm of difference circles, outside a realm of resistance that is informed by particular memories and experiences? It seems that a lot of people, scholars and non-scholars alike, hope for a joining-arm-in-arm-like reconciliation; that is, an embrace and joint exclamation across difference lines against the horrors of a conventional violence. This is essentially an act that ignores complexity and the work of engaging the little bruises that lead up to (contested) violent acts. Again, one cannot assume that a conventional connection is possible; rather, one should consider one kind of experience next to another, hoping for a recognition and possible connection. Specific to *DRT,* one should consider the act of police brutality in the film from the position of Other, as an eyewitness to Lee's narrative.

Lee "has sneered at a mass (not just white) audience upset with *DRT* because it didn't conclude with Mookie and Sal joining arms to sing "We Are the World" (Doherty, 1989:39). Partly because such a union, inadvertently or not, dismisses in many ways Radio Raheem's identity—Radio Raheem's difference in a dominant *we* society—both in life and in death. As an audience we should not expect "We Are the World"; rather, we should prepare ourselves for an alternating and competing reality informed by Lee's and other African Americans' historical memories and experience with the police. In doing so, those of us outside that difference circle allow a challenge to our sensibilities in that one might recognize different understandings about race and violence by considering how those historical memories and experiences held by African mericans inform their perceptions of reality and how those perceptions intermingle with a larger society.

Recognition, however, does not guarantee a common or universal understanding among different people. For example, Doherty explains how Danny Aiello (Sal) and Spike Lee could not come to terms with their two different interpretations or reads of their characters (recognizing how both Lee, as director, and Aiello, as actor, are co-authors of the character Sal). In a discussion about Sal's character, Lee declares flatly that he thinks Sal is a racist. Aiello disagrees and, according to Doherty, "on the screen, if not in the screen play his portrayal wins the argument" (1989:38). Regardless of whether an audience sees Sal as a racist, however, the director and author did.

One can see the multiple reads of *DRT* and the near impossibility at settling upon one truth or rational understanding of the film and its many important and complex subtexts (race, oppression, and violence being the major themes). Dyson contributes to this suggestion as he explains the ever-changing face of racial identity, and in many ways race relations across difference lines:

> *Racial identity is an ever-evolving, continually transforming process that is never fully or finally exhausted by genetics and physiology. It is constantly structured and restructured, perennially created and re-created, in a web of social practices, economic conditions, gendered relations, material realities, and historical situations that are themselves shaped and re-shaped (1989:76).*

One could argue that violence, like race or racism and racial identity, is one of those socially and politically contested terms, ever-evolving. The nuances that shape our understandings of the conventional term and the implications of those various understandings of violence affect our sensibilities regarding racial identity, race relations, and community in complex and different ways. For example, Robert C. Rowland (*Social Function, Polysemy and Narrative-Dramatic Form: A Case Study of Do the Right Thing,* 1994) document the varying interpretations of *DRT* and specifically the position of its presentation

of violence/self-defense.I In doing so, he suggests that the many reads of *DRT*, and the controversies surrounding those reads, contribute to a larger national dialogue that for many years has been dormant and believed to be unnecessary:

> *There is little question that DRT can be treated as an exemplar of a radically polysemic work. This is evident in the contrasting interpretations of the film. Some saw it as advocating violence against white oppression, others as opposing violence and attacking Black culture. Many commentators interpreted the film as a strong attack on white racism. One critic noted that 'the film depicts white bigotry with all due contempt' (Klawans, 1989:99). Cardullo claimed that Lee treats white characters as "omnipresent white oppressors" (1990:616). Perkins commented that Lee "clearly shows how the barriers of institutional racism maintain this segment of the Black population in a mental and physical ghetto" (1990:8). In the eyes of some the attack on the white community was so strident that the film itself should be labeled as racist (Crouch, 1989:76). A number of commentators interpreted the film's response to white oppression as a "reckless incitement of urban violence" (Logan, 1989:113). Writing in New York, Denby argued that Lee "created the dramatic structure that primes Black people to cheer the explosion [the riot in the film] as an act of revenge" (1989:54). Denby later concluded that Lee could be "partly responsible" for violence that might follow screenings of the film (54). Klein went farther, labeling the film as "reckless," and arguing that it would "increase racial tensions in the city" (1989:14). In addition, a number of critics denied that Lee advocated violence (Kroll, 1989; Orenstein, 1989). For example, Poussaint characterized the message of the film as "anti-violence," arguing that it shows that "everyone loses with violence" (1989:B23). Some commentators even argued that Mookie, who initiated the riot by throwing a trash can through a window of Sal's pizzeria, acted in order to "divert a crowd's anger away from Sal and his two sons" (Wall, 1989:74).*

Clearly, *DRT* is a film that can be read in a variety of ways as is explained by Rowland and Strain. The film can be seen as both presenting violence as counterproductive and necessary in a fight against racism. Significantly, however, the film has fostered and nurtured a dialogue on race that is important and informative for those of us considering issues of justice and democracy in our society.

As I have written earlier, African Americans are no more one dimensional than non-African Americans. Black people, according to Lee, are both responsible and not responsible for the social and economic ills facing various integrated communities. Here there is a recognized complexity and a presentation of not only multiple reads of violence in *DRT*, but a presentation of multiple selves through the painstaking attention Lee gives to his characters' development. Lee's characters stand in contrast to a traditional Hollywood presentation and depiction of blacks in film. Again, I point to Rowland and Strain and specifically their explanation of a polysemic read of *DRT*:

> *A defense of violence in response to racism, without the corresponding indictment of it as counterproductive, would risk inciting purposeless violence. On the other hand, a story that merely showed how violence helped no one would play into the hands of the racists. Similar tension is needed in the treatment of Black poverty. It is only through acceptance of multiple and inconsistent messages that the problems can be confronted (1994:220).*

Perhaps we should embrace multiple and alternate messages that are presented regarding problems that need to be confronted in our democratic society; in other words, an abandonment of that

utopian place where all problems are solved and all people are pleased may be in order. Stanley Fish has explained, albeit within a different context, how the problems that are presented in (a) film are not necessarily exposed and explored in order to be solved; rather, they are "meant to be experienced" (1980:149). We do not go as individuals to the cinema, and specifically films like *DRT* or Van Sant's *Idaho*, with the intention of solving the complex problems that infect our various cultures and larger society. Instead, we see film and we view art so to consider its power and allow it to inform, challenge, and shape our sensibilities. At times these sensibilities are altered, transformed in the viewing experience. Clearly, *DRT* has accomplished this in many ways, some more complete than others. Spike Lee's narrative has contributed not only to a larger dialogue on what the *right thing* is or is not when it comes to issues of race in this country, but the film has affected our imaginations in that it has challenged the conventional ways in which we have framed that dialogue.

Making Room for and Experiencing the Other in American Cinema

Film without the American contribution is unimaginable. The fact that film has been the most potent vehicle of the American imagination suggests all the more strongly that movies have something to tell us not just about the surfaces, but about the mysteries of American Life (Schlesinger, Jr., 1992:109).

While I wholeheartedly agree with Schlesinger's comment, and especially his understanding of film's partnership with an "American imagination," they, the words, are at the same time hard to swallow coming from a man, who in *The Disuniting of America* advocates what I call an overt and unabashed violence of assimilation. Divorcing for a moment Schlesinger from his assertions about the importance of film, I am inclined to stress the significance of his statement and the opportunity it affords to someone interested in imagining differently our communities, our selves, and the Other. Yes, film does explore the mysteries of "American life"; however, often the exploration is through a particular racial lens that privileges a dominant cultural hegemon and its many supporting voices (noting *Six Degrees of Separation*).

Continuing with this theme of imaginative importance, one might consider the work of Julie Johnson and Colby Vargas (*The Smell of Celluloid in the Classroom: Five Great Movies that Teach*, 1994) and their attention to the cinema's definitive contribution to "American identity." Specifically, they select *DRT* as one of five great movies that demand inclusion in American classrooms. Myself, and many others no doubt, welcome this introduction of *DRT* into the realm of cinema worthy of being included in both secondary and college curriculum[37] and thus challenging the conventional ways and tools that are used in education to frame discussion and debate. Johnson and Vargas explain that "any course that studies American culture should draw in some manner from our country's cinematic archives" (1994:109). They argue that

Cinema is probably the most democratic of arts in its audience appeal. The thesis of Sklar's book (Movie-Made America: A Cultural History of American Movies, 1975) is that cinema and urban industrialization progressed hand-in-hand, with movies becoming our most important medium of culture, 'from the bottom up, receiving their principal support from the lowest and most influential

[37]Viewing *DRT* and completing written work that is both critical and imaginative is required in my Introductory American Politics course as well as my Race, Power, and Politics class.

classes in American society.' For the first time, Americans all over the continent of different classes, races, and literacy levels were exposed to the same culture and art almost simultaneously (109).

What is worrisome, though, is that this presentation or exposure of what is considered to be *same culture*. Art simultaneously being distributed to a whole or mass of those living in the United States—in a fashion that meets the criteria or description of propaganda and thus a tool of reinforcement and affirmation of the/a dominant culture and its insensitivity toward the Other. *DRT,* however, is on the cutting edge in presenting and giving voice to a segment of the American imagination that has been held still for some time, Black America. To their credit, Johnson and Vargas have not fallen victim to an exclusive Hollywood and major studio mentality that suggests that a film with a black voice, a voice of resistance, is a losing proposition. On the contrary, they have suggested that *DRT* is worthy of instruction because of its complex depiction of those who live on the margins of our dominant *we* society.

They base their assessment on *DRT's* appeal to students and specifically the film's ability to motivate students in exploring supportive written materials that confront, more fully, issues of race and difference in the United States. In other words their suggestion is that film, and *DRT* individually, has the power to affect one's sensibilities in a way that can be both transformative and enlightening. Johnson and Vargas come to this conclusion through a recognition of the limitations inherent in written materials. These materials are unable to communicate experiences unfamiliar to students with the intensity of cinema, modern-day movies.

DRT offers "dramatized themes and ideas from history and literature in ways that amplify and illuminate these issues [race relations]," issues pertaining to difference (Johnson and Vargas, 1994:109). And we as moviegoers are able to assess our culture, and the "tastes and ideologies" of those who comprise our society by viewing film and giving analysis to a film's artistic and aesthetic makeup. For example, the juxtaposition of Dr. King's and Malcolm X's written words and the controversy in the film that they inform serves, in *DRT,* as a visual learning tool. It emphasizes and informs an ongoing debate over the use of (conventional) violence and the relationship between African Americans and the police and peoples not-of-color, while also informing the direction of a contemporary civil rights movement within a multicultural/ethnic community. Johnson and Vargas explain their use of the film text:

> *We show the film after reading Ralph Ellison's Invisible Man, which, although written in 1947, works in many of the same ways as Lee's film, creating characters and groups to exemplify many strands of thought in the African-American struggle for equality. Invisible Man also illustrates the importance of the city to an African-American experience, and it culminates in a riot similar in circumstance to the climax of Do the Right Thing (1994:112).*

In essence, Johnson and Vargas's inclusion of *DRT* in their work is an inclusion of a contemporary black voice and a recognition of its rightful place in the American imagination. This act makes, in some ways, a discussion of a film's ability to affect our sensibilities in a positive and transformative way a bit more concrete. Films written and directed by black auteurs and films driven by black actors and crew members give voice to words conceived by those writers and directors are emerging as a major independent cinematic force. The aesthetics, the art, and the politics of *DRT* speak to and confirm this. But as David Seelow cautions, a "Black director, in attempting to develop counter images to those of an established cinema, must operate not only outside the Hollywood paradigm, but against an entire

social perception that filters images through a racial lens" (1996:157). A recognition of sorts of what W.E.B. DuBois called:

> *Double conscience, [the] sense of always looking at one self through the eyes of others, of measuring one's soul by the tape of a world that looks on in amused contempt and pity, one even feels his two-ness—an American, a Negro; two souls, two thoughts, two unreconciled strivings; two warring ideals in one dark body, whose dogged strength alone keeps it from being torn asunder (1903:3).*

The challenge for filmmakers who identify as being on the periphery, as black independent filmmakers, is resisting consumption by a dominant cultural hegemon and all that comes with that domination—socially and politically, or in this case, the controls of the Hollywood major studios and the images that are produced through a particular racial lens.

BOYZ 'N THE HOOD

Two years after the release of Spike Lee's *DRT*, John Singleton's *Boyz 'N the Hood* (*Boyz*) opened to a real and live violence.[38] And unlike *DRT*, *Boyz* was not an overt attack on white racism and bigotry (although these themes are not absent from Singleton's film text); rather, the film focuses on America's urban corridors and a gang violence that pervades neglected multiracial or ethnic neighborhoods. Except for a few scenes, white filmgoers are left off the hook, spared the finger-pointing that was perceived to exist in Lee's work. The film *Boyz* and its director and writer, Singleton, garnered two Academy Award nominations.[39]

Like Spike Lee, John Singleton has said that, "[He] always wanted to do a real film about what it's like growing up Black" ("Angry, Assertive and Aware," Ebony, 1991:162). "A powerful drama depicting the first realistic portrayal of what it's like to be young, Black and American in the '90s" (162). Singleton is one of many young black filmmakers,[40] taking their cue from Spike Lee, who assert themselves and their unique voices and stories into the mix of middle-North-American cinema.[41] Film critic Janice Simpson believes that Singleton's *Boyz* has risen above the competition with its "vividly individual characters instead of stereotypes, dialogue that hummed with the rhythms of the way people really talk, a powerful story and the reassuring message that parental love and guidance can still rescue Black youths from drugs, gangs, and the despair of the inner city" (1992:23). *Boyz* is very much a conventional story set in the inner city.

[38]On July 12, 1991 (opening night of *Boyz*), "young Black gang members in roughly 20 of the 829 theaters in which the movie was playing shot off their guns, wounding 33 and killing one" (Denby, 1991b:49).

[39]Singleton was nominated for Best Director (the first black director as well as the youngest) and for best Original Screenplay by the Academy of Arts Motion Picture Association.

[40]Other black filmmakers making their way after many obstacles were shattered by Spike Lee and his work are: Charles Lane (*True Identity*, U.S.A., 1991), Matty Rich (*Straight Out of Brooklyn*, U.S.A., 1991), Robert Townsend (*The Five Heart Beats*, U.S.A., 1991), and Topper Crew (*Talkin' Dirty After Dark*, U.S.A., 1991).

[41]*Boyz 'N the Hood* cost $6 million dollars to make and grossed over $57 million dollars making it 1991's most profitable movie (Simpson, 1992:60).

Columbia Pictures/Photofest

Boyz 'N the Hood, 1991

Having been influenced by white coming-of-age films like *American Graffiti* (U.S.A., 1973) and *Rebel Without a Cause* (U.S.A., 1954), Singleton set out in *Boyz* to capture and then present an accurate account of what it is like to grow up black in one of United States' toughest urban corridors, South Central Los Angeles. South Central is not a new environment in the American imagination. Through documentary and news coverage of the Rodney King riots, most Americans, regardless of whether they live in South Central, have a sketch of the environment in their minds, albeit one presented through a white lens. At the film's beginning, Singleton introduces his text by presenting some important statistics to the audience. For example, Singleton, in his autobiographical like coming-of-age narrative, begins by adapting this classic style or genre of filmmaking in order to "probe" or confront the different problems and the difficult tensions that pervade an experience of growing up black and urban in the 1990s—drugs, sex, violence, and poverty. Displayed in white lettering on a dark screen, the audience learns that suicide is a leading cause of death for black men ages 18 to 29; that black males' life expectancy is ten years less than white men; that 32 percent of black males are currently unemployed; and that black men, while only 12 percent of the nation's total population, make up 48 percent of the nation's prison population. The most disturbing piece of information: The leading cause of death for black men ages 15 to 34 is black-on-black homicide. Michael Dyson (*Growing Up Under Fire: Boyz 'N the Hood and the Agony of the* Black *Man in America*, 1991) explains the film's introduction this way: "These words are both summary and opening salvo in Singleton's battle to reinterpret and redeem the Black male experience. With *Boyz*, we have the most brilliantly executed and fully realized portrait of the coming-of-age odyssey that Black boys must undertake in the suffocating conditions of urban decay and civic chaos" (74). This film with its rhythm and attention to growing up black stands in contrast to the many white coming-of-age films that depicted young white suburban teenagers and young adults interested in having fun, in that Singleton's film focuses on basic human survival.

Singleton never lets up after this introduction. Whether it is the extreme neglect that is visible with regard to healthcare, education, poverty, joblessness, and physical violence, an audience becomes aware, early in the film, of the auteur's social and political intent. *Boyz* is a didactic endeavor on

the part of its creator from the first frame to the last: introducing the film's protagonist and hero, Tre (Cuba Gooding Jr.), as a young boy, resisting and thus challenging his elementary school teacher's Eurocentric beliefs and teachings in the midst of a social studies history lesson. Tre's "enthusiasm for Afrocentric learning is labeled as disrespectful" (Seelow, 1996:167) and consequentially lands Tre in his father's, Furious Styles (Larry Fishburne), care. This sets up the film's central relationship between a young black boy and his strong father, and, more subtly, the reclaiming of a black male authority.[42]

Singleton is committed to reclaiming a black male voice and its rightful partnership in the African American community. Early in the film an audience senses Tre's school's, and other white institutions', power to reinforce white masculine values while considering disrespectful and unacceptable a different voice. In this narrative it is a black male voice that speaks of the importance of an adult black male's experience and thus partnership in the rearing of young boys. David Seelow suggests that by making the black male visible, Singleton's work aims at redemption for the black male voice. He says,

> *Singleton inscribes the male image on the screen and by privileging the marginal figure he radically challenges social, critical, and artistic stereotypes. He presents Furious as what Kunjufu calls a counter-conspiracy image*[43] *and the film enacts, as a central them, Tre's rites of passage into this counter image of Black manhood (1996:168).*

This image is juxtaposed with neighborhood households that are maintained by single, Black, and unemployed mothers and their children. Playing on the "facts" established in Daniel Patrick Moynihan's 1965 report on the African American family (*The Negro Family*), Singleton makes visible the black male in a culture that has taken Moynihan's identification of inequality and injustice, of unequal status afforded to black Americans, as a consequence of racism and poverty that in turn has undermined the black family. Where Moynihan has argued that racism and poverty have taken and made invisible the black man, and then persecuted him for abandonment, Singleton is making visible and giving authority to that image, that voice.

Singleton's narrative centers on Tre and two other young black boys—brothers growing up in the Hood, Ricky (Morris Chestnut) and Doughboy (Rapper Ice Cube). The narrative works diligently at an expression of a black male voice, one that speaks with authority and one that should be supported and valued in American culture. Singleton cannot present this narrative in a vacuum; therefore, one recognizes an inescapable co-authorship between various black male experiences and the inflections of race and class, and the economics of poverty, drugs, and violence in the United States.

Perhaps the most visible partner and co-author in the Hood is the political economy of crack and the conditions that are created by an exercise of creating and maintaining drug territories in urban centers. The conditions created by this economy rob a neighborhood of basic social functions

[42]Singleton has been accused of depicting black women, who raise families by themselves in light of the African American male's absence, as members of a "much maligned social group" vilified for a promiscuity and stereotyped by a helplessness and reliance on the state. This appears to me to be unfair, as I believe Singleton presents women in his work as complex partners in the urban community, and more specifically, black families. However, where I do believe Singleton can be faulted is in his unwillingness to confront the absence of fathers in a more in-depth fashion, while presenting Furious Styles as the redemptive black male voice; that is, Singleton is uncritical of a black man's impact, in his absence, on the two brothers, Ricky and Doughboy, thereby fueling a critic's charge that Singleton has created a dichotomous understanding of good versus bad child rearing in the Hood. For example, Tre's success in getting out of the Hood after being raised by a strong black father is contrasted to Ricky and Doughboy's murders and their inability to avoid the ills of urban America. These brothers are reared in a single female household.

[43]Kunjufu. *Countering the Conspiracy to Destroy Black Boys*, 1985:27–33.

(Dyson, 1996:76) that allow residents of any community to maintain their identities. For example, one of the most powerful metaphors in *Boyz* is the constant hum of the police surveillance helicopters that continually circle above South Central, always out of sight, but with a presence that is always known.

Seelow explains the helicopters as having the "effect of a social panoptican mobile enough to transform an entire metropolitan region into an invisible prison" (1996:171). For Michel Foucault (<u>Discipline and Punish</u>, 1979) the panoptican represents the power of the state where everything becomes visible to that power. Seelow continues, "The helicopters serve to organize and enclose space. The inhabitants can then be disciplined, acted upon, and contained. Although the Black man may appear invisible, he is also, paradoxically, always visible to the powerful gaze of the white power structure" (171). All of these contributions to a black urban experience—the helicopters, the poverty, the violence—are given equal time—sharing the celluloid so to speak as Singleton-the-auteur gives voice from the margins. Specifically, his characterization of three young male

Boyz 'N the Hood, 1991

protagonists—their experiences from pre-teen to post-adolescence—illustrates both a variety of choices available to them while growing up in the Hood and the devastating limitations that inform their lives. In essence, Singleton "turns the typical coming-of-age drama into an expression of the contemporary social pressures affecting young Black American males, while also showing what sparks their imaginative lives" (White, 1991:10).[44]

Peter Brunette (1991 <u>Sight and Sound</u>) called *Boyz*, "A tough, raw film. The sense of frustration and urgency expressed is so great that at times Singleton's characters seem to mount invisible soapboxes to address the audience directly and shake some sense into them" (1991:13). It is clear that Singleton is aware of the fact that human character is not defined by the choices we make as individuals alone. Instead, he suggests, and I agree, that we are boxed (some of us more tightly than others) between "social structures and personal fortune." The choices that do arise are accurately depicted in *Boyz* through the life experiences of Ricky and Doughboy, the brothers who live across the street from Tre and his father, and their single mother, Brenda. Singleton's vision is not one racked with either wholly positive or negative images of black life and culture; instead, *Boyz* aims at presenting the visible choices that do exist in the Hood and how people make their decisions within the construct of particular urban limitations. Although Singleton is clear in not presenting choice as a "property of autonomous moral agents acting in an existential vacuum" (Dyson, 1996:75), he does display choice as exercised in partnership with social, political, and economic conditions and forces of everyday life in the Hood. Ricky is

[44]In an interesting aside, White comments on the unusualness of *Boyz* in the current Hollywood environment: "To realize how unusual this is for modern Hollywood [the presentation of this black narrative], one need only contrast *Boyz 'N the Hood* with the 80s Brat Pack films: in the former, Black teens see life in terms of survival; in the latter, white teens see it in terms of fun" (10).

the young black male in search of a college athletic scholarship, and he is clearly favored by his mother as she sees him as a vehicle out of poverty, while Doughboy, in Seelow's words, is "the figure most representative of young Black males living among the inner cities of America" (1996:170)—unemployed, in trouble with the law, and having gang relations—a throwaway (not only by society, but his mother as well[45]) and a danger to white society. These two boys represent alternate choices or paths; however, Singleton's inclusion of Furious Styles as a strong male presence steers Tre in a direction clear from the more serious ills of the Hood.

The difficult themes in the film are numerous. One is the relationship between adult black men and women as illustrated through the relationship between Tre's mother (Angela Bassett) and father and their attempts at raising a son while living apart in a destructive urban neighborhood. Another is the depiction of a single black woman in Ricky and Doughboy's mother, Brenda (Trya Ferell), and her attempts to rear her two children while living on public assistance and in the mix of a drug environment. A third is the devastating effects of a crack economy that affects all those who live within the urban corridor—tempting those who are poor to either engage in and thus sell illegal drugs or engage in their consumption so to escape, in one fashion, the ills of the neighborhood. Finally, there is the gang violence that is fueled by all of these said factors, and the audience is forced to bear witness to what has become a national embarrassment—urban decay and an overt disregard of a poverty and all its effects on a population of people of color. David Denby (*New York*) remarks, "At the end of *Boyz 'N the Hood*, you feel you've learned something about a whole community trapped in a malaise. It's a stirring and candid movie" (1991a:43). He continues, "We have to decide whether we are satisfied with leadership that has allowed the urban environment to collapse to the point of chaos" (49). For those people who do not live on the margins in an inner city or in a poverty reflective of the Hood described in Singleton's film, these experiences and memories belonging to this community are simply not known or understood by a majority culture. These lives are not recognized.

Singleton believes that *Boyz* will have an effect on the condition of the ghetto. He says, "Films serve different purposes, some are meant just to entertain, but there's also room for other films that inform as well" (Brunette, 1991:13). Hopefully, a film that has an anti-violence (conventional violence) message, like *Boyz*, can affect a filmgoing community in ways other than the continued displays of gunfire and violence as witnessed during the opening of the film as *Boyz* allows those who live in urban corridors, Singleton says, "to see themselves on film and [they can] reflect upon it. [They can] think about [their representation] and the situation of their friends and their family" (1991:13). And for those who live outside the ghetto or Hood, Singleton believes that *Boyz*, "can open up new worlds . . . [as] they learn a little more about the language" and culture (Leland, 1991:49) and possibly recognize how lives across difference can connect, one kind of experience with another. As eyewitnesses, a moviegoer can be challenged by a story that is new to him or her in that he or she can transcend space and arrive

[45]David Seelow explains the complexity of the relationship, and thus the choices available to Ricky and Doughboy: "Ricky is the more positive of the brothers, perhaps because his absent father contributed less than Doughboy's dad to the boy's identity confusion. Brenda's hatred toward Doughboy's father is strong, "You ain't shit," she says. "You just like yo' Daddy. You don't do shit, and you never gonna amount to shit." She transfers her rage against Doughboy's father to his son and this condemns the son to life on the streets. He goes from delinquent to criminal, becoming exactly what his mother ordained. Ricky, on the other hand, has athletic talent, and Brenda praises and encourages his ability. She sees this son as a possible way out of the ghetto. In this regard Brenda cannot be blamed. She simply reinforces the value society, here white society, holds up as positive. The Black athlete is sought after by colleges. He is an entertainer and consequently a valuable product for the sports industry. Doughboy, lacking Ricky's athletic talent, is a danger to white society, which is why most of his time is spent locked up" (1996:169).

in a place where his or her sensibilities must be (re)considered. This is the power of film and of *Boyz* particularly.

At the film's end, not unlike the beginning, an audience is again presented with the heavy vision of the filmmaker—Singleton's commitment to a black male voice that has been absent from a middle-North-American imagination. It is as if Singleton is responding to Ralph Ellison's (The Invisible Man, 1947), description of the invisible man:

I am invisible, understand, simply because people refuse to see me. Like the bodiless heads you see sometimes in circus sideshows, it is as though I have been surrounded by mirrors of hard, distorting glass. When they approach me they see only my surroundings, themselves, or figments of their imagination—indeed everything, and anything except me (3).

The film medium and the art of the cinema has allowed filmmakers like John Singleton and Spike Lee to depict and make visible representative images, voices, of an African American culture that often finds itself defined by a dominant culture and depicted through a racial lens that distorts identity and silences voices from the margin of a dominant *we* society or culture.

SUMMARY

By focusing on Lee's *DRT* and Singleton's *Boyz* in this chapter, I have underscored both the importance of making visible stories shaped and presented by black auteurs as well as uncovered a complexity that is inherent in all people's lives—across difference lines.

Lee's highly stylized work facilitates discussion and debate regarding a variety of contemporary social and political controversies. Specifically, I have chosen to focus on the complex and contested notion of race and violence in Lee's work; that is, the divide that is exposed both on the celluloid and in the theatre when one asks what the *right thing* is or is not when the controversy is entrenched in the little bruises inflicted by distrust, hate, and racism.

The film is important on at least two counts: One, Lee as a black director raises his voice at a time when Other was virtually eliminated from an American cinema, giving voice, texture, and rhythm to memories and experiences of lives that are rich and full of humanity and that are imagined differently than those off and out from the margins and fully assimilated into a dominant culture. Two, *DRT* makes clear and real the inaccessible. In other words, through the depiction of Mookie, Radio Raheem, Buggin' Out, Da Mayor, and others, and through the subject and plot created by Lee, we are led to believe that a same politics is not possible nor is it accessible. I say this because notions of universal rationality, truth, and violence are out of reach. Yet, before we embrace a politics of separation, we as an audience—as eyewitnesses to the complexities and the differences in memories and experiences—may find ourselves (re)considering our sensibilities in a way that challenges our own perceptions, memories, and experiences. While this is not meant to suggest that a dominant perspective can be turned inside-out so as to reject a particular set of memories and experiences for another, it does suggest how a dominant feel and space might be altered in some way—where Other, once invisible, unnoticed, or silenced and ignored, becomes visible, recognized, and respected.

Lee's *DRT* can spark such a transformation in some filmgoers as can Singleton's *Boyz*. Both films were, at the time of their release, challenges to many themes, practices, and policies of the Reagan administration and the fever it spurned in many parts of this country. And while *Boyz* is quite different than *DRT*, in that its focus is on the strength of the Black family, ethics, and virtue, the fact remains that it, like *DRT*, is a story about black Americans, directed by a black writer, for black America.

The end result is a return of the gaze; that is, these two films reflect an oppression that is inherent in a dominant cinema's gaze upon Other. While the lives of those on the screen are complex, the point of my argument is simple: For a democratic politics to be just we must see justice as recognition. *DRT* and *Boyz* can affect our sensibilities in ways that prompt our pause and (re)thinking of Other, ourselves, and what is just.

Conclusion

I believe we should seek unifying (un)common places that can lead to a yet unnamed brand of cooperative and sustainable democratic politics. And therefore ask, whether *we*, some identifiable and politically salient *we*, can envision U.S. democratic politics across lines of difference? This is one of the most salient political questions of our time. Not unlike those political and social theorists who argue for recognition through dialogue and a just democracy through deliberation and recognition, I have chosen to engage difference, or be engaged by Other, in conversations and dialogues that are informed both in and out of what one calls the certitudes of our (post)modern world view. We do this so a place of new or newly imagined politics might become visible. And not unlike my suggestion that one consider film, specifically independent film, as an alternative form of democratic communication for its unique stories, voices, and perspectives, suggesting that one consider Others' understandings of the world and of the differences that divide us in order to (re)consider and then (re)imagine the possibilities for a shared and (un)common democratic politics, a politics that transcends difference without eliminating or erasing it, has great value. Here, the suggestion is that in imagining politics and difference in new ways, *things* might be uncovered or discovered that may have been overlooked or not known to a large, and often dominant, segment of our society.

I have explained my similar aims by exploring the possibilities for unifying (un)common locations that are informed by a language of film, one that allows for a just democratic politics and one that is based upon a recognition of difference through stories or narratives of difference presented on the movie screen. Film represents an important element in our socialization and cognitive process and warrants our attention as the medium allows for an incredible and strong and imaginative and emotional transporting or migration of the self.

I, too, have suggested that we should engage and be engaged by those persons who see and understand the world differently from those who sit comfortably within a dominant *we* society so that we might (re)imagine or discover a new place for democratic politics. And as filmgoers who find ourselves more susceptible emotionally to the stimuli presented in a movie theatre, we can at times experience vicariously, yet deeply, the events, the stories, the lives of those who are different from ourselves.

As individuals living in a multicultural and diverse society we should consider opening ourselves up to and welcoming such engagement and the possibilities for personal transformation in our individual sensibilities. Such a transformation might occur when one considers and compares the experiences of his or her life and the impact of those experiences on his or her identity next to those raw materials that make-up or construct the identity(ies) of those who are different from them, specifically those who have been marginalized, disregarded, and silenced by a dominant *we* society.

I have suggested that when one truly sees Other, sees and hears the stories of difference crafted and told by the Other in film, one might come to respect the different voices and stories of those lives and thus allow him or herself to see and experience life from a new position, a transformed sensibility, where politics transcend convention. In other words, when we consider our lives next to those who are different from us, when we frame those different human stories next to our own personal human narrative we may come to understand how a particular human uncertainty and vulnerability informs all of our lives. I have illustrated in Chapters Three and Four how particular film narratives can prompt such recognition. And I have specifically suggested how this type of recognition can lead to one's personal sensibilities regarding sexuality, gender, and race to be transformed.

I argue for the importance of film because it seems that, in many respects, conventional communication and argument have failed and have forced us to consider alternative forms of democratic communication. There is an obvious need to (re)imagine a politics that both respects and honors difference and one that can serve to connect one kind of human experience with another. Whether it be sexuality, gender, or race, the recognition of the experiences, and thus lives of Others, can lead one to (re)consider his or her own life view. My hope is that in allowing our sensibilities to be transformed one can begin to imagine a U.S. democratic politics differently; that is, to imagine ourselves and Others differently by giving way to a respectful and caring understanding of difference that has been informed by a film narrative created by those who reside on the margins of a dominant *we* society. I am still cautious and fearful, however, of a non-conventional violence that I have often described as assimilation. In other words, in searching for a just democratic politics I have remained wary of a utopian vision that is presented by some theorists—a vision where all differences are resolved and all members of society share in a universal rationality, Truth, and understanding. The goal should not be to escape difference, but to engage it and be engaged by it in a way that might enrich our public debate and better our understanding of our shared human uncertainties and vulnerabilities— and to do a cooperative politics, if only from time to time.

While democratic theorists have advocated particular forms of conventional dialogue and conversation, I have presented *film* as an important alternative form of democratic communication. This, at times, seems elementary as many people would not challenge the cinema's communicative role in U.S. culture. However, I have suggested that film, and specifically independent film, be seen as an important tool in our (re)imagining of a just democracy and of any point of connection where one might see his or her sensibilities regarding difference—sexual orientation, gender, race—transformed. Film as an

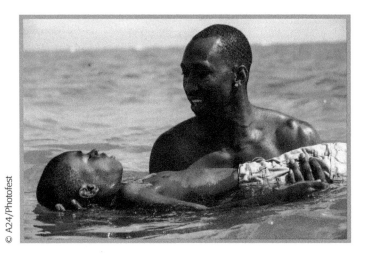

Moonlight, 2016

alternative form of democratic communication, a nonlinear, non-conventional form of self expression, is a powerful way of giving voice to those experiences, those raw materials, that construct all of our identities. Yet in this suggestion I have not meant to diminish the importance of other deliberative theorists; on the contrary, I have suggested we use film in a way that complements those more conventional assertions regarding democratic communication and deliberation; one where film is seen not only as an art form—an act of self-expression—but also as a form of democratic

communication—an artistic medium that allows an individual to become an eyewitness to the diverse stories of those who share his or her neighborhoods, communities, and lives. Because of its mass audience and its ability to "reproduce the raw material of the physical world within the (a) work of art" (Kracauer, 1992), the fictional realism of film allows for a sharing of the radically different experiences and can serve as a tool to help uncover some commonalties within our various social or cultural identities. In other words, film facilitates the search for a location from which to

Moonlight, 2016

envision a democratic politics that both respects and transcends difference by providing an opportunity to theorize a new politics from a position of eyewitness. And in being an eyewitness, one can bear witness to the disregarding, the silencing, the marginalizing of difference in a dominant *we* society. Simply, the power of film, the power in the viewing experience, can be harnessed to help us gain access to our cultural values and assist in transcending the space between the moviegoer and the motion picture movie screen—and the space that divides us as people living in a dominant *we* society and those who live on the margins of that dominant society, individuals living within difference circles.

Film can also nurture a political and social recognition of difference and thus effectively challenge a dominant *we* society by the way it prompts a person to pause and then (re)consider and (re)imagine one's life and one's experiences, next to someone's whose life and experience are different, a person who is Other. Independent film pushes the boundaries of a conventional discussion and dialogue regarding democracy and difference as it has become the medium that best uncovers and explores American culture and difference. It has become a vehicle of communication for a variety of unique changing perspectives of our world and of ourselves. And in the words of film theorist Edmund Carpenter, each film "allows us to see from here, another from there, a third from still another perspective; taken together they give us a more complete whole, a greater

truth" (209). This greater truth is representative of one's desire to see from new or special vantage points and then better understand our world by opening ourselves up to those *things* many of us may have missed.

I have posed a series of questions regarding democracy and difference. Specifically I have asked whether or not there might exist some (un)common locations from which we as a diverse people may come together and do or achieve a just democratic politics, a cooperative politics. From the onset I have been cautious as to whether or not

Boy's Don't Cry, 2000

© Fox Searchlight Pictures/Photofest

Boys_Dont_Cry, 1999

such a location existed or was within our political grasp, or whether or not a politics of separation is the best way in which we could respect difference. And in addressing this question I have situated myself amongst deliberative democratic theorists who warn against conclusions directed at anti-politics or a utopian location where rationality and Truth are perceived to be universal and achievable concepts.

Having positioned myself alongside those who are convinced of continual struggle, conflict, and debate has informed the conclusions I have arrived at in my work. Film will not save our society from difference. And again, nor would we want it to. But film as an artistic medium does provide for those of us who are willing to open ourselves up to the complexities of diversity and difference, an opportunity to see differently, to imagine differently, the framing of our identities and the meaning(s) of our lives, our experiences. There are no simple answers; yet there are ways in which we can engage our own imaginations with those who are our neighbors and who are different from ourselves and walk away forever changed. I do not mean to suggest that all moviegoers who see Gus Van Sant's *My Own Private Idaho* or Spike Lee's *Do the Right Thing* will walk away with their sensibilities changed or transformed. That is not entirely important. What is important, however, is that the possibility exists that *some* moviegoers will be deeply transformed and will see themselves and others and the environment for which difference exists in this country in radically different ways and will care more deeply about those who are not like themselves.

The aesthetic of film, and particularly the experiential narratives in the films I have presented, can inform a newly imagined sense of democracy by focusing on the experiential qualities perceived in the cinema. The study of these qualities suggests that contrary to a modern cultural perception where our differences are concrete, are black versus white, the world is really a postmodern place where contingency, uncertainty, and vulnerability connect our lives, from time to time, through common or connected experience—a transcendence of sorts to an (un)common location I have imagined. A recognition of difference and the relation of experience across lines of difference can lead to a newly imagined space where one might attempt to (re)imagine the self and one's place in our U.S. democracy.

Additional Theoretical Readings

The articles presented here contribute to an ongoing academic dialogue regarding the study and analysis of difference, particularly the politics of difference in American life, and narratives of the Other. They are included in this text in order to provide the reader with further resources when considering whether or not it is possible to envision U.S. democratic politics across difference lines.

Larry M. Preston's *Theorizing Difference: Voices from the Margins* (1995) asks whether or not using conventional theoretical language as a discursive voice of all can "fairly and fully" represent those who reside on the margins of a dominant "*we*" society. He states, "We need to reconsider the ways in which a dominant language (the language-of-theory?) presumes to speak for all. As we do so, we may begin to see the ways in which women, minorities, and others outside society's mainstream have developed resistances to that language and, in doing so, fashioned tongues of their own." (94) Preston's turn to narrative, and specifically his faith in Toni Morrison and her claim that narrative is the best way to learn about difference, affirms the use of cinema for the exploration of and potential recognition of voices that have been lost in conventional theoretical language and an American politics.

Alison Landsberg's *Memory, Empathy, and the Politics of Identification* (2009) leads us to a richer understanding of memory where a person "does not simply learn about the past intellectually, but takes on a more personal, deeply felt memory of a past event through which he or she did not live in the traditional sense." (121) She argues that the act of learning to engage with those who are different within a dominant "we" society, both intellectually and emotionally, is "crucial to the development of empathy, which in turn enables the larger political project of advancing egalitarian social goals through a more radical form of democracy." (122) It is from this position that Landsberg calls for the employ of cinema in an effort to intellectually and emotionally contact, what she calls, "circumstances that lie well beyond our own lived experiences, and in the process can force us to confront, and enter into a relationship of responsibility and commitment toward Others." (123).

Thomas Byrne Edsall and Mary D. Edsall's *Race* (1991) is as significant today as the day it was first published in The Atlantic Monthly. The authors aptly state, "When the official subject is presidential politics, taxes, welfare, crime, rights, or values the real subject is **race**" (in America). The article stands as an his(her)storical reflection of the costs of American liberalism, the impact of prejudice and the erection of values barriers intended to divide and cloud the(a) concept of fairness in American politics and democracy. A contemporary read of Edsall and Edsall's work feels to be a right fit in our 21st Century America, post Obama, as we continue to ask whether or not it is possible to construct and do an American democratic politics across lines of difference.

From *American Political Science Review*, Vol. 89, Issue 4, by Larry Preston. Copyright © 1995 American Political Science Association. Reprinted with the permission of Cambridge University Press.

Dr. Martin Luther King's *Letter from Birmingham Jail* (1963) is included here for students to read the famous defense of nonviolent resistance to the violent marginalization and willful exploitation and exclusion of black Americans in the United States. The letter is key to understanding the mood and tone from the margins of a society divided by race, class, and more. Dr. King's response to white clergymen calling for a different political strategy exposed then and reminds us now of the divides amongst our people and the importance of experience as the raw materials of not just individual identity but a national one, too.

Also included in this section are excerpts from the forthcoming, *Abraham Lincoln and the Expansion of Presidential War Powers* (Tahvildaran-Jesswein).

THEORIZING DIFFERENCE: VOICES FROM THE MARGINS

by Larry M. Preston Northern Arizona University

Theorists of widely different persuasions are making serious efforts to understand difference and to bring the concerns and ideals of others within the reach of intellectual and political visions. Yet this attention to difference continues to be examined almost entirely through precise, rigorous, and sophisticated theoretical language. This is only appropriate if we presume that this language, the language-of-theory, is able to represent—and serve as the master interpreter of—all ideas and ideals, all senses of self and politics. I believe that this presumption is deeply flawed. Theoretical language passes over and distorts the differences it would understand. Theory more attentive to difference needs to gain access to the meanings that circulate within different lives, especially as reflected in literary writing of those who, themselves, speak and write from sites of difference.

The footprint in the sand that so worried Crusoe's nights, that compelled him to build a fortress, and then another to protect his new world order, disappears from his nightmares once Friday embraces, then internalizes, his master's voice and can follow the master's agenda with passion.

> —Toni Morrison, Introduction to Race-ing Justice, En-gender-ing Power

What I resent most, however, is not his inheritance of a power he so often disclaims, disengaging himself from a system he carries with him, but his ear, eye, and pen, which record in his language while pretending to speak through mine, on my behalf.

> —Trinh Minh-ha, Woman, Native, Other

For the master's tools will never dismantle the master's house.

> —Audre Lorde, Sister Outsider

There is now little doubt that our sense of who we are and what we hold to be true and good stops at the water's edge of a common language and the shared meanings about personal or social reality that are produced by and carried on within that language. In the face of voices that insist on difference,

there are growing doubts about the reach of any cultural or political common-ness. An older presumption that one common language is able to represent the tremendous array of gender, ethnic, and cultural differences based on its capacity to serve as a neutral, consensual passageway seems impossible to maintain.

Yet the problem of "What is to be done?" theoretically and politically in this time of difference is far from being resolved. Mainstream theorists (read liberal and communitarian)[1] adopt a view of difference-as-sameness, presuming that underneath all expressions of gender or ethnic or other differences, a reasoned and informed reading of "our" political tradition shows that on fundamental matters "we" all do agree or through dialogue can reach agreement (Flathman 1987, 1992; Rawls 1987, 1993; Taylor 1992). By contrast, poststructuralist- or postmodern-in-spired deconstructive theorists keep insisting on a kaleidoscope of ungrounded differences, a grab-bag of contingent, genealogically shaped desires and prejudices and tales masquerading as reason and truth (Connolly 1993; Derrida 1981a, 1981b, 1982; Foucault 1979). With perhaps greater intellectual and political urgency but also working irreverently within and outside the canon's long shadow, a rich if long-silenced mosaic of dissenting voices by feminists and scholars of color have denied theoretical claims of a single, common intellectual and political tradition (Allen 1986; Anzaldúa 1987; Butler 1993; Cixous 1976; Cliff 1980; de Lauretis 1987, 1990; Haraway 1991; hooks 1989; Irigaray 1985a, 1985b, 1993; Minh-ha 1989; Spivak 1987, 1993). Speaking and writing for and often as those who are Other, these theorists insist that there are distinct and perhaps deeply opposed differences—sometimes shaped through dominant notions of biology or race or culture; sometimes adopted for reasons of ethical necessity; sometimes lived as joyful, creative, mixed identities outside the reach of domination—that undermine presumptions of a shared political tradition and its esteemed, central values. In recent decades, theories that have been put forward from each of these varied sites now dot the intellectual landscape.

The implications of these disparate theoretical approaches for the ways in which we try to understand difference—how we view the tasks of theory, the language(s) we use to carry on and present our views—have received rather little attention. The problem is viewed as a matter of picking just the right theory and getting on with the work of analysis, not one of questioning the language with which theorizing is carried on. Yet I doubt that conventional theoretical language and analysis as framed by that language are (still) able to *pass* as the intellectual cart large enough to carry all differences within it. With respect to theorizing difference, the language-of-theory remains . . . undertheorized.

A number of ideas and practices associated with *passing* will be used to help diagnose what I view as unavoidable flaws when rigorous theoretical language is used to detect the pulse of difference in its changing rhythms and varied locations. The problematics of difference within the arena of political theory are related to issues of passing and passages in a number of ways. Those using theoretical language presume that this language can pass as the discursive voice of all, capable of fairly and fully representing who people are and would be and what binds or divides them—tracing the maps of their identities and intuitions, articulating their hopes and fears, divining the political ideas and arrangements by which they would live. On the basis of such presumptions, theorists seem to view their language as a (the?) neutral passageway through which all identities and differences can be seen and interpreted.

The practice of passing is well known to those who live in society's margins. Many who reside in the margins come to know, through what they are taught and through bitter experience, that a high price is paid for being named as Other. They spend their lives silently but (in)visibly shaping and measuring themselves by a dominance that so long as they successfully pass and their secret is kept, enables them, on occasion, to be let in. Still others refuse to try to pass even if they can—resist passing even if it seems they must. And in poorly understood ways, those who have felt compelled to pass or learned to pass or refused to

pass may have developed ideas of autonomy and community and other political "concepts" that are neither heard nor seen by those who, with a nervous confidence, stick to the dominant passageways of social and political life.

From Mary Wollstonecraft (1975) and Virginia Woolf (1929, 1931), to Hélène Cixous (1991, 1993) and Audre Lorde (1982, 1984), to Michelle Cliff (1980, 1985, 1987) and Gloria Anzaldúa (1987), many women and minority writers have written volumes about these efforts, in countless sites and for a long time. Their challenges have called into question dominant philosophical ideas and visions about who they are and the circumstances within which they (would) live. For the most part, however, the philosophical voice's language-of-theory and the sources from which it is drawn remain untouched. Implicitly or explicitly, the language-of-theory is presumed to pass as the master linguistic voice that, without loss or distortion, is able to represent all the complex differences and histories embedded within them.

I suspect that an indispensable part of our being (somewhat) able to understand and comment on the lives of those who reside in society's margins is that we have some way of connecting, some way of imaginatively and reflectively passing over into parts of their lives, of reaching into where they have been and what they have become, of (re)tracing the paths that have led them there, of understanding what they know and how they know it, of feeling what they cherish and what they loathe. We need to reconsider the ways in which a dominant language (the language-of-theory?) presumes to speak for all. As we do so, we may begin to see the ways in which women, minorities, and others outside society's mainstream have developed resistances to that language and, in doing so, fashioned tongues of their own.

I want to explore such matters; in doing so, I shall consider how we might pass somewhat beyond the language-of-theory to carry out the tasks of theorizing in this time of difference. Partly for such reasons but also because it offers an instance of how it may be possible to extend theory's reach, I want to write briefly about some of my experience with passing. Hoping that I do not improperly appropriate the term, two events come to mind that reflect my own limited experience with passing—that help me to imagine, at least to some extent, the ways in which the demands of passing seduce and frighten and discipline.

The first incident involves my father. Though receiving less than an eighth-grade education, he was an active and respected member of a small farming community in central Wisconsin several decades ago. A sign of this esteem was that everyone called him by his given name, Gerald. And that was the name he always used for himself. He served on the local school board and township board, was active in a Masonic Lodge, and read widely on political issues in local and statewide newspapers. For reasons largely beyond his control (asthma and the declining fortunes of small farms), he moved, when he was nearly 50, to a large city in the Southwest. He looked in vain for full-time employment for over a year—selling brushes and detergents door to door, trying to sell real estate from a too-ordinary car, doing seasonal work on a large dairy operation. Finally, he came home one day and told us that he had a good, permanent job as a full-time janitor in an elementary school. To do so, he sensed strongly that he had to pass downward, as it were: at the school, he told everyone that his name was Jerry, and that was the name he and they used from then on.

An "advantage" for me of the long move to the booming Southwest was finishing my early education in a large, not-quite-suburban school rather than the one-room school of the early years. There was also the opportunity, almost certainly unavailable otherwise, of attending college. In the process, my barnyard language and vocabulary, generously spiced with long cursing and short, infrequent sentences, was slowly abandoned. I learned, in the words of a Don Williams song, to talk like the man on the six o'clock news. Along the way (but by then, I knew it was only a way-station),[2] I followed in my father's

footsteps and worked full-time as a janitor in a large hospital. Holding a "float" position, I eventually worked on nearly every wing and floor of the hospital—mopping floors, cleaning toilets, emptying trash cans of discarded litter and cigarette butts. Unless they were asking me to do a particular task, I recall no occasion during the year or so of my employment when any professional person, doctor or nurse or technician, ever spoke to me.

This leads to a second experience of passing. A few years ago, well into my academic career, I had occasion to be near that same hospital about lunch time. For reasons of convenience and familiarity, I decided to eat at the hospital's cafeteria. Something quite remarkable happened as I walked through the hospital in my standard academic uniform of grey slacks, navy-blue blazer, white shirt and tie. Almost every nurse and doctor made a point of speaking to me: "Good morning!" "Hello, how are you?" To make sure that I wasn't misreading the situation, I turned around and walked through several more floors and wings of the hospital; and the same thing happened, over and over. As a white, professionally dressed, mature-looking man, I passed as a medical doctor without even trying.

I use personal narrative to help introduce this essay with some uneasiness. It seems self-indulgent, it reflects personal nongeneralizable experience, it is incompatible with the task of theoretical analysis and reasoning. Yet it is an appropriate way of entering what I want to say about how we might re-vision[3] theory for purposes of better understanding difference and the role that marginalized voices may play in that project. In particular, the imaginative reach of personal narrative and other forms of more literary writing allows us important access into the lives of particular people in particular places. I am reminded of Nancy Miller's (1991, chap. 1) suggestion that a regular dose of the more personal reflections that are central to literary writing is a healthy antidote to the generalizations that characterize so much theorizing. And I am encouraged by Toni Morrison's simple observation that "narrative remains the best way to learn anything" (1993, 372).

Imaginative, literary writing need not be antitheoretical. Looking at ourselves and others with the more or less simultaneous helping hands of literary and analytical writing affords a larger passageway through which to gain a better sense of what we and others share or hold in common, what unites or divides us, what may be unavoidably, irretrievably different. Theory choreographed by literary writing may still have a place in its dances for carefully prescribed, analytical movements; yet literary and analytical languages need to learn how to dance together, leading and following and moving together in turn as suggested by the tempo of different rhythms. To see better that this is so requires some consideration of ideas that have surfaced with respect to the ways in which the language(s) we use and the senses we have of our selves and others are deeply interwoven.

Passing For: Theoretical Life and the Language-of-Theory

The view that language is central to how we understand ourselves and others is now rather unproblematic (Derrida 1982; Kolodny 1985; Miller 1988; Rorty 1989; Showalter 1982, 1985; Wittgenstein 1953; and countless others). I want to focus initially on a few ideas of Wittgenstein because he both supports much of what I want to suggest and represents a view of theoretical or philosophical language that I contest. Wittgenstein (1953) suggested that language has been developed among those who share a form of life. As we participate in a form of life, we learn the practices by which it is carried on: we learn to use its language. We become who we are and we learn to interpret ourselves and our circumstances by gaining linguistic mastery, by using the language we acquire to characterize the activities we engage in. We are and do what we speak; we speak what we do and are. More specifically, we acquire a facility in language by participating in language games. As explained by Wittgenstein, "Here the term 'language-*game*' is meant to bring into prominence the fact that the *speaking* of language is part of an activity, or of a form of life" (pp. 11–12, emphasis original.)

Wittgenstein's ideas, now widely accepted in philosophy and beyond, call into question essentialist conceptions of sameness or difference. People find it necessary to pass or to resist passing because they have acquired a language—its words, its meanings, the practices associated with those words and meanings—that tells them who they are, not because they are biologically or culturally or otherwise essentially the same or different. Women and gays and lesbians are constructed and named as such—as Other—through a language they adopt or resist. They are not born different, and they are not the produced and opposed subjects of materialist historical forces or the natural carriers of different, vested interests. Whether they conform or resist, they do so within a language or within linguistic innovations that circulate within or stretch and reform a dominant language. This means that views of difference that emphasize contrasting "ways of life" as though these were naturally or as an empirical matter attached to different sorts of people are misleading. Such "empirical" patterns emerge because they reflect the ways in which linguistic meanings and practices have played out within the context of social life. They reflect the sedimented results of lived and internalized linguistic codings, not the patterned outcomes of natural (sexual, racial) or historical (interest, class) forces. Skin color, certain organs, and the ownership or nonownership of something named property do not demand, ex nihilo, to be viewed as socially significant markers. Their selection as critical markers to be named as race, sex, and class and the filled-to-the-brim meanings attached to those names are intimately connected to a particular language and to the form of life within which that language is embedded.

I think this perhaps-obvious point is worth emphasizing, because it helps me both to focus my discussion of how to theorize difference in a time of difference and also to challenge to ways in which this theorizing has been done. It means, to follow Wittgenstein's lead, that it is no longer sensible to view different sociological "ways of life" as anything more than the distinct meanings and practices—the language games—associated with different linguistic "forms of life." Wittgenstein understood these matters better than most. What he and his followers seem not to understand is that the scope of those who share a given language and its meanings may be far more limited than they have imagined, that there may be a multiplicity of languages and forms of life within a given society, even among those who use similar words. Yet this multiplicity is not reflected in theorists' language. Self-conscious analysts and advocates of difference move as easily as defenders of the canon to a detached linguistic site, writing in a strong and confident, sophisticated voice that presumably comprehends and speaks for everyone. Theorists' habits of living and writing remain untouched, a narrow(ing) vision in the midst of a richly varied and diverse social world.

It seems worthwhile, then, to consider at least briefly the language and form of life learned and carried on by social and political theorists. Then we will be in a better position to consider whether that language reflects a form of life shared by all, whether it is able to speak for all. First, a few examples in which the language-of-theory speaks—unequivocally, masterfully, without hesitation, without doubt. In the following exemplars of theoretical writing and in those to be considered later, I want to underscore the tremendous similarity in the mode of expression, the virtually indistinguishable tone and style and structure exhibited in the writing. Always to be kept in mind, as well, is the form of life associated with those who are expert practitioners of this theoretical language, of those who readily and with analytical and professional pride write such passages as the following:

> The self becomes an individual in that it becomes a "social" being capable of language, interaction and cognition. The identity of the self is constituted by a narrative unity, which integrates what "I" can do, have done and will accomplish with what you expect of "me," interpret my acts and intentions to mean, wish for me in the future, etc. (Benhabib 1992, 5)

Human beings who are not severely diseased or demented are regarded as desire- and belief-forming, intentional, purposive, and more or less rational. To the extent that individuals use these capabilities and are partly apprised of the considerations that have informed the actions of other persons, they are typically able to comprehend and to make pertinent responses to one another's actions. (Flathman 1992, 125)

We are the beneficiaries of three centuries of democratic thought and developing constitutional practice; and we can presume not only some public understanding of, but also some allegiance to, democratic ideals and values as realized in existing political institutions. (Rawls 1987, 2)

We agree surprisingly well, across great differences of theological and metaphysical belief, about the demands of justice and benevolence, and their importance. There are differences, including the stridently debated one about abortion. But the very rarity of these cases, which contributes to their saliency, is eloquent testimony to the general agreement. (Taylor 1989, 515)

These brief quotations are models of the language-of-theory, drawn from the writing of some of today's most prominent theorists. What form of life is associated with such linguistic mastery? I would note, first, a number of similarities in the voice that appears in these theoretical pronouncements. Prominent among these are strong author responsibility and detachment, confidence-in-understanding, omniscience with respect to the issues discussed, comprehensiveness, analytical rigor, and complexity. The writing employs an extensive and specialized philosophical vocabulary (expressed through a complex syntax) that makes it possible to build idea upon idea and weld together strong, precise connections. A long and often fruitless search is required to find expressions of uncertainty or doubt, hints of confusion, or just plain guesswork.[4] The sources of theoretical writing remain almost entirely the writing of other theorists—those in one's own camp for purposes of drawing support and wrongheaded folks in other camps to highlight mistakes associated with their flawed ways of thinking.

Built into this confident, precise, knowing p(r)ose is a sense of self as being-in-control that matches comfortably with the privileges and practices that comprise such theorists' lives. Each lecture and paper and monograph is a carefully scripted movement from precisely formulated assumption to painstaking conceptual clarification to fully derived principles and propositions. Avoidance-of-inconsistency with its overriding analytical ethos seems to be the formative monitor and judge that shape the sense of theoretical achievement, marking the identity of the theoretical self. And somehow the implicit or explicit assumption remains that this singularly privileged form of life in which planning and participation and perfectly scripted sentences make sense is shared by all, that the analytical writing drawn from it speaks for all.

All others are presumed to be "just like us," and their concerns can be met by carefully turning the antenna of philosophical analysis in their direction. Everyone, it is claimed, embraces basic ideals that are presumed to be the hallmark of philosophical and political development during the last three hundred years or so of modern Western societies—individual rights, representative institutions, equal opportunity, market exchange, agreement on "high" moral values. It is not that others have incommensurably different ideas of themselves or embrace different views of social or political life or speak and live by the meanings and practices of different languages. It is only that insufficient efforts have been made to include them within a discourse that they share with everyone in "modern Western societies" (Flathman 1987, 319; Rawls 1987). Marginalized people are thought to embrace liberal ideas of individual independence and rights and democracy-by-formal-consent. Those few who do not, Richard Rorty confidently tells us, are properly viewed as "mad" (1991, 187). And pretty much everyone is said

to have adopted the personal and social virtues that characterize the "high" moral tradition in these societies, for if they did not, Charles Taylor assures us, "they would be at sea" and "wouldn't know anymore, for an important range of questions, what the significance of things was for them" (1989, 27).

Yet if language both reflects and carries within it the practices and meanings that comprise a form of life, nagging questions keep coming to mind with respect to the knowing, confident theoretical voice that would speak for all: Whose voice is this? What form of life does it carry? Isn't the language-of-theory falsely passing as a language that can speak for everyone? Is it not only the echoed voice of those who have been constructed by—who speak and write from—the practices and routines of the language-of-theory? The erudite, precise language indelibly imprinted onto the secure, comfortable form of life of academic theorists?

Rather curiously, this same knowing voice is also evident among poststructuralist theorists bent on deconstructing the works and ideas of major philosophers. Consider the following:

> The judges of normality are present everywhere. We are in the society of the teacher-judge, the doctor-judge, the educator-judge, the "social-worker"–judge; it is on them that the universal reign of the normative is based; and each individual, wherever he may find himself, subjects to it his body, his gestures, his behaviour, his aptitudes, his achievements. (Foucault 1979, 304)

> In the case of [Adam] Smith, his construction of the double self, one acting and one imagined as outside the actor observing from an impartial perspective, is the primary move through which he naturalizes the self's relationship to normativity. (Shapiro 1993, 121)

> Agonistic respect, as I construe it, is a social relation of respect for the opponent against whom you define yourself even while you resist its imperatives and strive to delimit its spaces of hegemony. Care for the strife and interdependence of contingent identities and the differences through which they define themselves, for instance, means that "we" (the we is an invitation) cannot pursue the ethic that inspires us without contesting claims to the universality and sufficiency of the moral fundamentalisms we disturb. (Connolly 1993, 155)

These analyses are ostensibly motivated by a concern to incorporate ideas drawn from forms of life that have resided in the gaps and erasures of the dominant discourse, from the fractured identities and unanchored, ambiguous meanings associated with those who are Other. And much deconstructive effort has gone into showing how the identities of people carrying on within those forms of life have been socially constructed in ways that are missed by dominant theoretical interpretations. Yet somehow, the deconstructive theorist is able to suggest her or his ungrounded—but nonetheless more "interesting" and analytically powerful—deconstructed interpretation from a distant social and linguistic site. In any case, it is difficult to see how the voices of the marginalized themselves speak when analyzed by the linguistic tools of deconstruction. The writing of Foucault, Connolly, Shapiro, and other deconstructionists is, if anything, even more esoterically theoretical than canonical theory. Jacques Derrida certainly moves outside linear, tightly reasoned theoretical writing. Yet it is not clear what alternative voice, what different form of life, Derrida speaks from or for; and Derrida, no less than Foucault or Connolly or Shapiro, retains a knowing analytical voice. Canonical texts and meanings provide the basis for analysis, even if the canon's major ideas and ideals are challenged; there is closure, even if a lack of closure is called for; and there is a tone of articulate certainty, even if ambiguity is recommended.

Is this surprising? Probably not. Occasional intellectual doubts are no match for years of virtuoso performances in the master language when these are reinforced by longstanding, unambiguous,

at-the-center-of-things identities. Inheritors of such identities are more inclined to speak than to listen, to judge than to be judged, to allow or deny passage to others while comfortably carrying on within the protected space of social-linguistic dominance. In this space, energetic forays into the theoretical nuances of otherness can only be expected, once again, to assimilate different voices or to render them mute.[5]

While far more difficult to detect and assess, acquired habits of dominance and their skillfully crafted messages also hinder the efforts of theorists who, themselves, speak from difference.[6] Gayatri Spivak is among the most careful and reflective theorists to do so. She is cognizant of her own status as a socially constituted, postcolonial theorist as she interrogates the meanings that have been imposed on those residing in the margins of Indian society and culture under the dominance of Empire and, later, Nation. She recognizes that most theorists' drive to generalize—whether for the purpose of promoting dominant meanings or of challenging them in the name of the postcolonial marginalized, the subaltern—typically imposes the meanings it claims to discern or through which it would liberate (Spivak 1987, 1990). In a now extensive, impressively informed, and analytically sophisticated work, she exposes the layers of meaning that have been produced and recreated and imposed, over and over, on Indian cultural life. Yet this impressive work that shows the several faces of dominance also seems to carry within it a denial of agency and a perhaps unwanted assimilation imposed by another theoretically driven silencing. In her discussion of *sati* (widow suicide), for example, it is noteworthy that there seems to be no place for any agency or subjectivity on the part of the widows themselves (Spivak 1988). Spivak argues, "What I find useful is the sustained and developing work on the *mechanics* of the Other; we can use it to much greater *analytic* and interventionist advantage than invocations of the *authenticity* of the Other" (p. 294; emphasis on *analytic* mine).[7] It is both surprising and troubling that perhaps the central conclusion of Spivak's essay is that the subalterns cannot speak: their identities and their choices are thoroughly constructed; they have and can have no voice.[8] Any who would claim otherwise are said either to impose Euro-centered notions of autonomy or to appeal to a nonexistent native identity. Paradoxically, the silencing of difference under the guise of difference-as-sameness may have been replaced by a view of deconstructive difference that insists that the marginalized have no voice to silence, no voice to represent.[9]

Others' senses of themselves are analytically assimilated, as the language of poststructuralist theory and the form of life of its practicing theorists require, into the terms of endlessly open, decentered, fractured, unanchored identities. Any hint of an essential or foundational grounding is theoretically disallowed, whatever the views of those who are subjected to deconstructive analysis. Armed with the confidence of her social site and the analytical tools of her theoretical assumptions, Spivak traces the discursive mechanics through which others have been entirely constituted. It seems that others' senses of themselves and their agency need not be consulted in the theoretical project of deconstruction. Unlike those theorizing them, they are thought to have no agency to consult, no language of their own in which to speak.

Does postmodern or poststructuralist theory, even in the hands of those attentive to difference, leave any openings in its terminology of erasures and social constructions, subjects-as-effects, and fractured identities for the voices of others? Unless and until such theory joins hands with a language that respects them as possible subjects and speaks in their voices, I doubt it. I am inclined to follow Kalpana Ram in her suspicion that the analytical project of deconstructive theory "ends up being a tool of an assimilationist and universalizing drive—all the harder to name as such because of the continual celebratory rhetoric of difference, diversity, heterogeneity, and localisms" (1993, 11).

My doubts are not lessened by the writing of other strongly self-identified deconstructive theorists who, with Spivak, offer interpretations of the sense of self, ideas and ideals held by those who are

Other. Donna Haraway (1991), Teresa de Lauretis (1987, 1990), and Judith Butler (1990, 1993) map the construction of subjectivity at various sites within the web of (post) modernity. The subjectivities they reveal are far removed from dominant readings: selves constituted as postmodern cyborgs, formed by but nonetheless subjective participants within the impulses of electronic technology and late-capitalist imperatives (Haraway 1991, chap. 8); selves who take on the celluloid images of film but who nonetheless retain an agency (somewhat) of their own in the "elsewhere" of those images (Lauretis 1987, chap. 1; idem 1990); selves who are en-gendered as male or female but who, knowing that gender has been fully constructed by socially prescribed norms, create a particular agency of their own through performances that move within/outside those norms (Butler 1990).

The theoretical reconstructions of de Lauretis, Haraway, and Butler argue that the Other has a capacity for agency. I wonder, though, whether any others could recognize themselves in the theoretically painted landscape. Again, consider some examples:

> One does not stand at an instrumental distance from the terms by which one experiences violation. Occupied by such terms and yet occupying them oneself risks a complicity, a repetition, a relapse into injury, but it is also the occasion to work the mobilizing power of injury, of an interpellation one never chose. (Butler 1993, 123)

> The only way to characterize the informatics of domination is as a massive intensification of insecurity and cultural impoverishment, with common failure of subsistence networks for the most vulnerable. (Haraway 1991, 172)

> If in the master narratives, cinematic and otherwise, the two kinds of spaces are reconciled and integrated, as man recontains woman in his (man)kind, his hom(m)o-sexuality, nevertheless the cultural productions and micropolitical practices of feminism have shown them to be separate and heteronomous spaces. (de Lauretis 1987, 26)

Analytically, these theoretical views claim to allow a place for the marginalized to speak. Yet it is uncertain whether and how any others have been consulted; for the most part, their agency is allowed and defined through the grace of analysis. What they have to say and whatever agency they retain have been determined by and passed through the language-of-theory. Again, the nagging questions come to mind: Whose language is this? From what form of life does it speak?

A number of scholars who write of and from difference, less concerned with wearing the crown of theory, share the doubts raised by these questions and have developed political ideas and ideals in writing that moves beyond theoretical language. In an effort to pass beyond the male-centered character of dominant theory, French feminists Monique Wittig (1969, 1980), Hélène Cixous (1976, 1991), and Luce Irigaray (1985a, 1985b, 1993) move back and forth between writing literature (essays, novels) and theory. This is also evident in the writing of Gloria Anzaldúa (1987), bell hooks (1984, 1989, 1990), Patricia Williams (1991), Paula Gunn Allen (1986), and Trinh Minh-ha (1989). And still others such as Cherríe Moraga (1993), Michelle Cliff (1985, 1987), Audre Lorde (1982, 1984), and Adrienne Rich (1979, 1986) have come to present their ideas entirely within literary forms truer to their own inherited and undeniably present, shifting and chosen identities.

It is impossible to comment here on the scope and depth of the ideas presented in this tremendously diverse writing. With respect to theorizing difference, however, a number of impressions come to mind. The most undeniable is simply the greater range and depth of what is written. Images of feminist identity are presented by Wittig and Cixous and Irigaray that make canonical conceptions of

virtue and autonomy appear incomplete and empty. In works that are both literary and theoretical, these writers show us the masculine character of dominant theoretical conceptions of self (independence, power, aggressiveness), trace the deep penetration of that self throughout Western language and culture, and contrast this with the quite different senses of self and relationships (caring, eros, *jouissance*) that are shared by women as a result of their different languages and forms of life. In Luce Irigaray's words, "You have built an anaesthetic world. But when our greatest pains or greatest joys are abolished by calculation, is that not the worst destruction? A realm beyond pain, where suffering no longer exists" (1992, 55).

There are other impressions. The relationship between theoretical and literary writing remains uncertain. French feminists challenge ideas in dominant theories but seem uncertain whether theorizing is, in itself, an oppressive social and linguistic practice. They are both repulsed by and drawn to theoretical language, viewing it as the voice of oppression while also wanting to see more clearly the connections that produce that oppression and to engender transformations beyond oppression. And theory of some sort often seems needed to make those connections and to pursue those transformations. Thus theory appears in the background of the writing by hooks, Williams, and Allen; yet when it surfaces, its ideas seem awkward, forced, included as a matter of academic expectation, fitting poorly into ideas developed within the more literary narratives. Of course, the essays and poetry of Moraga and Anzaldúa, Rich and Lorde are often simply denied the status of theory. And such writers typically pay a price for their irreverence. Luce Irigaray was removed from her academic position for her writing (1993, 52). In literature, Carolyn Heilbrun (1988) followed George Eliot and George Sand and found it necessary for years to write under a pseudonym. Gloria Anzaldúa and bell hooks recognize that writing essays and poetry outside the analytical mold means that their work is often not taken seriously as theory.[10] Trinh Minh-ha (1989) and Cherríe Moraga (1993) write poignantly of how learning to write in the voice of academic analysis meant the loss of their own voice and, with that loss, a diminished ability to see and write about compelling issues.

Like a just-returned-from-afar, overbearing world traveler[11] in the midst of an evening's conversation, the confident analytical voice draws everyone's attention to itself, stifling others' comments in midsentence, forcing everyone first to silence and then to occasional whispers. Unless the cosmopolite leaves or manages to force himself into a quieter and more attentive way of listening and speaking, all other conversations must be carried on surreptitiously, a comment here and there, a passed note or brief remark when the self-absorbed, knowing intruder's back is turned.

A central difficulty remains. How are those "we" who would theorize difference able to gain access to some potentially imaginable "others" as we go about the tasks of theorizing? An important opening to this question has been suggested by a number of the feminists and scholars of color mentioned above. Literature and literary writing both ranges beyond the narrow scope of theoretical analysis and, perhaps, makes it (somewhat) possible to gain access to others, to the Other that ranges within ourselves.[12]

Literary Life and Language: Passing Beyond the Language-of-Theory

If not routine, the use of literature and literary forms of writing are not absent from social and political theory. Allegories and metaphors, as well as writing that is richly literary, are central to Plato's *Republic* and figure prominently in the writing of such disparate philosophers as Niccolo Machiavelli (1957, 1988), Jean Jacques Rousseau (1931, 1964, 1979), Friedrich Nietzsche (esp. 1966, 1967, 1968, 1974), Michael Walzer (1988), and Richard Rorty (1989). Such attention to literature and literary forms undoubtedly extends the reach of careful analysis and theoretical argument. Indeed, it is

literary metaphors that are often the focus of theoretical praise or critique: Plato's imagery of the cave, Rousseau's story of Emile, countless Nietzschean metaphors presented in a virtuosity of literary writing.

Yet these and similar references to or the use of literature and literary forms in social and political theory are problematic in theorizing difference for a number of reasons. Perhaps the central difficulty is that with the exception of Nietzsche, this literary writing is viewed primarily as a hired hand in the work of analysis. The references to literature are brought in to help make a theoretical point. In the *Republic*, Plato's allegory of the cave and myth of the noble lie serve the development of his theory of justice; Rousseau's literary account of Emile's education is meant to teach us about citizenship; Walzer (1988) praises George Orwell and criticizes Albert Camus in ways that promote his conception of community; and Richard Rorty (1989) interprets George Orwell and Vladimir Nabokov to support his theoretical division of public and private. And what of Nietzsche? Sometimes, to be sure, his brilliant epigrams and metaphors are largely centered on cutting away the metaphysical braces which support canonical philosophical ideas and ideals. He encourages those of us living in postmodern times to forge a will, an aesthetic, within the confines of our genealogical inheritance. Much of Nietzsche's intellectual brilliance is precisely because he writes great literature that ranges courageously outside theoretical concerns and theoretical writing, that gives aesthetic expression to a form of life beyond academic security and Apollonian reason.

I have tremendous respect for these ventures beyond the language-of-theory. Without them, the history of social and political theory would be far more barren than it is. Yet others' voices may be as absent from canonical literature as they are from canonical theory. Much recent feminist literary criticism insists on this point (Christian 1985, 1989; Heilbrun 1988; hooks 1989; Jacobus 1979; Kolodny 1985; Miller 1988; Morrison 1992a; Showalter 1982). Even Nietzsche's impressive literary writing painted dismissive, disturbing pictures of those who are Other (women, the herd). But which "women" and who among the "herd" did Nietzsche consult? I doubt that their brushes ever touched the canvases on which their portraits appear.

Literature and literary writing drawn from the dominant discourse moves further into the pulses of personal and political life than detached, precise analysis; but, as Toni Morrison (1992a) so clearly shows in *Playing in the Dark*, major literature is typically written from the meanings offered by the dominant discourse. Here, too, others either have no voice or are interpreted through dominant social codes.

Passing('s) Through: Minority Life and Literature

Special difficulties are met when trying to engage minority voices more fully. Marginalized people have little choice but to speak and write in the master tongue. To the degree that they bring senses of themselves and beliefs and aspirations of perhaps radically different sorts to their use of that single tongue, minority writers must find ways of using it that express such differences. Knowing that they are using a master tongue, their different forms of life prod that tongue, move it off-center, fashion (somewhat) a tongue of their own.

Some of the dilemmas confronting minority writers who are obliged to use a major tongue are suggested by Gilles Deleuze and Felix Guattari (1983, 1986) in a discussion that focuses on the writing of Franz Kafka. Most fundamentally, writers from the margins are said to face the problem of deterritorialization. They speak and write in the major language even as it is known and felt as an alien tongue; they are viewed as alien while forced to communicate in an alien voice. Yet they learn to speak and write so that the language expresses who they are and would be. Always pursued by the master's linguistic scouts, they walk uncertainly through a thick forest of imposed and imposing words and meanings that at each step, threaten to absorb them into a dominant same-ness or expose them as lost, dreaded strangers should they move too boldly into its clearings.

In common with literature written from the dominant voice, minority literary writing[13] creates linguistic rhythms and strategies that circulate well beyond the narrow accounting of analytical exposition, beyond the "proud but calcified language of the academy" (Morrison 1994, 16). Yet Deleuze and Guattari (1983) suggest that great minority writers, who are neither captured by dominant meanings nor succumb to the fear of being exposed, create linguistic innovations that achieve a reterritorialization of language—forcing a major language to give life and breath to minority voices. This may be done through an intensification of a meaning in the major tongue that "spins it out along creative lines of escape," as in Kafka's relentless imagery of bureaucracy as seen by those within its grasp (p. 27). In addition to or in combination with such intensifications, refashioning the major language may occur through substituting a vernacular or mythic tongue (which is *here*, where a particular *we* live) for the referential tongue-of-society used by mainstream philosophers and writers (which presumes to be everywhere and to speak for all).

Speaking more from a particular literary voice than through the lens of theory, Michelle Cliff makes the point more strongly and directly: "To write as a complete Caribbean woman, or man for that matter, demands of us retracing the African part of ourselves, reclaiming as our own, and as our subject, a history sunk under the sea, or scattered as potash in the canefields, or gone to bush, or trapped in a class system notable for its rigidity and absolute dependence on color stratification. On a past bleached from our minds. . . . It means also, I think, mixing in the forms taught us by the oppressor, undermining his language and co-opting his style, and turning it to our purpose" (1985, 14).

The novels and essays of Toni Morrison are rich with language that offers creative literary intensifications, that imaginatively reveals the lives of black people in the United States—and thereby exposes repressive dimensions of the dominant discourse while providing access to the lived character of black life that have gone unnoticed by those who presume and write as though there were a single language. She begins *The Bluest Eye*, her first novel, with sentences that could have been drawn from a book which, a few decades ago, was the primer from which most American children first learned to read. "Here is the house. It is green and white. It has a red door. It is very pretty. Here is the family. Mother. Father, Dick, and Jane live in the green-and-white house. They are very happy. See Jane. She has a red dress. She wants to play. Who will play with Jane? See the cat. It goes meow-meow. Come and Play" (1970, 7).

The innocent for-whites-only images of childhood presented in the dominant discourse are undermined by a rich, haunting telling that reveals the horrors and despair associated with each sentence of a for-white-children writing. At each turn, the lines of the primer are relentlessly collapsed, anticipating the endless, violent lies they impose/hide. The chapter relating Pecola's rape by her father is boldly prefaced with

SEEFATHERHEISBIGANDSTRONGFATH

ERWILLYOUPLAYWITHJANEFATHERIS

SMILINGSMILEFATHERSMILESMILE. (1970, 10)

And the chapter in which Pecola is manipulated into poisoning a dog by a self-proclaimed minister begins with

SEETHEDOGBOWBOWGOESTHEDOG

DOYOUWANTTOPLAYDOYOUWANT

TOPLAYWITHJANESEETHEDOGRUNR. (p. 130)

In such ways, minority literature brings our attention to images of people who think and feel and live by genuinely different lights, who have a tangled rather than a uniform history. This writing explodes the presumption of a common language, of a theoretical language that can serve as the master speaker or translator for all tongues, of a high analytical prose that can interpret for and serve all, of a form of life that is common to all who speak the "same" language.

Those who would write political theory insist, of course, that analysis or, more loosely, inquiry must proceed further than the multiple, particular ways of seeing and believing that are held by different people. Politics does not stop at the water's edge of cultural or racial or gender particularity. The borders of difference cross and intersect; and our efforts to understand politics need to address such border crossings and to suggest principles and arrangements that amount to more than an arbitrary imposition of force. Also, the linguistic innovations of marginalized people are deeply connected to the dominant language, often to the point of being symbiotic. The ways in which a particular we(they) speak and understand is constructed, in large part, in relation to the meanings that we(they) have come to assign to them(us). The meanings carried by highly particular "final" vocabularies are interwoven with those embedded in the single, "common" language. This linguistic interconnectedness is emphasized by Toni Morrison: "As a disabling virus within literary discourse, Africanism has become, in the Eurocentric tradition that American education favors, both a way of talking about and a way of policing matters of class, sexual license, and repression, formations and exercises of power, and meditations on ethics and accountability. Through the simple expedient of demonizing and reifying the range of color on a palette, American Africanism makes it possible to say and not say, to inscribe and erase, to escape and engage, to act out and act on, to historicize and render timeless" (1992a, 7).

A language that identifies the good with light and truth with impartial reason is, at the same time, a language that associates evil with darkness and sees error as resulting from emotion, passion, and perhaps even simple caring. So dominant and marginalized voices are distinct yet inseparably joined—a joining often represented more by linguistic silencing and marginalization, internalization and assimilation, oppression and cooptation—than by mutual agreement.

Literary writing has far more potential than generic, rigorous analytical prose to reach into the deep and often unsavory (notice that the word which almost 'naturally' comes to mind here is *dark* rather than *unsavory*) forces that divide or join people. Bringing theory to difference would seem to require ways of writing that are deeply and fully connected to people's different forms of life, that imaginatively detect and engage the traces of writers' and readers' shared worlds. As noted by Toni Morrison in *Playing in the Dark*, "The ability of writers to imagine what is not the self, to familiarize the strange and mystify the familiar, is the test of their power. The languages they use and the social and historical context in which these languages signify are indirect and direct revelations of that power and its limitations" (1992a, 15).

Reflective Imagination: Minority Literary Writing and Refashioning the Master's Tools

Unlike the language-of-theory, literary writing is able to use the full range of a language's vocabulary and syntax, to capture mood, to note inflection, to seek out what inspires, and to detect what is evaded or hidden, to reveal not only the many senses of what is but to detect the stirrings of what might become. The creative reterritorialization of language by minority writers matters for purposes of political theory. It matters in terms of the ways in which theory is written, the range of experience that informs theoretical writing, and the conceptions of important political ideas that are the heart of theoretical visions.

Consider briefly the problem of individualism. Toni Morrison throughout her novels and essays, Gloria Anzaldúa (1987), Edward Abbey (1956, 1975, 1988), and Andrea Dworkin (1986, 1990) share liberal theorists' deep concern for individual freedom, for people's ability to lead lives outside the blinding light of oppression. Yet an understanding of what it means to have found refuge from that light—of individuals who lead lives of their own choosing—takes on quite different meanings when viewed through the imagination of these minority writers. The "individuals" whom these writers see live in a highly particular *here*, not within a social and linguistic *everywhere*. Abbey writes of people whose sense of themselves has been built in relation to the austere challenge of the American Southwest's richly barren desert rock and sand, the frightening solace of its imposing mountain peaks with their precious and fragile, harsh and unforgiving beauty. Toni Morrison writes of those who know they are the targeted "others" within a social landscape of racist hatred and violence and a racially coded language but who, nonetheless, have created a way of living of their own. So, too, presumptions of or a search for the core, individual self make little sense to those who are aware of themselves as *mestizas* in the borderlands of conflicting cultures because

> to live in the Borderlands means you are neither *hispaña india negra española ni gabacha, eres mestiza, mulata,* half-breed caught in the crossfire between camps while carrying all five races on your back not knowing which side to turn to, run from

(Anzaldúa 1987, 194).

There is an individuality within these particular, marginalized sites; but it is one in which who one is and would be is woven into the physical and/or social landscape in ways that are strongly sensed and poorly understood, yet seen as deeply a part of the self that would choose and act. Thus a concern for individuals' freedom would seem to begin with protecting those dimensions of people's physical and social worlds that they themselves have come to cherish. And what is cherished varies tremendously. Those who share Edward Abbey's self-vision embrace a natural landscape left in a wild state filled with life-threatening mountain blizzards and inescapable desert heat, Gila monsters and mountain lions and whistling swans. Abbey and his kind know that they are who they are because they have been shaped by this land—by days of hiking across Death Valley or the Great Salt Basin with no assurance of enough water, by nights spent in the open as cries of coyote and owl fill the wind, by eyes filled with rim after rim after rim of Colorado River-formed rock walls forged through eons of time. "Improve" or "develop" this land with highways and resorts and you destroy a central part of who they are and would be.

Andrea Dworkin and the women of New York's Lower East Side for whom she speaks have been shaped by fear and anger and rage that come from being relentlessly subjected to rape and the threat of rape; to winds that curve around corners and seek out thinly covered flesh huddled in exposed doorways; to rain that comes in sheets, saturates clothes, and leaves a chilling cold that never goes away. Some of her deepest desires are for a place of peace and warmth, serenity and beauty that is far from threatening streets and never-warm, never-secure apartments with their endless, wanton sexual and physical abuse. The mountains she would have would be like the Berkshires—green and rounded and peaceful, viewed through the sun-lit rooms of quiet and secure lodges. Take away this possibility, and you also deny her sense of a self and a social order within which life could be more than just the physically strong seeking out victims as lust and power demand, you carry away her vision of what makes sense and what must be resisted.

It is not that theoretical presumptions of or searches for an unambiguous individuality are empty. For at least a number of minority writers, there clearly is some sort of "individuality" lurking about. Yet minority writing reverses the foreground and background of privileged, "independent" individuality. Living in the invisible spaces that often help provide the perquisites of privilege, marginalized people cannot blink away connections between dominant social and linguistic meanings and the rhythms by which they think and act. Marginalized people's senses of the pervasiveness of those rhythms is not diminished by the language-of-theory's analytic pronouncements that they, too, share a robust autonomy, participate in a high moral tradition, or can exhibit their individuality through playful irony and subtle ambiguity. These minority voices suggest that if cherished parts of their particular stories are made secure, no one need waste analytical prose shoring up the individuality of their choices.

When theory is brought to difference, dominant conceptions of community in terms of the presumably elevated, fundamental moral values of a society's general history and culture also recede from view. The writing of Toni Morrison shows us a protective rather than a morally exalted or policing community. Blacks in the United States protect each other against incursions from whites—all whites—while offering each other comfort and support, respecting the need to suffer pain and humiliation in silent anger or violent rage or sheer madness, celebrating richness and vitality, praising and blaming without stopping to figure out precisely what deserves praise or blame. Strong judgments are few and forgiveness is given if unstated.[14]

Epilogue/Conclusion: Imagining Theoretical (Im)possibilities

The regularly changing voices I try to hear, from which I would now write and speak, are not those of a person who clearly knows who he is nor even of a person who puts much stake in or has much pride in seeing himself—or in being seen—as a *he*. Dig all the way down into identity or subjectivity and there isn't any person-with-a-voice to be found. Like most people, I suspect, I am some mixed combination of what I have done, of what has happened to me and my reflective efforts to place all of that into coherent if temporary notions about the self and politics, into efforts to pass as and not to pass, to pass silently within and to pass imaginatively beyond. I am drawn to Mary Gordon's sense of self and of living in her story, *The Rest of Life*, which lets go of precise, theoretically driven ideas of self and the good and the right: "But how do any of us recognize ourselves? By being around familiar objects, by performing actions that have some similarity to the actions of the past. I think that's all" (1993, 6).

That's not all, of course. Yet I see Gordon's portrait of a self as showing the good sense not to say more, eschewing efforts to represent the strong but contingent connection between our selves and our habits with reductionist notions borrowed from this theory or that. There are hints of Wittgenstein in Gordon's image, even stronger ones of Foucault. I suppose that in our theorizing, such strong readings and the elaborate connections they make between who we are and where we happen to be have a place. But I wonder.

Why not leave disparate, reflective/literary accounts in place, clearly associated with the form of life that has called them up—doubting any effort to prioritize them or to analyze just which one is more basic or consistent or true by some general view. With this questioning of the need to say more—to analyze more—may come a reflective sense of self that more fully sees the richness and ambiguity and utter contingency of the rest of life, of all those parts of life that circulate within/beyond analytical ideas about true selves and what they should believe and how they should be measured, when they are free and what they are entitled to. If it seems important to say more, to trace

out the forces that have shaped selves who are also agents, I suspect we should try to match the richness and simple grace of Gordon's writing. If we cannot, I doubt that we add anything to her or to anyone's literary/theoretical accounts.

What comes to mind after this somewhat unorthodox metatheoretical foray into the pitfalls and promises of taking differences seriously? My own strongest impression as I have worried over the issues raised here is a reaffirmation of Foucault's view that intellectuals who have a penchant for firmly gluing together general claims or prescriptions from carefully selected scraps of aristocratic presumption and intuition are to be regarded with great caution (1972, 126–33). I continue to think this penchant is woven into the language-of-theory and its form of life—sometimes as a whisper, sometimes as a command—as they shape the writing of self-conscious social and political theorists of widely different persuasions.

Does this mean that those who would (re)fashion theories may face the prospect of also learning to write as novelists and poets, essayists and play-wrights? I suspect so, at least some of the time. If we are to proceed from metapolitical theory to political-theories-without-a-gaze, it is hard to see how passing beyond the voice of secure and confident, detached analysis can be avoided. It is also difficult to imagine that those who pass their days entirely within the form of life of privileged academic theorists can acquire much facility in using anything but theoretical language. Yet those who have little or no facility to reach imaginatively into and to write about the differences within particular people's lives are probably not to be trusted when they would fashion the principles and politics that affect those lives. Their analytical reach exceeds their imaginative grasp.

So, yes, a strong dose of imaginative, literary writing, fully employing the vernacular and mythic tongues at play in the heretofore forgotten or silenced or ignored margins of the rest of life runs through all of the theoretical (im)possibilities that I see. In the words of Audre Lorde: "We can train ourselves to respect our feelings and to transpose them into a language so they can be shared. And where that language does not yet exist, it is our poetry which can help fashion it. Poetry is not only dream and vision; it is the skeleton architecture of our lives" (1984, 37–38).

As reflective/imaginative literary theorists, we may be able to find or create, here and there and for a time, particular sites where careful attention shows us widespread agreement on the details of a specific vision. If so, I'm sure that familiar habits of close analysis will and probably should reassert themselves. If difference calls into question and moves beyond even as it is woven into dominant ways of seeing and believing, analysis and metaphor and allegory also probably need to be interwoven, each coming into play as the choreography needed to understand and transform ourselves more fully is endlessly put together and rehearsed and performed.

Devotion to a philosophy and politics that fine-tunes established principles and refines their written expression may be at an end.[15] Perhaps we should begin pursuing the openings that that improbable end now makes possible, rather than standing guard over fallen ideals or repeating warnings about the certain decay and violence that follow from ideas and arrangements that are "too" local or "too" separatist.[16] With a little imagination, perhaps such concerns can pass.

Notes

Patricia Ellen Taylor, Timothy Martinez, Richard Flathman, Barbara Aglaia, Richard Tomich, Carol Thompson, and Carleen Jaspers made valuable comments on earlier drafts of this article. Carleton College, the Center for Advanced Feminist Studies at the University of Minnesota, and the Graduate College of Northern Arizona University provided important research support.

1. I am conflating liberal and communitarian theorists because, from the intellectual vantage point of difference, they offer remarkably similar views. In intellectual league against the charges of feminism

and, especially, poststructuralism, they are more and more alike in their insistence that marginalized others are "just like us," beneficiaries of certain progressive moral and political ideals within the modern Western tradition. Richard Flathman (1987) and John Rawls (1987, 1993) advance this view in promoting liberal ideals of freedom and justice; Michael Walzer (1988) and Charles Taylor (1992) do so in recommending the "high" moral values of community.

2. I mention this in recognition of those residing in the margins who know their location there is *not* a way-station, who sense with every breath and movement that this will always be their lot. From that recognition and the endlessly repeated routines that push it further and further into their consciousness, a sense of self and a sense of the character and possibilities of social life are forged that, it seems to me, bear little resemblance to the ways of considering one's self and situation that come to be held by any (such as myself) who only pass through.

3. I borrow the term from Adrienne Rich (1979, 35).

4. There are instances of writing that expresses a particular, uncertain voice among a few contemporary political theorists, although the language of analysis remains prominent in their writing (e.g., Elshtain 1981; Flax 1990).

5. The strong impetus of poststructuralist theory to assimilate the meanings of others into its own terms or, alternatively, to silence them altogether is suggested by Kalpana Ram (1993).

6. I want to be cautious here. I know that I'm entering new and uncertain ground, and my pace slows at the range of unknown and unexplored complexities that appear, on all fronts, in any thoughtful attempt to understand difference. My caution is heightened with the realization that, in what follows, I critique scholars notably marked by difference even as I am not. And I do not want to detract from the important, if still incomplete, work that has been done by many who speak of and analyze difference, because they, far more clearly than I, know difference first-hand.

7. The task of consulting the voices of marginalized, post-colonial women, particularly those who lived in earlier times, poses difficult and perhaps insurmountable problems. Despite Spivak's unassailable intention to understand dominant constructions of postcolonial women and to address their oppressions, I am led to believe that the particular language-of-theory she has mastered and its associated social-linguistic site betray her project. As noted by Kalpana Ram, also a postcolonial woman and theorist, the movement from the site of academic, middle-class Indian women to First World institutions may occur (too) smoothly, with Third World traces receding quickly into the background.

8. In a recent presentation, Spivak (1995) suggested that subalterns' inability to speak does not mean that they cannot talk. I simply don't know what this means, what it can mean. And I doubt that many of the postcolonial women for whom Spivak claims to speak either recognize or appreciate this subtle theoretical distinction.

9. Spivak's view that the subaltern cannot speak is perilously close to Richard Rorty's insistence that until marginalized people become articulate in the "common" language, the "job of putting their situation into language is going to have to be done for them by somebody else" (1989, 94). His sentiment is echoed by Susan Moller Okin: "*Committed* outsiders can often be better analysts and critics of social justice than those who live within the relevant culture" (1994, 19; emphasis original).

10. This point was made by hooks and Anzaldúa during lectures I attended in the spring of 1992. Anzaldúa spoke at the University of Minnesota, Twin Cities, and hooks, at Carleton College.

11. I adopt María Lugones' (1990) conception "world-traveling" as a way of moving across divides of difference deliberately, if with considerable uneasiness. I do so because I find little or no place in the

notion of world-traveling for the marginalized. This may be a notion that (some) others embrace, but we only have Lugones's theoretical claim that this is the case.

12. For an elaboration of this point, see Kristeva 1991.

13. I will collapse minor (noncanonical) literature with minority (others') literature, using the single term of *minority literature* to cover both meanings.

14. This is strongly portrayed, for example, by Sula in *Sula*, Milkman in *Song of Solomon*, Denver in *Beloved*, and Joe and Violet in *Jazz* (Morrison 1973, 1977, 1987, 1992c).

15. I use *end* in the varied senses offered by Jacques Derrida—as an attitude of deep regret felt with the closing out of an age, as an aesthetic refusal to look back on a former time, as a celebration of the possibilities offered by new if uncertain beginnings (1982, esp. 134–36).

16. In calling for social and political theorists to come to know and to write about difference as imaginative, literary artists, I fully acknowledge my own halting, tentative, and (as yet) quite unsuccessful efforts to do so—hence the writing here. In part, this is because pursuit of a general view and absorption of my writing self into the language-of-theory has accompanied my many years as a self-identified political theorist. (Having learned to swear mightily by the age of seven and to speak in the vernacular of a rural Wisconsin farming community, acquiring facility in the high Standard English of analytical prose required considerable work.) Also, the attention to rich meanings that inhabit particular sites from which imaginative, literary writing draws is blunted by years of analytical and experiential distance. So imaginative theoretical writing may come, at best, as the meanings embedded within deeply particular sites are engaged with great care and attentiveness. As that process moves forward, I suspect that overall views of society, the divining of general principles, rigorously constructed arguments, and the language-of-theory may also be transformed through a greater attentiveness to the particular sites that comprise social and political life.

References

Abbey, Edward. 1956. *The Brave Cowboy*. Albuquerque: University of New Mexico Press.

Abbey, Edward. 1975. *The Monkey Wrench Gang*. New York: Avon Books.

Abbey, Edward. 1988. *The Fool's Progress*. New York: Holt.

Allen, Paula Gunn. 1986. *The Sacred Hoop*. Boston: Beacon.

Anzaldúa, Gloria. 1987. *Borderlands La Frontera*. San Francisco: Aunt Lute Books.

Benhabib, Seyla. 1992. *Situating the Self*. New York: Rout-ledge.

Butler, Judith. 1990. *Gender Trouble*. New York: Routledge.

Butler, Judith. 1993. *Bodies That Matter*. New York: Routledge.

Christian, Barbara. 1985. *Black Feminist Criticism*. New York: Pergamon.

Christian, Barbara. 1989. "The Race for Theory." In *Gender and Theory*, ed. Linda Kauffman. New York: Basil Blackwell.

Cixous, Hélène. 1976. "The Laugh of the Medusa." *Signs* 1(Summer):309–21.

Cixous, Hélène. 1991. *"Coming to Writing" and Other Essays*. Ed. Deborah Jenson. Trans. Sarah Cornell, et al. Cambridge: Harvard University Press.

Cixous, Hélène. 1993. *Three Steps on the Ladder of Writing*. New York: Columbia University Press.

Cliff, Michelle. 1980. *Claiming an Identity They Taught Me To Despise*. Watertown, MA: Persephone.

Cliff, Michelle. 1985. *The Land of Look Behind*. New York: Firebrand Books.

Cliff, Michelle. 1987. *No Telephone to Heaven*. New York: Vintage.

Connolly, William E. 1993. *The Augustinian Imperative*. Ed. Morton Schoolman. Modernity and Political Thought Series, vol. 1. Newbury Park: Sage.

de Lauretis, Teresa. 1987. *Technologies of Gender.* Bloomington: Indiana University Press.

de Lauretis, Teresa. 1990. "Eccentric Subjects: Feminist Theory and Historical Consciousness." *Feminist Studies* 16:115–50.

Deleuze, Gilles, and Felix Guattari, 1983. "What Is a Minor Literature?" *Mississippi Review* 11:13–33.

Deleuze, Gilles, and Felix Guattari, 1986. *Kafka toward a Minor Literature.* Minneapolis: University of Minnesota Press.

Derrida, Jacques. 1981a. *Positions.* Trans. Alan Bass. Chicago: University of Chicago Press.

Derrida, Jacques. 1981b. *Disseminations.* Trans. Barbara Johnson. Chicago: University of Chicago Press.

Derrida, Jacques. 1982. *Margins of Philosophy.* Trans. Alan Bass. Chicago: University of Chicago Press.

Dworkin, Andrea. 1986. *Ice and Fire.* New York: Weidenfeld & Nicolson.

Dworkin, Andrea. 1990. *Mercy.* New York: Four Walls Eight Windows.

Eishtain, Jean Bethke. 1981. *Public Man, Private Woman.* Princeton: Princeton University Press.

Flathman, Richard E. 1987. *The Philosophy and Politics of Freedom.* Chicago: University of Chicago Press.

Flathman, Richard E. 1992. *Willful Liberalism.* Ithaca: Cornell University Press.

Flax, Jane. 1990. *Thinking Fragments.* Los Angeles: University of California Press.

Foucault, Michel. 1972. *Power/Knowledge.* Ed. Colin Gordon. New York: Pantheon Books.

Foucault, Michel. 1979. *Discipline and Punish.* Trans. Alan Sheridan. New York: Vintage Books.

Gordon, Mary. 1993. *The Rest of Life.* New York: Viking.

Haraway, Donna. 1991. *Simians, Cyborgs, and Women.* New York: Routledge.

Heilbrun, Carolyn G. 1988. *Writing a Woman's Life.* New York: Ballantine Books.

hooks, bell. 1984. *Feminist Theory: From Margin to Center.* Boston: South End.

hooks, bell. 1989. *Talking Back.* Boston: South End.

hooks, bell. 1990. *Yearning.* Boston: South End.

Irigaray, Luce. 1985a. *This Sex Which Is Not One.* Ithaca: Cornell University Press.

Irigaray, Luce. 1985b. *Speculum of the Other Woman.* Trans. Gillian C. Gill. Ithaca: Cornell University Press.

Irigaray, Luce. 1992. *Elemental Passions.* New York: Routledge.

Irigaray, Luce. 1993. *Je, tu, nous.* Trans. Alison Martin. New York: Routledge.

Jacobus, Mary. 1979. *Women Writing and Writing about Women.* New York: Barnes & Noble.

Kolodny, Annette. 1985. "A Map for Rereading." In *The New Feminist Criticism,* ed. Elaine Showalter. New York: Pantheon Books.

Kristeva, Julia. 1991. *Strangers to Ourselves.* New York: Columbia University Press.

Larry M. Preston is Professor of Political Science, Northern Arizona University, Flagstaff, AZ 86011-5036.

Lorde, Audre. 1982. *Zami: A New Spelling of My Name.* Freedom, CA: Crossing.

Lorde, Audre. 1984. *Sister Outsider.* Trumansburg, NY: Crossing.

Lugones, María. 1990. "Playfulness, 'World'-Traveling, and Loving Perception." In *Making Face, Making Soul Haciendo Caras,* ed. Gloria Anzaldua. San Francisco: Aunt Lute Foundation.

Machiavelli, Niccolo, 1957. *Mandragola.* Trans. Anne & Henry Paolucci. New York: Macmillan.

Machiavelli, Niccolo, 1988. *The Prince.* Ed. Quentin Skinner. New York: Cambridge University Press.

Miller, Nancy K. 1988. *Subject to Change.* New York: Columbia University Press.

Miller, Nancy K. 1991. *Getting Personal.* New York: Routledge.

Minh-ha, Trinh T. 1989. *Woman, Native, Other.* Bloomington: Indiana University Press.

Moraga, Cherríe. 1993. *The Last Generation.* Boston: South End.

Morrison, Toni. 1970. *The Bluest Eye.* New York: Washington Square.

Morrison, Toni. 1973. *Sula.* New York: Penguin.

Morrison, Toni. 1977. *Song of Solomon.* New York: Signet.

Morrison, Toni. 1987. *Beloved*. New York: Signet.

Morrison, Toni. 1992a. *Playing in the Dark*, Cambridge: Harvard University Press.

Morrison, Toni. 1992c. *Jazz*. New York: Knopf.

Morrison, Toni. 1993. "Interviews." In *Toni Morrison*, ed. Henry Louis Gates and K. A. Appiah. New York: Amistad.

Morrison, Toni. 1994. *Lecture and Speech of Acceptance upon the Award of the Nobel Prize for Literature*. New York: Knopf.

Nietzsche, Friedrich. 1966. *Beyond Good and Evil*. Ed. Walter Kaufmann. New York: Vintage.

Nietzsche, Friedrich. 1967. *Ecce Homo*. Ed. Walter Kaufmann. New York: Vintage.

Nietzsche, Friedrich. 1968. *Twilight of the Idols and the Anti-Christ*. New York: Penguin.

Nietzsche, Friedrich. 1974. *The Gay Science*. Ed. Walter Kaufmann. New York: Vintage.

Okin, Susan Moller. 1994. "Gender Inequality and Cultural Differences." *Political Theory* 22(February):5–24.

Ram, Kalpana. 1993. "Too 'Traditional' Once Again: Some Poststructuralists on the Aspirations of the Immigrant/Third World Female Subject." *Australian Feminist Studies* 17:5–28.

Rawls, John. 1987. "The Idea of an Overlapping Consensus." *Oxford Journal of Legal Studies* 7:1–25.

Rawls, John. 1993. *Political Liberalism*. New York: Columbia University Press.

Rich, Adrienne. 1979. *On Lies, Secrets, and Silence*. New York: Norton.

Rich, Adrienne. 1986. *Blood, Bread, and Poetry*. New York: Norton.

Rorty, Richard. 1989. *Contingency, Irony, and Solidarity*. New York: Cambridge University Press.

Rorty, Richard. 1991. *Objectivity, relativism, and truth*. New York: Cambridge University Press.

Rousseau, Jean Jacques. 1931. *Confessions*. New York: E. P. Dutton.

Rousseau, Jean Jacques. 1964. *The First and Second Discourses*. New York: St. Martin's Press.

Rousseau, Jean Jacques. 1979. *Emile*. New York: Basic Books.

Shapiro, Michael J. 1993. *Reading "Adam Smith."* Ed. Morton Schoolman. Modernity and Political Thought Series, vol. 4. Newbury Park: Sage.

Showalter, Elaine. 1982. "Feminist Criticism in the Wilderness." In *Writing and Sexual Difference*, ed. Elizabeth Abel. Chicago: University of Chicago Press.

Showalter, Elaine. 1985. *The New Feminist Criticism*. Ed. Elaine Showalter. New York: Pantheon Books.

Spivak, Gayatri Chakravorty. 1987. *In Other Worlds*. New York: Methuen.

Spivak, Gayatri Chakravorty. 1988. "Can the Subaltern Speak?" In *Marxism and the Interpretation of Culture*, ed. Cary Nelson and Lawrence Grossberg. Chicago: University of Illinois Press.

Spivak, Gayatri Chakravorty. 1990. "Criticism, Feminism, and the Institution." In *The Post-Colonial Critic*, ed. Sarah Harasym. New York: Routledge.

Spivak, Gayatri Chakravorty. 1993. *Outside in the Teaching Machine*. New York: Routledge.

Spivak, Gayatri Chakravorty. 1995. (Untitled lecture.) Presented at Silencing Women Conference, Center for Ideas and Society, University of California, Riverside.

Taylor, Charles. 1989. *Sources of the Self*. Cambridge: Harvard University Press.

Taylor, Charles. 1992. *Multiculturalism and "The Politics of Recognition."* Princeton: Princeton University Press.

Walzer, Michael. 1988. *The Company of Critics*. New York: Basic Books.

Williams, Patricia J. 1991. *The Alchemy of Race and Rights*. Cambridge: Harvard University Press.

Wittgenstein, Ludwig. 1953. *Philosophical Investigations*. Trans. G. E. M. Anscombe. New York: Macmillan.

Wittig, Monique. 1969. *Les Guerilleres*. Boston: Beacon Press.

Wittig, Monique. 1980. "The Straight Mind." *Feminist Issues* 1:103–11.

Wollstonecraft, Mary. 1975. *Vindication of the Rights of Woman*. Ed. Miriam Brody. New York: Norton.

Woolf, Virginia. 1929. *A Room of One's Own*. New York: Harcourt, Brace, Jovanovich.

Woolf, Virginia. 1931. *The Waves*. New York: Harcourt, Brace, Jovanovich.

I have argued elsewhere (Landsberg 2004) that a new from of public memory emerged at the turn of the last century, as a result of two simultaneous developments. While social and economic modernization disrupted traditional forms of community and lent a new urgency to the transmission of memories, the birth of the cinema and other mass cultural technologies produced an unprecedented circulation of images and narratives about the past, making possible a portable and non-essentialist form of memory. In this context, it became increasingly possible to take on memories of events through which one did not live, memories that, despite their mediated quality, had the capacity to transform one's subjectivity, politics, and ethical engagements. While there have always been technologies of memory, strategies for passing on group memory, with the mass dissemination of film, the circulation of narratives about the past—and hence, of potential memories—increased exponentially. Even more importantly, unlike earlier technologies of memory, which were mostly geared toward consolidating and passing on group memory in the service of group identity, the memories made available by film and mass culture were equally available to all for the price of a ticket. The sensuous engagement that these technologies enable creates the formation of a memory of an event that wasn't lived in the traditional sense, and might not be acquired in any "natural" hereditary or voluntary way.

I have called these memories prosthetic memories because they are not the product of lived experience, but are derived from engagement with a mediated representation, such as a film or an experiential museum, and like an artificial limb, they are actually worn on the body; these are sensuous memories produced by an experience of mass-mediated representations. Their ability to circulate widely is occasioned by their commodified form. It is precisely the commodified nature of mass cultural representations, that makes them so widely available to people who live in different places and hail from different backgrounds, races, and classes, and that ultimately precludes them from being the private property of a particular group. Finally, I call these memories prosthetic to underscore their usefulness. Because they feel real, they help condition how a person thinks about the world and might be instrumental in articulating an ethical relation to the other.

Prosthetic memories emerge at the interface between a person and a historical narrative about the past, at an experiential site such as a movie theater or museum. In this moment of contact, an experience occurs through which a person sutures him or herself into a larger historical narrative. In this process, the person does not simply learn about the past intellectually, but takes on a more personal, deeply felt memory of a past event through which he or she did not live in the traditional sense. These prosthetic memories, as I will elaborate more fully in this essay, might help to condition how a person thinks about the world and might be instrumental in articulating an ethical relation to the other or

With kind permission from Springer Science+Business Media: *International Journal of Politics, Culture and Society*, Volume 22, 2009, Pages 221–229, by Alison Landsberg. Copyright © 2009, Springer.

123

in advancing egalitarian social values. I will argue that cinematic technology, by which I mean also to include the dominant cinematic conventions and practices used in the Hollywood style of filmmaking, is an effective means for structuring vision. Through specific techniques of shooting and editing, films attempt to position the viewer in highly specific ways in relation to the unfolding narrative. When the film takes the historical past as its subject, the possibility of acquiring prosthetic memories is even more pronounced. Sometimes, in such films, viewers are brought into intimate contact with a set of experiences that fall well outside of their own lived experience and, as a result, are forced to look as if through someone else's eyes, and asked to remember those situations and events. And sometimes that experience can be quite uncomfortable. Learning to engage both intellectually and emotionally with another who is radically different from oneself is crucial to the development of empathy, which in turn enables the larger political project of advancing egalitarian social goals through a more radical form of democracy.

Empathy is a modality quite different from, though often confused with, sympathy. The Oxford English Dictionary defines sympathy as "A(n) affinity between certain things, by virtue of which they are similarly or correspondingly affected by the same influence, affect or influence one another (esp. in some occult way), or attract or tend towards each other." Sympathy assumes similarity, a pre-existing connection between sympathizer and sympathizee. In sympathy, one shares the feelings of another person. And most notably, when one sympathizes with another, one focuses on oneself, on how she would feel in the other's situation. According to the OED, sympathy first appeared in 1579, and by 1601 conveyed the now central idea of "fellow-feeling", and emotional conformity.

Empathy, a much more modern concept, also seems the more complicated of the two, as it requires one to imagine the other's situation and what it might feel like, while simultaneously recognizing one's difference from her. First appearing in German (Einfühlung) in connection to aesthetic response,[1] the English term empathy appears first in 1904. The OED defines empathy as "The power of projecting one's personality into (and so fully comprehending) the object of contemplation." With empathy there is a leap, a projection, from the empathizer to the object of contemplation, which implies that a distance exists between the two. The experience of empathy requires an act of imagination—one must leave oneself and attempt to imagine what it was like for that other person given what he or she went through. Empathy, unlike sympathy, requires mental, cognitive activity, it entails an intellectual engagement with the plight of the other; when one talks about empathy one is not talking simply about emotion, but about contemplation as well. Contemplation and distance, two elements central to empathy, are not present in sympathy. Empathy takes work and is much harder to achieve than sympathy. In part, empathy is about developing compassion not for our family or friends or community, but for others—others who have no relation to us, who resemble us not all, whose circumstances lie far outside of our own experiences.

Some have argued that the act of reading novels can inform and train ethical thinking.[2] Legal scholar Martha Nussbaum (2001), for example, following Henry James' assertions in *The Art of the Novel*, argues that, "The artist can assist us by cutting through the blur of habit and the self-deceptions habit abets; his conduct is ethical conduct because it strives to come to terms with reality in a world that shrinks from reality. When we follow him as attentive readers, we engage in ethical conduct" (p. 59). In this formulation, both novel writing and novel reading can be ethical work. Her claim is twofold: first, that "specific literary works develop those imaginative abilities" (p. 65) that are instrumental is developing compassion, and second, that they have a practical effect: "by being examples of moral conduct . . . they strengthen the propensity so to conduct oneself in other instances" (p. 70).

[1] Juliet Koss has written on empathy as an aesthetic response. See Koss (2006).

[2] See, for example, Davis and Womack (2001).

Nussbaum signals out Dickens as a premier example of an author whose works foster ethical thinking, for his novels "take us into the lives of those who are different in circumstances from ourselves and enable us to understand how similar hopes and fears are differently realized in different social circumstances" (p. 66).

Without downplaying the power of certain realist novels to function this way, I would like to make the case that the cinema might be an even more powerful technology for structuring just this kind of ethical thinking. What makes cinematic technology and practice so central to my understanding of prosthetic memory, and its relationship to empathy, has to do with both its broad reach (many more people go to the cinema than read novels), and its capacity to position viewers in relation to the unfolding narrative. The subject of cinematic spectatorship—the relationship between viewer and moving image—has received much scholarly attention and has provoked much scholarly debate, and for good reason. Understanding how viewers are positioned by a film and how they enter into identifications with different characters is crucial to understanding the larger issue of how films might shape an individual's subjectivity and politics. In opposition to the dominant strain of spectatorship theory in the 1970s, which focused on the cinematic apparatus as an ideological apparatus,[3] contemporary film theory has offered a more nuanced and fluid account of spectatorship.[4] This body of scholarship is an important corrective to the deterministic and ahistorical model of spectatorship developed by the apparatus theorists, and I firmly believe that spectatorship is a fluid process, and that spectators might well move in and out of identifications with different characters over the course of a film. Nevertheless, it would be a mistake not to recognize the particular qualities of the medium—point of enunciation, point-of-view shots, close-ups, etc.—that conspire to situate the spectator in a particular position in relation to the story. In other words, while films themselves are polysemic, and our identifications with particular characters and situations are inevitably inflected by our own subject positions, it is still the case that films create a preferred vantage point for us as viewers, and sometimes occupying that vantage point requires us to look at the world differently from how we would normally see it, looking as it were, as if through someone else's eyes. I am arguing for an account of spectatorship that recognizes both the complicated and fluid nature of cinematic identification, but also the virtuosity of the medium as an instrument for positioning viewers to confront images from a specific point of view.

While reading a novel certainly enables us to stand in someone else's shoes, the experience of the cinema is different in several ways. In the cinema, we are bombarded with life-size images. Unlike reading, where we can put down the book at will, in the cinema, we must submit ourselves to the images, and to the pace and logic of the narrative even if what we see disturbs us. And finally, there is an experiential component to cinematic spectatorship, for we respond in a bodily, mimetic way to the images before us. The editing and cinematographic practices can situate us as viewers in foreign and sometimes uncomfortable positions, and in the process force us to take on memories of events we did not live through in the traditional sense.

[3]"Apparatus theory" refers to a body of work produced in the 1970s by French film theorists such as Christian Metz and Jean-Louis Baudry which claimed that ideology was present not only in the filmic representations, but also in the cinematic apparatus itself. While the particulars of their arguments differ, they shared a belief that the cinema was first an apparatus for the positioning of the spectator as subject. See Metz (1986). See also Baudry, J-L. The apparatus: Metapsychological approaches to the impression of reality in the cinema, and Ideological effects of the basic cinematographic apparatus. Both in Rosen (1986).

[4]Contemporary film theory has contested the notion that the spectator is locked into a single and largely passive viewing position, arguing instead for a model of spectatorship where viewers move in and out of identifications with different characters, in part as a result of cinematic devices and in part as a result of their own pre-existing subject position. See, for example, Hansen (1986); Williams (1995); Berenstein (1995); Clover (1992).

While clearly our own subject positions (male, female, gay, straight, etc.) influence how we respond to the cinematic images before us, there are specific filmic strategies—both in terms of cinematography and editing—that encourage the spectator to identify with a particular character. One such technique is the close-up: with the camera trained on another's face we are afforded intimate contact with that person's emotional life. As her face registers pleasure or pain or humiliation or anger, we cannot help but feel our own body respond in kind. We experience, in fact, a kind of mimesis. In the words of anthropologist Michael Taussig (1993), mimesis means "to get hold of something by means of its likeness" (p. 21), which for him, implies both "a copying or imitation, and a palpable, sensuous, connection between the very body of the perceiver and the perceived" (p. 21). Walter Benjamin (1978), who observed that the mimetic faculty has changed over time in response to changing historical circumstances, was particularly interested in its new incarnations in modernity (p. 333). In exploring Benjamin's ideas about the impact of cinema on the mimetic faculty, Jennifer Bean (2001) writes, "Mimesis stresses the reflexive, rather than reflection; it brings the subject into intimate contact with the object, or other, in a tactile, performative, and sensuous form of perception, the result of which is an experience that transcends the traditional subject—object dichotomy" (p. 46). And for Benjamin, there is a political component to mimesis, for as Susan Buck-Morss (1989) notes, in mimesis "cognitive reception is no longer contemplative but tied to action" (p. 270).

Another cinematic technique that powerfully fosters our sense of identification with a character in the film is the point-of-view shot. A point-of-view shot is actually two shots joined together. The first reveals a character looking, though not what she actually sees. In the second shot, the camera is positioned where the character's eyes would be, so it is as if we are seeing through her eyes. Point-of-view shots force us to look at the world through someone else's eyes, from their literal perspective, thus pulling us into the action of the film, and into the mental and emotional life of the protagonist. In so doing, the cinema offers viewers access to another person's mind and motivations, a person who might have had radically different life experiences, convictions, and commitments, and to whom the viewer has no "natural" connection.

I am proposing that the cinema has the capacity to bring us into intellectual and emotional contact with circumstances that lie well beyond our own lived experiences, and in the process can force us to confront, and enter into a relationship of responsibility and commitment toward, "others." Because this coming to terms with the other requires intellectual work, it lays the groundwork for the development of empathy. Films that depict historical traumas are particularly well suited to this task, but only if they force us to negotiate new terrain on both the emotional and intellectual level, if they construct a form of identification structured not on sameness and similarity, but on distance and difference between viewer and subject.

Roman Polanski's 2002 film *The Pianist* is an interesting case because of the complicated ways in which it sets up cinematic identification. While the film tries to elicit spectatorial identification with the Jews, it recognizes that absence, not presence, characterizes the Holocaust experience. Instead of simply identifying with present bodies, the spectator also identifies with, or has an experience of, absence. Certainly, the film attempts to get the audience to identify with the Jews, and yet it recognizes how complicated such an identification might be. For most audiences, the Holocaust lies well outside of personal experience. Those who did not live through it will never know what it felt like to endure such pro found deprivations, dispossessions, and violence. This film is a powerful and difficult film in part because it recognizes and affirms that distance and difference, not proximity, absence, and not presence, constitute our relationship to the Holocaust experience. While this film begins in a realist vein, inviting us to identify with the protagonist and feel connected to him, it changes course approximately half-way through almost to the point of surrealism. In the latter part of the film, we are left

to identify with a character that we have very little emotional access to, a character that seems almost inhuman. And it is through this very difficult identification, I will argue, that we begin to experience empathy.

The Pianist begins with scenes of assimilated middle-class Jews living in Warsaw, Poland, and encourages us to identify with the Jewish characters before depicting their dehumanization. The film introduces us to the protagonist, Wladyslaw Szpilman (Adrien Brody), a pianist and one of four children in the Szpilman family. Painstakingly, Polanski details the gradual degradation and dispossession of this family. In the first instance, the family learns of the new requirement that all Jews must wear armbands emblazoned with the Star of David. We see first the family's horror at such an idea, followed in subsequent scenes by their acceptance of this shameful marker. Their dispossession occurs in stages: first their displacement to a smaller apartment within the confines of the ghetto, then the erection of the ghetto walls, and finally the liquidation of the ghetto. At this point, the Szpilmans, along with the other Jews, report to a central square to await the trains that will carry them to "work camps." By a stroke of luck, Wladyslaw escapes this fate and remains behind in Warsaw.

This degradation and dispossession is accompanied by an unflinching and unrelenting look at the extreme violence of the Nazi regime. As spectators, we are brought face to face with a young woman shot in the head for asking a question, an older man in a wheelchair pushed out of his window, and instances of people being called out of line and shot for no reason at all. This violence never, however, becomes available for sadistic or voyeuristic purposes, as we are positioned so strongly by the film to identify with the Jews. This positioning is particularly vivid later in the film, when the building Wladyslaw is hiding in is bombed. Following the explosion, all sound on the soundtrack becomes muffled, except for a persistent ringing, as if we ourselves were present at a deafening explosion. This intimate look at, and immersion in, the irrational and excessive violence inflicted on Jews is obviously meant to give us an experience of the horror and unfairness of the Holocaust.

After Wladyslaw's family is deported, though, the film's strategy and focus shift. Instead of being confronted viscerally with violence, we watch as Wladyslaw struggles for survival. The second part of this film is more about absence and loss than it is about brutality. After hiding out for several days, Wladyslaw reemerges in the empty ghetto. In an image that might serve as a microcosm for the plight of the survivor, Wladyslaw comes to the square where the Jews awaited their deportation. Once alive with Jews huddled together, the square is now empty—or at least empty of people. All that remains are the suitcases and belongings of the Jews who were taken away. These piles of possessions, now without owners, reinforce the absence created by the Holocaust. That this absence is being registered symbolically by the presence of ownerless objects suggests the complicated nature of the identification solicited here. Viewers must recognize intellectually that people are absent. Because we understand absence through signification—the presence of things that stand in for the absence of bodies—there is a layer of mediation between viewers and narrative. The distance opened up by mediation, and the cognitive activity required to negotiate it, is central to the production of empathy. We as viewers must make the intellectual bridge.

Once Wladyslaw escapes the ghetto, it is as if he is the lone remaining Jew: the film dramatizes this by focusing on his solitary struggle. Here, the film's realism gives way to something much more akin to surrealism. This part of the film feels long and tedious and hard to watch not because it is so disturbing (though of course it is), but rather because so little is said, or done. We see him wandering alone outside, the sole survivor in an otherwordly bombed-out landscape. The starving Wladyslaw is emaciated, too weak to eat or act except in the most pressing of circumstances, and he is so alone that there is rarely occasion for him to speak. Although he is the only real object for spectatorial investment, he has been deprived of the most basic human requirements for personhood. In many ways,

Wladyslaw is here depicted as a *Muselmann*. As Giorgio Agamben (2002) has explained, the word itself means Muslim, and as such signals a radical alterity; in part, it designated the effect of malnutrition on the body (p. 41, 43). But as Agamben describes, it is precisely here, where the grounds of ethics must reside: "Simply to deny the *Muselmann's* humanity would be to accept the verdict of the SS and to repeat their gesture. The *Muselmann* has, instead, moved into a zone of the human where not only help but also dignity and self-respect have become useless. But if there is a zone of the human in which these concepts make no sense, they are not genuine ethical con-cepts, for no ethics can claim to exclude a part of humanity, no matter how unpleasant or difficult that humanity is to see" (p. 63–4). And this is part of the project of the film, to force us to stay with Wladyslaw, to recognize his humanity, no matter how altered and unrecognizable it has become. It is challenging to stay with him, as there is precious little gratification for the viewer, but persist we must. And yet, this case underscores as well that our identification with him is tenuous, resting in part on a recognition of a profound difference between him and us. We must stay with him even as we recognize the limits of our identification with him. We are not, in other words, *sympathetic* to his plight, as it remains in significant ways alien to us. Our sense of connection to him is based on a simultaneous recognition of distance and difference, coupled with a sense of compassion and responsibility. This ethical call here bears much resemblance to the one articulated by the philosopher Emmanuel Levinas in the wake of the Holocaust. In his introduction to Levinas's *Time and the Other*, Richard Cohen (1987) writes, "The *I* is responsible not only to know the Other, or to share an understanding of the world which the Other also shares, but is responsible to respond to the very alterity of the Other, to an alterity which is always on the verge of presence but never comes to presence. . ." (p. 18). We are both compelled to him and yet pushed away, held off, and it is this complicated negotiation with the other that *The Pianist* seems to engage.

That we are supposed to develop a sense of commitment to this character even in the face of his profound difference from us is actually staged by the narrative of the film itself. When Wladyslaw is hiding in the attic of an abandoned house in bombed-out Warsaw, he is discovered by a German officer (Thomas Kretschmann). Upon learning that Wladyslaw is a Jew, the officer interrogates him about his former life. When Wladyslaw confesses to having been a pianist, the officer leads him to a piano and motions for him to play. In this scene, the camera watches Wladyslaw, but it also watches the German officer watching Wladyslaw. That we are presented the German's gaze upon the pianist suggests that this moment is important in part for what the German officer is able to see. This moment, too, seems to evoke Levinas's (1987) phenomenology of sociality, which Levinas grounds in the face of the other: "I have attempted a 'phenomenology' of sociality starting from the face of the other person—from proximity—by understanding in its rectitude a voice that commands before all mimicry and verbal expression, in the mortality of the face, from the bottom of this weakness. It commands me not to remain indifferent to this death, to not let the Other die alone, that is, to answer for the life of the other person, at the risk of becoming an accomplice in that person's death. . . The alterity of the Other is the extreme point of the 'thou shalt not kill' and, in me, the fear of all the violence and usurpation that my existing, despite the innocence of its intentions, risks committing" (p. 109–110). Here, the German officer looks into the face of the Muselmann. Despite Wladyslaw's emaciated, starved state, he plays passionately, and the German officer appears moved and able to see Wladyslaw on some level as human. Not only does the officer refuse to turn in the pianist, but he returns periodically with food for him. Wladyslaw is doubly alien to the German officer: he is a dehumanized creature and he is a Jew. And yet the German officer develops empathy for the starving Jew, and this experience enables him to take responsibility for, and demonstrate his commitment toward Wladyslaw. The film positions us to do the same: it attempts to engender empathy by enabling us to experience an intimacy with Wladyslaw even as we are forced to remain estranged from him. Even though *The Pianist* begins by encouraging our emotional identification with Wladyslaw, his progressive dehumanization makes this

difficult to sustain and ultimately requires us to develop a more intellectual engagement with him and with the circumstances of his existence. *The Pianist* thus explores the possibilities for identification in the face of absence; the film elicits empathy by enabling viewers to experience an intimacy with Wladyslaw even as they are forced to remain estranged from him. The film explores the possibilities for bodily, experiential memory in the face of absence, allowing viewers a limited, though powerful, form of access to these traumatic events of the past.

The question remains, though, of why it might be important to take on these traumatic prosthetic memories of the past, and toward what ends the empathy such a practice fosters might serve. Aside from the very real obligations to history, to speak for the one who, as Edith (Wyschogrod 1993) describes, "is absent, cannot speak for herself, one whose actual face the historian may never see" (p. xii) there might be political reasons as well. As Nussbaum argues, some literary works, by provoking ethical thinking, might actually make a valuable contribution to citizenship (p. 66). Furthermore, learning to recognize a commitment to the face of the other, even in the face of the other's radical alterity, might be a step toward the goal Chantal Mouffe (1993) has set out of "reestablish[ing] the lost connection between ethics and politics" (p. 65). Rather than attempting to ground democratic politics in a common purpose, she proposes instead an "'ethico-political' bond based on a sense of loyalty to one another" (p. 66). Mouffe calls for citizenship, therefore, "not as a legal status, but as a form of identification" (p. 65). What I am proposing is that the cinema might function as a training ground for this kind of engagement, both as it rehearses a complicated, non-essentialist form of identification with the other who is presented as someone with whom we have no common ground other than our shared humanity. The cinema, I am arguing, has the unique ability to force us to confront those histories from which our impulse leads us to turn away, encourages us to take them on and let them become part of the archive of experience not as something familiar, but as something foreign. Do I think this happens every time one sets foot in the cinema? Of course not. But I do think that even dominant film practices and strategies might be deployed to serve a pedagogical function, to teach viewers how to identify with the other especially in the face of difference, to encourage spectators to take on traumatic prosthetic memories that might lead to the development of empathy, and that might open the door to more radical democratic engagements and movements in the future.

References

Agamben, G. (2002). *Remnants of Auschwitz: the witness and the archive. Trans. D. Heller-Roazen.* New York: Zone Books.

Bean, J. M. (2001). Technologies of early stardom and the extraordinary body. *Camera Obscura, 16*(3), 8–57, 48.

Benjamin, W. (1978). On the mimetic faculty. In W. Benjamin (Ed.), *Reflections. Trans. E Jephcott.* New York: Schocken.

Berenstein, R. (1995). Spectatorship as drag: the act of viewing and classic horror cinema. In L. Williams (Ed.), *Viewing positions: ways of seeing film*, pp. 231–270. New Brunswick: Rutgers UP.

Buck-Morss, S. (1989). *The dialectics of seeing: Walter Benjamin and the arcades project.* Cambridge: MIT Press.

Clover, C. J. (1992). *Men, women and chain saws: Gender in the modern horror film.* Princeton, NJ: Princeton UP.

Davis, T. F., & Womack, K. (2001). *Mapping the ethical turn.* Charlottesville: U of Virginia Press.

Hansen, M. (1986). Pleasure, ambivalence, identification: Valentino and female spectatorship. *Cine J. 25* (4), 6–32.

Koss, J. (2006). On the limits of empathy. The Art Bulletin, http://findarticles.com/p/articles/mi_m0422/is_1_88/ai_n26855862

Landsberg, A. (2004). *Prosthetic memory: The transformation of American remembrance in the age of mass culture*. New York: Columbia UP.

Levinas, E. (1987). *Time and the other. Trans. Richard A. Cohen*. Duquesne UP: Pittsburgh.

Metz, C. (1986). *The imaginary signifier*. Bloomington: Indiana UP.

Mouffe, C. (1993). *The return of the political*. London: Verso.

Nussbaum, M. (2001). Exactly and responsibly: a defense of ethical criticism. In T. F. Davis & K. Womack (Eds.). *Mapping the ethical turn*. Charlottesville: University of Virginia Press.

Rosen, P. (ed.) (1986) *Narrative, apparatus, ideology*. New York: Columbia UP, 286–298 and 299–318

Taussig, M. (1993). *Mimesis and alterity*. New York: Routledge.

Williams, L. (1995). Introduction. In L. Williams (Ed.), *Viewing positions: ways of seeing film*, pp. 1–20. New Brunswick: Rutgers UP.

Wyschogrod, E. (1993). *An ethics of remembering*. Chicago: University of Chicago Press.

RACE

by Thomas Byrne Edsall with Mary D. Edsall

*When the official subject
is presidential politics, taxes, welfare,
crime, rights, or values . . .
the real subject is*

RACE is no longer a straightforward, morally unambiguous force in American politics; instead, considerations of race are now deeply imbedded in the strategy and tactics of politics, in competing concepts of the function and responsibility of government, and in each voter's conceptual structure of moral and partisan identity. Race helps define liberal and conservative ideologies, shapes the presidential coalitions of the Democratic and Republican parties, provides a harsh new dimension to concern over taxes and crime, drives a wedge through alliances of the working classes and the poor, and gives both momentum and vitality to the drive to establish a national majority inclined by income and demography to support policies benefiting the affluent and the upper-middle class. In terms of policy, race has played a critical role in the creation of a political system that has tolerated, if not supported, the growth of the disparity between rich and poor over the past fifteen years. Race-coded images and language changed the course of the 1980, 1984, and 1988 presidential elections and the 1990 elections for the governorships of California and Alabama, the U.S. Senate in North Carolina, and the post of Texas secretary of agriculture. The political role of race is subtle and complex, requiring listening to those whose views are deeply repellent to some and deeply resonant for others. The debate over racial policy has been skewed and distorted by a profound failure to listen.

"You could classify me as a working-class Democrat, a card-carrying union member," says Dan Donahue, a Chicago carpenter who became active in the campaign of a Republican state senator in 1988. "I'm not a card-carrying Republican—yet. We have four or five generations of welfare mothers. And they [Democrats] say the answer to that is we need more programs. Come on. It's well and good we should have compassion for these people, but your compassion goes only so far. I don't mind helping, but somebody has got to help themselves, you've got to pull. When you try to pick somebody up, they have to help. Unfortunately, most of the people who need help in this situation are black and most of the people who are doing the helping are white. We [white Cook County voters] are tired of paying for the Chicago Housing Authority, and for public housing and public transportation that we don't use. They [taxpayers] hate it [the school-board tax] because they are paying for black schools that aren't even educating kids, and the money is just going into the Board of Education and the teachers' union.

Moderate-income voters like Donahue pose a central dilemma for the Democratic Party. They are essential if the party is to have an economically coherent base, and if the party is legitimately to claim to represent not only the poor but also the average working man and woman. These voters have, however, been caught up in an explosive chain reaction of race, rights, values, and taxes which has propelled significant percentages of them out of the Democratic Party in presidential elections and into the "unreliable" column in state and local contests. Racism and racial prejudice fail to explain such voter defection

Copyright 1991 by Thomas Byrne Edsall and Mary D. Edsall. All rights reserved. The Atlantic Monthly; *May 1991; Race; Volume 267, No. 5 pages 53-86.*

adequately, and Democratic liberals' reliance on charges of racism guarantees political defeat and, more important, guarantees continued ignorance of the dynamics at the core of presidential politics.

THE COSTS OF LIBERALISM

The past two decades have seen a significant enlargement of the ideological and value-based under-pinnings of political conservatism and, to a large extent, of the Republican Party. Race, rights, and taxes have become key forces behind this enlargement, helping to bring about a new polarization of the electorate, a polarization that has effectively replaced the New Deal coalition structure of presidential contests.

This polarization is built on mutually reinforcing divisions of the electorate: taxpayers against tax recipients; those who emphasize responsibility against those who emphasize rights; proponents of deregulation and an unfettered free market against supporters of the regulatory state and of policies protecting or advancing the interests of specific groups; and, finally, whites against blacks. Public policies backed by liberals have driven these new alignments. In particular, busing, affirmative action, and much of the rights revolution in behalf of criminal defendants, prisoners, homosexuals, welfare recipients, and a host of other previously marginalized groups have, for many voters, converted the government from ally to adversary. The simultaneous increase, over the past two and a half decades, in crime, welfare dependency, illegitimacy, and educational failure have established in the minds of many voters a numbing array of "costs"—perceived and real—of liberalism. Major elements of the Republican Party have exploited and inflated the costs of liberal policies. Republican strategists and ideologues have furthermore capitalized on these costs to establish a new and evolving ideology: conservative egalitarianism, opposed to special preferences whether for blacks, unions, or any other liberal interest. Liberal Democratic support for preferential hiring on the shop floor and in the schoolroom—to make up for past discrimination—has enabled a conservative Republican Party to lay claim to the cause of equal opportunity, once the rallying cry of the civil-rights movement. In the wake of sustained group and individual conflicts over rights, preferences, and government benefits, an egalitarian populism of the right has emerged, one so strong that it was not only accessible to George C. Wallace in 1968 but remained available twenty years later to a scion of the old guard of the Northeast, George Herbert Walker Bush. Conservative populism has permitted the Republican Party to replace in the minds of many voters the idea of an "establishment" ruled by business interests with a hated new liberal establishment, adversarial to the common man: an elite—of judges, bureaucrats, newspaper editors, ACLU lawyers, academics, Democratic politicians, civil-rights and feminist leaders—determined to enact racially and socially redistributive policies demanding the largest sacrifices from the white working and lower-middle classes.

This new polarization drives a wedge right through the heart of the old Democratic presidential coalition, and threatens to undermine the genuine advances in racial equality which have occurred in the years since the passage of the 1964 Civil Rights Act. Race relations in America are, in fact, moving on two tracks. On one there has been an extraordinary integration of the races, a striking expansion of the black middle class, and a powerful contribution from blacks to the mainstream culture. American society is undergoing a transformation that may ultimately destroy many of the racial stereotypes that drive prejudice. In the years before the outbreak of the Second World War, 73 percent of all black college graduates became ministers or teachers, almost all serving exclusively black constituencies. In 1940 only 187,520 blacks held white-collar jobs, and over 100,000 of them were clergymen, teachers, or the owners of generally small, ghetto-based retail stores producing marginal incomes. By 1990, 1.91 million blacks held managerial and professional jobs. From 1950 to 1990 the black population doubled but the number of blacks holding white-collar jobs increased by 920 percent.

On the second track, racial progress has run into major roadblocks: crime, welfare dependency, ille-gitimacy, drug abuse, and a generation—disproportionately black—of young men and women unwilling either to stay in school or to take on menial labor, a group that has collided with a restructuring of the American economy and a dramatic loss of well-paid entry-level jobs. The worsening of the symptoms of social dysfunction over the past three decades has become a driving force in politics, for the symptoms are perceived as an unacceptable cost of liberalism not only in the neighborhoods of southwest Chicago but also, increasingly, in the more affluent sections of suburbia and in the business cores of cities.

A NEW LEASE ON PREJUDICE

Liberal elites have had major difficulty recognizing the costs both of racial conflict and of the broader rights revolution in behalf of groups as diverse as women, the mentally disabled, prison inmates, and immigrants from developing countries. Liberal elites have in addition disregarded the effects of burdensome taxes on working-class and middle-class voters, who may see themselves as being forced to finance a revolution challenging their own values and often undermining their hard-won security. Democratic liberalism has shown a consistent reluctance to confront the inherent distributional conflicts imbedded in liberal policies. After the 1984 election the Democratic National Committee commissioned a $250,000 voter study by CRG Communications, only to quash its release because it made explicit controversial sources of dissent from liberal orthodoxy. The study, drawn from a poll of 5,000 voters and thirty-three focus groups, found that Democratic defectors among white urban ethnics and white southern moderates believed that the Democratic Party has not stood with them as they moved from the working to the middle class. They have a whole set of middle-class economic problems today, and their party is not helping them. Instead it is helping the blacks, Hispanics and the poor. They feel betrayed [These voters] view gays and feminists as outside the orbit of acceptable social life. These groups represent, in their view, a social underclass [White urban ethnics] feel threatened by an economic underclass that absorbs their taxes and even locks them out of the job, in the case of affirmative action. They also fear a social underclass that threatens to violate or corrupt their children. It is these underclasses that signify their present image of the Democratic Party The Democrats are the giveaway party. Giveaway means too much middle-class money going to blacks and the poor.

In some communities, such as the white working-class suburbs of Detroit, positive assessments of the Democratic Party have been washed out altogether by anger and discontent that are open, unabashed, and extremely harsh. Voters from such communities have been crucial to the outcome of presidential elections for the past two decades—they are the silent majority of the 1970s and the Reagan Democrats of the 1980s. Their votes expanded the Republican coalition to produce election-year majorities, and their abandonment of the Democratic Party in presidential elections undermined the coalition of the have-nots and affirmed the ascendancy of a coalition of the haves, as disaffected moderate-income white voters joined forces with traditional Republicans. The views of working-class defectors from the Democratic Party were examined in a 1985 study of suburban Detroit by Stanley Greenberg, the president of the Analysis Group, a Democratic polling firm. The study found that these white Democratic defectors express a profound distaste for blacks, a sentiment that pervades almost everything they think about government and politics. Blacks constitute the explanation for their [white defectors'] vulnerability and for almost everything that has gone wrong in their lives; not being black is what constitutes being middle class; not living with blacks is what makes a neighborhood a decent place to live These sentiments have important implications for Democrats, as virtually all progressive symbols and themes have been redefined in racial and pejorative terms

The special status of blacks is perceived by almost all of these individuals as a serious obstacle to their personal advancement. Indeed, discrimination against whites has become a well-assimilated and ready explanation for their status, vulnerability and failures.

The bitterness and anger of the white Detroit voters is one consequence of a central tragedy of the past twenty-five years: the drive to achieve racial equality and the striking advances of the black middle class have coincided with a significant worsening of social dysfunction in the bottom third of the black community. Social dysfunction—crime, welfare dependency, joblessness, and illegitimacy—wreaks havoc, crushing recognition of the achievements of liberalism. When it is disproportionately associated with one group or race, social dysfunction assaults efforts to eliminate prejudice. Gordon W. Allport wrote in The Nature of Prejudice, Prejudice . . . may be reduced by equal status contact between majority and minority groups in the pursuit of common goals. The effect is greatly enhanced if this contact is sanctioned by institutional supports . . . and provided it is of the sort that leads to the perception of common interests and common humanity between members of the two groups.

The contact between whites and the black underclass has routinely violated every standard necessary for the breakdown of racial stereotypes. Most white contact with the underclass is through personal experience of crime and urban squalor, through such experience related by friends and family, or through the daily reports about crime, drugs, and violence which appear on television and in newspapers. The news includes, as well, periodic reports on out-of-wedlock births, welfare fraud, drug-related AIDS, crack babies, and inner-city joblessness.

"The stereotype is not a stereotype anymore," says Kenneth S. Tollett, a black professor of education at Howard University. "The behavior pattern in the underclass is not stereotypical in the pejorative sense, but it is a statement of fact. A stereotype is an overgeneralization, 'This is the way people are,' and then we say all are like that. The behavior of black males in the underclass is now beginning to look like the black stereotype. The statements we have called stereotypes in the past have become true."

Social dysfunction, and crime in particular, have tragically served over the past two and a half decades to reinforce racial prejudice. Statistics suggest the widespread problems among the black underclass.

In a nation that is 12 percent black and 84 percent white, there were in 1986, according to the Department of Justice, more black prison inmates than white or Hispanic. There were in 1988, according to the Department of Health and Human Services, more black welfare recipients than white. By the late 1980s, according to the Bureau of the Census, a majority of black families where headed by single or separated women. At the same time, according to the National Center for Health Statistics, more than 60 percent of all black children were born out of wedlock. Among black male high school dropouts aged twenty to twenty-four, according to the Bureau of Labor Statistics, the proportion who had not worked at all during the previous year rose from 15.1 percent in 1974 to a staggering 39.7 percent in 1986. The comparable figures for young white dropouts were 9.1 percent in 1974 and 11.8 percent in 1986, and for young Hispanic dropouts 8.8 percent and 9.6 percent. According to figures compiled by the Department of Justice in criminal-victimization surveys from 1979 to 1986—the surveys considered by law-enforcement professionals to contain the most reliable data on race—an annual average of 44.3 out of every 1,000 blacks were victims of a violent crime, with much higher rates in very poor areas, as compared with 34.5 out of every 1,000 whites. At the same time, however, a far higher percentage of the crimes committed by blacks than of the crimes committed by whites were interracial. In 1986 and 1987 whites committing crimes of violence—robbery, rape, and assault—chose white victims 97.5 percent of the time and black victims 2.5 percent of the time in those incidents in which the victim could identify the race of the offender. Blacks committing violent crimes chose white victims 51.2 percent of the time and black victims 48.8 percent of the time. For the specific crime of robbery the figures are similarly striking. In 1986–1987, of those robberies in which the race of the offender was identified by the victim, 95.1 percent of robberies committed by whites had white victims and 4.9 percent had black victims; 57.4 percent of robberies committed by blacks had white victims and 42.6 percent had black victims.

THE RACES POLARIZE OVER WHAT'S GONE WRONG

Violence, joblessness, drug abuse, and family disintegration have not only functioned to reinforce racial prejudice; they have also led to widely differing interpretations of what has gone wrong. Significant numbers of blacks, both middle-class and poor, see malevolent white power behind the disruption and dislocation in black neighborhoods. Take drug abuse. "It's almost an accepted fact," says Andrew Cooper, the publisher of the City Sun, a black weekly Brooklyn newspaper, echoing ideas often heard on black radio talk shows and in other all-black forums. "It's a deep-seated suspicion. I believe it. I can't open my desk drawer and say, 'Here it [the evidence] is.' But there is just too much money in narcotics. People really believe they are being victimized by The Man. If the government wanted to stop it, it could stop it." Louis Farrakhan, the leader of the Nation of Islam, brought an entire auditorium of black politicians, intellectuals, and organizers—men and women on the left of the political spectrum, but by no means on the outer fringes—to their feet during a 1989 speech in New Orleans which clearly captured elements of a black world view. He said, "The black man and woman in America is of no further use to the children of our former slavemasters and when a thing loses its use or utility, it loses its value. If your shoes wear out, you don't keep them around; if an old dress becomes old, you don't keep it around. Once it loses utility, you move to get rid of it We cannot accept the fact that they think black people have become a permanent underclass If we have become useless in a racist society, then you must know that not public policy but a covert policy is being already formulated to get rid of that which is useless, since the economy is going down and the world is going down. Follow me, brothers and sisters. According to demographers, if the plummeting birth rate of white people in America continues, in a few years it will reach zero population growth. As for blacks, Hispanics, and Native Americans, if their present birth rate continues, by the year 2080, demographers say, blacks, Hispanics, and Native Americans will conceivably be 50 percent or more of the United States population If things continue just birthwise, we could control the Congress, we could control the Supreme Court, we could control state legislatures, and then 'Run, Jesse, run,' or 'Run, Jesse Junior, run,' or 'Run, Jesse the Third, run.'"

The emergence of predominantly black underclass neighborhoods rife with the worst symptoms of social pathology has proved to be one of the most disturbing developments in the United States, both for city residents and for residents of surrounding areas. In his book Canarsie, the Yale sociologist Jonathan Rieder described the climate of opinion he found in the late seventies in one of Brooklyn's white urban ethnic enclaves:

Canarsie's image of ghetto culture crystalized out of all the visual gleanings, fleeting encounters, and racist presumptions. Lower-class blacks lacked industry, lived for momentary erotic pleasure, and, in their mystique of soul, glorified the fashions of a high-stepping street life. The hundreds of thousands of female-headed minority households in New York City, and the spiraling rate of illegitimate births, reinforced the impression that ghetto women were immoral When provincial Jews and Italians recoiled from the riven families of the ghetto, they were prisoners of ancient notions of right as well as vituperative passion. "The blacks have ten kids to a family," the Italian wife of a city worker observed" Bring up a few, give them love and education." . . . It is hard to exaggerate the bewilderment Canarsians felt when they considered the family patterns of the ghetto. To be without a family in southern Italy "was to be truly a non-being, un saccu vacante (an empty sack) as Sicilians say, un nuddu miscatu cu nenti (a nobody mixed with nothing)."

THE VALUES BARRIER

The intensity of public reaction to the world of the underclass has coincided with a larger conflict in America over values. This conflict has evolved, in complex ways, from one of the major struggles of the twentieth century: the struggle between so-called traditional values and a competing set of insurgent values.

Traditional values generally have been seen to revolve around commitments to the larger community—to the family, to parental responsibility, to country, to the work ethic, to sexual restraint, to self-control, to rules, duty, authority, and a stable social order. The competing set of insurgent values, the focus of rights-oriented political ideologies, of the rights revolution, and of the civil-rights movement, has been largely concerned with the rights of the individual—with freedom from oppression, from confinement, from hierarchy, from authority, from stricture, from repression, from rigid rule-making, and from the status quo.

On a level essentially ignored by liberal elites—but a level, nonetheless, of stark reality to key voters—the values debate has become conflated with racial politics. Among Democrats and liberals the stigmatization of racism in the 1960s had the unintended and paradoxical consequence of stigmatizing the allegiance of many voters to a whole range of fundamental moral values. In the late 1960s and early 1970s the raising of the "traditional values" banner over such issues as law and order, the family, sexual conduct, joblessness, welfare fraud, and patriotism was seen by liberals and blacks—with some accuracy—as an appeal to racist, narrow-minded, repressive, or xenophobic instincts, designed to marshal support for reactionary social policies. The conflation by the political right of values with attempts to resist racial integration, to exclude women from public life, and to discredit the extension of constitutional rights to minorities fueled an often bitter resistance by the left and by blacks to the whole values package.

The result was that liberal Democrats often barred from consideration what are in fact legitimate issues for political discourse, issues of fundamental social and moral concern which must be forth-rightly addressed by any national candidate or party. This stigmatization as "racist" or as "in bad faith" of open discussion of values-charged-matters—ranging from crime to sexual responsibility to welfare dependency to drug abuse to standards of social obligation—has for more than two decades created a VALUES BARRIER between Democratic liberals and much of the electorate. Insofar as many voters feel that their cherished policies and practices have been routed, the values barrier has been a major factor in fracturing a once deeply felt loyalty to a liberal economic agenda.

When rank-and-file white voters characterize the value structure of the underclass as aberrant, white liberals are not alone in their angry response. In segments of the black community the response is often a wounded outrage so extreme that it precludes all debate.

Bernard Boxill, a black scholar at the University of North Carolina, has, for example, argued that the growing problems of the underclass may be used by the white community as "an excuse to undo the legal, social and economic advances made by the black middle class, plunge the country into a race war, and worst of all, be a pretext for genocide."

Dr. Frances Welsing, a black psychiatrist, was loudly applauded at a predominantly black "town meeting" organized and televised in 1989 by ABC-TV and Ted Koppel when she argued that whites bear responsibility for whatever disorders there may be in black ghettos:

"Racism is a behavior system that is organized because white people are a minority on the planet If we understand the white fear of genetic annihilation, which is why Willie Horton [the Massachusetts prisoner who committed rape and assault while on furlough] could be used as a very pro-found symbol by the Republican Party to win this election, then we will understand what is happening to the black male in this society. The black male is a threat to white genetic annihilation. And so he is profoundly attacked in this society."

THE ROOTS OF OUR RACE-CHARGED POLITICS

In the gulf between Frances Welsing and Dan Donahue one can see evidence of a political struggle that goes back to the 1960s. When one looks at recent political history through the prism of our current race-charged politics, familiar events take on a new significance. From the perspective of 1991, for

example, the presidential election of 1964 stands out as a turning point in the politics of race in the United States. That election forced race, already a volatile national issue, into the partisan competition between the Democratic and Republican parties. The 1964 contest pitted the Democrat Lyndon Johnson, the leading supporter of the recently passed Civil Rights Act (which granted full U.S. citizenship rights to blacks for the first time in history), against the Republican Barry Goldwater, an ideological conservative and a strong opponent of the bill. By Election Day, 1964, an exceptional 75 percent of the electorate knew that Congress had that year passed the bill, with a striking 96 percent of those voters aware that Johnson had backed the measure and 84 percent aware that Goldwater had opposed it.

The Democratic and Republican nominees' polarized positions on civil rights immediately transformed public perceptions of the two parties. Two years before the 1964 election, polls conducted by National Election Studies showed virtually no difference in the public assessment of whether the Democratic or the Republican Party would be "more likely to see to it that Negroes get fair treatment in jobs and housing." Of those polled in the 1962 survey, 22.7 percent identified the Democrats as more likely to protect black interests, 21.3 percent identified the Republicans, and the remaining 56 percent said either that there was no difference between the parties or that they had no opinion. By 1964, however, fully 60 percent identified the Democratic Party as more likely to help blacks get fair treatment in seeking jobs, and only seven percent identified the Republican Party—the party of Abraham Lincoln.

By 1964 the Democrats had become the party of racial liberalism and the Republicans had become the party of racial conservatism. It was the first and last presidential election in which racial liberalism was politically advantageous.

The event most strikingly associated with the decline in political support for Democratic liberalism was the riot that broke out on August 11, 1965, in the Watts section of Los Angeles. Blacks throwing rocks and bottles at policemen shouted, "Burn, baby, burn!" as television cameras rolled. By August 16, after the National Guard had been called in and order slowly restored, there were thirty-four dead, more than 1,000 injured, over 800 buildings damaged or destroyed, and nearly 4,000 arrests. Even Martin Luther King, Jr., the leader of black protests since the Montgomery bus boycott in 1955, was unprepared for Watts. Stunned by the scope of anger among rioters, and by their perception that the civil-rights movement had been largely irrelevant to improving conditions in the ghetto, King "was absolutely undone" after visiting Watts, his close associate Bayard Rustin recalled.

A succession of other violent eruptions followed over the next three years. According to the Kerner Commission, appointed to investigate the causes of rioting, in 1967 there were 164 "disorders," eight of them ranked as "major" on the grounds that they involved "many fires, intensive looting, and reports of sniping; violence lasting more than two days; sizeable crowds; and use of National Guard or federal forces as well as other control forces." More than eighty people were killed, nearly 90 percent of them black civilians and 10 percent policemen, firemen, and other public officials. More than three quarters of the deaths were in two cities, Detroit (forty-three) and Newark (twenty-three). During the five-year period 1964–1968, according to one estimate, 329 significant outbreaks of violence took place in 257 cities. Seventy-two percent of rioters in Newark surveyed by the Kerner Commission said they agreed with the statement "Sometimes I hate white people"—a finding painful to white liberals.

The sea change in American presidential politics—the replacement of a liberal majority with a conservative majority—involved the conversion of a relatively small proportion of voters: the roughly five to ten percent of the electorate, made up primarily of white working-class voters, empowered to give majority status to either political party. Alabama Governor George C. Wallace was the politician who showed the Republicans how to seize lower-income white voters. Running as a third-party candidate in 1968, Wallace capitalized on the huge defection of white Democrats, particularly in the South, as the Democratic Party formally repudiated segregation. He won just under 14 percent of the vote. Wallace

and Nixon together that year won 57 percent of the vote, however, establishing what would become the conservative presidential majority. This majority carried every presidential election but one over the next twenty years—the exception being Southern Baptist Jimmy Carter's victory in the wake of Watergate, the worst Republican scandal in history.

The strength of Wallace's appeal in 1968 went beyond white backlash. Wallace defined a new right-wing populism, capitalizing on voter reaction to the emergence of racial, cultural, and moral liberalism. Wallace demonized an elite Democratic establishment, providing a desperately sought-after moral justification to those whites who saw themselves as victimized and displaced by the black struggle for civil rights and by broader social change. For these voters, Wallace portrayed the civil-rights movement not as the struggle of blacks to achieve equality—a goal impossible to challenge on moral grounds—but as the imposition of intrusive "social engineering" on working men and women by a coercive federal government in the hands of a liberal cabal: lawyers, judges, editorial writers, government bureaucrats, and intellectuals. "They have looked down their noses at the average man on the street too long," Wallace told disaffected voters. "They've looked down at the bus driver, the truck driver, the beautician, the fireman, the policeman, and the steelworker, the plumber, and the communications worker, and the oil worker, and the little businessman, and they say, 'We've gotta write a guideline. We've gotta tell you when to get up in the morning. We've gotta tell you when to go to bed at night.'" Wallace laid the groundwork for the Republican assault on "reverse discrimination." "You know who the biggest bigots in the world are—they're the ones who call others bigots," he declared at a Milwaukee rally, as he struggled to be heard over the shouts of protesters. In another campaign speech he said, "It's a sad day in the country when you can't talk about law and order unless they want to call you a racist. I tell you that's not true."

Perhaps most important for long-range Republican strategy, Wallace brought into mainstream presidential politics a new political symbol, a vilified Democratic establishment that replaced as an enemy of lower-income voters the Republican establishment of corporate America and the rich. Wallace effectively portrayed this Democratic establishment as bent on imposing a liberal, authoritarian, statist agenda on an unwilling electorate.

To voters resentful of the heavy hand of the new liberal establishment, Wallace said, "You are one man and one woman, and your thoughts are just as good as theirs."

Richard Nixon set out to win the Wallace vote. Nixon was among the first Republicans to understand how the changing civil-rights agenda could be manipulated to construct a new conservative majority. His strategy effectively straddled the conflict between increasing public support for the abstract principle of racial equality and intensified public opposition to government-driven enforcement mechanisms. Nixon found a message that encompassed the position of the growing majority of white Americans who had come to believe that the denial of basic citizenship rights to blacks was wrong, but who were at the same time opposed to the prospect of forced residential and educational integration, directed by the courts and the federal regulatory bureaucracy. When, in October of 1969, the Supreme Court rejected an Administration attempt to postpone the desegregation of Mississippi's schools, Nixon declared, "We will carry out the law," but he stressed that he did "not feel obligated to do any more than the minimum the law required." The Court ruling, Nixon warned, should not be viewed by "the many young liberal lawyers [in the Justice Department] . . . as a carte blanche for them to run wild through the South enforcing compliance with extreme or punitive requirements they had formulated in Washington." On the campaign trail in 1972 Nixon declared,

There is no reason to feel guilty about wanting to enjoy what you get and get what you earn, about wanting your children in good schools close to home, or about wanting to be judged fairly on your ability. Those are not values to be ashamed of; those are values to be proud of. Those are values that I shall always stand up for when they come under attack.

THE REPUBLICAN RACIAL STRATEGY

A central irony of the Nixon administration was that the development of a Republican alternative—»black capitalism»—to the traditional civil-rights agenda created a critical vulnerability for Democrats in the 1980s. Under black capitalism the federal government began actively to promote three racial-preference programs that would soon become controversial: a minority contracting program known as "8-a," which set aside fixed percentages of federal contracts for minority-owned businesses; the Office of Minority Business Enterprise, established within the Department of Commerce to assist minority business in securing government contracts; and, most important, the so-called Philadelphia Plan, designed to increase black access to high-paying union jobs.

The Philadelphia Plan established the authority of the federal government to require companies doing business with the government to set up "goals and timetables" for the hiring and promotion of minority members. The plan set specific percentage "ranges" for blacks and other minority groups for craft-union jobs. For example, plumbers and pipefitters, of whom only twelve out of 2,335 in Philadelphia were black (0.5 percent), were given a hiring goal of five to eight percent in 1970, a range that would rise to 22 to 26 percent by 1973. The goals-and-timetables mechanism was incorporated in 1970 into the regulations governing all federal procurement and contracting—affecting a universe of corporations that employed more than a third of the nation's work force.

Nixon in 1969 did not anticipate that the affirmative-action provisions of his Philadelphia Plan would become, in the course of the next twenty years, essential to a Republican strategy of polarizing the electorate along lines of race—and thus be vital to constructing a presidential partisan realignment. It did not take him long to learn, however: by the 1972 election Nixon was campaigning against the quota policies that his own Administration had largely engendered.

It was Nixon's re-election campaign that developed a relatively comprehensive Republican racial strategy stressing whenever possible the costs of remedies for discrimination, especially in the cases of busing and affirmative action. On March 17, 1972, Nixon escalated his assault on busing. The school bus, "once a symbol of hope," had become a "symbol of social engineering on the basis of abstractions," he said. Seeking to reap political rewards from the growing stockpile of blue-collar resentment, Nixon turned against his own Philadelphia Plan: "When young people apply for jobs . . . and find the door closed because they don't fit into some numerical quota, despite their ability, and they object, I do not think it is right to condemn those young people as insensitive or even racist."

THE DEMOCRATS BECOME A WHITE-COLLAR PARTY

In devising a political strategy for capturing white working-class and southern voters, the Nixon Administration in 1972 would have had difficulty designing a scenario more advantageous to the Republicans, and more damaging to the Democratic-Party, than the one the Democrats devised for themselves. This scenario grew out of a seemingly minor development at the 1968 Democratic convention. As a token gesture of appeasement to the forces of Eugene McCarthy and Robert Kennedy, Democratic Party regulars allowed the creation of a special Commission on Party Structure and Delegate Selection, to ensure that "all feasible efforts have been made to assure that delegates are selected through party primary, convention, or committee procedures open to public participation within the calendar year of the National Convention."

No one, neither Democratic Party regulars nor the press, had any notion of the scope of what had been set in motion. "There was not much attention to the Rules Committee reports," Max Kampelman, one of Hubert Humphrey's major strategists, recalled later. "Our objective was to get a nominee We said to ourselves, if you are going to STUDY it, you can control it. If you get

the nomination, you'll have control of the DNC [Democratic National Committee]. If you have the DNC, then you'll control any study. A study commission could be a way of harmonizing the issue." Few political judgments have proved more incorrect.

The liberal-reform wing of the Democratic Party—in part made up of veterans of the civil-rights and student anti-war movements—dominated the party-structure commission and achieved a radical alteration of the presidential-delegate selection process. The new rules shifted the power to nominate presidential candidates from the loose alliance of state and local party structures, which had in the past been empowered to use their control of the party to pick delegates, to the universe of activists, often rights-oriented liberal reformers, who were now granted direct access to the machinery of delegate selection. "Before reform," Byron Shafer wrote in his book describing the party rules changes, Quiet Revolution, there was an American party system in which one party, the Republicans, was primarily responsive to white-collar constituencies and in which another, the Democrats, was primarily responsive to blue-collar constituencies. After reform, there were two parties each responsive to quite different white-collar coalitions, while the old blue-collar majority within the Democratic Party was forced to try to squeeze back into the party once identified predominantly with its needs.

In other words, those who unquestionably lost power in the Democratic presidential-nomination process were the white working- and lower-middle-class voters who were already leaving the party in droves because they felt the heaviest burdens of the civil-rights revolution had been placed on their shoulders.

Party reforms produced a substantive ideological upheaval. Before 1972, Democratic presidential delegates were only slightly more liberal than the public at large, according to delegate surveys, while Republican delegates were considerably more conservative than the electorate. Delegates to the 1972 Democratic convention, however, were significantly further to the political left of the electorate at large than the Republican delegates that year were to the right.

No development better summarizes the shift in intra-party power than the decision by the McGovern forces at the 1972 convention to oust the fifty-nine-member Cook County delegation under the control of Chicago Mayor Richard Daley. Since 1932 the Chicago organization had been more important to the success or failure of Democratic presidential candidates than any other city machine. Without Daley in 1960, for example, John F. Kennedy would not have carried Illinois by an 8,858-vote margin.

The Cook County delegation, elected in a March 21 Illinois primary, was vulnerable to challenge because Daley's machine had slated candidates in closed meetings, and because the composition of the Chicago delegation did not include the required proportions of women and blacks.

Pro-McGovern reformers successfully voted out the Daley delegates and replaced them with a slate "chosen no one knew quite how," according to Theodore H. White. White wrote, In the 1st Congressional District of Chicago, for example, a group of people had met at the home of one James Clement and decided that only ten of those present might vote for an alternate to Mayor Daley's slate; those ten had chosen 7 delegates, including the Reverend Jesse Jackson. This rival hand-picked alternate slate offered the exact proportion of women, blacks and youth required by the McGovern reform rules. Yet the elected slate in the 1st Congressional had been voted in by the people of Chicago, and these had not.

In an open letter to Alderman William Singer, the leader of the Chicago reformers, the Chicago Sun-Times columnist Mike Royko wrote, I just don't see where your delegation is representative of Chicago's Democrats About half of your delegates are women. About a third of your delegates are black. Many of them are young people. You even have a few Latin Americans. But as I looked over the names of your delegates, I saw something peculiar . . . There's only one Italian there. Are you

saying that only one out of every 59 Democratic votes cast in a Chicago election is cast by an Italian? And only three of your 59 have Polish names Your reforms have disenfranchised Chicago's white ethnic Democrats, which is a strange reform Anybody who would reform Chicago's Democratic Party by dropping the white ethnic would probably begin a diet by shooting himself in the stomach.

After the credentials committee voted seventy-one to sixty-one to oust the Daley delegation, Frank Mankiewicz, a spokesman for the McGovern campaign, dryly noted, "I think we may have lost Illinois tonight."

In the 1972 general election, George McGovern lost not only Illinois but forty-eight other states, being defeated by 61 percent to 38 percent, or 18 million votes. For the long-run future of the capacity of the Democratic Party to nominate and elect Presidents, the central issue was not just the magnitude of McGovern's defeat. It was the inability of the Democratic Party to absorb competing factions and to mediate the differences among them. The new rules removed from the presidential-nomination process those white elected and party officials who were closer to the racial and cultural conflicts plaguing the party than the liberal reformers who dominated the proceedings. Among those who did not attend the 1972 convention were 225 of 255 Democratic congressmen, the Democratic mayors of Los Angeles, Detroit, Boston, Philadelphia, and San Francisco, Mayor Daley and his Chicago loyalists, and uncounted city councilmen, state legislators, and leaders of Democratic ward organizations.

These leaders represented white voters who were on the front lines of urban housing integration; who were the subjects of busing orders; who were competitors for jobs as policemen and firemen and union craftsmen which were governed by affirmative-action consent decrees; who regarded as incomprehensible many liberal Supreme Court decisions on criminals' rights, abortion, sexual privacy, school prayer, busing, and obscenity. These voters and their political representatives were, and still are, largely relegated to peripheral status in the Democratic presidential-primary process. With the withdrawal of socially conservative white voters from the nomination process, Democratic presidential candidates have negotiated that process in the context of an artificially liberal primary electorate that puts the candidates outside the ideological mainstream and provides them with virtually no training in the kinds of accommodation and bargaining essential to general-election victory.

THE CIVIL RIGHTS AGENDA BECOMES REDISTRIBUTIVE

As the white working-class voters who had formed the core of the New Deal coalition began to lose clout within the Democratic Party, the economy began to falter. Steady economic growth, which had made redistributive government policies tolerable to the majority electorate, came to a halt in the mid—1970s. With stagnation the threat to Democratic liberalism intensified. Just as the civil-rights movement reached its height, high-paying union jobs and big-city patronage—which had served to foster upward mobility for each succeeding immigrant generation—began to dry up. Many blacks lost even a toehold on the ladder, while whites slipped down, sometimes just a rung, sometimes all the way to the bottom.

The end of vigorous post-Second World War economic growth came in 1973. Hourly earnings, which had grown every year since 1951 in real, inflation-adjusted dollars, fell by 0.1 percent in 1973, by 2.8 percent in 1974, and by 0.7 percent in 1975. Weekly earnings fell more sharply, by 4.1 percent in 1974 and by 3.1 percent in 1975. Median family income, which had grown from $20,415 (in 1985 inflation-adjusted dollars) in 1960 to $29,172 in 1973, began to decline; family income fell to $28,145 in 1974 and then to $27,421 in 1975.

In a whipsaw action the middle-class tax burden rose with inflation while the economy and real income growth slowed. The tax system was losing its progressivity, placing a steadily increasing share of the cost of government on middle- and lower-middle-class voters, vital constituencies for the Democratic Party. In 1953 a family making the median family income was taxed at a rate of 11.8 percent, while a family making four times the median was taxed at 20.2 percent, nearly double. By 1975 the figures had become 22.7 percent for the average family and 29.5 percent for the affluent family. In other words, for the affluent family the tax burden increased by 46 percent from 1953 to 1976, while for the average family it increased by 92.4 percent.

As the job market, income patterns, and growing pressure from many groups for spending on the poor created a competition for government funds in which there were more losers than winners, the civil-rights agenda itself became increasingly redistributive. In order to remedy past and present discrimination in both employment and education, the courts and the federal regulatory structure turned to tough affirmative-action policies. Federal directives and regulations—developed in part by the Equal Employment Opportunity Commission and endorsed by the Supreme Court in 1971 in Griggs v. Duke Power Co. and in later decisions—sharply restricted hiring and promotion procedures that adversely affected blacks.

The most aggressive efforts to provide jobs for blacks were directed at the most besieged white Democratic constituencies: the building-trades unions and police and fire departments. White men working as carpenters, plumbers, sheet-metal workers, iron workers, steamfitters, cops, and firemen became the focus of the anti-discrimination drive waged by the Civil Rights Division of the Justice Department.

The dilemma inherent in using racial preference to remedy past discrimination is sharply reflected in Justice William Brennan's 1976 majority opinion upholding the award of retroactive seniority to blacks in Franks v. Bowman Transportation Co., Inc., and in the dissenting opinion of Justice Lewis Powell.

Brennan wrote that retroactive seniority was essential for the victim of discrimination, because without it he will never obtain his rightful place in the hierarchy of seniority according to which these various employment benefits are distributed. He will perpetually remain subordinate to persons who, but for the illegal discrimination, would have been, in respect to entitlement to these benefits, his inferiors.

Powell, on the other hand, contended that the award of retroactive seniority would penalize "the rights and expectations of perfectly innocent employees. The economic benefits awarded discrimination victims would be derived not at the expense of the employer but at the expense of other workers."

The intensity of the conflict over affirmative action can be seen in less abstract terms in Birmingham, Alabama. Not until 1968—103 years after the end of the Civil War—did the Birmingham fire department hire its first black fireman. Throughout all those years blacks were systematically denied the opportunity not only of employment but also of building seniority and learning the promotional ropes. Legal proceedings were initiated against the city in 1974, the year the second black fireman was hired. Richard Arrington, Birmingham's first black mayor, was elected in 1979, and two years later the city agreed to a consent decree providing that every white hire or promotion would be matched, one for one, by a black hire or promotion, as long as blacks were available who had fulfilled basic test requirements.

In 1983 James Hanson, a white fireman, and Carl Cook, a black fireman, both took the Birmingham Fire Department test for lieutenant. Both passed, but Henson ranked sixth among all who took the test, with a score of 192, while Cook ranked eighty-fifth, with a score of 122. Under the consent decree Cook was promoted to lieutenant and Henson was not.

Henson became part of a group of whites attempting to challenge the consent degree. He argued, "I can understand that blacks had been historically discriminated against. I can also understand why people would want to be punitive in correcting it. Somebody needs to pay for this. But they want me to pay for it, and I didn't have anything to do with it. I was a kid when all this went on."

Cook countered, "Say your father robs a bank, takes the money and buys his daughter a Mercedes, and then buys his son a Porsche and his wife a home in the high-rent district. Then they discover he has embezzled the money. He has to give the cars and house back. And the family starts to cry: 'We didn't do anything.' The same thing applies to what the whites have to say. The fact is, sometimes you have to pay up. If a wrong has been committed, you have to right that wrong."

The Birmingham case represents an extreme: pitting white and black workers against each other in a competition for government-controlled jobs and employment benefits. Over time these racial divisions reverberated in Birmingham's political system. Once, every elected official in this city was a Democrat; now racial conflict has begun to translate into a local partisan realignment. By the end of the 1980s Jefferson County, which encompasses Birmingham, had its eighteen seats in the state House of Representatives split between blacks and whites. In partisan terms there were eight black Democrats, one white Democrat, and nine white Republicans. Among the white Republican state representatives was Billy Gray, a former president of the Firefighters Union. Race had become central to establishing partisan difference.

The same zero-sum element of affirmative action in employment is applicable to higher education. "We are committed to a program of affirmative action, and we want to make the university representative of the population of the state as a whole," James A. Blackburn, the dean of admissions at the University of Virginia, said in 1988. "That means fewer spaces for the traditional mainstream white students who have come here from around the country If you were looking at the academic credentials, you would say Virginia has it upside down. We take more in the groups with weaker credentials and make it harder for those with stronger credentials."

REAGAN AND RACE

Explosive forces—stagnant incomes, declining numbers of manufacturing jobs, inflation-driven increases in marginal tax rates, sharply accelerating welfare dependency, skyrocketing crime, soaring illegitimacy, and affirmative-action competition for jobs and college placement—began to reach the point of combustion in the mid-to-late 1970s. Democrats failed to recognize the threat these forces represented; leaders of the party were given false comfort by the belief that Watergate had done irreparable harm to the Republicans.

The importance of race in the chain of events that brought Ronald Reagan to the White House—from the Great Inflation of the 1970s to the California tax revolt—cannot be overestimated. Reagan, echoing Goldwater from sixteen years before, strengthened the image of the Republicans as the party of racial conservatism. Under Reagan in 1980 the percentage of voters who said the Republican Party was "not likely" to help minorities shot up to 66 percent (from 40 percent in 1976), while those who said that the party would help minorities collapsed to 11 percent (from 33 percent). Unlike Goldwater in 1964, however, Reagan in 1980 demonstrated that racial conservatism was no longer a liability—that in fact it was a clear asset—as his party made gains at every level of electoral competition from state legislative seats to the White House.

Under Reagan the Republican Party in 1980 was able to stake out a conservative civil-rights stand that won strong majority support. Advocacy of "equal opportunity"—the original

clarion call of the civil-rights movement—became the center-right position, the core of the new conservative egalitarian populism. Republican and Democratic differences over what Equal Opportunity meant reflected, in part, differences in the opinions of whites and blacks. By the 1980 election the ideological divergence had extended beyond issues of civil rights to basic questions about the role and responsibilities of the federal government. In 1980 blacks who believed that it was the responsibility of government to provide jobs outnumbered those who contended that "government should just let every person get ahead on his own" by a margin of 70–30, according to National Election Studies poll data. Whites, however, split in the opposite direction, contending by a 62–38 margin that government should just let "everyone get ahead on his own" rather than guaranteeing work.

Responses to this question also revealed the extent to which ideology, voting patterns, and race had become commingled. In addition to polarizing blacks and whites, the question was found to polarize Reagan and Carter voters, with Carter getting 80 percent of those who most strongly supported government intervention to provide work, and Reagan winning 79 percent of those most strongly opposed to such intervention.

In a parallel split, Carter received 93 percent of the vote from those citizens, white and black, who most strongly supported government efforts "to improve the social and economic position of blacks," while Reagan got 71 percent of those who felt most adamantly that "the government should not make any special effort to help because they should help themselves."

Race, ideology, and partisanship had become inextricably linked, a linkage that empowered the Republican Party in its new populism. Lee Atwater, who ran southern operations for the 1980 campaign and managed George Bush's 1988 campaign, has argued, "In the 1980 campaign we were able to make the establishment, insofar as it is bad, the government. In other words, big government was the enemy, not big business. If the people are thinking that the problem is that taxes are too high and government interferes too much, then we are doing our job. But if they get to the point where they say the real problem is that rich people aren't paying taxes, that Republicans are protecting the realtors and so forth, then I think the Democrats are going to be in pretty good shape. The National Enquirer readership is the exact voter I'm talking about. There are always some stories in there about some multimillionaire that has five Cadillacs and hasn't paid taxes since 1974, or so-and-so Republican congressman hasn't paid taxes since he got into Congress. And they'll have another set of stories of a guy sitting around in a big den with liquor saying so-and-so fills his den with liquor using food stamps." So what determines whether conservative or liberal egalitarianism is ascendant, Atwater says, is "which one of those establishments the public sees as a bad guy."

Reagan focused on the right-wing populist strategy described by Atwater, playing on the combustible mix of race, big government, and white working-class anger. One of Reagan's favorite anecdotes was the inflated story of a Chicago "welfare queen" with "eighty names, thirty addresses, twelve Social Security cards" whose "tax-free income alone is over $150,000." The food-stamp program, in turn, was a vehicle to let "some young fellow ahead of you buy T-bone steak" while "you were standing in a checkout line with your package of hamburger."

Such implicitly race-laden images, and the values conflict associated with welfare and food stamps, furthered the Republican Party's efforts to expand beyond its traditional base and establish a sustained policy majority—which supported the first major retrenchment of the liberal government policies of the 1930s and the 1960s, ranging from assaults on labor to a broad attempt to dismantle the civil-rights regulatory structure and to overturn court rulings favoring minorities. In direct contrast to the "bottom-up" coalition of the New Deal Democratic Party, the new Republican presidential majority was—and is—a "top-down" coalition.

WHAT "FAIRNESS"—TO WHOM?

While the Reagan administration repeatedly stressed the costs to white America of civil-rights enforcement, especially affirmative-action remedies, the Democratic Party, deliberately or inadvertently, continued to find itself identified with those costs. Throughout the 1984 campaign Walter Mondale was repeatedly enmeshed in negotiations with Jesse Jackson, with organized labor, with feminist groups, and, most damaging of all, with those seeking to raise taxes to fuel what many voters saw as an intrusive federal government. The vulnerability of the Democratic Party was reflected in the deeply hostile public reaction to Mondale's proposal to raise $30 billion in new revenues to "promote fairness."

The Democratic "fairness" message in 1984 was viewed by a crucial sector of the white electorate through the prism of race. The Analysis Group, reporting on the views of white Democratic defectors in Macomb County, Michigan, found that conventional Democratic themes, like opportunity and fairness, are now invested with all the cynicism and racism that has come to characterize these sessions [focus groups]. In effect, the themes and Party symbols have been robbed of any meaning for these Democratic defectors. On hearing the term 'fairness,' these voters recall, on the one hand, 'racial minorities' or 'some blacks kicking up a storm,' and on the other hand, 'only politics' or politicians who are 'lying.' It never occurred to these voters that the Democrats were referring to the middle class.

Similar views abound among white voters in such communities as Boston, Philadelphia, New Orleans, Chicago, and rural East Texas. These views are particularly devastating to the Democratic Party because fairness has become a central Democratic theme. The 1980 Democratic platform declared, "In all of our economic programs, the one overriding principle MUST BE FAIRNESS." The platform of four years later asserted, "A nation is only as strong as its commitment to justice and equality. Today, A CORROSIVE UNFAIRNESS eats at the underpinnings of our society." (Emphases added.)

In addition, fairness remains a strong and legitimate issue for the legions of black Democratic voters. "The issues that concern working-class minorities comprise the traditional 'fairness' agenda of jobs, housing, welfare, and education," the voter study by CRG Communications found. "They want more benefits for themselves and their children. [They] strongly assert the validity of the 'fairness' theme. They believe that they are entitled to certain governmental benefits and view the diminishment of those benefits as a betrayal of a trust."

The association in the minds of many white voters of "fairness" with "fairness to minorities" has made it very difficult for the Democratic Party to capitalize on the striking increase in the disparity of income over the past decade not only between rich and poor but also between the working and lower-middle classes and the rich. During the 1980s the top one percent saw after-tax family income grow by 87 percent, from $213,675 in 1980 to $399,697 in 1990 (both figures in 1990 dollars); families just above the median, in the sixth decile, saw their after-tax income grow by only three percent, from $25,964 in 1980 to $26,741 in 1990.

In the 1988 election no one knew better than Michael Caccitolo, the Republican committeeman of Chicago's 23rd Ward, the difficulty of the Democratic Party's struggle to revive the issue of fairness among the once-Democratic voters of southwest Chicago. "Every night I sit at home and watch the news," he said. "I see Jesse [Jackson] up there talking about 'black empowerment, our people,' and that's sending a message out there that no Democratic precinct captain can possibly overcome. When the Dan Ryan [Expressway] was being built, the old lady from Operation Push [Rev. Willie Barrow, at that time the president of Jackson's Operation Push] comes out and says, 'We are going to close the Dan Ryan down unless we get more blacks on construction.' The people in the neighborhood remember that. Nobody threatened to close the Dan Ryan down to get Polish people on. And they [city and state officials] backed down and they gave a bunch of black guys entry-level jobs. And look who they threw off and got sent back to the neighborhood and told, 'Get on unemployment.' All it takes is two

or three of them. Would you define them as Republican precinct captains? No. Is it advantageous for the Republicans to watch a guy like that sitting in a tavern drinking his beer and telling the story about how he got bumped? And then all of a sudden it's six o'clock and [on TV] it's Jesse. It's bad and it ain't going to get better."

THE SIGNAL OF "CRIME"

In 1988 the Bush campaign assembled and deployed a range of symbols and images designed to tap into voters' submerged anxieties about race, culture, rights, and values—the anxieties that had helped to fuel the conservative politics of the post-civil-rights era. The symbols of the Bush campaign—Willie Horton, the ACLU, the death penalty, the Pledge of Allegiance, the flag—and rhetoric such as "no new taxes," the "L-word," and "Harvard boutique liberal" conjured up the criminal defendants'- and prisoners'-rights movements, black crime, permissive liberal elites, a revenue-hungry state, eroding traditional values, tattered patriotism, and declining American prestige.

Willie Horton represented, for crucial sectors of the electorate, the consequences of an aggressively expansive liberalism—a liberalism running up against majority public opinion, against traditional values, and, to a certain degree, against common sense. Horton came to stand for liberalism's blurring of legitimate goals, such as helping prisoners judged suitable for rehabilitation (prisoners, for example, without long records of violence), with the illegitimate goal, in the majority view, of "coddling" violent and dangerous criminals whom much of society judges irredeemable.

Republican strategists recognized that the furloughing of Willie Horton epitomized an evolution of the far-reaching rights movement, an evolution resented and disapproved of by significant numbers of voters. These voters saw crime as one of a number of social and moral problems aggravated by liberalism. The evolving rights movement was seen as extending First Amendment privileges to hard-core pornography, as allowing welfare recipients to avoid responsibility for supporting their children, as fostering drug use, illegitimacy, homosexual promiscuity, and an AIDS epidemic. All these led, in turn, to demands on taxpayers to foot skyrocketing social-service and health-care bills.

"Crime" became a shorthand signal, to a crucial group of white voters, for broader issues of social disorder, evoking powerful ideas about authority, status, morality, self-control, and race. "On no other issue is the dividing line so clear, and on no other issue is my opponent's philosophy so completely at odds with mine, and I would say with the common-sense attitudes of the American people, than on the issue of crime," Bush declared in an October 7, 1988, campaign speech to police officers in Xenia, Ohio, adding, There are some—and I would list my opponent among them—who have wandered far off the clear-cut path of common sense and have become lost in the thickets of liberal sociology. Just as when it comes to foreign policy, they always 'Blame America First,' when it comes to crime and criminals, they always seem to 'Blame Society First.' . . . [Criminal justice under Dukakis is] a 'Twilight Zone' world where prisoners' 'right of privacy' has more weight than the citizen's right to safety.

THE RACIAL CHASM

The divisive power of race and race-infused preoccupations with values, class, and social disorder endured throughout the 1980s, reverberating across the electorate. Differences of opinion between blacks and whites intensified over the decade. A 1989 voter study conducted by KRC Research and Consulting for Democrats For the 90's, a private organization affiliated with the Democratic Party, revealed the extent to which key white Democratic voters "take issue with the Democratic rhetoric

of representing the 'middle class and the poor.' These [voters] perceive themselves to be neither rich nor poor, and they do not like being referred to in the same breath as 'the poor.' They describe themselves as 'working people.'" Black urban Democratic voters, conversely, "feel that the country and the Democratic Party are increasingly racist and that the party cares little for their needs and interests."

Divisions between the races have emerged on a host of fronts. On the basic question of whether judges and courts treat whites and blacks even-handedly, 56 percent of white New Yorkers in a 1988 WCBS-New York Times poll said they believed that the system was fair and 27 percent said the system favored one race over another, with that 27 percent evenly split between those who saw black favoritism and those who saw white favoritism. Among black New Yorkers only 30 percent saw the system as fair, and 49 percent saw it as unfair, with the overwhelming majority of those who perceived unfairness seeing a bias in favor of whites.

Such highly controversial cases as the 1987 allegations of rape by Tawana Brawley and the 1984 shooting by the "subway vigilante" Bernhard Goetz of four black teenagers provoked sharply divergent views from blacks and from whites. After a grand jury determined in 1988 that Brawley had fabricated her story, 73 percent of white New Yorkers polled by WCBS-New York Times said she lied, while only 33 percent of blacks were prepared to make that judgment (18 percent said she told the truth, 14 percent said she didn't know what happened to her, and 35 percent were unwilling to express an opinion). In the case of Goetz, the WCBS-New York Times poll found in 1985 that the proportion of whites describing themselves as supportive of the shooting, relative to those who were critical, was 50–37, as compared with 23–59 among blacks. Whites felt that Goetz was innocent of attempted murder by a margin of 47–18 (with the rest undecided), while blacks said that he was guilty by a margin of 42–19. (Hispanics sided more with whites than with blacks, favoring innocence over guilt at 41–23.)

Underlying these differences in public opinion is a profound gulf between blacks and whites over the cause of contemporary differences between the races. In seeking to clarify these differences of opinion, Ron Walters, a black political scientist at Howard University, has argued that the fundamental issue in the contemporary politics of race is "Who is responsible for our condition?" He says, "Once you draw the line on that, you draw the line on a lot of other race-value issues. Whites see blacks as generally responsible for their own situation, which means that whites refuse to take responsibility. Blacks see it differently. They believe there ought to be a continuing assumption of responsibility for their condition by the government, in addition to what they do for themselves. And therein lies a lot of the difference."

This racially loaded confrontation over the issue of responsibility, both historical and contemporary, is perhaps best illustrated by the views of the political analysts Roger Wilkins and Patrick Buchanan. Wilkins, a black professor of history at George Mason University and a well-known commentator who served as an assistant attorney general in the Johnson Administration and was an editorial writer for The New York Times and The Washington Post, has written, The issue isn't guilt. It's responsibility. Any fair reading of history will find that since the mid-seventeenth century whites have oppressed some blacks so completely as to disfigure their humanity. Too many whites point to the debased state of black culture and institutions as proof of the inferiority of the blacks they have mangled [The logical implication] is simple: black people simply need to pull up their socks. That idea is wrong and must be resisted Like it or not, slavery, the damage from legalized oppression during the century that followed emancipation, and the racism that still infects the entire nation follow a direct line to ghetto life today.

On the other side, Buchanan, an Irish Catholic who was a ranking conservative strategist for the Nixon and Reagan administrations and remains a widely followed political columnist and television commentator of the hard right, has written, Why did liberalism fail black America? Because it was built

on a myth, the myth of the Kerner Commission, that the last great impediment to equality in America was 'white racism.' That myth was rooted in one of the oldest of self-delusions: It is because you are rich that I am poor. My problems are your fault. You owe me!

There was a time when white racism did indeed block black progress in America, but by the time of the Kerner Commission ours was a nation committed to racial justice

The real root causes of the crisis in the underclass are twofold. First, the old character-forming, conscience-forming institutions—family, church, and school—have collapsed under relentless secular assault; second, as the internal constraints on behavior were lost among the black poor, the external barriers—police, prosecutors, and courts—were systematically undermined

What the black poor need more than anything today is a dose of the truth. Slums are the products of the people who live there. Dignity and respect are not handed out like food stamps; they are earned and won . . .

The first step to progress, for any group, lies in the admission that its failures are, by and large, its own fault, that success can come only through its own efforts, that, while the well-intentioned outsider may help, he or she is no substitute for personal sacrifice.

CAN AMERICA AFFORD AFFIRMATIVE ACTION?

The conflict represented by Wilkins and Buchanan is driven not only by a fundamental difference over values and responsibility but also by economic and demographic forces. These forces are helping to make the political struggle for public resources and benefits increasingly bitter and increasingly irreconcilable. In many respects these forces are working in tandem to make the process of incorporating new groups into the mainstream of American society more difficult. They include the globalization of the economy, the growing disparity between the wages paid to the college-educated and the wages paid to those with a high school diploma or less, the drop in college entry by blacks, and the emergence of a suburban voting majority.

The globalization of the economy constitutes a fundamental attack on the mechanisms traditionally relied upon to integrate new untrained and poorly educated groups into the mainstream of American life. Before the internationalization of manufacturing, policies and practices ranging from widespread political patronage to legislation creating the pro-union National Labor Relations Board forced the incorporation of immigrant groups into the work force.

The threat represented by overseas competition has thrust American companies into a battle for survival in which there is little or no room to accommodate the short-term costs of absorbing blacks and other previously excluded minority groups into the labor force. And while affirmative action performs for blacks and other minorities the same function that patronage performed for waves of immigrants from Ireland and southern Europe, it also imposes costs that place American companies at a disadvantage in international competition.

These costs lie at the core of the debate over the civil-rights bill of 1991. Although the issue of quotas has dominated public discussion of the civil-rights bill, the real battle is over legislating the precise cost to companies that affirmative-action programs will involve. In an attempt to overturn recent conservative rulings by the Supreme Court (now dominated by Republican appointees), the Democratic leadership of Congress has proposed legislation strictly limiting the use of ability tests and other hiring procedures with potentially discriminatory impact, even in the absence of discriminatory intent. If hiring or promotion procedures are found to have "adverse impact" on blacks—that is, if disproportionately more blacks (or other minorities) than whites are rejected—employers must demonstrate that such tests are essential for business operation and meet a stringent "business necessity" standard.

The legislation would in effect overturn a 1989 Supreme Court decision, Wards Cove Packing Co. v. Atonio, that allowed companies to use ability tests and other hiring criteria that adversely affect blacks and Hispanics if such criteria met the far less stringent standard of "business justification." Wards Cost explicitly declared that "there is no requirement that the challenged practice be 'essential' or 'indispensable' to the employer's business." Such seemingly arcane and legalistic phrases as "business necessity" and "business justification" can have profound consequences. If, for example, companies were permitted to use scores on ability tests as a hiring criterion, it would at present be a major setback to the hiring of blacks and Hispanics—unless scores were adjusted for differences among whites, blacks, Hispanics. and other groups (a scoring process termed "within-group scoring," "within-group adjustment," or "race-norming").

The importance of restricted ability testing for the employment prospects of blacks and Hispanics has been documented in two book-length studies, Ability Testing (1982) and Fairness in Employment Testing (1989), by the National Research Council. On almost all ability tests studied, the council found (without engaging the unresolved issue of causes), blacks scored substantially below whites, and Hispanics scored somewhere in between. One study found, for example, that on average, if hiring were done strictly on the basis of ability-test scores, an employer selecting from a pool of 100 whites and 100 blacks would take only three blacks in the first twenty-three applicants chosen, and only six blacks in the first thirty-six. The differences in test-score results are reduced, but remain substantial, for blacks and whites of similar income and education.

The contemporary conflict over affirmative action is rooted in the issue of test scores. Everywhere from college admissions to hiring for jobs, tests have become a primary instrument for determining personal status, income, and security. On one side of the debate it is argued that the unrestricted use of ability tests imposes an extraordinary burden on blacks, Hispanics, and other minorities; on the other that prohibiting ability testing imposes costs on the economy in terms of lost productivity and efficiency.

THE NEW SEGREGATION

While low-skill, entry-level jobs have moved overseas to low-wage countries, the domestic job market has changed in ways that work to enlarge, rather than to lessen, disparities in the incomes of whites and of blacks. The growing demand for college-educated workers and the decline in demand for low-skill manual workers have in recent years substantially changed wage patterns.

From 1975 to 1988 the average earnings of entry-level workers with college or more-advanced degrees rose from about 130 percent to about 180 percent of the earnings of workers with high school diplomas. This shift was inherently damaging to blacks: in 1988, 13.1 percent of blacks between the ages of twenty-five and thirty-four had college degrees, as compared with 24.5 percent of whites.

Compounding this disparity is a second development: just as the value of a college education has skyrocketed, the percentage of blacks between the ages of eighteen and twenty-four who go on to college and get a degree has fallen. From 1976 to 1988 the percentage of blacks aged eighteen to twenty-four enrolled in college fell from 22.6 to 21.1, while the percentage of whites rose from 27.1 to 31.3.

The effect of these two trends has been to undermine what was a powerful drive toward economic and educational equality between the races. In the ten years immediately following the passage of the 1964 Civil Rights Act, the economy pushed the earnings of both blacks and whites who were in the work force steadily upward. There was a strong convergence of shared prosperity and growing racial equality. From 1963 to 1973 average weekly earnings for everyone grew from $175.17 to $198.35, in 1977 inflation-adjusted dollars. As wages rose for whites and blacks, income differentials were sharply reduced: from 1963 to 1977–1978 the difference between black and white wages dropped from the

45 percent range down to the 30 percent range, a drop of about one percentage point a year. For younger, well-educated workers the gap had almost disappeared by the mid—1970s.

Starting in the late 1970s and continuing into the early 1980s, however, the situation began to change radically. While the income of college graduates continued to rise, the income of high school graduates began to fall. At the same time that the so-called "college wage premium" rose, the wage levels for job categories that employ disproportionately more whites (professionals, managers, and sales personnel) grew substantially faster than wage levels for those categories employing disproportionate numbers of blacks (machine operatives and clerical, service, and household workers).

The result has been a striking shift in racial wage patterns. Starting at the end of the 1970s the convergence between the incomes of working blacks and whites—a convergence that had the potential in the long run to enlarge the economic common ground between the races—came to a halt. In the late 1970s black wages abruptly stopped catching up to white wages, with the differential stagnating at roughly 30 percent.

For a Democratic Party seeking to build a majority coalition aligning the interests of blacks and whites, this was a grave blow. The failure of the trend toward wage equality to continue has encouraged the conflict between black and white world views, in which black gains are seen as a cost to whites, and white advantages are seen as a manifestation of racism.

RACE AND THE SUBURBS

Just as wage and education patterns are working to undermine what was a trend toward economic equality between the races, the dominant demographic trend in the nation—suburbanization—is working to intensify the geographic separation of the races, particularly of whites from poor blacks.

The 1992 election will be the first in which the suburban vote, as determined from U.S. Census data, will be an absolute majority of the total electorate. From 1968 to 1988 the percentage of the presidential vote cast in suburbs grew from 35.6 percent to 48.3 percent, and there will be a gain of at least two percent by 1992 under current trends.

Suburban growth will in all likelihood profoundly change national politics, and will further deepen schisms between the public-policy interests of the two races. Although opinion polls show increasing support for government expenditures on education, health, recreation, and a range of other desired public services, a growing percentage of white voters are discovering that they can become fiscal liberals at the local SUBURBAN level while remaining conservative about federal spending. These voters can satisfy their need for government services through increased local expenditures, guaranteeing the highest possible return to themselves on their tax dollars, while continuing to demand austerity at the federal level. Suburbanization has permitted whites to satisfy liberal ideals revolving around activist government while keeping to a minimum the number of blacks and poor people who share in government largesse.

For example, the residents of Gwinnett County, Georgia, which is one of the fastest-growing suburban jurisdictions in the United States, heavily Republican (76 percent for Bush), affluent, and predominantly white (93.6 percent)—have been willing to tax and spend on their own behalf as liberally as any Democrats. County voters have in recent years approved a special recreation tax; all school, library, and road bond issues; and a one percent local sales tax.

The accelerated growth of the suburbs has made it possible for many Americans to pursue certain civic ideals (involvement in schools, cooperation in community endeavors, a willingness to support and to pay for public services) within a smaller universe, separate and apart from the consuming failure (crime, welfarism, decay) of the older cities.

If a part of the solution to the devastating problems of the underclass involves investment in public services, particularly in the public school systems of the nation's major cities, the growing division between city and suburb lessens white self-interest in making such an investment. In 1986 fully 27.5 percent of all black schoolchildren, and 30 percent of all Hispanic schoolchildren, were enrolled in the twenty-five largest central-city school districts. Only 3.3 percent of all white students were in these same twenty-five districts. In other words, 96.7 percent of white children are educated outside these decaying school systems.

Even within major cities there is a growing divergence of interest between blacks and whites. Many of the more affluent citizens in racially mixed cities are turning to private service providers, including independent and parochial schools. Private police and security services, proliferating private recreational clubs, and private transportation companies.

THE END OF THE DEMOCRATIC PARTY?

In political terms race clearly remains a republican trump card, while racial fissures within the Democratic Party leave it weakened and vulnerable.

On a broad strategic scale the Republican Party over the past two years has taken steps to capture the fairness issue and to defuse charges of Republican racism, initiating an aggressive drive to win the support of affluent blacks and even running, on occasion, fully competitive black candidates. Income trends in the black community suggest a reservoir of prospective Republican support: the income of the top fifth of black families has over the past two decades been growing at a significantly faster rate than the income of the top fifth of white families. Trends among the well-to-do of both races have led to increasing racial equality of income, in sharp contrast to trends among the least affluent blacks and whites: the bottom fifth of the black community is falling steadily further behind the bottom fifth of the white community

Insofar as the Republican drive to win support among affluent middle-class blacks is successful, and insofar as the party is able to insulate itself from charges of racism, it will further isolate the national Democratic Party as the party of poor, underclass black America. The isolation of the Democratic Party continues a process damaging to the vitality of the American political system.

Fissures resulting from racial conflict, and fissures resulting from tensions over rights, culture, and values, separate the national Democratic Party from many of its former constituents. Such fissures have forced the party to increase its dependence on special interests in order to maintain its congressional majority.

Without the resource of plurality voter loyalty, Democratic members of the House of Representatives—the seemingly unshakable bastion of Democratic power in Washington—have come to rely increasingly on an essentially corrupt system of campaign finance, on the perquisites of incumbency, on pork-barrel spending, and on the gerrymandering of districts in order to thwart continuing demographic and ideological shifts favoring their opponents.

As recently as the mid-1970s the Democratic Party was able to portray itself as the party of political reform battling a Republican Party dominated by moneyed interests. Now Democrats in the House of Representatives are more dependent on institutionalized special-interest groups than are their Republican adversaries. In 1990 the majority—52.6 percent—of the campaign contributions received by Democratic incumbent House members running for re-election came from political-action committees, while the percentage of support from individual donors represented a steady decline, from 44.8 percent in 1984 to 38.0 percent in 1990. Republican House incumbents, in contrast, received 50.9 percent of their financial support from individuals in 1988, and 41.1 percent from PACs, in a

pattern virtually the mirror image of the Democrats'. In 1988 not only did labor PACs follow tradition by giving far more to Democratic House incumbents ($16.7 million) than to Republican incumbents ($1.9 million), but corporate PACs—the contemporary version of "moneyed interests"—gave more money to Democratic House incumbents ($15.7 million) than to their Republican counterparts ($13.5 million). While helpful to incumbents in the short term, this kind of contribution pattern weakens any claim the Democratic Party may make to provide popular representation.

The Democratic reliance on special interests in fact extends beyond Congress to a second party stronghold, the nation's major cities. The public's ability to direct essential services—most important, the public school system—has been lost in varying degrees to institutionalized bureaucracies. Within urban school systems faced with declining tax bases and lessened federal support, associations and unions representing teachers, principals, administrators, clerical staff, custodians, carpenters, and security guards have become politically influential in protecting their members' tenure while carefully limiting their responsibility for meeting the larger goal—that of producing well-educated students.

Democratic vulnerability on this terrain is perhaps nowhere better reflected than in Detroit— possibly the most Democratic municipality in the nation, a city with one of the nation's worst school systems and perhaps the worst delivery of public services. In recent years Detroit voters elected a black Republican school-board president and a black Republican city councilman. Both were elected on platforms of promises to break through bureaucratic ossification and revive competitive market forces, through parental choice in school assignments, through private alternatives to public services, and through the transfer of power and responsibility from administrators downtown to principals and teachers in the trenches.

The congressional wing of the Democratic Party has become locked into an alliance with the forces of reaction—with interests and bureaucracies conducting largely futile efforts to resist, among other things, the consequences of international economic change. The Democratic Party has, in many respects, discovered that survival depends on the creation of a congressional party entrusted by the people to look after parochial interests—from water projects to rice subsidies to highways to health care for the elderly. However, to the degree that presidential elections have become referenda on the nexus of social, moral, racial, and cultural issues in the broadest sense, the Democratic Party has in five of the past six elections been at a competitive disadvantage.

The losers in this process are not only the Democratic Party and liberalism but also the constituencies and alliances they are obliged to represent. The fracturing of the Democratic coalition has permitted the moral, social, and economic ascendance of the affluent in a nation with a strong egalitarian tradition, and has permitted a diminution of economic reward and of social regard for those who simply work for a living, black and white. Democratic liberalism—the political ideology that helped to produce a strong labor movement, that extended basic rights to all citizens, and that has nurtured free political and artistic expression—has lost the capacity to represent effectively the allied interests of a biracial, cross-class coalition. Liberalism, discredited among key segments of the electorate, is no longer a powerful agent of constructive change. Instead, liberal values, policies, and allegiances have become a source of bitter conflict among groups that were once common beneficiaries of the progressive state.

The failures of Democratic liberalism pose a larger problem. With the decline of liberal hegemony, conservatism has gained control over national elections and, to a significant degree, over the national agenda. No matter what its claims, conservatism has served for much of the twentieth century as the political and philosophical arm of the affluent. Entrusting the economic interests of the poor and the working class to such a philosophy risks serious damage to both groups.

That conservatism represents the interests of the well-to-do is to be expected—and even respected— as part of the system of representation in American democracy. A far more threatening development

is that as liberalism fails to provide effective challenge, the country will lack the dynamism that only a sustained and vibrant insurgency of those on the lower rungs can provide. Such an insurgency, legitimately claiming for its supporters an equal opportunity to participate and to compete and to gain a measure of justice, is critical, not only to the politics and the economics of the nation but also to the vitality of the broader culture and to democracy itself.

Over the past twenty-five years liberalism has avoided confronting, and learning from, the experience of voter rejection, as institutional power and a sequence of extraneous events—ranging from Watergate to the 1981–1982 recession—have worked to prop up the national Democratic Party. For the current cycle to reach closure, and for there to be a breakthrough in stagnant partisan competition, the Democratic Party may have either to suffer a full-scale domestic defeat, including (to deal in the extremes of possibility) loss of control of the Senate and the House, or at the very least to go through the kind of nadir—intraparty conflict, challenge to ideological orthodoxy, in short, a form of civil war—experienced by the Republican Party and the right in the 1960s. The original strength of Democratic liberalism was its capacity to build majorities out of minorities—a strength that comes only from a real understanding of what it means to be out of power, from direct engagement in the struggle to build a majority, and from an understanding of what is worth fighting for in this struggle. Recapturing the ability to build a winning alliance requires learning the full meaning of defeat, and developing a conscious awareness of precisely what the electorate will support politically, what it will not, and when—if ever—something more important is at stake.

My Dear Fellow Clergymen:

While confined here in the Birmingham city jail, I came across your recent statement calling my present activities "unwise and untimely." Seldom do I pause to answer criticism of my work and ideas. If I sought to answer all the criticisms that cross my desk, my secretaries would have little time for anything other than such correspondence in the course of the day, and I would have no time for constructive work. But since I feel that you are men of genuine good will and that your criticisms are sincerely set forth, I want to try to answer your statement in what I hope will be patient and reasonable terms.

I think I should indicate why I am here in Birmingham, since you have been influenced by the view which argues against "outsiders coming in." I have the honor of serving as president of the Southern Christian Leadership Conference, an organization operating in every southern state, with headquarters in Atlanta, Georgia. We have some eighty five affiliated organizations across the South, and one of them is the Alabama Christian Movement for Human Rights. Frequently we share staff, educational and financial resources with our affiliates. Several months ago the affiliate here in Birmingham asked us to be on call to engage in a nonviolent direct action program if such were deemed necessary. We readily consented, and when the hour came we lived up to our promise. So I, along with several members of my staff, am here because I was invited here. I am here because I have organizational ties here.

But more basically, I am in Birmingham because injustice is here. Just as the prophets of the eighth century B.C. left their villages and carried their "thus saith the Lord" far beyond the boundaries of their home towns, and just as the Apostle Paul left his village of Tarsus and carried the gospel of Jesus Christ to the far corners of the Greco Roman world, so am I compelled to carry the gospel of freedom beyond my own home town. Like Paul, I must constantly respond to the Macedonian call for aid.

Moreover, I am cognizant of the interrelatedness of all communities and states. I cannot sit idly by in Atlanta and not be concerned about what happens in Birmingham. Injustice anywhere is a threat to justice everywhere. We are caught in an inescapable network of mutuality, tied in a single garment of destiny. Whatever affects one directly, affects all indirectly. Never again can we afford to live with the narrow, provincial "outside agitator" idea. Anyone who lives inside the United States can never be considered an outsider anywhere within its bounds.

You deplore the demonstrations taking place in Birmingham. But your statement, I am sorry to say, fails to express a similar concern for the conditions that brought about the demonstrations. I am sure that none of you would want to rest content with the superficial kind of social analysis that deals merely with effects and does not grapple with underlying causes. It is unfortunate that demonstrations are taking place in Birmingham, but it is even more unfortunate that the city's white power structure left the Negro community with no alternative.

In any nonviolent campaign there are four basic steps: collection of the facts to determine whether injustices exist; negotiation; self purification; and direct action. We have gone through all these steps in Birmingham. There can be no gainsaying the fact that racial injustice engulfs this community. Birmingham is probably the most thoroughly segregated city in the United States. Its ugly record of brutality is widely known. Negroes have experienced grossly unjust treatment in the courts. There have been more unsolved bombings of Negro homes and churches in Birmingham than in any other

city in the nation. These are the hard, brutal facts of the case. On the basis of these conditions, Negro leaders sought to negotiate with the city fathers. But the latter consistently refused to engage in good faith negotiation.

Then, last September, came the opportunity to talk with leaders of Birmingham's economic community. In the course of the negotiations, certain promises were made by the merchants—for example, to remove the stores' humiliating racial signs. On the basis of these promises, the Reverend Fred Shuttlesworth and the leaders of the Alabama Christian Movement for Human Rights agreed to a moratorium on all demonstrations. As the weeks and months went by, we realized that we were the victims of a broken promise. A few signs, briefly removed, returned; the others remained.

As in so many past experiences, our hopes had been blasted, and the shadow of deep disappointment settled upon us. We had no alternative except to prepare for direct action, whereby we would present our very bodies as a means of laying our case before the conscience of the local and the national community. Mindful of the difficulties involved, we decided to undertake a process of self purification. We began a series of workshops on nonviolence, and we repeatedly asked ourselves: "Are you able to accept blows without retaliating?" "Are you able to endure the ordeal of jail?" We decided to schedule our direct action program for the Easter season, realizing that except for Christmas, this is the main shopping period of the year. Knowing that a strong economic-withdrawal program would be the by product of direct action, we felt that this would be the best time to bring pressure to bear on the merchants for the needed change.

Then it occurred to us that Birmingham's mayoral election was coming up in March, and we speedily decided to postpone action until after election day. When we discovered that the Commissioner of Public Safety, Eugene "Bull" Connor, had piled up enough votes to be in the run off, we decided again to postpone action until the day after the run off so that the demonstrations could not be used to cloud the issues. Like many others, we waited to see Mr. Connor defeated, and to this end we endured postponement after postponement. Having aided in this community need, we felt that our direct action program could be delayed no longer.

You may well ask: "Why direct action? Why sit ins, marches and so forth? Isn't negotiation a better path?" You are quite right in calling for negotiation. Indeed, this is the very purpose of direct action. Nonviolent direct action seeks to create such a crisis and foster such a tension that a community which has constantly refused to negotiate is forced to confront the issue. It seeks so to dramatize the issue that it can no longer be ignored. My citing the creation of tension as part of the work of the nonviolent resister may sound rather shocking. But I must confess that I am not afraid of the word "tension." I have earnestly opposed violent tension, but there is a type of constructive, nonviolent tension which is necessary for growth. Just as Socrates felt that it was necessary to create a tension in the mind so that individuals could rise from the bondage of myths and half truths to the unfettered realm of creative analysis and objective appraisal, so must we see the need for nonviolent gadflies to create the kind of tension in society that will help men rise from the dark depths of prejudice and racism to the majestic heights of understanding and brotherhood.

The purpose of our direct action program is to create a situation so crisis packed that it will inevitably open the door to negotiation. I therefore concur with you in your call for negotiation. Too long has our beloved Southland been bogged down in a tragic effort to live in monologue rather than dialogue.

One of the basic points in your statement is that the action that I and my associates have taken in Birmingham is untimely. Some have asked: "Why didn't you give the new city administration time to act?" The only answer that I can give to this query is that the new Birmingham administration must be prodded about as much as the outgoing one, before it will act. We are sadly mistaken if we feel that the election of Albert Boutwell as mayor will bring the millennium to Birmingham. While Mr. Boutwell is

a much more gentle person than Mr. Connor, they are both segregationists, dedicated to maintenance of the status quo. I have hope that Mr. Boutwell will be reasonable enough to see the futility of massive resistance to desegregation. But he will not see this without pressure from devotees of civil rights. My friends, I must say to you that we have not made a single gain in civil rights without determined legal and nonviolent pressure. Lamentably, it is an historical fact that privileged groups seldom give up their privileges voluntarily. Individuals may see the moral light and voluntarily give up their unjust posture; but, as Reinhold Niebuhr has reminded us, groups tend to be more immoral than individuals.

We know through painful experience that freedom is never voluntarily given by the oppressor; it must be demanded by the oppressed. Frankly, I have yet to engage in a direct action campaign that was "well timed" in the view of those who have not suffered unduly from the disease of segregation. For years now I have heard the word "Wait!" It rings in the ear of every Negro with piercing familiarity. This "Wait" has almost always meant "Never." We must come to see, with one of our distinguished jurists, that "justice too long delayed is justice denied."

We have waited for more than 340 years for our constitutional and God given rights. The nations of Asia and Africa are moving with jetlike speed toward gaining political independence, but we still creep at horse and buggy pace toward gaining a cup of coffee at a lunch counter. Perhaps it is easy for those who have never felt the stinging darts of segregation to say, "Wait." But when you have seen vicious mobs lynch your mothers and fathers at will and drown your sisters and brothers at whim; when you have seen hate filled policemen curse, kick and even kill your black brothers and sisters; when you see the vast majority of your twenty million Negro brothers smothering in an airtight cage of poverty in the midst of an affluent society; when you suddenly find your tongue twisted and your speech stammering as you seek to explain to your six year old daughter why she can't go to the public amusement park that has just been advertised on television, and see tears welling up in her eyes when she is told that Funtown is closed to colored children, and see ominous clouds of inferiority beginning to form in her little mental sky, and see her beginning to distort her personality by developing an unconscious bitterness toward white people; when you have to concoct an answer for a five year old son who is asking: "Daddy, why do white people treat colored people so mean?"; when you take a cross county drive and find it necessary to sleep night after night in the uncomfortable corners of your automobile because no motel will accept you; when you are humiliated day in and day out by nagging signs reading "white" and "colored"; when your first name becomes "nigger," your middle name becomes "boy" (however old you are) and your last name becomes "John," and your wife and mother are never given the respected title "Mrs."; when you are harried by day and haunted by night by the fact that you are a Negro, living constantly at tiptoe stance, never quite knowing what to expect next, and are plagued with inner fears and outer resentments; when you are forever fighting a degenerating sense of "nobodiness"—then you will understand why we find it difficult to wait. There comes a time when the cup of endurance runs over, and men are no longer willing to be plunged into the abyss of despair. I hope, sirs, you can understand our legitimate and unavoidable impatience.

You express a great deal of anxiety over our willingness to break laws. This is certainly a legitimate concern. Since we so diligently urge people to obey the Supreme Court's decision of 1954 outlawing segregation in the public schools, at first glance it may seem rather paradoxical for us consciously to break laws. One may well ask: "How can you advocate breaking some laws and obeying others?" The answer lies in the fact that there are two types of laws: just and unjust. I would be the first to advocate obeying just laws. One has not only a legal but a moral responsibility to obey just laws. Conversely, one has a moral responsibility to disobey unjust laws. I would agree with St. Augustine that "an unjust law is no law at all."

Now, what is the difference between the two? How does one determine whether a law is just or unjust? A just law is a man made code that squares with the moral law or the law of God. An

unjust law is a code that is out of harmony with the moral law. To put it in the terms of St. Thomas Aquinas: An unjust law is a human law that is not rooted in eternal law and natural law. Any law that uplifts human personality is just. Any law that degrades human personality is unjust. All segregation statutes are unjust because segregation distorts the soul and damages the personality. It gives the segregator a false sense of superiority and the segregated a false sense of inferiority. Segregation, to use the terminology of the Jewish philosopher Martin Buber, substitutes an "I it" relationship for an "I thou" relationship and ends up relegating persons to the status of things. Hence segregation is not only politically, economically and sociologically unsound, it is morally wrong and sinful. Paul Tillich has said that sin is separation. Is not segregation an existential expression of man's tragic separation, his awful estrangement, his terrible sinfulness? Thus it is that I can urge men to obey the 1954 decision of the Supreme Court, for it is morally right; and I can urge them to disobey segregation ordinances, for they are morally wrong.

Let us consider a more concrete example of just and unjust laws. An unjust law is a code that a numerical or power majority group compels a minority group to obey but does not make binding on itself. This is difference made legal. By the same token, a just law is a code that a majority compels a minority to follow and that it is willing to follow itself. This is sameness made legal.

Let me give another explanation. A law is unjust if it is inflicted on a minority that, as a result of being denied the right to vote, had no part in enacting or devising the law. Who can say that the legislature of Alabama which set up that state's segregation laws was democratically elected? Throughout Alabama all sorts of devious methods are used to prevent Negroes from becoming registered voters, and there are some counties in which, even though Negroes constitute a majority of the population, not a single Negro is registered. Can any law enacted under such circumstances be considered democratically structured?

Sometimes a law is just on its face and unjust in its application. For instance, I have been arrested on a charge of parading without a permit. Now, there is nothing wrong in having an ordinance which requires a permit for a parade. But such an ordinance becomes unjust when it is used to maintain segregation and to deny citizens the First-Amendment privilege of peaceful assembly and protest.

I hope you are able to see the distinction I am trying to point out. In no sense do I advocate evading or defying the law, as would the rabid segregationist. That would lead to anarchy. One who breaks an unjust law must do so openly, lovingly, and with a willingness to accept the penalty. I submit that an individual who breaks a law that conscience tells him is unjust, and who willingly accepts the penalty of imprisonment in order to arouse the conscience of the community over its injustice, is in reality expressing the highest respect for law.

Of course, there is nothing new about this kind of civil disobedience. It was evidenced sublimely in the refusal of Shadrach, Meshach and Abednego to obey the laws of Nebuchadnezzar, on the ground that a higher moral law was at stake. It was practiced superbly by the early Christians, who were willing to face hungry lions and the excruciating pain of chopping blocks rather than submit to certain unjust laws of the Roman Empire. To a degree, academic freedom is a reality today because Socrates practiced civil disobedience. In our own nation, the Boston Tea Party represented a massive act of civil disobedience.

We should never forget that everything Adolf Hitler did in Germany was "legal" and everything the Hungarian freedom fighters did in Hungary was "illegal." It was "illegal" to aid and comfort a Jew in Hitler's Germany. Even so, I am sure that, had I lived in Germany at the time, I would have aided and comforted my Jewish brothers. If today I lived in a Communist country where certain principles dear to the Christian faith are suppressed, I would openly advocate disobeying that country's antireligious laws.

I must make two honest confessions to you, my Christian and Jewish brothers. First, I must confess that over the past few years I have been gravely disappointed with the white moderate. I have almost reached the regrettable conclusion that the Negro's great stumbling block in his stride toward freedom is not the White Citizen's Counciler or the Ku Klux Klanner, but the white moderate, who is more devoted to "order" than to justice; who prefers a negative peace which is the absence of tension to a positive peace which is the presence of justice; who constantly says: "I agree with you in the goal you seek, but I cannot agree with your methods of direct action"; who paternalistically believes he can set the timetable for another man's freedom; who lives by a mythical concept of time and who constantly advises the Negro to wait for a "more convenient season." Shallow understanding from people of good will is more frustrating than absolute misunderstanding from people of ill will. Lukewarm acceptance is much more bewildering than outright rejection.

I had hoped that the white moderate would understand that law and order exist for the purpose of establishing justice and that when they fail in this purpose they become the dangerously structured dams that block the flow of social progress. I had hoped that the white moderate would understand that the present tension in the South is a necessary phase of the transition from an obnoxious negative peace, in which the Negro passively accepted his unjust plight, to a substantive and positive peace, in which all men will respect the dignity and worth of human personality. Actually, we who engage in nonviolent direct action are not the creators of tension. We merely bring to the surface the hidden tension that is already alive. We bring it out in the open, where it can be seen and dealt with. Like a boil that can never be cured so long as it is covered up but must be opened with all its ugliness to the natural medicines of air and light, injustice must be exposed, with all the tension its exposure creates, to the light of human conscience and the air of national opinion before it can be cured.

In your statement you assert that our actions, even though peaceful, must be condemned because they precipitate violence. But is this a logical assertion? Isn't this like condemning a robbed man because his possession of money precipitated the evil act of robbery? Isn't this like condemning Socrates because his unswerving commitment to truth and his philosophical inquiries precipitated the act by the misguided populace in which they made him drink hemlock? Isn't this like condemning Jesus because his unique God consciousness and never ceasing devotion to God's will precipitated the evil act of crucifixion? We must come to see that, as the federal courts have consistently affirmed, it is wrong to urge an individual to cease his efforts to gain his basic constitutional rights because the quest may precipitate violence. Society must protect the robbed and punish the robber.

I had also hoped that the white moderate would reject the myth concerning time in relation to the struggle for freedom. I have just received a letter from a white brother in Texas. He writes: "All Christians know that the colored people will receive equal rights eventually, but it is possible that you are in too great a religious hurry. It has taken Christianity almost two thousand years to accomplish what it has. The teachings of Christ take time to come to earth." Such an attitude stems from a tragic misconception of time, from the strangely irrational notion that there is something in the very flow of time that will inevitably cure all ills. Actually, time itself is neutral; it can be used either destructively or constructively. More and more I feel that the people of ill will have used time much more effectively than have the people of good will. We will have to repent in this generation not merely for the hateful words and actions of the bad people but for the appalling silence of the good people. Human progress never rolls in on wheels of inevitability; it comes through the tireless efforts of men willing to be co workers with God, and without this hard work, time itself becomes an ally of the forces of social stagnation. We must use time creatively, in the knowledge that the time is always ripe to do right. Now is the time to make real the promise of democracy and transform our pending national elegy into a creative psalm of brotherhood. Now is the time to lift our national policy from the quicksand of racial injustice to the solid rock of human dignity.

You speak of our activity in Birmingham as extreme. At first I was rather disappointed that fellow clergymen would see my nonviolent efforts as those of an extremist. I began thinking about the fact that I stand in the middle of two opposing forces in the Negro community. One is a force of complacency, made up in part of Negroes who, as a result of long years of oppression, are so drained of self respect and a sense of "somebodiness" that they have adjusted to segregation; and in part of a few middle-class Negroes who, because of a degree of academic and economic security and because in some ways they profit by segregation, have become insensitive to the problems of the masses. The other force is one of bitterness and hatred, and it comes perilously close to advocating violence. It is expressed in the various black nationalist groups that are springing up across the nation, the largest and best known being Elijah Muhammad's Muslim movement. Nourished by the Negro's frustration over the continued existence of racial discrimination, this movement is made up of people who have lost faith in America, who have absolutely repudiated Christianity, and who have concluded that the white man is an incorrigible "devil."

I have tried to stand between these two forces, saying that we need emulate neither the "do nothingism" of the complacent nor the hatred and despair of the black nationalist. For there is the more excellent way of love and nonviolent protest. I am grateful to God that, through the influence of the Negro church, the way of nonviolence became an integral part of our struggle.

If this philosophy had not emerged, by now many streets of the South would, I am convinced, be flowing with blood. And I am further convinced that if our white brothers dismiss as "rabble rousers" and "outside agitators" those of us who employ nonviolent direct action, and if they refuse to support our nonviolent efforts, millions of Negroes will, out of frustration and despair, seek solace and security in black nationalist ideologies—a development that would inevitably lead to a frightening racial nightmare.

Oppressed people cannot remain oppressed forever. The yearning for freedom eventually manifests itself, and that is what has happened to the American Negro. Something within has reminded him of his birthright of freedom, and something without has reminded him that it can be gained. Consciously or unconsciously, he has been caught up by the Zeitgeist, and with his black brothers of Africa and his brown and yellow brothers of Asia, South America and the Caribbean, the United States Negro is moving with a sense of great urgency toward the promised land of racial justice. If one recognizes this vital urge that has engulfed the Negro community, one should readily understand why public demonstrations are taking place. The Negro has many pent up resentments and latent frustrations, and he must release them. So let him march; let him make prayer pilgrimages to the city hall; let him go on freedom rides -and try to understand why he must do so. If his repressed emotions are not released in nonviolent ways, they will seek expression through violence; this is not a threat but a fact of history. So I have not said to my people: "Get rid of your discontent." Rather, I have tried to say that this normal and healthy discontent can be channeled into the creative outlet of nonviolent direct action. And now this approach is being termed extremist.

But though I was initially disappointed at being categorized as an extremist, as I continued to think about the matter I gradually gained a measure of satisfaction from the label. Was not Jesus an extremist for love: "Love your enemies, bless them that curse you, do good to them that hate you, and pray for them which despitefully use you, and persecute you." Was not Amos an extremist for justice: "Let justice roll down like waters and righteousness like an ever flowing stream." Was not Paul an extremist for the Christian gospel: "I bear in my body the marks of the Lord Jesus." Was not Martin Luther an extremist: "Here I stand; I cannot do otherwise, so help me God." And John Bunyan: "I will stay in jail to the end of my days before I make a butchery of my conscience." And Abraham Lincoln: "This nation cannot survive half slave and half free." And Thomas Jefferson: "We hold these truths to be self

evident, that all men are created equal . . ." So the question is not whether we will be extremists, but what kind of extremists we will be. Will we be extremists for hate or for love? Will we be extremists for the preservation of injustice or for the extension of justice? In that dramatic scene on Calvary's hill three men were crucified. We must never forget that all three were crucified for the same crime—the crime of extremism. Two were extremists for immorality, and thus fell below their environment. The other, Jesus Christ, was an extremist for love, truth and goodness, and thereby rose above his environment. Perhaps the South, the nation and the world are in dire need of creative extremists.

I had hoped that the white moderate would see this need. Perhaps I was too optimistic; perhaps I expected too much. I suppose I should have realized that few members of the oppressor race can understand the deep groans and passionate yearnings of the oppressed race, and still fewer have the vision to see that injustice must be rooted out by strong, persistent and determined action. I am thankful, however, that some of our white brothers in the South have grasped the meaning of this social revolution and committed themselves to it. They are still all too few in quantity, but they are big in quality. Some -such as Ralph McGill, Lillian Smith, Harry Golden, James McBride Dabbs, Ann Braden and Sarah Patton Boyle—have written about our struggle in eloquent and prophetic terms. Others have marched with us down nameless streets of the South. They have languished in filthy, roach infested jails, suffering the abuse and brutality of policemen who view them as "dirty nigger-lovers." Unlike so many of their moderate brothers and sisters, they have recognized the urgency of the moment and sensed the need for powerful "action" antidotes to combat the disease of segregation.

Let me take note of my other major disappointment. I have been so greatly disappointed with the white church and its leadership. Of course, there are some notable exceptions. I am not unmindful of the fact that each of you has taken some significant stands on this issue. I commend you, Reverend Stallings, for your Christian stand on this past Sunday, in welcoming Negroes to your worship service on a nonsegregated basis. I commend the Catholic leaders of this state for integrating Spring Hill College several years ago.

But despite these notable exceptions, I must honestly reiterate that I have been disappointed with the church. I do not say this as one of those negative critics who can always find something wrong with the church. I say this as a minister of the gospel, who loves the church; who was nurtured in its bosom; who has been sustained by its spiritual blessings and who will remain true to it as long as the cord of life shall lengthen.

When I was suddenly catapulted into the leadership of the bus protest in Montgomery, Alabama, a few years ago, I felt we would be supported by the white church. I felt that the white ministers, priests and rabbis of the South would be among our strongest allies. Instead, some have been outright opponents, refusing to understand the freedom movement and misrepresenting its leaders; all too many others have been more cautious than courageous and have remained silent behind the anesthetizing security of stained glass windows.

In spite of my shattered dreams, I came to Birmingham with the hope that the white religious leadership of this community would see the justice of our cause and, with deep moral concern, would serve as the channel through which our just grievances could reach the power structure. I had hoped that each of you would understand. But again I have been disappointed.

I have heard numerous southern religious leaders admonish their worshipers to comply with a desegregation decision because it is the law, but I have longed to hear white ministers declare: "Follow this decree because integration is morally right and because the Negro is your brother." In the midst of blatant injustices inflicted upon the Negro, I have watched white churchmen stand on the sideline and mouth pious irrelevancies and sanctimonious trivialities. In the midst of a mighty struggle to rid our nation of racial and economic injustice, I have heard many ministers say: "Those are social issues,

with which the gospel has no real concern." And I have watched many churches commit themselves to a completely other worldly religion which makes a strange, un-Biblical distinction between body and soul, between the sacred and the secular.

I have traveled the length and breadth of Alabama, Mississippi and all the other southern states. On sweltering summer days and crisp autumn mornings I have looked at the South's beautiful churches with their lofty spires pointing heavenward. I have beheld the impressive outlines of her massive religious education buildings. Over and over I have found myself asking: "What kind of people worship here? Who is their God? Where were their voices when the lips of Governor Barnett dripped with words of interposition and nullification? Where were they when Governor Wallace gave a clarion call for defiance and hatred? Where were their voices of support when bruised and weary Negro men and women decided to rise from the dark dungeons of complacency to the bright hills of creative protest?"

Yes, these questions are still in my mind. In deep disappointment I have wept over the laxity of the church. But be assured that my tears have been tears of love. There can be no deep disappointment where there is not deep love. Yes, I love the church. How could I do otherwise? I am in the rather unique position of being the son, the grandson and the great grandson of preachers. Yes, I see the church as the body of Christ. But, oh! How we have blemished and scarred that body through social neglect and through fear of being nonconformists.

There was a time when the church was very powerful—in the time when the early Christians rejoiced at being deemed worthy to suffer for what they believed. In those days the church was not merely a thermometer that recorded the ideas and principles of popular opinion; it was a thermostat that transformed the mores of society. Whenever the early Christians entered a town, the people in power became disturbed and immediately sought to convict the Christians for being "disturbers of the peace" and "outside agitators.'" But the Christians pressed on, in the conviction that they were "a colony of heaven," called to obey God rather than man. Small in number, they were big in commitment. They were too God-intoxicated to be "astronomically intimidated." By their effort and example they brought an end to such ancient evils as infanticide and gladiatorial contests.

Things are different now. So often the contemporary church is a weak, ineffectual voice with an uncertain sound. So often it is an archdefender of the status quo. Far from being disturbed by the presence of the church, the power structure of the average community is consoled by the church's silent—and often even vocal—sanction of things as they are.

But the judgment of God is upon the church as never before. If today's church does not recapture the sacrificial spirit of the early church, it will lose its authenticity, forfeit the loyalty of millions, and be dismissed as an irrelevant social club with no meaning for the twentieth century. Every day I meet young people whose disappointment with the church has turned into outright disgust.

Perhaps I have once again been too optimistic. Is organized religion too inextricably bound to the status quo to save our nation and the world? Perhaps I must turn my faith to the inner spiritual church, the church within the church, as the true ekklesia and the hope of the world. But again I am thankful to God that some noble souls from the ranks of organized religion have broken loose from the paralyzing chains of conformity and joined us as active partners in the struggle for freedom. They have left their secure congregations and walked the streets of Albany, Georgia, with us. They have gone down the highways of the South on tortuous rides for freedom. Yes, they have gone to jail with us. Some have been dismissed from their churches, have lost the support of their bishops and fellow ministers. But they have acted in the faith that right defeated is stronger than evil triumphant. Their witness has been the spiritual salt that has preserved the true meaning of the gospel in these troubled times. They have carved a tunnel of hope through the dark mountain of disappointment.

I hope the church as a whole will meet the challenge of this decisive hour. But even if the church does not come to the aid of justice, I have no despair about the future. I have no fear about the outcome of our struggle in Birmingham, even if our motives are at present misunderstood. We will reach the goal of freedom in Birmingham and all over the nation, because the goal of America is freedom. Abused and scorned though we may be, our destiny is tied up with America's destiny. Before the pilgrims landed at Plymouth, we were here. Before the pen of Jefferson etched the majestic words of the Declaration of Independence across the pages of history, we were here. For more than two centuries our forebears labored in this country without wages; they made cotton king; they built the homes of their masters while suffering gross injustice and shameful humiliation -and yet out of a bottomless vitality they continued to thrive and develop. If the inexpressible cruelties of slavery could not stop us, the opposition we now face will surely fail. We will win our freedom because the sacred heritage of our nation and the eternal will of God are embodied in our echoing demands.

Before closing I feel impelled to mention one other point in your statement that has troubled me profoundly. You warmly commended the Birmingham police force for keeping "order" and "preventing violence." I doubt that you would have so warmly commended the police force if you had seen its dogs sinking their teeth into unarmed, nonviolent Negroes. I doubt that you would so quickly commend the policemen if you were to observe their ugly and inhumane treatment of Negroes here in the city jail; if you were to watch them push and curse old Negro women and young Negro girls; if you were to see them slap and kick old Negro men and young boys; if you were to observe them, as they did on two occasions, refuse to give us food because we wanted to sing our grace together. I cannot join you in your praise of the Birmingham police department.

It is true that the police have exercised a degree of discipline in handling the demonstrators. In this sense they have conducted themselves rather "nonviolently" in public. But for what purpose? To preserve the evil system of segregation. Over the past few years I have consistently preached that nonviolence demands that the means we use must be as pure as the ends we seek. I have tried to make clear that it is wrong to use immoral means to attain moral ends. But now I must affirm that it is just as wrong, or perhaps even more so, to use moral means to preserve immoral ends. Perhaps Mr. Connor and his policemen have been rather nonviolent in public, as was Chief Pritchett in Albany, Georgia, but they have used the moral means of nonviolence to maintain the immoral end of racial injustice. As T. S. Eliot has said: "The last temptation is the greatest treason: To do the right deed for the wrong reason."

I wish you had commended the Negro sit inners and demonstrators of Birmingham for their sublime courage, their willingness to suffer and their amazing discipline in the midst of great provocation. One day the South will recognize its real heroes. They will be the James Merediths, with the noble sense of purpose that enables them to face jeering and hostile mobs, and with the agonizing loneliness that characterizes the life of the pioneer. They will be old, oppressed, battered Negro women, symbolized in a seventy two year old woman in Montgomery, Alabama, who rose up with a sense of dignity and with her people decided not to ride segregated buses, and who responded with ungrammatical profundity to one who inquired about her weariness: "My feets is tired, but my soul is at rest." They will be the young high school and college students, the young ministers of the gospel and a host of their elders, courageously and nonviolently sitting in at lunch counters and willingly going to jail for conscience' sake. One day the South will know that when these disinherited children of God sat down at lunch counters, they were in reality standing up for what is best in the American dream and for the most sacred values in our Judaeo Christian heritage, thereby bringing our nation back to those great wells of democracy which were dug deep by the founding fathers in their formulation of the Constitution and the Declaration of Independence.

Never before have I written so long a letter. I'm afraid it is much too long to take your precious time. I can assure you that it would have been much shorter if I had been writing from a comfortable desk, but what else can one do when he is alone in a narrow jail cell, other than write long letters, think long thoughts and pray long prayers?

If I have said anything in this letter that overstates the truth and indicates an unreasonable impatience, I beg you to forgive me. If I have said anything that understates the truth and indicates my having a patience that allows me to settle for anything less than brotherhood, I beg God to forgive me.

I hope this letter finds you strong in the faith. I also hope that circumstances will soon make it possible for me to meet each of you, not as an integrationist or a civil-rights leader but as a fellow clergyman and a Christian brother. Let us all hope that the dark clouds of racial prejudice will soon pass away and the deep fog of misunderstanding will be lifted from our fear drenched communities, and in some not too distant tomorrow the radiant stars of love and brotherhood will shine over our great nation with all their scintillating beauty.

Yours for the cause of Peace and Brotherhood,
Martin Luther King, Jr.

Published in:
King, Martin Luther Jr. "Letter from the Birmingham jail." In *Why We Can't Wait*, ed. Martin Luther King, Jr., 77–100, 1963.

The privilege of the writ of habeas corpus shall not be suspended, unless when in Cases of Rebellion or Invasion the public Safety may require it.

U.S. Constitution, Article 1, Section 9, Clause 2

Through an executive order, President Abraham Lincoln suspended the privilege of the writ of habeas corpus on April 27, 1861.[1] Two months after the creation of the Confederate State of America and fifteen days after the attack on Fort Sumter, Lincoln found it within his executive authority to suspend civil liberties. This action created one of the most controversial constitutional questions in our republic's history.

Unlike the naval blockade, the suspension of habeas corpus was far more reaching in its power to disrupt individual lives. If Lincoln's call for a troop build-up was intended to declare war on the South; the suspension of habeas corpus was meant to declare war on his Northern opponents. The focus of this chapter will be the apparent reversal by the Supreme Court of its support of President Lincoln's executive authority; specifically the use of military tribunals to try civilians for treason. Here we will examine the Court's refusal to grant certiorari in *Ex Parte Merryman* and review the Court's decision in *Ex Parte Milligan* as a posthumous defeat for President Lincoln.

UPROAR IN BALTIMORE

The fall of Washington would be most disastrous. Communication ought to and must be kept open to Washington. Baltimore must not stand in the way. It should be seized and garrisoned, or, if necessary to the success of our glorious cause, laid in ruin.[2]

Following the attack on Fort Sumter, there were many concerns for the safety of Washington D.C. Lincoln called for 75,000 troops to come to the aid of the Union. On April 15, 1861, 850 Massachusetts volunteers heeded the call of the president and began their way to the defense of Washington.[3] The Minutemen of 1861, as they chose to be called, were mostly without uniforms and reliable rifles.[4]

[1]Dean Sprague, *Freedom Under Lincoln*, (Boston: Houghton Mifflin Company, 1965), p. 25.

[2]Mark E. Neely, Jr., *The Fate of Liberty: Abraham Lincoln and Civil Liberties* (New York: Oxford University Press, 1991), p. 6.

[3]Ibid., p. 206.

[4]Ibid., p. 2.

SOURCE: This article appears as a chapter in, *Abraham Lincoln and the Expansion of Presidential War Powers* by Richard Tahvildaran-Jesswein.

In many ways the citizens of Baltimore and that state of Maryland represented the historic "mercurial temperament" of a Southern City. For Lincoln and the administration, Maryland was vital to the safety and security of Washington against the Confederate forces. Hence, it became absolutely essential that the federal government survive in Maryland so that the capital not be cut off from the whole of the Union. When the citizens of Baltimore heard of the Minutemen's planned passage through their city, efforts were made to prevent the passage of the federal forces. Led by Lieutenant John Merryman, the Baltimore Horse Guards began to burn bridges, destroy rails, and intimidate local Unionists.[6]

The Sixth Regiment of the Union Army, led by General Benjamin Franklin Butler, a supporter of Jefferson Davis, devout Democrat, but uniquely a staunch Union man, was the first to arrive in Baltimore on the 19th after being called four days earlier. These Minutemen were unable to gain passage. The regiment was attacked by the mob as it attempted to move through the city. It was this action, where the president saw the laws he had sworn to execute faithfully resisted, that led to Lincoln's initial suspension.

Although the Constitution does allow for the writ of habeas corpus to be suspended during a crisis such as the Civil War, there was the question of who had the constitutional authority to suspend the writ. The authors of the Constitution addressed the suspension of the writ of habeas corpus in Article 1, section 9, while framing the authority of the legislative branch of government. President Lincoln initially suspended the writ along "the military line . . . used between the city of Philadelphia and the city of Washington."[7] He did so as Commander-in-Chief. While Lincoln was aware and concerned with the appearance of military dictatorship he found it necessary to call for troops, institute a naval blockade of the Southern ports, and suspend the writ of habeas corpus to deal with the very real demands of the situation. Lincoln stated that he suspended the writ in order to:

> *Arrest and detain without resort to the ordinary processes and forms of law . . . anyone considered dangerous to the public safety. This Authority has been purposely exercised but sparingly.[8]*

The president's action may appear to be an abuse of presidential authority. However, it is important to look into what may have been Lincoln's thought process and examine the options that were available to him. If possible, we should focus on whether or not his actions were political or a mode of earnest defense on the part of the Union. This direction will uncover flirtations with martial law and its limits with regard to the situation.

Abraham Lincoln did not wake up on the morning of April 20, 1861, with designs to usurp the civil liberties of his Northern opponents. He was faced with the real challenges of an undefended Union capitol surrounded by a formidable enemy eager to declare an early success. Lincoln found himself pushed in every direction by a Northern sense of panic when the Baltimore Mob had successfully blocked the troops from reaching Washington. With crisis bearing down on his shoulders, Lincoln looked for precedents to support his resolve and the actions the administration were about to undertake.

The president, in communication with Attorney General Edward Bates, sought the implementation of military law "to the extent of allowing an infraction."[9] The allowed infraction refers to the Fifth

[5]Ibid.

[6]Ibid.

[7]Ibid., p. 4.

[8]Don E. Fehrenbacher, *Abraham Lincoln: A Documentary Portrait Through His Speeches and Writings* (Stanford: Stanford University Press, 1964), p. 165.

[9]Neely, *The Fate of Liberty*, p. 5.

Amendment and its guarantee of grand jury indictment for all capital crimes. As Commander-in-Chief, Lincoln was afforded this authority, declaration of military law, by the U.S. Constitution. However, military law would only apply to those individuals in the service of the military and not civilians, as detailed by Congress in the Articles of War, 1806.[10] Difficult to define and control, military law would not achieve the end for which the administration was searching. To many, including William Blackstone, the thought of military law was one of no law at all. Hence, Lincoln arrived at the combination of suspension and martial law giving the administration the needed tools to suppress treasonable activities.

The privilege guarantees that a citizen not be arrested arbitrarily and denied due process of law. The suspension allowed Union officers to detain and arrest those individuals who openly opposed the Union Army and was to free them from the courts' possible objections. In general, the suspension allowed "summary arrests, detention without judicial hearing to show cause, and without indictment on the basis of an offense recognized by the civil law."[11] John Merryman's burning of bridges and destruction of rails was considered treason and open opposition to the Union Army. Merryman's arrest was not a political act by the administration, but one that was made to protect the existence of the Union.

While there had never been a suspension of the writ of habeas corpus in the United States prior to the Civil War, nor has there been one since, it was the topic of discourse thirty years prior to the Civil War. Supreme Court Justice Joseph Story was of the opinion that only the Congress could suspend the writ. Justice Story, in his work, <u>Commentaries on the Constitution of the United States</u>, wrote:

> *No Suspension of the writ has ever been authorized by Congress since the establishment of the Constitution. It would seem as the power is given to Congress to suspend the writ of habeas corpus in case of rebellion or invasion, that the right to judge, whether exigency has arisen must exclusively belong to that body.*[12]

Justice Story clearly stated his own beliefs but did not explain them. While he did propose that there may occur a time when the public safety would require the action, there were virtually no moorings that Lincoln could use except for a wise warning of the complications that might arise if the writ were to be suspended. Justice Story said,

> *It is obvious, that cases of a peculiar emergency may arise, the temporary suspension of the right to this writ. But as it has frequently happened in foreign countries, and even in England, that the writ has, upon various pretexts and occasions, been suspended, whereby persons, apprehended upon suspicion have suffered a long imprisonment, sometimes from design, and sometimes, because they were forgotten, the right to suspend it is expressly confined to cases of rebellion or invasion, where the public safety may require it; a very just and wholesome restraint, which cuts down at a blow a fruitful means of oppression, capable of being abused in bad times to the worst of purposes.*[13]

[10]Ibid.

[11]Ibid., p. 153.

[12]Joseph Story, *Commentaries on the Constitution of the United States* (Orig. pub. 1833; Durham: Carolina Academic Press, 1987), p. 483, cited by Mark E. Neely, Jr., *The Fate of Liberty*, p. 5.

[13]Ibid.

If Lincoln purposely ignored the wisdom of Justice Story, he decidedly followed the example of General Andrew Jackson. President Lincoln was an admirer of Jackson's resolve during the War of 1812. During that war and under martial law in New Orleans, Jackson ignored writs and on one occasion arrested the judge who issued a writ of habeas corpus.[14] Lincoln understood that he too must be a forceful leader. Many Northerners, including General Bates, felt that the president was not responding as fast as the Maryland situation warranted. Within a matter of days following the Baltimore Riots, Lincoln was criticized as not being forceful enough. The complaints of Republicans and Northerners alike made the administration aware that they would be "sustained in everything except half way measures."[15]

Governor Thomas Hicks, who had caved in on his stance of neutrality during the riots, called a special session of the Maryland legislature presumably to call the question of secession. The special session was called for April 26, 1861. Attorney General Bates vowed to arrest any "secession-minded Maryland politician." During the crisis, Lincoln demonstrated his stature as a wise leader. He opposed Bates by stating:

> *The Maryland Legislature assembles tomorrow . . . and, not improbably, will take action to arm the people of that State against the United States. The question has been submitted to . . . me, whether it would not be justifiable . . . for you . . . to arrest, or disperse the members of that body. I think it would not be justifiable; nor, efficient for the desired object. First, they have a clearly legal right to assemble; and, we cannot know in advance, that their action will not be lawful, and peaceful. And if we wait until they shall have acted, their arrest, or dispersion, will not lessen the effect of their action. Secondly, we cannot permanently prevent their action. If we arrest them, we cannot long hold them as prisoners; and when liberated, they will immediately reassemble, and take their action. And, precisely the same if we simply disperse them. They will immediately re-assemble in some other place. I therefore conclude that it is only left to the commanding General to watch, and await their action, which, if it shall be to arm their people against the United States, he is to adopt the most prompt, and efficient means to counteract, even, if necessary, to the bombardment of their cities and in the extremist necessity, the suspension of the writ of habeas corpus.[16]*

Lincoln's orders to General Winfield Scott, in reference to General Bates' suggestion of arrest, exhibited good judgment and proof of Lincoln's non-politics during the crisis. The Maryland legislature, composed and dominated by Democrats, met on April 26, 1861, (one day after troops arrived in Washington) and refused to consider a secession ordinance.[17] Oddly enough, Lincoln chose the very next day to officially declare a suspension of the writ of habeas corpus. No one was informed of the executive act; not the courts or any other civil authorities.[18] The order was sent to General Scott:

[14]Neely, *The Fate of* Liberty, p. 6.

[15]Ibid., p. 7.

[16]Ibid.

[17]Ibid.

[18]Ibid., p. 9.

You are engaged in repressing an insurrection against the laws of the United States. If at any point on or in the vicinity of any military line, which is now or which shall be used between the City of Philadelphia and the City of Washington, you find resistance which renders it necessary to suspend the writ of habeas corpus for the public safety, you, personally or through an officer in command at the point where the resistance occurs, are authorized to suspend the writ.[19]

The purpose of the suspension was to keep open the military lines. While the initial suspension can be argued as a necessity, there are questions about the evolution of Lincoln's orders. Later in this chapter, we will focus on the legality of military tribunals to try civilians under the suspension. At this point, however, it should be noted that the Lincoln administration spread these orders throughout the North, even in areas where military lines did not exist. In addition, just as Justice Story had warned, there were individuals arrested and forgotten for both political and purely accidental reasons. During the course of the Civil War, it is estimated that 13,535 arrests were made.[20] It was Chief Justice Taney who first brought the issue of the suspension before the American people because Lincoln had kept his orders to General Scott quiet.

Chief Justice Taney declared that, "no official notice has been given to the courts of justice or the public by proclamation or otherwise that the president claims this power."[21] Before Taney's disclosure the Democratic opposition press had been in the dark about the suspension.

LINCOLN UNDER FIRE

The controversy surrounding Lincoln's decision to suspend the writ does not necessarily focus on the idea of suspension. Rather, the great cry from Lincoln's opponents and strict constitutionalists was the call that Lincoln had acted illegally by taking action that only the Congress could undertake. The suspension of habeas corpus clause appears in the section of the Constitution which speaks directly to legislative powers. The executive order suspending the writ right after the Baltimore Riots was penned while Congress was in recess. The issue would be brought before Congress at the special session of July 4, 1861, the same session discussed earlier in reference to the *Prize Cases*.

Lincoln's opponents argued just as they had with regard to the naval blockade: Lincoln should have called Congress into special session much earlier. Even though his suspension order was meant to be used sparingly, the far reaching effects of his actions mirrored an abuse of power. The controversy raised several questions. Does the Constitution's failure to directly spell out the branch of government with the power to suspend lend credibility to Lincoln or to his opponents who pointed to the placement of the clause in the legislative section of the Constitution? Was the power meant to be concurrent between both branches of government . . . the executive and legislative? If we come down on the side of Lincoln, we must then discuss the legality of Lincoln's delegation of this immense authority to his subordinates. Finally, did rebellion in one part of the land justify the suspension of the writ of habeas corpus throughout all of it?

[19]Ibid.

[20]James Garfield Randall, *Constitutional Problems Under Lincoln* (Gloucester: University of Illinois Press, 1963), p. 152.

[21]Neely, *The Fate of Liberty*, p. 9.

THE CASE OF MERRYMAN

John Merryman, a lieutenant of a secessionist drill company was arrested for treason by General Cadwallader and placed in Fort McHenry on May 25, 1861.[22] Merryman was just one of hundreds of individuals arrested for opposition to the Northern cause. Chief Justice Taney, while riding circuit, heard a petition on behalf of Merryman and issued a writ of habeas corpus. Justice Taney in essence was ordering General Cadwallader to produce "the body;" the person of Merryman in court. The General declined to honor Taney's writ and cited the orders of his Commander-in-Chief, President Lincoln. As the power play continued, Taney issued a response that included the attachment of contempt for Cadwallader. The marshal entrusted with Taney's orders was unable to gain access into the fort to serve Cadwallader with Taney's response. Without any other recourse, Taney, in an opinion recorded with the U.S. Circuit Court, denounced the president's actions as illegal and an abuse of executive authority. A copy of Taney's opinion was sent to the president. This first conflict between the judiciary and the executive branch of government brought the controversy full circle to the American people.

In *Ex Parte Merryman*, the Chief Justice held that only Congress could suspend the writ of habeas corpus.[23] Once again it is worth mentioning that opposition to Lincoln was not directed to the idea of suspending the writ of habeas corpus, but instead to the legality of which branch of government had the authority to do so. Taney argued the president was without jurisdiction to declare the suspension, let alone delegate it to subordinates. In addition, John Merryman was not allowed a judicial hearing, a violation of the Fifth Amendment which guarantees an individual's right to a grand jury indictment. Under the administration's policies, Merryman would be tried by a military tribunal. This point was to become the only issue that the Supreme Court eventually would rule on.

Just as Lincoln had sought precedents to strengthen his act of suspension, so did Taney search for precedents for his argument that the president had overstepped his legal authority. However, Taney could not find an American precedent in arguing his case. Consequently, he turned to English and colonial law to justify his position.[24] Under English law, the parliament is the only branch of the government allowed the authority to suspend the writ of habeas corpus. The qualifying difference from the English Parliamentarian position is the direction the Constitution takes in allowing the suspension only during times of invasion or rebellion. The English Parliament, without a written constitution, can suspend the writ at any time.[25]

Taney argues that Merryman, and others like him, should have been reported to the district attorney for the district in which they resided, not the military authorities, for judicial prosecution. However, as mentioned earlier the number of arrests was high. It would have been impossible for the courts to handle the number of individuals involved in treasonable activities. This was the administration's response to why a military tribunal would try a civilian for treason while the regular courts were open and operable.

[22]Randall, *Constitutional Problems Under Lincoln*, p. 152.

[23]Neely, *The Fate of Liberty*, p. 10.

[24]Ibid., p. 120.

[25]Ibid.

CERTIORARI DENIED AND NO AGREEMENT IN SIGHT

Our government relies on the Supreme Court to interpret the Constitution and resolve controversies that surround it. Merryman petitioned the U.S. Supreme Court for a writ of certiorari. The Court denied the petition. While denial appeared to be an early success for the administration, the argument was far from settled. Indeed, the Chief Justice characterized life in America at that time as follows:

> *The people of the United States are no longer living under a government of laws; but every citizen holds life, liberty, and property at the will and pleasure of the Army officer in whose military district he may happen to be found.*[26]

The president on the other hand was not without supporters, and had a well-defined defense for his actions. Lincoln argues that he had sworn to uphold the Constitution and to protect the integrity of the government of the United States. However, since the Constitution does not specify which branch of government has the authority to suspend, the administration's line of argument was the same as that in the *Prize Cases*. The president felt that the rebellion qualified as an emergency. As in the *Prize Cases*, Lincoln could not have asked the rebels to wait for the convening of Congress or permission from the courts. Rather, Lincoln drew a natural inference that he should take the authority as president of the nation.

President Lincoln assigned Attorney General Bates, a conservative Missouri attorney, to defend the administration's position by responding to the many charges of abuse of power. Bates argued that it was the president's primary responsibility, as preserver, protector and defender of the Constitution, to put down rebellion, especially where the courts were too weak to do so. The executive, with the power of Commander-in-Chief, has the means to suppress rebellion whereas the courts do not. Citing *Martin vs. Mott*, Bates argued that the president "is the judge of the exigency and the manner of discharging his duties."[27] "A habeas corpus hearing is like an appeal, and a judge at chambers cannot entertain an appeal from a decision of the president."[28] Obviously, the president's supporters claimed he had the power to suspend and was under no obligation to answer to the courts when it involved the capturing of traitors and insurgents.

In response to Taney's use of English precedent, Horace Binney, a Lincoln supporter, pamphleteer, and prominent Philadelphia lawyer with great legal abilities, pointed to the fact that the Crown at one time could arrest, without warrant, individuals for "high treason." Suspension of the writ was not declared an exclusive authority of Parliament until 1679.[29] In addition, with the Civil War raging less than 100 years after the revolution there remained many Americans who chose to distance themselves and their government from the British. Binney and other Lincoln supporters stressed the importance of judging the U.S. Constitution by itself and not by any English precedent.

[26]Ibid., p. 121.

[27]Ibid., p. 124.

[28]Ibid.

[29]Ibid., p. 125.

FOCUS ON THE FOREFATHERS

The controversy invoked great discourses on the meaning of American democracy, the Constitution, and civil liberties. The framers of our Constitution were not as boisterous in their opinions to which branch of government would receive the power to suspend as were the two Union camps. Instead, the founding fathers were very quiet as to assignment.

The first draft of the suspension clause read: "The privilege should not be suspended by the legislature except on the most urgent and pressing conditions and for a limited time not exceeding _____ months."[30] The clause as we now know it was presented by Gouveneur Morris who offered it to the convention while the powers of the judiciary were under consideration.[31] Interestingly enough, it was the committee on style that placed the clause where Congressional authorities and responsibilities are outlined. However, the word "legislature" was deleted from the final text. Binney argued that this intentional removal of the word "legislature" was an indication that the forefathers chose to leave the question "up in the air."

The calling out of the militia had been established as a presidential authority before the outbreak of the Civil War. It had been established both by *Martin vs. Mott* and the *Prize Cases* that the president has the power to respond to an emergency. The executive does not have to wait for the legislative or judicial branches of government to declare that national emergency.

What is true as regards the calling of the militia is equally true concerning the suspension of the habeas corpus privilege, for considering the methods and devices of rebellion, open and covert, the power of suspending is a most reasonable attribution to the executive power.[32]

At the end of this chapter we will focus on the *Milligan Case* which took a quite different legal turn as opposed to the direction of Merryman. For now, we should clearly organize the direction of the administration. The riots in Baltimore pushed Lincoln to initially suspend the writ of habeas corpus. This is not to say that he would not have done so if the riots had not occurred. Rather, it does signify the circumstances for which the administration based its actions. Immediately following the Merryman arrest and the ensuing battle between Taney and Lincoln, the administration found itself forced to defend itself in detail for its actions. Bates took his responsibilities seriously:

The judiciary department has no political power and claims none, and therefore . . . no court or judge can take cognizance of the political acts of the president or undertake to revise and reverse his political decisions. I think it will hardly be seriously affirmed that a judge at chambers can entertain an appeal in any form from a decision of the president of the United States, and especially in a case purely political.[33]

Ten weeks elapsed between the starting point of the war, the arrest of Merryman, and the convening of the special July 4, 1861, session of Congress.

[30]Ibid., p. 126.

[31]Ibid.

[32]Ibid., p. 127.

[33]Sprague, <u>Freedom Under Lincoln</u>, p. 117.

CONGRESS FAILS TO ASSERT ITS AUTHORITY

When Congress convened for the July 4th, special session, *Joint Resolution Number One* was introduced onto the Senate floor for discussion. The resolution supported several actions taken by the Lincoln administration. First, the resolution approved the calling of 75,000 men; secondly, the creation of a naval blockade was affirmed; lastly, the suspension of habeas corpus was sanctioned.[34] However, as discussions progressed it was only the last item, sanctioning the suspension that went without final Senate approval. Senators from the border states of Kentucky, Maryland and Delaware would not allow themselves to support the sanctioning of Lincoln's suspension. Senator Lyman Trumbull of Illinois said, "I am not disposed to say that the administration has unlimited power and can do what it pleases after Congress meets."[35] Slowly the momentum the resolution carried lapsed and the clause which approved the suspension was dropped from the whole. The administration's desire to achieve Congressional sanctioning for its actions had succeeded in every aspect except for the suspension of the writ of habeas corpus. Although it appeared that the administration had failed, it is quite significant to note that Congress did not assert its authority to suspend the writ or reprimand the executive for abuse of power. The end result was a Congress that had no impact on the Civil War program. Lincoln was forced to do alone what he felt he had to do to save the Union.

HABEAS CORPUS ACT OF 1863

The 37th Congress was more involved in the habeas corpus controversy and provided legislation stating:

That it is and shall be lawful for the President of the United States, whenever in his judgment by reason of "rebellion or invasion the public safety may require it," to suspend, by proclamation, the privilege of the writ of habeas corpus throughout the United States or in any part thereof, and whenever the said writ shall be suspended . . . , it shall be unlawful for any of the judges of the several courts of the U.S. or of any state, to allow said writ.[36]

The legislation was amended to state "during the present rebellion." This legislation, called the Habeas Corpus Act of 1863, was a compromise between the executive and the judiciary. President Lincoln's authority was recognized by Congress and an indemnity clause for the arresting officer was created. However, Lincoln's authority was not unlimited. The act provided that a list of prisoners be submitted to the District and Circuit Courts and that a prisoner have afforded to him a grand jury indictment. If the grand jury found no grounds for indictment, the prisoner was to be released within twenty days after taking an oath of allegiance.[37] In addition, recognizance for good behavior was established with the court setting the amount for bail. If the administration failed to provide the required list a judge could issue a writ of habeas corpus and the administration would have to honor it. Essentially, the power of arrest before this act was exclusively held in Lincoln's hands. He was responsible for every individual arrested and subsequently those that were released. This was the only action taken by Congress during the Civil War with regards to the suspension of habeas corpus.

[34]Ibid., p. 118.

[35]Ibid., p. 119.

[36]Randall, *Constitutional Problems Under Lincoln*, p. 129.

[37]Ibid., p. 156.

ARBITRARY ARRESTS AND MARTIAL LAW

The suspension of the writ was believed to be in the best interest of the public as a whole. Justice Story would probably have pointed to those individuals arrested for giving sympathy to the Confederate cause, selling Confederate goods, or telling of their dislike of President Lincoln as the unrestrained acts of an overzealous administration. However, these arrests were few in comparison to the individuals arrested for being spies, furnishing supplies to the Confederates, encouraging desertion, theft, or destruction of bridges and railways.

In certain areas of the North, where military crisis was apparent, Lincoln had imposed martial law in addition to the suspension. The imposition of martial law, according to the administration, allowed for prosecution of civilians by military trial for "offenses unknown to the civil law." Martial law and military law are not the same. Martial law is intended to replace the entire system of justice under the civil law when there is a crisis or emergency. Lincoln, as the Commander-in-Chief, is lawmaker, executive, and judge under martial law. The Whiskey Rebellion was a valid precedent for Lincoln in this area; however, the administration went in a different direction.

The Whiskey Rebellion was handled without the implementation of martial law. Arrests were made by the civil authorities and the individuals tried in the civil courts. The military respected this civil authority during the Whiskey Rebellion and the entire situation served as a precedent for the Burr Conspiracy.[38] It was believed that where the civil courts were open and without threat, their authority must be respected. However, during the Civil War, trials were held by military tribunal, in most cases disregarding the civil courts that were operable. This issue of military tribunals, serving as justice over civilians, was the exclusive issue that the Supreme Court addressed in Milligan.

CLEMENT L. VALLANDIGHAM — FORERUNNER TO MILLIGAN

Lincoln proclaimed:

All rebels and insurgents, all persons discouraging enlistment, resisting the draft or guilty of any disloyal practice are subject to martial law.[39]

Washington D.C., Delaware, Maryland, and Pennsylvania were all under martial law in addition to the border states of Kentucky and Missouri, where rebels were active and served as a real threat. It was difficult for the civil courts to operate in the border states because these states themselves were pieced together by different military factions. In these states, where serious threats from Confederate forces were apparent, it appears that martial law was appropriate. In contrast, one must ask what purpose martial law served in areas where there were no risks for military operations. Martial law and military tribunals would seem unnecessary in such regions of the country.

[38]Ibid., p. 146.

[39]Ibid., p. 152.

General Burnside, Commander of the "Department of the Ohio" issued "General Order No. 38" on April 19, 1863:

Any persons committing acts for the benefit of the enemy will be executed as spies or traitors . . . the habit of declaring sympathies for the enemy will no longer be tolerated . . . persons committing such offenses will be at once arrested, with a view to being tried [as spies or traitors] or sent beyond our lines into the lines of their friends.[40]

On May 1, 1863, Clemen L. Vallandigham delivered a speech at Mount Vernon, Ohio, where he openly spoke against the Union and solicited support for the Confederate cause. An "anti-war agitator," Vallandigham was arrested by order of General Burnside for violation of General Order No. 38.[41]

A military commission was established to try Vallandigham. He was afforded counsel, cross examination privileges, and compulsory attendance of witnesses he may have wished to call on his behalf. However, Vallandigham refused to plead guilt or innocence, as he charged that the commission was without jurisdiction. Arguing that the charge was unknown to the civil laws, he was deprived his constitutional guarantees to due process. Vallandigham was found guilty and sentenced to confinement until the conclusion of the war.

Vallandigham petitioned Judge Leavitt of the U.S. Circuit Court at Cincinnati for a writ of habeas corpus. Citing President Lincoln's suspension of the writ and General Burnside's order, Judge Leavitt refused to grant Vallandigham's request. In addition, Vallandigham petitioned the Supreme Court on a motion of certiorari. Certiorari was denied.

More significant than the Court's refusal to hear Vallandigham's case, was the Court's explanation for the refusal. The Court ruled that it did not have jurisdiction to review the proceedings of a military commission.[42] The Court explained that it receives its original jurisdiction from the Constitution and its appellate jurisdiction from the Judiciary Act of 1789. "A military Commission is not a court within the meaning of that act."[43] After Vallandigham exhausted his avenues for remedy, his sentence was commuted and he was banished by President Lincoln to the South.

Our whole discussion of Lincoln's suspension of the writ has centered on its legality. There was no shortage of individuals who took exception to Lincoln's actions; however, there was an odd silence on the part of the Congress and the Supreme Court. Both Merryman and Vallandigham afforded the other two branches of government the opportunities to remedy the president's actions had they been out of line with prescribed executive authority. On both occasions the administration went unchecked. It was not until after the cessation of the war and Lincoln's assassination that the Supreme Court would offer an opinion, a feeble one at that, which focused on the president's authority to suspend the writ and try civilians by military justice.

[40]Ibid., p. 177.

[41]Ibid.

[42]Ibid., p. 179.

[43]Ex Parte Milligan, 4 Wall. (U.S.), 2–142, (1866).

WORD FROM THE SUPREME COURT: *EX PARTE MILLIGAN*

Lambdin P. Milligan was arrested on October 5, 1864, by the order of General Hovey of Indianapolis. Milligan was accused of being a member of the anti-Union groups the "Sons of Liberty" and the "Order of the American Knights."[44] A charge of conspiracy to release rebel prisoners in the states of Kentucky and Missouri was leveled against Milligan. A military tribunal found him guilty and sentenced him to hang on May 19, 1865.[45] A writ of habeas corpus was preyed upon by Milligan to the U.S. Circuit Court of Appeals. A division in that court pushed the case into the Supreme Court.

Before we discuss the decision of the Court, we should summarize the questions raised thus far in this chapter. The issue, of course, is the suspension of the writ of habeas corpus and the legality of Lincoln's actions. Does the placement of the suspension clause in Article I of the Constitution sufficiently signify the proper branch of government accorded this authority? Is it possible that the authority is concurrent between the executive and the legislative branches of government? If we take either side—legislative or executive—can either branch of government delegate the authority to suspend the writ? Finally, does rebellion in one part of the nation justify the suspension of the writ of habeas corpus in other regions not in rebellion? The Supreme Court did not address the obvious question of suspension in the *Milligan Case*. Instead, the controlling question in the case was this: "Upon the facts stated in Milligan's petition, and the exhibits filed, had the Military Commission mentioned in it the jurisdiction, legally, to try and sentence him?"[46]

THE DECISION

The Supreme Court concluded that the military tribunal was without jurisdiction to have tried Milligan. Further, the court found that Congress did not have the constitutional authority to allow the use of military tribunals as it did in the 1863 Habeas Corpus Act. The decision was a small defeat for the Lincoln Administration. However, the war had concluded and Lincoln was dead, thus tempering the mood of the nation and of the Supreme Court. It is significant to illustrate the evolution of the Supreme Court throughout the Civil War with regard to its support of the administration. Beginning with the victory for Lincoln in the *Prize Cases*, the Merryman denial, and the subsequent denial in Vallandigham, the Supreme Court continually kept its hands off Civil War policy. But in a direct reversal, the court moved from claiming no jurisdiction over a military commission in Vallandigham to having jurisdiction in the *Milligan Case*. Justice Davis, delivered the opinion of the court, and spoke to the mood:

> *During the late wicked rebellion, the temper of the times did not allow that calmness in deliberation and discussion so necessary to a correct conclusion of a purely judicial question. Then, considerations of safety were mingled with the exercise of power; and feelings . . . prevailed which are happily terminated. Now that public safety is assured, this question, as well as others, can be discussed and decided without passion or the admixture of any element not required to form a legal judgment.*[47]

[44]Randall, *Constitutional Problems Under Lincoln*, p. 180.

[45]*Ex Parte* Milligan, 4 Wall. (U.S.), 2–142, (1866).

[46]Ibid.

[47]Ibid.

Milligan had been a resident of Indiana for twenty years. He had never lived in a state that took up arms against the United States, nor did he serve the Union. The Supreme Court's majority opinion found the Habeas Corpus Act flawed for its latitude given to the executive with regard to military tribunals. The Congress could not openly allow the executive or military tribunals in the region of the country that was not threatened by rebellion and where the civil courts remained operable:

Martial law cannot arise from a threatened invasion. The necessity must be actual and present; the invasion real, such as effectually closes the courts and deposes the civil administration . . . martial rule can never exist where the courts are open, and is the proper and unobstructed exercise of their jurisdiction. It is confined to the locality of actual war.[48]

It appears that this statement does give a partial answer to the question regarding the expansion of the suspension and martial law in parts of the country that were not threatened. However, I find it quite interesting that the Supreme Court did not address the question that truly was at the heart of the entire matter: Did Lincoln have the authority to suspend the writ of habeas corpus? The December 17, 1866 decision from the Supreme Court did not address that question.

The Court found that the Habeas Corpus Act was flawed in the manner it provided for military justice. But on the other hand, the court found that the *Milligan Case* violated the Act by not allowing a grand jury to investigate the charges against Milligan. The Act was clear in specifying that if a grand jury found no indictment, the prisoner was to be released by judicial order after taking an oath of allegiance. Milligan was not afforded this opportunity:

On the second day of January, 1865, after the proceedings of the Military Commission were at an end, the circuit court of the United States for Indiana met at Indianapolis and impaneled a grand jury, who were charged to inquire whether the laws of the United States had been violated, and if so, to make presentments. The court adjourned on the 27th day of January, having prior thereto discharged from further service the grand jury, who did not find any bill of indictment or make any presentment against Milligan for any offense whatever, and, in fact, since his imprisonment, no bill of indictment has been found or presentment made against him by any grand jury of the United States.[49]

This point is in direct violation of the Habeas Corpus Act of 1863.

Not unlike the decision in the *Prize Cases*, the *Milligan Case* was a close call on one point. The five to four decision did have a small dissent penned by Chief Justice Chase. The dissenters did not follow with the majority's opinion that the Congress was without authority to authorize the use of military commissions. While the Chief Justice agreed that Milligan should be released on the grounds that his trial violated the Habeas Corpus Act, he stressed Congress's authority to allow for the military commission: "Since Congress has the power to declare war, it necessarily has many subordinate and auxiliary

[48]Ibid.

[49]Ibid.

powers. Congress had power to provide for organization of a military commission and for trial by that commission of persons engaged in this conspiracy."[50]

CONCLUSIONS

While the Court did not answer the main questions of this chapter, and it appears that a definitive answer will forever be unattainable, the court's actions do support the thesis of expanded presidential war powers. President Lincoln successfully, whether conscious of it or not, garnered, collected, accumulated, or embodied, whatever the terminology, greater war powers in the hands of the executive.

President Abraham Lincoln sought to hold this nation together as one during the most bloody civil strife the United States has ever known. Lincoln's tenure in the presidency, and his actions taken during this troublesome time, availed extraordinary war powers to the office of the President of the United States. The powers he assumed were far reaching in the sense that he was able to use the office to confiscate personal property without due process, and arrest and jail individuals, on some occasions, for merely speaking in opposition to the Union cause.

If these actions bordered on dictatorship, then Lincoln's conduct of war policy was extraordinarily out of step with our republic's concept of democracy.

Our Constitution provides for checks and balances among the three branches of government. However, the mood and attitude that swept across the land during the Civil War was one of dependency on one man. Abraham Lincoln has not become this country's vision of an overzealous dictator, but that of a martyr who sacrificed temporarily his own beliefs in civil liberties as well as his life for the greater good of liberty and democracy. Congress must be held accountable for the great avenues it offered to the administration. Congress only focused on the issues of legal constitutional conduct after long delays. Moreover, when the legislative branch of government did review Lincoln's actions, it virtually rubber stamped them with exception to the suspension of habeas corpus. And, even in this respect, the Habeas Corpus Act sanctioned the administration's deeds.

For the most part, the courts were also willing to allow Lincoln to wage war on his own. Both *Vallandigham* and *Milligan* represent the Supreme Court's unwillingness to check the executive branch. On the whole, Milligan provides nothing more than an illustration of technicality, as the civil courts did very little to suppress treason.

In the first chapter we dealt specifically with the naval blockade and the *Prize Cases*. Here we have examined an even greater use of power through the suspension of habeas corpus. Even though the Constitution allows the writ to be suspended, Lincoln claimed this power for the executive exclusively. These two acts together, I believe, helped define the prosecution of the war and its subsequent success.

If there is an actual precedent of the Civil War it is the "outstanding fact that the Chief Executive suspended the writ of habeas corpus, and that, so far as the legal consequences were concerned, he was not restrained in so doing by Congress nor by the courts."[51]

What was Lincoln's motivation? How did he see himself and the authority of the office of the president? This is the direction of the next chapter. At the time of the Civil War, as well as today, it was recognized that Lincoln was a man of strong beliefs in the area of personal liberty. His balancing act between that of martyr and dictator is a topic for great discussion. The following quotation from Justice Davis appears towards the end of the Milligan opinion. Davis is aptly aware of the magnitude of Lincoln's restraint and wise use of what truly was immense presidential authority.

[50]Randall, *Constitutional Problems Under Lincoln*, p. 182.

[51]Ibid., p. 137.

This nation, as experience has proved, cannot always remain at peace, and has no right to expect that it will always have wise and humane rulers, sincerely attached to the principles of the Constitution. Wicked men, ambitious of power, with hatred of liberty and contempt of law, may fill the place once occupied by Washington and Lincoln; and if this right is conceded, and the calamities of war again befall us, the dangers to human liberty are frightful to contemplate.[52]

This article appears as a chapter in, *Abraham Lincoln and the Expansion of Presidential War Powers* by Richard Tahvildaran-Jesswein.

Lincoln and Presidential Prerogative

The last two chapters have focused upon two controversial actions taken by the Lincoln Administration in its efforts to suppress the rebellion. On both issues, the naval blockade and the suspension of the writ of habeas corpus, Lincoln made his decisions fully aware that he would be accused of dictatorship and usurpation of civil liberties. Regardless, Lincoln acted as he did. This chapter will examine Alexander Hamilton's argument for a strong executive as outlined in the Federalist Papers and the Prerogative Theory as described by John Locke. In addition, we will illustrate the evolution not only of presidential power in the abstract (prerogative president), but the very clear evolution of Lincoln from clerk to revolutionary leader. Our discussion will direct us to the issue of an evolved strong executive, one that many of our forefathers may have feared, and to an examination of the acceptance of prerogative by the judiciary during times of crisis.

Why did Lincoln see the rebel movement as rebellion and not revolution, what were the foundations of his thoughts and directions, and how did his mastery of persuasion fit within our discussion that he, as an individual, expanded the war powers of the executive? Before we move to our final discussion, applying the Lincoln precedent, it is imperative we understand Lincoln's choices.

ADVOCATE FOR A STRONG EXECUTIVE

There is an idea, which is not without its advocates, that a vigorous executive is inconsistent with the genius of republican government. The enlightened well-wishers to this species of government must at least hope that the supposition is destitute of foundation; since they can never admit its truth, without at the same time admitting the condemnation of their own principles. Energy in the executive is a leading character in the definition of good government. It is essential to the protection of the community against foreign attacks; it is not less essential to the steady administration of the laws; to the protection of property against those irregular and high-handed combinations which sometimes interrupt the ordinary course of justice; to the security of liberty against the enterprises and assaults of ambition, of faction, and of anarchy. Every man the least conversant in Roman history knows how often that republic was obliged to take refuge in the absolute power of a single man, under the formidable title of dictator . . .[53]

[52]*Ex Parte* Milligan, 4 Wall. (U.S.), 2–142, (1866).

[53]Alexander Hamilton, James Madison, and John Jay, *The Federalist Papers* (New York: New American Library, 1961), p. 423.

Alexander Hamilton was by no means sitting on the fence when the question of how strong the executive should be was discussed by our founding fathers. For Hamilton a "feeble executive" meant "bad government." There are several of the Federalist Papers, authored by Hamilton, that propose a strong executive with "energy." We should not look to the Federalist Papers as Lincoln's sole source of power. However, because it is probably the greatest political work written in the United States, it should be included in our mosaic of Lincoln's source of power. We can only assume that Lincoln himself was well versed with the Federalists Papers and their arguments.

The earlier quotation taken from Federalist No. 70 is appropriate to the situation during the Civil War. Hamilton in his development of a good executive outlines four main manifestations of the energy this officer should have: unity, duration, adequate provisions for its support, and competent powers. We will focus on the first two and the last.

Only with one chief magistrate could the republic survive, according to Hamilton. The discussions in the area of unity arose as many called for a council or committee of executives rather than one man to serve in the position of chief executive. Hamilton argued that whenever more than one individual was vested with such authority there would surely be differences of opinion. With these differences of opinion there could be no unity. This non-unity lessens "the respectability, weakens the authority, and distracts the plans and operations of those whom they divide."[54]

Lincoln of course, was the chief executive charged with executing the laws of the land. However, our focus upon Hamilton's discourse should direct us to the arena of plurality. Obviously, those individuals in disagreement with Hamilton sought to divide the power of the executive among two or even three men. This idea of plurality in the executive has prompted questions with regard to the executive and his ability to prosecute war. While the Constitution provided for one executive, Lincoln's detractors called for a plurality in the prosecution of the Civil War. This call would have involved the Congress more in war policy. In comparison, while Hamilton argued against the plurality and for unity in the office of the president, there is no difference in the rejection of Congressional involvement, because Lincoln sought a policy that was uniform, quick, and strong. Hamilton argued against plurality in the executive during war: "In the conduct of war, in which the energy of the executive is the bulwark of national security, everything would be apprehended from its plurality."[55] Had Lincoln been at odds with the Congress regarding the prosecution of the war effort, one might assume that Hamilton's warnings of weakened authority may have prevailed and blurred the assignment of responsibility.

The modern form of the presidency lends support to the hypothesis that plurality in the executive (war making) not only may weaken our efforts during a time of war but, in addition, may also blur the responsibility for the prosecution of the Civil War. Franklin Roosevelt and Harry Truman are not that much different with regard to making tough decisions without the consent of Congress and accepting the responsibility. However, our country's involvement in Vietnam poses a stark contrast in this direction. It appears that in WWII as well as in the Civil War, our efforts were spearheaded by the executive branch of government. In contrast, it is difficult to say the same about Vietnam. Our failure in Indochina is not easily assessed and neither is the responsibility, because that war evolved into a conflict prosecuted by plurality.

Again I point to Hamilton: "The executive power is more easily confined when it is one; that is far more safe there should be a single object for the jealousy and watchfulness of the people; and, in a word, that all multiplication of the executive is rather dangerous than friendly to liberty."[56] During the

[54] Ibid., p. 426.

[55] Ibid., p. 427.

[56] Ibid., p. 430.

Civil War there were many men jealous of Lincoln and the power he wielded. However, Hamilton's argument would support Lincoln's efforts and directions during the rebellion. In discussing Hamilton's call for unity, I have replaced the committee or counsel of the president with the interaction of Congress. For this particular crisis, liberty may have been in jeopardy had Lincoln not acted in the manner in which he did. From April 19, 1861 to July 4, 1861, and really during the entire duration of the rebellion, Lincoln acted without the direct involvement of Congress. Hamilton would have called this unity while others have called it tyranny.

President Lincoln feared, until the capture of Atlanta, that he would not win re-election in 1864. This brings us to the second of Hamilton's points:

> *It is a general principle of human nature that a man will be interested in whatever he possesses, in proportion to the firmness or precariousness of the tenure by which he holds it; will be less attached to what he holds by a momentary or uncertain title, than to what he enjoys by a durable or certain title; and, of course, will be willing to risk more for the sake of the one than for the sake of the other. This remark is not less applicable to a political privilege, or honor, or trust, than to any article of ordinary property.*[57]

Hamilton speaks to the man who has little attachment to his political power as he knows that he holds it for only a limited time and at the will of the people. Lincoln never became a man who fed on liberty. Rather, he was its protector. Expecting defeat in the 1864 election, there is no evidence that Lincoln would not have relinquished the office of the president. Hence, we cannot describe Lincoln as a tyrant and absolute ruler. Instead, we describe Lincoln as a leader with a sense of community who swore to uphold the Constitution. Hamilton writes:

> *The republican principle demands that the deliberate sense of the community should govern the conduct of those to whom they intrust the management of their affairs; but it does not require an unqualified complaisance to every sudden breeze of passion, or to every transient impulse which the people may receive from the arts of men, who flatter their prejudices to betray their interests.*[58]

If Hamilton's Federalists Papers were a part of Lincoln's mosaic of thoughtfulness, surely the allocation of competent powers was of great significance. Hamilton argues that the executive would need

[57]Ibid., p. 431.

[58]Ibid., p. 432.

certain powers to uphold the Constitution, execute the laws, and protect the American people from attack. Hamilton sought to concentrate the military authority solely in the executive:

> *Of all the cares or concerns of government, the direction of war most peculiarly demands those qualities which distinguish the exercise of power by a single hand. The direction of war implies the direction of the common strength; and the power of directing and employing the common strength forms a usual and essential part of the definition of the executive authority.*[59]

Abraham Lincoln did believe that he had these powers through the office of Commander-in-Chief. This clause of our Constitution became the "locus" for Lincoln's thoughts and actions: "I think the Constitution invests its Commander-in-Chief clause with the law of war, in time of war."[60] Lincoln continued, "As Commander-in-Chief . . . I have a right to take any measure which may best subdue the enemy."[61]

Before Alexander Hamilton and Abraham Lincoln even existed John Locke was addressing this idea of extraordinary powers during times of peril. While our Constitution does not confront the idea of prerogative power, Locke did. Even though the Constitution may not address such a political controversy, be assured that our founding fathers did so with great discourse. According to Arthur Schlesinger, Jr., "Our founding fathers were more influenced by John Locke than by any other political philosopher; and, as students of Locke, they were all acquainted with the *Second Treatise of Government*."[62]

"OF PREROGATIVE"

Locke's social contract, the foundation for classical liberalism, is well read and respected. The basis for the contract being the "reciprocal obligation of ruler and ruled within the frame of law."[63] However, Locke did recognize and even espoused the use of prerogative power during times of crisis where "a strict and rigid observation of the laws may do harm" to the nation.[64] Simply put, prerogative power is that power of self preservation. While Lincoln never directly spoke of this power, his actions support its existence and purpose. Locke's prerogative power was rejected by the American constitutionalists.[65] However, while the founding fathers did not include prerogative in the Constitution, they did provide for the suspension of habeas corpus. At times, Locke wrote, "the laws themselves should . . . give way to the executive power, or rather to this fundamental law of nature and government, viz., that, as much as may be, all members of society are to be preserved."[66] The concern for the founding fathers and even for constitutionalists today

[59]Ibid., p. 447.

[60]Arthur M. Schlesinger, Jr., *The Imperial Presidency* (Boston: Houghton Mifflin Company, 1973), p. 62.

[61]Ibid., p. 63.

[62]Ibid., p. 8.

[63]John Locke, *Second Treatise of Government*, cited by Arthur M. Schlesinger, Jr., *The Imperial Presidency*, p. 14.

[64]Ibid., p. 8.

[65]Edward Keynes, *Undeclared War: Twilight Zone of Constitutional Power* (University Park: Pennsylvania State University Press, 1982), p. 11.

[66]John Locke, *Second Treatise of Government*, cited by Arthur M. Schlesinger, Jr., *The Imperial Presidency*, p. 8.

is the question of who decides if an emergency exists. Locke claims that the community decides and if unable to sanction the executive's claim to prerogative than revolution should ensue.

President Lincoln took extraordinary political measures to aid the Union in putting down the rebellion. Congress perceived the emergency as real and sanctioned most of his actions taken while the Congress was at recess. Locke would claim that Lincoln acted responsibly in his attempts to preserve the Union with the community sanction of his actions. Locke believed that the executive must have this reserve power "to act according to discretion for the public good, without the prescription of law and sometimes even against."[67]

Whereas Schlesinger writes, "this doctrine was accepted by every single one of our early states-men . . . [and] can be easily shown; it simply was not included in the construction of the executive."[68] It was believed that it would better serve the nation to not define such a prerogative power and instead allow the president to act if an emergency occurred and then consult Congress for sanctioning. This is the exact course Lincoln followed. Congressman Alexander White of the First Congress explained that it is better, "to extend his power on some extraordinary occasion, even where he is not strictly justified by the Constitution, than the legislature should grant him an improper power to be exercised at all times."[69]

We should note however that Locke did not intend the use of prerogative power to serve as a prec-edent. The emergency acts of Lincoln's administration and the use of extraordinary powers in no way should signify the "all clear" for presidents to use these immense powers at leisure.

Lincoln clearly broke the law in the minds of many Americans when he assembled the militia, enlarged the army and navy, implemented conscription, spent public funds without appropriation, suspended the writ of habeas corpus and put to use a naval blockade. His response to his critics was not that of an executive claiming to have worked within the limits of his office. Rather, Lincoln stated, "whether strictly legal or not, [these actions] were ventured upon under what appeared to be a popu-lar demand and a public necessity; trusting then as now that Congress would readily ratify them."[70] Lincoln sounded as if he were echoing Locke's claim to prerogative, "the people's permitting their rulers to do several things of their own free choice, where the law was silent, and sometimes, too, against the direct letter of the law, for the public good, and their acquiescing in it when so done."[71] Locke advo-cated prerogative for the public good. Lincoln believed that he was acting for the public good when fighting off rebellion in his attempts to protect the Constitution. Hence, Lincoln drew his authority from the Constitution and its Commander-in-Chief clause stating,

> When rebellion or invasion comes, the decision is to be made . . . and I think the man whom, for the time, the people have, under the Constitution, made the Commander-in-Chief of their army and navy, is the man who holds the power and bears the responsibil-ity of making it.[72]

Lincoln speaks only in terms of defensive war stating rebellion or invasion. Obviously, if the execu-tive were to launch a war and attempt to play it off as a defensive measure, the community would reject his claims to prerogative. Then again, the modern presidency has shown that this may not be so.

[67]Ibid., p. 9.

[68]Schlesinger, *The Imperial Presidency*, p. 10.

[69]Ibid.

[70]Ibid., p. 58.

[71]Ibid., p. 8.

[72]Ibid.

In 1862, William Whiting wrote <u>War Powers Under the Constitution of the United States</u>. Whiting speaks to the doctrine of defensive war in a timely manner that only gave greater credibility to Lincoln:

> *If the Commander-in-Chief could not call out his forces to repel an invasion unless the Legislative department had previously made a formal declaration of war, a foreign enemy, during a recess of Congress, might send out its armed cruisers to sweep our borders and march, unopposed, from Canada to the Gulf before a majority of our Representatives could be convened to make that declaration. The Constitution, made as it was by men of sense, never leaves the nation powerless for self-defence . . . Nothing is clearer than this, that when such a state of hostilities exists as justifies the president in calling the army into actual service, without the authority of Congress, no declaration of war is requisite, either in form or substance, for any purpose whatsoever.*[73]

Whiting's writings foreshadowed the Supreme Court's decision in the *Prize Cases*, discussed earlier, and certainly gave the administration added confidence in its pursuits.

Hamilton wrote of the executive well endowed with "energy" and capable of providing unity for that office. In succession we discussed Locke and his definition of prerogative. During the course of writing this paper it has been necessary to separate the romanticism of Lincoln's character from his actions. However, we cannot help but ask ourselves if another man would have acted in the same manner; a manner of genius. Hamilton and Locke provide a foundation of Lincoln's thoughts. Of course it is impossible to fully understand where this practical man received his insight. It may have all been original.

Abraham Lincoln was changed by his presidency as all presidents are. Significantly, it has been claimed that Lincoln was a man who put practical solutions before constitutional concerns; that he was a conservative man without tendencies of a revolutionary leader, and had the South not forced Lincoln's hand, he merely would have been what Richard Neustadt calls a presidential clerk.

REVOLUTIONARY LEADER OR CLERK?

Lincoln's war aims were very specific at the onset of the rebellion. He sought to prevent the border states from joining in the secession and prevent those states that had seceded from doing so permanently. Nowhere in his plan was the emancipation of slaves. Then why is it that when people refer to Lincoln they do so as the "Great Emancipator?" The point of this question is to accurately draw a composite of Lincoln's so called revolutionary character. Had Lincoln not freed the slaves, even though he was an anti-slavery man, he would be considered far less a revolutionary, and more a general protector of the principles of our first revolution.

James Randall, whom James M. McPherson refers to as the "foremost Lincoln scholar of a generation ago," describes Lincoln's presidency as "prudent adherence to tested values, avoidance of rashness,

[73]William Whiting, *War Powers Under the Constitution of the United States*, 43rd ed., (Boston, 1871), cited by Arthur Schlesinger, *The Imperial Presidency*, p. 64.

and reliance upon unhurried, peaceable evolution, [then] Lincoln was a conservative."[74] In calling Lincoln a conservative, Randall and McPherson type Lincoln as a man who only sought to repress the rebellion. As history records, Lincoln did much more. A revolution is an act, whether violent or not, which forever changes the social and cultural institutions of a country. Our revolutionary war against Britain does not much qualify under the text book model. However, the Civil War appears to have evolved from the suppression of an uprising to the repression of a way of life. Of Lincoln, Mark Twain wrote:

[He] uprooted institutions that were centuries old, changed the politics of a people, transformed the social life of half the country, and wrought so profoundly upon the entire national character that the influence cannot be measured short of two or three generations.[75]

Lincoln believed in the right of revolution but did not consider the Confederate cause to fall into that category. Rather, he saw secession as pure and simple rebellion. The South, of course, believed that their movement was revolution and paralleled the United States' break from Great Britain. Lincoln claimed he would take any measure necessary to repress the rebellion. The emancipation of slaves was a revolutionary action.

Lincoln's original plans followed a blueprint for gradual compensated emancipation with the Southern States' input and participation.[76] Lincoln's plans failed because seven states seceded from the Union before he took office. McPherson suggests that the Southern States rebelled, as a child would, when they were unsuccessful in pressing their own agenda. This was Lincoln's thought as well. The Democratic party had controlled the national government for the two previous generations. With Lincoln, a newly elected Republican, the South realized there would be objections and obstacles to their economic and cultural ways of life.

If the South succeeded, Lincoln believed that a terrible precedent would destroy the "great American experiment." Simply put, the minority could secede whenever their objectives were not the same as the majority. Coupled with Lincoln's thoughts on liberty and democracy, the issue was set:

This issue embraces more than the fate of these United States. It presents to the whole family of man, the question, whether a constitutional republic, or a democracy . . . can, or cannot, maintain its territorial integrity. The struggle is for a vast future . . . On the side of the Union it is a struggle for maintaining in the world that form and substances of government whose leading object is to elevate the condition of men . . . to afford all an unfitted start, and a fair chance in the race of life.[77]

[74]James M. McPherson, *Abraham Lincoln and the Second American Revolution* (New York: Oxford University Press, 1990), p. 23.

[75]Ibid., p. 24.

[76]Ibid.

[77]Ibid., p. 29.

Lincoln succeeded in his war aims: the South was restored to the Union and the Constitution preserved. However, the South that returned would forever be changed as was Lincoln. Lincoln who sought only to uphold the Constitution, started down a path of "prudent adherence to tested values." He once wrote Horace Greeley, "My paramount object in this struggle is to save the Union, and is not either to save or to destroy slavery . . . what I do about slavery and the colored race, I do because I believe it helps save the Union."[78] In the end the Lincoln administration had destroyed the social structure of the South economically and socially through the eradication of slavery. Regardless of his reasoning, Lincoln had led the Union to reconciliation with its Declaration of Independence, often publicly revered by Lincoln, and moved himself from maintenance man to revolutionary. Unfortunately, we cannot measure Lincoln's personal evolution or even the degree of his understanding of the impact his presidency would have on the nation and the world. Karl Marx proclaimed Lincoln "the single-minded son of the working class . . . who led his country through the matchless struggle for the rescue of an enchained race and the reconstruction of a social world."[79]

PRACTICAL POLICIES OVER CONTROVERSIAL CONSTITUTIONAL ISSUES

According to Mark Neely, author of The Fate of Liberty, Lincoln "did not by habit think first of the constitutional aspect of most problems he faced. His impulse was to turn to the practical."[80] Neely discusses Lincoln's early career as a state legislator and the direction he navigated in the statehouse. Lincoln was a Whig politician twice as long as he was a Republican. Whigs had the reputation of being "broad viewed" with regard to the Constitution. Lincoln, a proponent of the national bank and public improvements, found himself arguing for a greater authority for the federal government while his Democratic colleagues believed that the Constitution did not allow the federal government the authority to interfere in state affairs.

In essence, Neely describes Lincoln as a practical man with a practical view of politics. This characteristic had a profound impact on the prosecution of the Civil War. It was this practical quick response to the rebellion that raised some concerns. However, Lincoln would have been much more comfortable as the politician working to create and rebuild canals, roads, bridges, and railroads. "The practical legislator from Illinois was not comfortable on the high ground of inflexible constitutional principle."[81] Lincoln often opted for the Declaration of Independence over the Constitution in his oratory, displaying a "gruff and belittling impatience with constitutional arguments."[82]

Neely makes an important distinction between the practical Lincoln and the statesman addressing the country's future. President Lincoln believed that the suspension of habeas corpus was a temporary safeguard during the course of the war. He did not expect the suspension to last far into the nation's future. On the other hand, Lincoln recognized that if he did free the slaves, there were serious concerns about how to protect the freedmen from re-enslavement and prejudices. It is on this point that Lincoln merges his practical political skills and the Constitution. In 1864, Lincoln sought an amendment to guarantee the freedom of the slave therefore cementing his emancipation proclamation.

[78]Ibid., p. 41.

[79]Ibid., p. 25.

[80]Mark E. Neely, Jr., *The Fate of Liberty: Abraham Lincoln and Civil Liberties* (New York: Oxford University Press, 1991), p. 210.

[81]Ibid., p. 212.

[82]Ibid.

Lincoln's skill as a practical man and politician held together the Union. In addition, his picture of the nation's future guided him in his decision to support an amendment to the Constitution and to work immediately for reconstruction. Neely writes, "This ability to balance short-term practicality and long-term ideals is perhaps the essence of statesmanship. In Lincoln's case, the one helped preserve the Constitution as the law of the land, and the other brought such changes as made it worth preserving 'throughout the indefinite peaceful future.'"[83]

SUMMARY

President Lincoln based his actions on some of the issues discussed in this chapter. The intent of this chapter was to establish the nature of Lincoln's actions as well as distinguish between the protector of liberty and the dictator or despot.

Our focus on the Federalist Papers, specifically No.'s 69–71 authored by Alexander Hamilton, show that at the time of Lincoln's presidency there existed prestigious historical documents that supported Lincoln's claim to a prerogative power. It is not coincidence that Hamilton speaks of the president's military authority and Lincoln utilized the said authority through his post as Commander-in-Chief.

I sought to establish Hamilton's writings as a piece of the Lincoln thought mosaic. Through a discussion of unity, duration, and competent powers, we draw support for Lincoln's actions. Prerogative power, as described by John Locke, is of even greater significance, as Lincoln's actions during the Civil War mirror Locke's model.

These two points are mere speculation due to the fact that Lincoln never specifically stated where he derived the power or authority to act as he did. But then as the practical politician, he did not think it necessary to engage in a constitutional debate whether or not he had said authority. Rather, Lincoln's first priority was to save the Union.

Is there a Lincoln propensity toward the use of presidential war powers? In the next chapter we will investigate three applications of what could be considered a Lincoln precedent. In this chapter, we have taken the pieces that construct the mosaic and arranged them in a manner that depicts a practical individual who set upon a course to maintain the Union and would do whatever was necessary to protect liberty.

[83]Ibid., p. 222.

Credits

Multiculturism and "The Politics of Recognition": An Essay by Taylor, Charles. Reproduced with permission of Princeton University Press in the format Book via Copyright Clearance Center.

Excerpts from *Real to Reel: Race, Class, and Sex at the Movies* by Bell Hooks. Copyright 1997 by Taylor & Francis Group LLC—Books. Reproduced with permission of Taylor & Francis Group LLC—Books in the format Textbook via Copyright Clearance Center.

Excerpts from "My Own Private Idaho" by Harvey R. Greenberg from *Film Quarterly*, Vol. 46, No. 1. Copyright © 1992, The Regents of the University of California. Reprinted by permission of The Regents of the University of California and the author.

From "My Own Private Idaho" by Jim Kline from Frank Magill, editor, *Magill's Cinema Annual—1992*. Copyright © 1992 Gale, a part of Cengage Learning, Inc. Reprinted by permission.

From "Queer Questions" by Cherry Smith, *Sight & Sound*, September 1992. Reprinted courtesy of British Film Institute.

Excerpts from "Talkin' 'Bout Their Generation" by John Ottenhoff from *Christian Century*. Copyright 1994 by the Christian Century Foundation. Reproduced with permission of Christian Century Foundation in the format Textbook via Copyright Clearance Center.

Excerpts from "Shakespeare Out in Portland: Gus Van Sant's My Own Private Idaho, Homoneurotics, and Boy Actors" by David Roman, from *Eroticism and Containment*, edited by Carol Siegel and Ann M. Kibbey, pp. 312, 319, 320. Copyright © 1994 New York University. All rights reserved. Reprinted by permission.

Excerpt from *The Political Companion to American Film*, edited by Gary Crowdus (Lake View Press, 1994), p. 396. Reprinted by permission of the University of Minnesota Press.

From "Objects of Desire" by Amy Taubin, *Sight & Sound*, January 1992. Reprinted courtesy of British Film Institute.

From "My Own Private Idaho" by Lizzie Francke, *Sight & Sound*, April 1992. Reprinted courtesy of British Film Institute.

"Keanu Reeves / River Phoenix" by Gini Sikies and Paige Powell. Originally published in *INTERVIEW Magazine*, November 1991. Courtesy of Interview, Inc.

Excerpts from *Fugitive Cultures: Race, Violence, and Youth*, by Henry Giroux. Copyright 1996 by Taylor & Francis Group LLC—Books. Reproduced with permission of Taylor & Francis Group LLC—Books in the format Textbook via Copyright Clearance Center.

Excerpts from "Fierce Love and Fierce Response" by David Roman from *Journal of Homosexuality*, Vol. 26, No. 2 (February 12, 1994). Copyright © 1993 Routledge. Reprinted by permission of Taylor & Francis Group, http://www.informaworld.com and the author.

Excerpts from "Films of Power and Grace in '89" by James Wall from Christian Century. Copyright 1990 by the Christian Century Foundation. Reproduced with permission of Christian Century Foundation in the format Textbook via Copyright Clearance Center.

From "Film Noir" by Michael Dyson, Tikkun, 4, 1989. Reprinted by permission of TIKKUN: A Bimonthly Interfaith Critique of Politics, Culture & Society.

Excerpts from "Do the Right Thing" by Thomas Doherty from Film Quarterly, Vol. 43, No. 2. Copyright © 1989, The Regents of the University of California. Reprinted by permission of The Regents of the University of California and the author.

Excerpts from "Do The Right Thing: A Jarring Look at Racism" by James Wall from Christian Century. Copyright 1989 by the Christian Century Foundation. Reproduced with permission of Christian Century Foundation in the format Textbook via Copyright Clearance Center.

From "Spike Lee & The American Tradition" by Colette Lindroth from Literature-Film Quarterly 24 (1996). Reprinted with permission of Literature/Film Quarterly © Salisbury University, Salisbury, MD 21801.

From "Spike Lee & The American Tradition" by Colette Lindroth from Literature-Film Quarterly 24 (1996). Reprinted with permission of Literature/Film Quarterly © Salisbury University, Salisbury, MD 21801.

From "Spike Lee's Bed-Stuy BBQ" by Marlaine Glicksman, Film Comment, 25, 1989. Reprinted by permission of the author.

From "Spike Lee, Corporate Populist" by Jerome Christensen, Critical Inquiry, 17(3), (1991), p. 583; 588; 589; 591. Reprinted courtesy of The University of Chicago Press.

From "Seeing Do the Right Thing" by W.J.T. Mitchell, Critical Inquiry, 17 (1991), p. 596. Reprinted courtesy of The University of Chicago Press.

From "The Smell of Celluloid in the Classroom" by Julie Johnson and Colby Vargas Social Education, 58 (1994), pp. 109, 112. (Silver Spring, MD: National Council for the Social Studies, 1994). Reprinted courtesy of the National Council for the Social Studies.

Excerpts from "Look Forward in Anger" by David Seelow from The Journal of Men's Studies: A Scholarly Journal about Men and Masculinities. Copyright 1996 by Men's Studies Press, LLC. Reproduced with permission of Men's Studies Press, LLC in the format Textbook via Copyright Clearance Center.

From "Flipper Purify and Furious Styles" by Armond White, Sight & Sound, August 1991. Reprinted courtesy of British Film Institute.

References

*"A Chill on the Heart." Time (July 22, 1991):65.

*Amoda, Moyibi. *Black Politics and Black Vision*. Philadelphia: Westminister Press, 1972.

*Andersen, Margaret, and Collins, Patricia, eds. *Race, Class, and Gender: An Anthology*. Belmont, CA: Wadsworth Publishing Company, 1992.

*"Angry, Assertive and Aware: A New Group of Filmmakers Is Bringing a Different Look to the Big Screen." *Ebony* (November 1991):160–164.

*Ansen, David. "Where the Boyz Are, Inner-City Style." *Newsweek* (July 15, 1991): 56.

*Anzaldua, Gloria, ed. *Making Face, Making Soul: Haciendo Caras: Creative and Critical Perspectives by Feminists of Color*. San Francisco: Aunt Lute Books, 1990.

*Arnheim, Rudolf. "Film and Reality." *In Film Theory and Criticism*. Mast, Gerald, et al., eds. New York: Oxford University Press, 1992: 268–271.

*Arnheim, Rudolf. "The Complete Film." In Film Theory and Criticism. Mast, Gerald, et al., eds. New York: Oxford University Press, 1992: 48–51.

*Arnheim, Rudolf. *Film as Art*. Berkeley: University of California Press, 1957.

*Aronowitz, Stanley. *The Politics of Identity: Class, Culture, Social Movements*. New York: Routledge, 1992.

*Austin, Bruce. *The Film Audience: An International Bibliography of Research*. *London:* The Scarecrow Press, 1983.

*Awkward, Michael. *Negotiating Difference: Race, Gender, and the Politics of Positionality*. Chicago: University of Chicago Press, 1995.

*Balazs, Bela. *Theory of Film: Character and Growth of a New Art*. New York: Roy Publishers, 1953.

*Balazs, Bela. *Theory of the Film*. New York: Dover Press, 1970.

*Baldwin, James. *The Fire Next Time*. New York: Dial Press, 1963.

*Banton, Michael. *Racial Consciousness*. New York: Longman, 1988.

*Barber, Benjamin. "Foundationalism and Democracy." *In Democracy and Difference: Contesting the Boundaries of the Political*. Seyla Benhabib, ed. Princeton, NJ: Princeton University Press, 1996: 348–360.

*Barber, Benjamin. *Jihad vs. McWorld: How Globalism and Tribalism Are Reshaping the World*. New York: Ballantine Books, 1995.

*Barber, Benjamin. *Strong Democracy: Participatory Politics for a New Age.* Berkeley: University of California Press, 1984.

*Bazin, Andre. "The Evolution of the Language of Cinema." In Film Theory and Criticism. Mast, Gerald, et al., eds. New York: Oxford UniversityPress, 1992: 155–167.

*Bazin, Andre. "The Myth of Total Cinema." In *Film Theory and Criticism.* Mast, Gerald, et al., eds. New York: Oxford University Press, 1992: 34–37.

*Bell, Elizabeth, Haas, Lynda and Sells, Laura, eds. From Mouse to Mermaid: *The Politics of Film, Gender, and Culture.* Bloomington: Indiana University Press, 1995.

*Benhabib, Seyla. "Toward a Deliberative Model of Democratic Legitimacy." *In Democracy and Difference: Contesting the Boundaries of the Political.* Seyla Benhabib, ed. Princeton, NJ: Princeton University Press, 1996: 67–94.

*Benhabib, Seyla. *Democracy and Difference: Contesting the Boundaries of the Political.* Princeton, NJ: Princeton University Press, 1996.

*Bennett, William. *Book of Virtues: A Treasury of Great Moral Stories.* New York: Simon & Schuster, 1993.

*Bennett, William. *The De-Valuing of America.* Simon and Schuster, 1992.

*Bickford, Susan. *The Dissonance of Democracy: Listening, Conflict, and Citizenship.* New York: Cornell University Press, 1996.

*Block, Adam. "Inside Outsider Gus Van Sant." *The Advocate* (September 24, 1991):80–85.

*Bloom, Allan. *The Closing of the American Mind.* New York: Simon and Schuster, 1987.

*Boger, John, and Wegner, Judith, eds. *Race, Poverty, and American Cities.* Chapel Hill: The University of North Carolina Press, 1996.

*Bordwell, David, and Thompson, Kristin. *Film Art: An Introduction.* New York: McGraw Hill, 1993.

*Bradby, David, James, Louis, and Sharratt, Bernard, eds. *Performance and Politics in Popular Drama: Aspects of Popular Entertainment in Theatre, Film, and Television, 1800–1976.* Cambridge: Cambridge University Press, 1980.

*Broune, Nick, ed. *Cahiers du Cinema 1969–1972: The Politics of Representation.* Cambridge: Harvard University Press, 1990.

*Broune, Nick. "The Spectator-in-the-Text: The Rhetoric of Stagecoach." *In Film Theory and Criticism.* Mast, Gerald, et al., eds. New York: Oxford University Press, 1992: 210–226.

*Brown, Jerry. *Dialogues.* Berkeley, CA: Berkeley Hills Books, 1998.

*Browne, Ray, and Ambrosetti, Ronald, eds. *Continuities in Popular Culture: The Present in the Past and the Past in the Present and Future.* Bowling Green, OH: Bowling Green State University Popular Press, 1993.

*Browne, Ray. *Popular Culture and the Expanding Consciousness.* New York: Wiley Press, 1973.

*Brunette, Peter. "Singleton's Street Noise." *Sight and Sound* 1 (1991):13.

*Bryant, Wayne. *Bisexual Characters in Film: From Anais to Zee.* New York: The Haworth Press, 1997.

*Burke, Phyllis. *Gender Shock: Exploding the Myths of Male & Female.* New York: Doubleday, 1996.

*Butler, Judith. *Gender Trouble.* New York: Routledge, 1990.

*Calhoun, Craig, ed. *Social Theory and the Politics of Identity.* Oxford: Blackwell, 1994.

*Campbell, Russell. *Cinema Strikes Back: Radical Filmmaking in the United States, 1930–1942.* Ann Arbor: University of Michigan Press, 1982.

*Carey, John. "Conventions and Meaning in Film." In *Film/Culture: Explorations of Cinema in its Social Context.* Sari Thomas, ed. NJ: The Scarecrow Press, 1982: 110–125.

*Castro, Janice. "Bored in the Hood." *Time* (December 7, 1992):21.

*Cham, Mbye, and Andrade-Watkins, eds. *Critical Perspective on Black Independent Cinema.* Cambridge, MA: The MIT Press, 1988.

*Chapple, Richard, ed. *Social and Political Change in Literature and Film: Selected Papers from the Sixteenth Annual Florida State University Conference on Literature and Film.* Gainesville: University Press of Florida, 1994.

*Cheney, Lynne. *Telling the Truth: Why Our Culture and Our Country Have Stopped Making Sense-and What We Can Do About It.* New York: Simon and Schuster, 1995.

*Chrisman, Robert. *"Do the Right Thing." The Black Scholar* 21 (1990):53.

*Christensen, Jerome. "Spike Lee, Corporate Populist." *Critical Inquiry* 17 (1991): 582–595.

*Churchill, Ward. *Fantasies of the Master Race: Literature, Cinema and the Colonization of American Indians.* Monroe, ME: Common Courage Press, 1992.

*Cohen, Jean. "Democracy, Difference, and the Right of Privacy." In *Democracy and Difference: Contesting the Boundaries of the Political.* Seyla Benhabib, ed. Princeton, NJ: Princeton University Press, 1996: 187–217.

*Cohen, Joshua. "Procedure and Substance in Deliberative Democracy." In *Democracy and Difference: Contesting the Boundaries of the Political.* Seyla Benhabib, ed. Princeton, NJ: Princeton University Press, 1996:95–119.

*Combs, James, and Combs, Sara. *Film Propaganda and American Politics: An Analysis and Filmography.* New York: Garland Publishers, 1994.

*Con Davis, Robert, and Schleifer, Ronald, eds. *Contemporary Literary Criticism: Literary and Cultural Studies.* New York: Longman, 1994.

*Connolly, William. *Appearance and Reality in Politics.* New York: Cambridge University Press, 1981.

*Connolly, William. *Identity/Difference: Democratic Negotiations of Political Paradox.* New York: Cornell University Press, 1991.

*Connolly, William. *The Ethos of Pluralism.* Minneapolis: University of Minnesota Press, 1995.

*Cook, Bruce. "Why TV Stars Don't Become Movie Stars." *American Film* 1 (1976): 58–60.

*Corkin, *Stanley. Realism and the Birth of the Modern United States: Cinema, Literature, and Culture.* Athens: University of Georgia Press, 1996.

*Corliss, Richard. "Boyz of New Black City." *Time* (June 17, 1991):64–68.

*Corrigan, Timothy. *A Cinema Without Walls: Movies and Culture After Vietnam.* New Brunswick, NJ: Rutgers University Press, 1991.

*Coupland, Douglas. *Generation X: Tales for an Accelerated Culture.* New York: St. Martin's Press, 1991.

*Croteau, David. Politics and the Class Divide: Working People and the Middle Class Left. Philadelphia: Temple University Press, 1995.

*Crowdus, Gary, ed. *The Political Companion to American Film.* New York:Lakeview Press, 1994.

*Dallmayr, Fred. "Democracy and Multiculturalism." In *Democracy and Difference: Contesting the Boundaries of the Political.* Seyla Benhabib, ed. Princeton, NJ: Princeton University Press, 1996: 278–294.

*Dart, Peter. "The Concept of Identification in Film Theory." Paper presented at the Thirtieth Annual conference of the University Film Association, Iowa State University, 1976.

*Davis, Thulani. "Local Hero: Workin' 40 Acres and a Mule in Brooklyn." *American Film* 14 (1989):26–54.

*de Lauretis, Teresa. *Technologies of Gender: Essays on Theory, Film, and Fiction.* Bloomington: Indiana University Press, 1987.

*Denby, David. "*Boyz 'N the Hood.*" *New York* (July 22, 1991a):40–43.

*Denby, David. "Gus Van Sant's *My Own Private Idaho* May Be Disorderly, But It's Also a Tenderly Comical and Beautiful Piece of Work." *New York* (October 7, 1991):79–80.

*Denby, David. "John Singleton's Honest *Boyz 'N the Hood* Is Nothing if Not
Responsible . . ." *New York* (July 29, 1991b):49.

*Denby, David. "Spike Lee Vows to Do the Right Thing." *New York* (September 1992):50.

*Dixon, Wheeler. It Looks at You: *The Returned Gaze of Cinema.* Albany: State University of New York Press, 1995.

*"*Do The Right Thing.*" *Variety* (November 10, 1989):83.

*Doherty, Thomas. "*Do the Right Thing.*" *Film Quarterly* 43 (1989):35–40.

*Downing, John, ed. *Film, Politics, and the Third World.* New York: Praeger, 1987.

*Dryzek, John. *Discursive Democracy: Politics, Policy, and Political Science.* Cambridge, UK: Cambridge University Press, 1990.

*Dyson, Michael Eric. "Film Noir." *Tikkun* 4 (1989):75–78.

*Dyson, Michael. "Growing Up Under Fire: *Boyz n the Hood* and the Agony of the Black Man in America." *Tikkun* 6 (1991):74–78.

*Ehrenstein, David. "Gus Van Sant is an Exception Among Gay Filmmakers." *The Advocate* (September 24, 1991):85.

*Elder, Bruce. *Image and Identity: Reflections on Canadian Film and Culture.* Waterloo, ONT: Wilfrid Laurier University Press, 1989.

*Ellis, John. "Stars as a Cinematic Phenomenon." In *Film Theory and Criticism.* Mast, Gerald, et al., eds. New York: Oxford University Press, 1992: 614–621.

*Flood, Richard. "Dealer's Choice." *Artforum* (February 1994):9–10.

*Foucault, Michel. *Discipline & Punish: The Birth of the Prison.* New York: Vintage Books, 1979.

*Francke, Lizzie. "*My Own Private Idaho.*" *Sight and Sound* 1 (1992):55–56.

*Fraser, Nancy. "Gender Equity and the Welfare State." *In Democracy and Difference: Contesting the Boundaries of the Political.* Seyla Benhabib, ed. Princeton, NJ: Princeton University Press, 1996: 218–242.

*Fukuyama, Francis. *The End of History.* New York: Free Press, 1992.

*Furhammar, Leif. *Politik Och Film.* New York: Praeger Publishers, 1971.

*Gellner, Ernest. *Culture, Identity, and Politics.* New York: Cambridge University Press, 1987.

*Gerald Markle and Frances McCrea. Minutes to Midnight. Newbury Park, CA: Sage Publications, 1989.

*Giroux, Henry. *Fugitive Cultures: Race, Violence & Youth.* New York: Routledge, 1996.

*Glicksman, Marlaine. "Spike Lee's Bed-Stuy BBQ." *Film Comment* 25 (1989):12–18.

*Gordon, Geoff. "Six Degrees of Trepidation: Will Smith Plays Gay with Apprehension." *The Advocate* (February 8, 1994):54–56.

*Gould, Carol. "Diversity and Democracy: Representing Difference." *In Democracy and Difference: Contesting the Boundaries of the Political.* Seyla Benhabib, ed. Princeton, NJ: Princeton University Press, 1996: 171–186.

*Grant, Edmond. "*Boyz N the Hood.*" *Films in Review* 43 (1992):53–4.

*Greenberg, Harvey. "*My Own Private Idaho.*" *Film Quarterly* 46 (1992):23–25.

*Greenberg, James. "*Imitation of Life.*" *American Film* 14 (1989):13–14.

*Grenier, Richard. *Capturing the Culture: Film, Art, and Politics.* Washington DC: Ethics and Public Policy Center, 1991.

*Guare, John. *Six Degrees of Separation.* New York: Random House, 1990.

*Guinier, Lani. *The Tyranny of the Majority: Fundamental Fairness in Representative Democracy.* New York: The Free Press, 1994.

*"Gus Comes Clean." *Monk Magazine* (April 23, 1998). www.monk.com.

*Gutmann, Amy. "Democracy, Philosophy, and Justification." *In Democracy and Difference: Contesting the Boundaries of the Political.* Seyla Benhabib, ed. Princeton, NJ: Princeton University Press, 1996: 340–347.

*Gutmann, Amy. *Color Conscious: The Political Morality of Race.* Princeton, NJ: Princeton University Press, 1996.

*Gutmann, Amy. *Democracy and Disagreement.* Cambridge, MA:Belknap Press, 1996.

*Hamilton, Alexander, Madison, James and Jay, John. *The Federalist Papers.* New York: Penguin Books, 1961.

*Hardin, Russell. One for All: *The Logic of Group Conflict.* Princeton, New Jersey: Princeton University Press, 1995.

*Hollows, Joanne, and Jancovich, Mark, eds. *Approaches to Popular Film.* New York: St. Martin's Press, 1995.

*Honig, Bonnie. "Difference, Dilemmas, and the Politics of Home." In Democracy and Difference: Contesting the Boundaries of the Political. Seyla Benhabib, ed. Princeton, NJ: Princeton University Press, 1996: 257–276.

*hooks, bell. *Black Looks: Race and Representation.* Boston: South End Press, 1992.

*hooks, bell. *Reel to Real: Race, Sex, and Class at the Movies.* New York: Routledge, 1996.

*hooks, bell. *Talking Back: Thinking Feminist, Thinking Black.* Boston: South End Press, 1989.

*hooks, bell. *Yearning: Race, Gender, and Cultural Politics.* Boston: South End Press, 1990.

*Hoover, Kenneth. *A Politics of Identity.* Urbana: University of Illinois Press, 1975.

*Irigaray, Luce. *je, tu, nous: Toward a Culture of Difference.* New York: Routledge, 1993.

*Irigaray, Luce. *thinking the difference: For a Peaceful Revolution.* New York: Routledge, 1994.

*Isherwood, Charles. "*Six Degrees of Separation.*" *Variety* (October 28, 1996):79.

*Jacobs, Lewis. *The Rise of the American Film, A Critical History.* New York: Teachers College Press, 1968.

*James, David E. Allegories of Cinema: *American Film in the Sixties.* Princeton, NJ: Princeton University Press, 1989.

*John Stuart Katz, ed. Boston: Little, Brown and Company, 1971: 227–233.

*Johnson, Julie, and Vargas, Colby. "The Smell of Celluloid in the Classroom: Five Great Movies That Teach." *Social Education* 58 (1994):109–113.

*Johnson, Victoria. "Polyphony and Cultural Expression: Interpreting Musical Traditions in *Do the Right Thing.*" *Film Quarterly* 47 (1993):18–29.

*Jordan, June. *On Call: Political Essays.* London: Pluto Press, 1985.

*Kaplan, Ann. *Looking for the Other: Feminism, Film, and the Imperial Gaze.* New York: Routledge, 1997.

*Katz, John, ed. *Perspectives on the Study of Film.* Boston: Little, Brown and Company, 1971.

*Kauffmann, Stanley. "Stanley Kauffmann on Films." *The New Republic* (December 27, 1993):24–25.

*Kermode, Mark. "*Boyz N the Hood.*" *Sight and Sound* 1 (1991):37.

*Kirkham, Pat, and Thumim, Janet, eds. *Me Jane: Masculinity, Movies, and Women.* New York: St. Martin's Press, 1995.

*Klawans, Stuart. "*Do the Right Thing.*" *The Nation* (July 17, 1989):98–100.

*Klawans, Stuart. "*My Own Private Idaho.*" *The Nation* (October 28, 1991):528–529.

*Klawans, Stuart. "*Six Degrees of Separation.*" *The Nation* (January 3,1994):32.

*Kline, Jim. "*My Own Private Idaho.*" *Magill's Cinema Annual* (1992):247–251.

*Knapper, Karl. "Media Activism and Difference." *Socialist Review* 23 (1993):109–121.

*Kracauer, Siegfried. "Basic Concepts." In *Film Theory and Criticism.* Mast, Gerald, et al., eds. New York: Oxford University Press, 1992a: 9–20.

*Kracauer, Siegfried. "The Establishment of Physical Existence." In *Film Theory and Criticism.* Mast, Gerald, et al., eds. New York: Oxford University Press, 1992b: 249–259.

*Kymlicka, Will. "Three Forms of Group-Differentiated Citizenship in Canada." In *Democracy and Difference: Contesting the Boundaries of the Political.* Seyla Benhabib, ed. Princeton, NJ: Princeton University Press, 1996:153–170.

*Kymlicka, William. *Multicultural Citizenship.* Oxford: Clarendon Press, 1995.

*Lafrance, J.D. "Fringes of Society." April 23, 1998. www.ridley.on.ca/Personal/lafjd/ private%20 *Idaho*.html.

*Landy, Marcia. *Film, Politics, and Gramsci.* Minneapolis: University of Minnesota Press, 1994.

*Lapsley, Robert. *Film Theory: An Introduction.* Manchester, UK: Manchester University Press, 1988.

*Larner, Jeremy. "*Do the Right Thing.*" *Dissent* 36 (1989):559–561.

*Lee, Spike. "Spike Lee Replies: 'Say It Ain't So, Joe.'" *New York* (July 17, 1989):6.

*Leland, John. "A Black Omen for Black Movies?" *Newsweek* (July 29, 1991):48–49.

*Light, Alan. "Not Just One of the Boyz." *Rolling Stone* (September 5, 1991):73–4.

*Lindroth, Colette. "Spike Lee & The American Tradition." *Literature-Film Quarterly* 24 (1996):26–30.

*Linton, James. "The Nature of the Viewing Experience: The Missing Variable in the Effects Equation." In *Film/Culture: Explorations of Cinema in its Social Context.* Sari Thomas, ed. NJ: The Scarecrow Press, 1982: 184–194.

*Lorde, Audre. *Sister Outsider: Essays & Speeches by Audre Lorde.* Freedom, CA: The Crossing Press, 1984.

*MacCabe, Colin, ed. *High Theory/Low Culture: Analyzing Popular Television and Film.* Manchester, UK: Manchester University Press, 1986.

*MacIntyre, Alasdair. *After Virtue: A Study in Moral Theory.* Notre Dame, IN: University of Notre Dame Press, 1984.

*Macnab, Geoffrey. *"Six Degrees of Separation." Sight and Sound* 5 (1995):53–54.

*Magiera, Marcy. "Violence, Film Marketing Aren't Linked: Singleton." *Advertising Age* (January 27, 1992):42.

*"Making *Do the Right Thing." Variety* (September 6, 1989):29.

*Maloney, Frank. *"My Own Private Idaho."* April 23, 1998. http://us.imdb.com/ Reviews/12/1211.

*Mansbridge, Jane. "Using Power/Fighting Power: The Polity." In *Democracy and Difference: Contesting the Boundaries of the Political.* Seyla Benhabib, ed. Princeton, NJ: Princeton University Press, 1996: 46–66.

*Marable, Manning. *Race, Reform and Rebellion: The Second Reconstruction in Black America, 1945–1982.* Jackson: University of Mississippi Press, 1984.

*Massey, Douglas, and Denton, *Nancy. American Apartheid: Segregation and the Making of the Underclass.* Cambridge, MA: Harvard University Press, 1993.

*Mast, Gerald, Cohen, Marshall, and Braudy, Leo, eds. *Film Theory and Criticism.* New York: Oxford University Press, 1992.

*McCarthy, Todd. *"My Own Private Idaho." Variety* (September 9, 1991):64.

*McGillian, Pat. "If Critics Picked the Oscars." *American Film* 15 (1990):26–31.

*Melucci, Alberto. "The New Social Movements: A Theoretical Approach." *Social Science Information* 19 (1980): 199–226.

*Minh-Ha, Trinh. *When the Moon Waxes Red: Representation, Gender and Cultural Politics.* New York: Routledge, 1991.

*Mitchell, W.J.T. "Seeing *Do the Right Thing." Critical Inquiry* 17 (1991):596–608.

*Mohanty, Satya. "The Epistemic Status of Cultural Identity: On Beloved and the Post-Colonial Condition." *Cultural Critique* (Spring 1993):41–80.

*Moon, Michael, and Davidson, Cathy, ed,. *Subjects and Citizens: Nation, Race, and Gender from Oroonoko to Anita Hill.* Durham, NC: Duke University Press, 1995.

*Moraga, Cherrie, and Anzaldua, Gloria, eds. *This Bridge Called My Back: Writings by Radical Women of Color.* New York: Kitchen Table, Women of Color Press, 1983.

*Morgan, Michael, and Leggett, Susan, *eds. Mainstream(s) and Margins: Cultural Politics in the 90s.* Westport, CT: Greenwood Press, 1996.

*Morrison, Toni. *Beloved.* New York: Penguin Books, 1988.

*Mouffe, Chantal, ed. *Dimensions of Radical Democracy: Pluralism, Citizenship, Community.* New York: Verso, 1992. Seyla Benhabib, ed. Princeton, NJ: Princeton University Press, 1996: 245–256.

*Mouffe, Chantal. "Democracy, Power and the Political." In *Democracy and Difference: Contesting the Boundaries of the Political.* Seyla Benhabib, ed. Princeton, NJ: Princeton University Press, 1996: 245–256.

*Mouffe, Chantal. *The Return of the Political.* New York: Verso, 1993.

*Nadell, James. *"Boyz N the Hood:* A Colonial Analysis." *Journal of Black Studies* 25 (1995):447–64.

*Noble, Gordon. *Children in Front of the Small Screen.* Beverly Hills, CA: Sage Publications, 1975.

*Nowell-Smith, Geoffrey. "Blackass Talk: *Do the Right Thing." Sight and Sound* 58 (1989):281.

*Omi, Michael, and Winant, Howard. *Racial Formation in the United States: From the 1960s to the 1990s*. New York: Routledge, 1994.

*Pawelczak, Andy. *"Six Degrees of Separation."* *Films in Review* 45 (1994):56–57.

*Perkins, V.F. "Form and Discipline." In *Film Theory and Criticism*. Mast, Gerald, et al., eds. New York: Oxford University Press, 1992: 52–58.

*Phillips, Anne. *"Dealing with Difference:* A Politics of Ideas, or a Politics of Presence?" In *Democracy and Difference: Contesting the Boundaries of the Political*. Seyla Benhabib, ed. Princeton, NJ: Princeton University Press, 1996:139–152.

*Phillips, Anne. Democracy and Difference. University Park: The Pennsylvania State University Press, 1993.

*Phillips, Anne. *The Politics of Presence*. New York: Oxford University Press, 1995.

*Pitman, Randy. *"Do the Right Thing."* *Library Journal* 115 (1990):164.

*Plano, Jack, and Greenberg, Milton. *The American Political Dictionary*. New York: Harcourt Brace College Publishers, 1993.

*Podhoretz, John. "Movie Violence Isn't an Excuse for Criminals." *Insight on the News* (August 12, 1991):44–5.

*Polan, Dana B. *The Political Language of Film and the Avant-Garde*. Ann Arbor: University of Michigan Press, 1985.

*Potamkin, Harry. The Compound Cinema: *The Film Writings of Harry Alan Potamkin*. New York: Teachers College Press, 1977.

*Prindle, David. *Risky Business: The Political Economy of Hollywood*. Boulder, CO: West-view Press, 1993.

*Quadagno, Jill. *The Color of Welfare: How Racism Undermined the War on Poverty*. New York: Oxford University Press, 1994.

*Quart, Leonard, and Auster, Albert. *American Film and Society Since 1945*. New York: Praeger, 1984.

*"Racism, 1989." *The Progressive* 53 (1989):10.

*Rainer, Peter. *"Do the Right Thing."* *American Film* 15 (1990):60.

*Rawls, John. "The Idea of an Overlapping Consensus." *Oxford Journal of Legal Studies* 7 (1987): 1–25.

*Rawls, John. *A Theory of Justice*. Cambridge, MA: Harvard University Press, 1971.

*Rawls, John. *Political Liberalism*. New York: Columbia University Press, 1993.

*Reid, Mark, ed. *Spike Lee's* Do the Right Thing. Cambridge, UK: Cambridge University Press, 1997.

*Rhines, Jesse. *Black Film/White Money*. Rutgers, NJ: Rutgers University Press, 1996.

*Rich, Frank. "Review of John Guare's Six Degrees of Separation." *New York Times* (15 June 1990), national ed.: C1.

*Roman, David. "Fierce Love and Fierce Response: Intervening in the Cultural Politics of Race, Sexuality, and AIDS." *Journal of Homosexuality* 26 (1993):195–219.

*Roman, David. "Shakespeare Out in Portland: Gus Van Sant's My Own Private Idaho, Homoneurotics, and Boy Actors." *Journal of Homosexuality*.

*Rosenbaum, Jonathan. *Movies as Politics*. Berkeley: University of California Press, 1997.

*Rowland, Robert. "Social Function, Polysemy and Narrative-Dramatic Form: A Case Study of Do the Right Thing." *Communication Quarterly* 42 (1994):213–228.

*Ryan, Michael, and Kellner, Douglas. *Camera Politica: The Politics and Ideology of Contemporary Hollywood Film.* Bloomington: Indiana University Press, 1988.

*Sandel, Michael, ed. *Liberalism and Its Critics.* New York: New York University Press, 1984.

*Sarris, Andrew. *Politics and Cinema.* New York: Columbia University Press, 1978.

*Sarris, Andrew. *The American Cinema.* New York: E.P. Dutton & Co., 1993.

*Schillaci, Anthony. "Film and Environment." In *Perspectives on the Study of Film.* John Stuart Katz, ed. Boston: Little, Brown and Company, 1971: 214–226.

*Schlesinger, Arthur Jr. *The Disuniting of America: Reflections on a Multicultural Society.* New York: W.W. Norton & Company, 1992.

*Seaton, James. *Cultural Conservatism, Political Liberalism: From Criticism to Cultural Studies.* Ann Arbor: University of Michigan Press, 1996.

*Seelow, David. "Look Forward in Anger: Young, Black Males and the New Cinema." *The Journal of Men's Studies* 5 (1996):153–78.

*Sharkey, Betsy. "Knocking on Hollywood's Door: Black Filmmakers like Spike Lee Struggle to See and Be Seen." *American Film* 14 (1989):22–25.

*Signorile, Michelangelo. "Absolutely Queer." *The Advocate* (November 19, 1991):35.

*Sikes, Gini and Powell, Paige. "Keanu Reeves/River Phoenix." November 1991. www. nostromo.no/ norwegianwood/articles/i/intv/1191/html.

*Silverman, Kaja. *The Threshold of the Visible World.* New York: Routledge, 1996.

*Simon, John. "Growing Pains, Growing Joys." *National Review* September 23, 1991:54–5.

*Simpson, Janice. "Not Just One of the Boyz." *Time* (March 23, 1992):60–61.

*Singh, Amritjit, Skerrett, Joseph, and Hogan, Robert, eds. *Memory and Culture Politics: New Approaches to American Ethnic Literature.* Boston: Northeastern University Press, 1996.

*"*Six Degrees of Separation.*" *New York* (December 20, 1993):170–171.

*Sklar, Robert. *Movie-Made America: A Cultural History of American Movies.* New York: Random House, 1975.

*Smith, Cherry. "Queer Questions." *Sight and Sound* 2 (1992):34–35.

*Smith, Murray. *Engaging Characters: Fiction, Emotion, and the Cinema.* New York: Clarendon Press, 1995.

*Sobchack, Vivian. "Genre Film: Myth, Ritual, and Sociodrama." In *Film/Culture: Explorations of Cinema in Its Social Context.* Sari Thomas, ed. NJ: The Scarecrow Press, Inc., 1982: 147–167.

*"Spike Lee Talks About His Best Films." *Jet* (October 1, 1995):33.

*Stein, M.L. "Do the Right Thing? Filmmaker Spike Lee Says He'd Prefer to be Interviewed by Black Reporters; Los Angeles Times Balks." *Editor & Publisher* 125 (1992):9–10.

*Stevens, D. "I Make Films for an Open-Minded Audience." *Newsweek* (July 29, 1991):48–49.

*Stevenson, William. "Fine Line Finesses Art-House Mainstays." *Variety* (August 10, 1992):40–44.

*Stone, Robert, ed. *Essays on the Closing of the American Mind.* Chicago: Chicago Review Press, 1989.

*Story, Richard. "Six Degrees of Preparation." *New York* (June 7, 1993):38–43.

*Suarez, Juan. Bike Boys, *Drag Queens & Superstars: Avant-Garde, Mass Culture, and Gay Identities in the 1960s Underground Cinema.* Bloomington: Indiana University Press, 1996.

*Taubin, Amy. "Objects of Desire." *Sight and Sound* 1 (1992):8–13.

*Taylor, Charles. The Ethics of Authenticity. Cambridge, MA: Harvard University Press, 1992a.

*Taylor, Charles. *Multiculturalism and "The Politics of Recognition." Princeton*, NJ: Princeton University Press, 1992b.

*Taylor, Charles. *Sources of the Self: The Making of the Modern Identity*. Cambridge, MA: Harvard University Press, 1989.

*Taylor, John Russell. "Movies for a Small Screen." *Sight and Sound* 44 (1975): 113–115.

*Thomas, Sari, ed. *Film/Culture: Explorations of Cinema in its Social Context*. Metuchen, NJ: Scarecrow Press, 1982.

*Thompson, David. *America in the Dark: Hollywood and the Gift of Unreality*. New York: William Morrow and Company, 1977.

*Thompson, Michael, Ellis, Richard, and Wildavsky, Aaron, eds. *Cultural Theory*. Boulder, CO: Westview Press, 1990.

*Traube, Elizabeth. *Dreaming Identities: Class, Gender, and Generation in 1980s Hollywood Movies*. Boulder, CO: Westview Press, 1992.

*Travers, Peter. "*Boyz N the Hood." Rolling Stone* (August 8, 1991):78.

*Travers, Peter. "Movies of the Eighties." *Rolling Stone* (December 14, 1989):23.

*Tudor, Andrew. "Film and the Measurement of Its Effects." *Screen* 10 (1969): 148–159.

*Van Sant, Gus. *Even Cowgirls Get the Blues & My Own Private Idaho*. Boston: Faber and Faber Press, 1993.

*Vanderbeek, Stan. "Re: Vision." In *Perspectives on the Study of Film*. John Stuart Katz, ed. Boston: Little, Brown and Company, 1971: 227–233.

*Wall, James. "*Do the Right Thing*: A Jarring Look at Racism." Christian Century 106 (1989):739–740.

*Wall, James. "Films of Power and Grace in '89." *Christian Century* 107 (1990):67–68.

*Wallace, Michele. "Invisibility Blues: Michele Wallace on *Do the Right Thing*." Artforum 28 (1989):21.

*Walzer, Michael. *What It Means to Be an American*. New York: Marsilio, 1992.

*Wellman, David. *Portraits of White Racism*. Cambridge, UK: Cambridge University Press, 1993.

*West, Cornel. *Race Matters*. New York: Vintage Books, 1994.

*White, Armond. "Flipper Purify and Furious Styles." *Sight and Sound* 1 (1991):8–13.

*Williams, Linda, ed. *Viewing Positions: Ways of Seeing Film*. Rutgers, NJ: Rutgers University Press, 1995.

*Wilmsen, Edwin, and McAllister, Patrick, eds. *The Politics of Difference: Ethnic Premises in a World of Power*. Chicago: University of Chicago Press, 1996.

*Wilson, William Julius. *The Declining Significance of Race: Blacks and Changing American Institutions*. Chicago: The University of Chicago Press, 1980.

*Wolin, Sheldon. "Democracy, Difference, and Re-Cognition." *Political Theory* 21 (1993): 464–482.

*Wood, Michael. *America in the Movies: "Santa Maria, It Had Slipped My Mind."* New York: Basic Books, 1993.

*Worth, Sol. "Film as a Non-Art: An Approach to the Study of Film." In *Perspectives on the Study of Film*. John Stuart Katz, ed. Boston:Little, Brown and Company, 1971: 180–199.

*Worth, Sol. "Pictures Can't Say Ain't." In *Film/Culture: Explorations of Cinema in its Social Context*. Sari Thomas, ed. NJ: The Scarecrow Press, 1982: 97–109.

*Young, Iris Marion. "Communication and the Other: Beyond Deliberative Democracy." In *Democracy and Difference: Contesting the Boundaries of the Political.* Seyla Benhabib, ed. Princeton, NJ: Princeton University Press, 1996: 120–136.

*Young, Iris Marion. *Justice and the Politics of Difference.* Princeton, NJ: Princeton University Press, 1990.

*Zahed, Ramin. "Indie Farm Team Fields Future H'wood Stars." *Variety* (February 23, 1998):a14.

*Zavarzadeh, Mas'ud. *Seeing Films Politically.* New York: State University of New York Press, 1991.